D0081510

IRENE RICE PEREIRA

American Studies Series
William H. Goetzmann, Editor

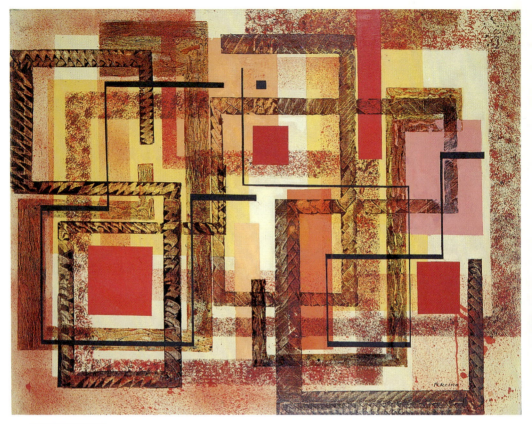

FRONTISPIECE

Radiant Source of Spring, 1952, oil on canvas, 40 × 50 in. Courtesy, Andre Zarre Gallery, New York City.

IRENE
RICE
PEREIRA

Her Paintings and Philosophy

BY KAREN A. BEAROR

 University of Texas Press

Copyright © 1993 by the University of Texas Press
All rights reserved
Printed in the United States of America
First edition, 1993

Requests for permission to reproduce material from this work should be sent to
Permissions, University of Texas Press, Box 7819, Austin, TX 78713–7819.

∞ The paper used in this publication meets the minimum requirements of
American National Standard for Information Sciences—Permanence of Paper for
Printed Library Materials, ANSI Z39.48–1984.

Library of Congress Cataloging-in-Publication Data

Bearor, Karen A. (Karen Anne), 1950–
 Irene Rice Pereira : her paintings and philosophy / by Karen A.
Bearor.—1st ed.
 p. cm.—(American studies series)
 Includes bibliographical references and index.
 ISBN 0-292-73858-7 (alk. paper)
 1. Pereira, I. Rice (Irene Rice). 1902–1971—Criticism and
interpretation. 2. Modernism (Art)—United States. I. Pereira,
I. Rice (Irene Rice), 1902–1971. II. Title. III. Series.
ND237.P36B43 1993
759.13—dc20 92-46895

The author gratefully acknowledges Andre Zarre, Andre Zarre Gallery, New
York, New York, for his courtesy and generosity in funding the color reproduc-
tions that appear in this book.

Dedicated to the women and men taking my first course devoted to women artists, held at the University of Houston during the spring term of 1991

and to the memory of Dwinell Grant
artist, filmmaker, friend to Pereira and to myself

Contents

Illustrations

Acknowledgments

This book has been nearly a decade in the making, and with any such project, there are many people to thank and so few words that might adequately convey my gratitude. I must first express my appreciation to Linda Dalrymple Henderson, who introduced me to Irene Rice Pereira's work and provided much guidance and encouragement through the work's incarnation as my dissertation. I am grateful, too, to the other members of my dissertation committee, John R. Clarke, Kenneth W. Prescott, William Stott, and Frederick M. Kronz, for their invaluable contributions, as well as to the art history faculty at the University of Texas at Austin, who contributed to a rich learning environment and nominated me for a University Fellowship, which funded portions of the initial research for this project.

My work has since benefited from substantial new research and the assistance of many other people. Foremost among these, I would like to recognize the generosity and encouragement of Andre Zarre, who has steadfastly kept Pereira's work visible in New York for the two decades since her death, and Djelloul Marbrook, the artist's nephew, who has graciously made archival materials available to me and to other scholars. I am grateful to the late Dwinell Grant, who gave so generously of his time and his remembrances in lengthy and cherished correspondence, and to his wife, Jean. I regret that he did not live to see the completion of this project. Harold LeRoy has provided me with information about the artist and kindly allowed me to read some of Pereira's letters to himself and his wife, Irene. I must also mention the efforts of Krystyna Wasserman, of the Library of the National

Museum of Women in the Arts, who not only made Pereira's library available to me for my work but has also fought to preserve these books for future scholars. I am grateful to the staff of The Arthur and Elizabeth Schlesinger Library on the History of Women in America, Radcliffe College, who provided access to the boxes of materials in the artist's archive. Much of the material there appears on microfilm at the Archives of American Art, Smithsonian Institution, Washington, D.C., which facilitated my research. I thank the staff of the archives and also the staffs of the Interlibrary Loan Services of the University of Texas at Austin, the University of Nebraska at Lincoln, the University of Illinois at Urbana-Champaign, and the University of Tennessee at Knoxville for their assistance in making this microfilm available. The George Reavey archive contains the Reavey-Pereira correspondence that is essential to any study of Pereira, and I appreciate the opportunity to read this uncataloged material at the Harry Ransom Humanities Research Center at the University of Texas at Austin. The following institutions also made archival materials available to me: the National Archives, Washington, D.C.; the Washington Women's Art Center, Washington, D.C.; the Museum of Modern Art, New York; the Whitney Museum of American Art, New York; The S. R. Guggenheim Museum, New York; The Brooklyn Museum, Brooklyn, New York; and the Library of the National Museum of American Art and National Portrait Gallery, Smithsonian Institution.

I would also like to thank the following individuals, each of whom provided information or other materials that enriched my understanding of Pereira: John and Marie Bocchieri, Chiang Huey-Na, Lawrence Campbell, Dorothy Dehner, Alice E. Fabian, Rosina A. Florio, Juanita Rice Guccione, Harry Holtzman, Herrick Jackson, Susan Larsen, Barbara Liebowits, Robert Liebowits, Richard A. Madlener, Donna Marxer, Alice Nichols, Peter Nichols, Eileen Pols, the Harvey W. Rambachs, the late Jean Bullowa Reavey, Therese Schwartz, the late Marvin Small and his wife, Dorothy, Judy Collischan Van Wagner, Joe Wissert, and Helen Ziegler. The following persons also facilitated my research: Vivian Barnett, Sonja Bay, Ward Jackson, Pat Lynagh, and Mark Palombo. I am grateful to Diane Easton, formerly with The Lowe Art Museum, University of Miami, Coral Gables, Florida, for assisting me in my photographing of the Pereira paintings in that collection, and to Bryan A. Dursum, director, and Denise Gerson, curator, at the same institution for their continued support of my work. My thanks are extended to Diane Fox for her help in pro-

ducing photographic prints for this project and to Engeline Tan for her assistance in preparing the manuscript. Jane Goldberg, Marianne Kinkel, and Lisa Morgan also contributed their time, for which I am greatly appreciative. Although too numerous to list, many museums and private collectors provided me with photographs or slides of Pereira's work, and I am indebted to them for facilitating my research. To series editor William Goetzmann and to Frankie Westbrook of the University of Texas Press, I extend my gratitude for providing me with the opportunity to share my work with others.

My former colleagues at the University of Nebraska at Lincoln, the University of Illinois at Urbana-Champaign, the University of Tennessee at Knoxville, and the University of Houston have been patient, understanding, and supportive, for which there are no adequate words of thanks. I am also indebted to the following long-time friends who have seen me through all the emotional peaks and valleys during my work on this project: Bobbye Barker, Eric Coffman, Ann Harris, Martha Horvay, V. D. Mistry, and Sandy Walker. More recently, Judith Steinhoff and Nan Cowick have been ready with just the right counsel. To all my other friends and colleagues, thank you.

A final word of thanks is extended to my family, particularly my brother, Frank Brothers, and my sister, Debbie Shehorn, for their forbearance, support, and love.

Introduction

During the decades following the solar eclipse of 1919, which "proved" Albert Einstein's theory of general relativity, theoretical cosmology flourished. Theories of an everchanging, evolving, and expanding universe were proposed during the 1920s by a Russian meteorologist-mathematician, Alexander Friedmann, and a Belgian cleric, Abbé Georges Lemaître, and confirmed by American astronomer Edwin P. Hubbel at Mount Wilson Observatory. Lemaître's cosmology, relatively unknown until the 1930s, proposed that the universe began as a "primeval atom" or "cosmic egg," containing all matter. Its disintegration marked the beginning of time and space.[1] His formulation anticipated the Big Bang theory, posited by George Gamow of George Washington University in the late 1940s. Rather than "cosmic egg," Gamow used the archaic English word *ylem,* meaning the primordial, elemental substance of all things, to describe the contracted state of matter prior to the initial event, the "bang," that created the universe.[2] Faced with overwhelming evidence that refuted his own view of the cosmos as static and finite, Einstein abandoned his initial views in 1930 and subsequently adopted a complex theory of an alternately expanding and contracting universe.[3]

Ironically, the cosmological models constructed by twentieth-century scientists and theorists bore striking resemblances to medieval ones. William Ralph Inge, the Anglican prelate and dean of St. Paul's in London, noted with joy Einstein's acceptance of the theory of cosmic expansion and contraction. Inge, who was instrumental in reviving an interest in the works of the Neoplatonic philosopher Plotinus, was comforted by Einstein's "return

to the old theory of cosmic cycles."[4] Furthermore, the investigations being made by particle accelerators, to transmute one element into another, led many to associate these scientists' activities to those of the medieval alchemists and their successors. Making gold from lead did not seem so farfetched an idea anymore.

One person who found these issues compelling—so much so that she called herself a "cosmologist" late in life[5]—was the American artist Irene Rice Pereira. Neither her paintings nor her philosophical writings are well known now, even by specialists. Yet she shared with Loren MacIver the honor of being the second woman, after Georgia O'Keeffe, to be given a retrospective at a major New York museum when, in 1953, the Whitney Museum of American Art showcased their works in a joint exhibition. Such an honor must indicate that she had made significant contributions to modernist art, but, if so, why is so little known about her now? What factors led to her relative invisibility in the histories of the period? How is it that, five years after her death in 1971, at the time of the last major exhibition of her work, *New York Times* critic John Russell could make a trivia guessing game of her name and reputation?[6] More to the point, does she merit recovery? If so, why?

It is not my purpose to write a romantic biography about Irene Rice Pereira, to celebrate her overcoming all odds to reach the pinnacle of success. That would certainly have been the book that Pereira herself would have preferred. Yet to do so would reproduce what Griselda Pollock has identified as one of the central myths of art history, that of the heroic artist-individualist, and I do not believe that such a program serves women well.[7] It is also not my purpose to demonstrate that Pereira deserved greater recognition during her lifetime. After all, she had a distinguished exhibition record comparable to or exceeding that of most artists of the period, male or female. Certainly, her contribution to American art has been undervalued since the time of her Whitney retrospective, but this study is not intended solely as a corrective. It is more important—and herein lies the answer to the last question above—to locate the artist and her works within a matrix of ideas and the forces that propelled them, and to examine the choices she was given and those she made in order to survive within the art world during her productive period of 1930 to 1971. Such a study provides more information about the nature of modernism in the United States during this period, as well as how women artists such as Pereira negotiated their ways into the modernist discourse and contributed their own voices to its direction. Furthermore, while the primacy of the authorial voice of the artist

has justly been challenged by critics in recent years, it seems reck-less to disregard the artist altogether. Thus, some effort has been made to examine selected examples of Pereira's work within dif-ferent contexts and from different vantages, to resist any single interpretation, whether hers or my own.

As Elaine Showalter said of women writers, women artists work both inside and outside patriarchal traditions simultane-ously.[8] Thus, it is not only important to indicate how Pereira's interests dovetailed with those of male colleagues, but also how she tried to inscribe "difference" into forms heavily promoted as "universal," to privilege her own sociopolitical position. One must also examine the major sources for the philosophical essays she began to publish in 1951 and how these writings were perceived by others within the art community. Although Pereira was also a poet, that body of work is left for others to analyze.

This study follows a loosely chronological path, with each chap-ter structured around a central theme. The reader is provided with some signposts regarding Pereira's personal life, particularly in the first chapter, but, ultimately, this is not a traditional biography. As there has been no major study of her work prior to this, and because much of the information that has been published is erro-neous, a chronology of significant events in her life and a list of the major exhibitions in which she participated are appended to assist those who might wish further biographical information.

Throughout this work, I have placed the words *masculine* and *feminine* in quotations where the usage is implied to refer to some set of characteristics presumed to be linked innately with being biologically male or female. My own view is that gender roles are social constructs and that there are no essentially "masculine" or "feminine" characteristics. However, Pereira, and several of the other figures who enter my study, particularly Carl G. Jung, be-lieved in and employed these stereotypes. The reader should be able to determine which biases are mine and which are theirs.

Pereira used the professional signature "I. Rice Pereira." Ap-parently, no one recorded her reason for hiding the "Irene" be-hind the "I"—the invisible woman behind the personal pronoun. Many of those who knew her assumed that this was a strategy by which she might insist that her work be judged, not her gender. It would be difficult to argue otherwise, although, as I mention without elaboration in the first chapter of this study, on at least one occasion she elided the "Irene" in her signature before be-coming an artist. Whether this was an isolated instance or stan-dard practice is unknown due to lack of extant documentation. However, she did experiment briefly in 1932 with a hyphenated

"Rice-Pereira" as her signature. With respect to how she wished to be addressed in professional encounters, she preferred "Pereira."[9]

Researching Pereira's life and work involves surmounting numerous barriers, the primary one being a lack of extant documentation concerning her early years. While she kept a scrapbook of clippings beginning in 1930, she did not save correspondence in any systematic way until about 1951. Furthermore, it was not until that year that she began to keep carbon copies of her own letters to others.[10] While there are several boxes of notes and manuscripts in her archive, most of the material is dated 1962 or later. Very few documents survive from the 1930s and 1940s. While natural attrition undoubtedly accounts for most of what has been lost, it is also likely that the artist herself "edited" her papers. In 1964, in a fit of despondency over the death of John F. Kennedy and what she feared would be a backlash against those artists and intellectuals who advanced spiritual values, she declared that she was going to have to keep her materials "cleared up" at all times.[11] She may have destroyed a quantity of her papers at this time. Furthermore, following her separation from George Reavey in 1956, she demanded that he return her letters for fear that they might fall into the wrong hands.[12] Fortunately, Reavey did not comply. As a result, one of the most important troves of information about her is not her own archive but his. Because of their intimacy, she felt greater freedom to share with him the results of her psychoanalysis, the titles of some of the books she was reading, as well as her nascent ideas concerning her philosophy. Without this cache of letters, for instance, one would not know the extent of her knowledge of alchemy nor, in 1950, the significance to her of Richard Wilhelm's translation of *The Secret of the Golden Flower* with Jung's commentary. Only a handful of references to this important book appear in the notes in her archive, and these are dated 1962.

These difficulties aside, one further comment is necessary regarding this book. To prevent confusion with omitted passages, the ellipses Pereira used to separate thoughts in her writing have been replaced with dashes in quotations throughout. Otherwise, all punctuation appears here as in the original sources. Her spelling and typographical errors have been corrected in quotations.

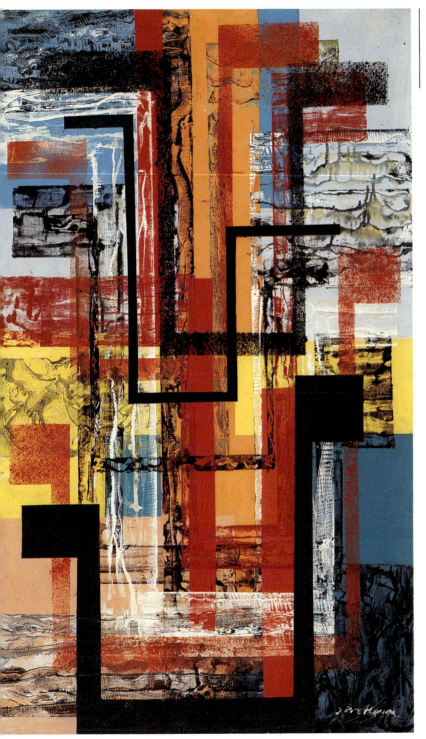

Pillar of Fire, 1955,
oil on canvas,
50 × 30 in.
Courtesy,
Andre Zarre
Gallery,
New York City.

Background, Training, and Early Philosophical Readings

Despite the fact that four decades have passed since its writing, the standard biography on Irene Rice Pereira (Figure 1) remains John I. H. Baur's brief essay in the catalogue accompanying her retrospective exhibition at the Whitney Museum of American Art in January 1953, eighteen years before her death.[1] The scattered articles written about her in more recent years depend either upon Baur's work or, in the case of those written by friends James Harithas and Therese Schwartz, upon what the artist chose to reveal to them. That the face she presented to friends might be frustratingly at odds with what she wrote in her letters, diaries, and philosophical essays is evidenced in Schwartz's efforts to "demystify" the work of a woman who, when given the opportunity late in life to select a label by which she should be identified, volunteered "metaphysician" rather than the anticipated "artist."[2] Yet Baur's résumé of the painter's life, too, contains numerous inaccuracies due to her adroit juggling of details to conform to her newly enhanced public image of artist-philosopher-poet. Pereira also glossed over her participation in liberal causes that had come under congressional attack, an understandable action considering the political climate of the period. This autobiographical "restructuring" (and occasional embellishment), which she had practiced to some extent since the early 1930s, does not minimize her contribution to the history of art. Coupled with her customary renaming of paintings two or three times apiece, however, it seriously impedes the progress of those trying to gain a more accurate picture of her professional and intellectual development. Yet such a task is necessary, for Pereira played a significant, if often overlooked, role in the development of modernism in America.

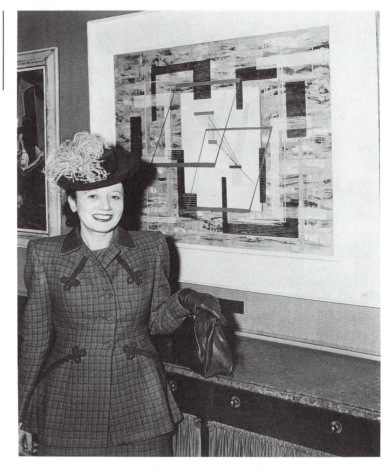

FIGURE I

Irene Rice Pereira
with painting
*Red, Yellow and
Blue* (1942), in 1946.
The Schlesinger
Library, Radcliffe
College.

Perhaps to conceal the fact that her decision to pursue a painting career did not occur until she was about twenty-four years old, Pereira gave her year of birth as 1907 throughout her career. Fiction became fact in her legal documents, for even her passport indicates 1907 as the year she was born. However, her birth certificate confirms that she was born Irene M. Rice (the middle initial was never used in her signature) in Chelsea, Massachusetts, on August 5, 1902. This document identifies her father as Emery Rice, a baker born in Poland, although the artist gave her father's name as Emanuel in 1953. The latter name also appears in the catalogue of her posthumous retrospective at the Andrew Crispo Gallery in New York in 1976, assembled with the aid of surviving family members. Her father had come to the United States as a child. Her mother, Hilda Vanderbilt Rice (Figure 2), whom the artist once described as "very, very proper," was a native Bostonian of German and Dutch descent. Irene Rice was the eldest of four

FIGURE 2

Hilda Vanderbilt
Rice with her half-
sister, Nettie. Date
of photograph
unknown. The
Schlesinger Library,
Radcliffe College.

FIGURE 3

Dorothy F. Rice.
Date of photograph
unknown. The
Schlesinger Library,
Radcliffe College.

children, with two sisters, Juanita Rice and Dorothy F. Rice (Figure 3), and a brother, James S. Rice.[3]

Little is known about Pereira's childhood, for she seldom reminisced about this period, even with close friends and associates.[4] However, for a time, at least, she lived in relative affluence. When she was very young, her father moved his family and the grain business from the Boston area to Pittsfield, in the Berkshire Hills of southwestern Massachusetts. Later, they moved a few miles south to Great Barrington, where her father bought a bakery. The family lived on an estate, with a large white house on a hill, where her father raised what Pereira described as "some of the best trotters on the Atlantic seaboard."

Pereira's childhood in Great Barrington, as she recalled with some nostalgia, was "very beautiful," although she felt isolated, with only her sisters and brother as playmates. She learned early how to hitch a horse to a sulky and ride into town, but otherwise "it was all very, very formal. I don't think I played very much. I read all the time." She also wrote poetry. Aunts, grandparents, and other relatives, all well educated in literature, music, and the arts, were frequent visitors to the Rice home. Her father's family included musicians and composers, and one uncle was a sculptor. As to her religious upbringing, Pereira remarked in 1968, "I think my father was very religious. My mother I don't think was. I used to go to church with the servants and not with my mother." She was presumably schooled in Protestant teachings; she converted to Catholicism in 1963.[5]

In addition to raising horses, Emanuel Rice collected fine porcelains and admired beautiful clothes, a passion his eldest daughter inherited. Characterized by her as "eccentric," he seldom concerned himself with household matters but spent much time at the horse races.[6] Apparently fascinated by the exotic, he congregated with "gypsies" and even bestowed upon Pereira the nickname "Gypsy."[7] Late in life, she declared that she identified more closely with her father than with her mother,[8] and, apart from area folklore concerning Salem witch-hunts, it may have been he who instilled in her, and in her sisters, an early interest in magic and the occult. Rice's business failed within a few years, and he moved his family back to Boston about the time Pereira was seven or eight. From there, about a year later, they relocated in Brooklyn, where Pereira subsequently attended Eastern District High School.[9]

Ironically, given her adult interest in the theoretical aspects of non-Euclidean geometry, Pereira claimed to dislike arithmetic in

school, but she continued to be fascinated by literature.[10] Frequently visiting the public library, she favored works by Louisa May Alcott, Jane Austen, Charles Dickens, and William Thackeray, as well as biographies of famous women. Ambitiously, she began to write a biography of one of the few well-known women heroes of history, Joan of Arc.[11] She also remembered being "surrounded" as a young girl by the influence of the Transcendentalist poets, whom she regarded late in life as more representative of the American spirit than any other literary school.[12] Her claims to have been reading Plato and Aristotle by the time she was twelve must be regarded with some skepticism, however.[13]

Emanuel Rice died about 1918.[14] His death left the Rice family in severe financial difficulty and, to cope with this crisis, his oldest daughter switched from the academic to the vocational curriculum in high school and reportedly finished three years' work in six months. Following this she took a three-week typing and stenography course that gave her the basic skills to become a stenographer in an accountant's office to help support her family.[15] Perhaps restless or seeking new employment skills, she began to take extension courses after work. Having designed clothes for her dolls and for family members as a young girl, she first enrolled in courses in fashion design at the Traphagen School of Fashion in Brooklyn, but, according to her later accounts, her instructor considered the dresses she drew to be too unconventional for her to have much of a future in this field.[16] To satisfy a lingering desire to become a writer, she also attended night courses in literature at New York University sometime during the early 1920s.

Around 1926, Pereira heeded the advice of her design teacher and began to take evening art classes at Manhattan's Washington Irving High School, a girls' school which painter Lee Krasner remembered as the only high school in New York City where young women could major in that subject.[17] Pereira did not seek instruction at a college or university, for, as Therese Schwartz has reminded us, when she was young, "most artists did not go to college, and most colleges did not even have studio art departments."[18] Nevertheless, given the creative interests of other members of her family and the apparent value placed upon a woman's attainment of some artistic skills within her home environment, Pereira's decision to enroll in art classes was a seemingly logical, if not inevitable, step.

Although Pereira came to be the most renowned, she was not the only artist in her immediate family, nor was she the first of the Rice children to seek advanced training. While her mother's cre-

ative ambitions extended little beyond making sketches on grocery lists,[19] her sister Dorothy took classes at the Art Students League with Charles B. Martin from 1923 to 1924, and later with Arthur Lee from 1940 until she was diagnosed with cancer in 1941. Juanita Rice studied with Hans Hofmann in the 1930s and received some acclaim in New York in the late 1940s and early 1950s under her married name, Marbrook.[20] Their brother, James, who became an international banker, pursued other interests.

Concurrent with her taking writing and art courses, Pereira immersed herself in the bohemian world of Greenwich Village. About 1926, she met poet and novelist Maxwell Bodenheim, whose reputation as a womanizer was perhaps more widely known than his publications. Bodenheim may have sensitized her to the social responsibilities of the artist, a recurring theme in his work. Through the Platonic imagery of his early poetry, he also sought to arrive at essential truths about humanity and the world, concerns the painter would similarly share throughout her life.[21] However, their affair was short-lived, and Pereira may have been little more to him than a source of funds. In constant poverty, he borrowed money from his friends and acquaintances, including her.[22] Nevertheless, as a memento of the romance, she kept copies of three of his books as well as a copy of Harriet Monroe's *Poets and Their Art.* Signed "I Rice 9/26," this last volume contains a section devoted to Bodenheim's work. Two of Bodenheim's books bear undated inscriptions by the author, the more affectionate of which appears in Pereira's copy of his autobiographical first novel, *Blackguard,* published in 1923. Here he made a cryptic reference to Pereira's pursuit of a "magical Horizon," while in her copy of *Ninth Avenue,* published in 1926, he described her as wearing a "flame-laced hood and jelab," an Arabian hooded cloak with wide sleeves. Her copy of his *King of Spain,* published in 1928, is uninscribed.[23]

With so little surviving information about Pereira's interests during this period, and considering her later obsession with alchemical literature and symbolism, Bodenheim's references to her dress and her "magical" pursuits take on heightened significance. At the least, they appear to confirm the artist's statement that she became interested in Orientalism soon after her father's death (and also, one might add, at the height of Rudolf Valentino's popularity).[24] This fascination with the Middle East is also supported by her possession of Manuel Komroff's *Oriental Romances,* published in 1930, a volume of love stories from Arabia, Persia, and India. Additionally, Pereira, like each of her sisters, demonstrated

a recreational interest in the occult during this period, if books in
her library, like her unmarked copy of Montague Summers' *History of Witchcraft and Demonology,* published in 1926, are any indication. A few volumes originally belonging to Dorothy and Juanita Rice are also mingled with hers. Two of these stand out, for they share a common theme: magical transformation or metamorphosis. One, *Petronius,* a 1916 edition inscribed with Dorothy Rice's signature, contains a translation of the *Satyricon,* including the "Banquet of Trimalchio." During the course of this narrative, characters tell two stories that involve either transformation or deceptive appearances. One concerns a werewolf, and in the other witches substitute a straw changeling for a boy. Pereira also kept a copy of Apuleius' *The Golden Ass,* inscribed "Nita Rice 1928." Alternately titled *Metamorphosis, The Golden Ass* relates the adventures of a young African follower of Plato's sect, Lucius, who begins his travels in Thessaly, the reputed home of witches. There, as a result of his curiosity, he is transformed into an ass, in which form he remains until the Egyptian goddess Isis returns him to his original state. Lucius, who we learn is the author Apuleius himself, is subsequently initiated into Isis' mysteries by the priest Mithras. The moral of *The Golden Ass* is that nothing may be taken at face value or be trusted to remain as it first appears.

In October 1927, at the age of twenty-five, Irene Rice followed her sister Dorothy's lead and enrolled in a night class at the Art Students League. This school, whose name appears in the biographies of virtually all the best-known New York artists of the first half of the twentieth century, had no entrance requirements, no required course of study, and no grading. Free to enroll or leave at any time, students chose their teachers, traditionally meeting with their classes twice a week, and paid tuition by the month. Within each class, students of varying levels of ability worked side by side, with selected advanced students, called monitors, supervising in the absence of the instructor of record.[25] Pereira studied with Richard F. Lahey through May 1928, with a break in April, when she attended William von Schlegell's class. Neither Lahey, an instructor at the League since 1923, nor von Schlegell, an instructor since 1922, had a strong impact upon Pereira, although she appreciated Lahey's "tolerance."[26]

Documenting Pereira's nascent interest in aesthetic philosophy during this period is her heavily marked copy of George Santayana's *The Life of Reason; Volume 4: Reason in Art,* a 1928 printing of the work first published in 1905, inscribed "IR 1928." Many of her notations, particularly those associated with the chapter on

"The Rationality of Industrial Art," may have been made at a later date. However, the passages marked do indicate her interest in the philosopher's discussion of beauty, artistic genius, the ameliorative function of art in society, as well as the importance of reason to refine and ennoble "primordial" sentient judgments. In words that would seem to underlie many of the assumptions Pereira held throughout her life, Santayana wrote, "The best men in all ages keep classic traditions alive. These men have on their side the weight of superior intelligence, and, though they are few, . . . added together, [they] may be more than the many who in any one age follow a temporary fashion."[27] Pereira underlined these sentences.

On January 8, 1929, Irene Rice married Humberto Pereira (Figure 4), a Spanish-speaking commercial artist of Sephardic Portuguese descent who came originally from Trinidad or Barbados.[28] A burly, pipe-smoking man with a commanding presence, her husband was an unsuccessful painter. He may have shown some promise as a photographer, however. He exhibited portraits, figure studies, and still lifes in February 1936 at the Photographic Galleries at 600 Madison Avenue. The couple probably met at the Art Students League, although Humberto did not of-

ficially enroll there until 1932, when he began to study with von
Schlegell. Apart from the financial difficulties they shared, little is
known about this relationship, although Irene later claimed to
have married Humberto to get away from her family.[29] They di-
vorced in 1938.

The most critical event in the early career of Irene Pereira was
her study with Jan Matulka at the Art Students League beginning
in October 1929. When Lahey began to teach during the daytime
hours, Matulka inherited many of his evening students, including
Pereira, Lucille Corcos (Levy), Edgar Levy, and David Smith.
The Czech artist taught twice-weekly evening classes in life draw-
ing, painting, and composition. His instruction was to have a
great impact on Pereira, for, while most of the faculty at the Art
Students League relied upon "academic" models for their instruc-
tion, he introduced his students to the art and theories of the
European avant-garde, particularly Cubism and Constructivism.
He also discussed Dada, Surrealism, the Bauhaus, German Ex-
pressionism, and the new architecture of Mies van der Rohe, Le
Corbusier, Eric Mendelsohn, and Walter Gropius.[30] Interested in
"primitive" art as well as modernism, he hung reproductions of
African sculpture and Picasso's paintings in his classroom. He
also encouraged his students to seek out the rare displays of mod-
ern art in New York, including Braque's paintings at the French
Consulate, the new work at the Reinhardt Galleries in the Heck-
scher Building, J. B. Neumann's New Art Circle, the Valentine
and Brummer galleries, and A. E. Gallatin's collection at New
York University.[31] Dorothy Dehner, who transferred from Kimon
Nicolaides' class and not Lahey's, recalled that the nucleus of stu-
dents who remained with Matulka from 1929 until 1931—including
Pereira, Dehner, Smith, Corcos, Levy, Richard Abernathy, Francis
Criss, Burgoyne Diller, Alfred Kraemer, Bella Kroll, Mary Lorenc,
George McNeil, Jim Robertson, and Peter Sekaer—were some-
times called "the Communists" for their rebellious insistence upon
keeping abreast of the revolutionary stylistic developments in Eu-
rope. According to Dehner, the students accepted their nickname
as a compliment and did not consider the term a serious political
label at the time.[32]

Like the other core members of the class, Pereira readily ad-
mitted her debt to Matulka, who introduced her to Picasso and
Matisse and encouraged her to experiment with "cubist abstrac-
tions."[33] A handful of her student works survive in private collec-
tions, as does an early attempt at Cubist portraiture (Figure 5).
The artist signed this study of an African-American model with

Irene
Rice
Pereira

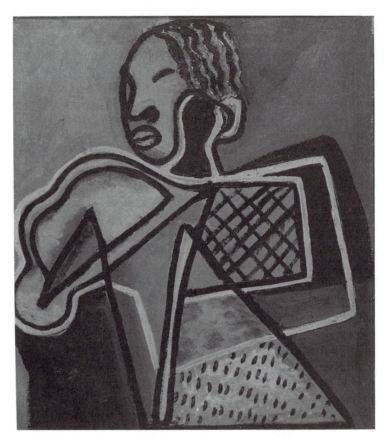

FIGURE 5

Portrait of a Negro,
1932, oil on canvas,
20¼ × 17 in. The
Lowe Art Museum,
The University of
Miami. Gift of
William E. Lange.
Photo, Karen A.
Bearor.

the hyphenated signature she used briefly in 1932. Black-and-white photographs of early still lifes, such as *Still Life #2* (Figure 6), of 1934, remain in her archive. The latter paintings are related to contemporary work by Matulka in terms of their organization, balance, and use of cross-hatching and decorative patterning. However, Pereira's early compositions are sometimes burdened by a too-insistent geometric structure and an over-reliance on parallel lines and triangles. Her application of paint during this period is generally loose and uneven; her colors are bright and lively.

Pereira's early paintings are far more dynamic and less dependent upon verticals and horizontals than those of the classical Cubists and the Purists. Yet her interest in geometric order ultimately derives from classicist theories of organization, reinforced by her reading of Santayana and Kant, as well.[34] Thus, she had some familiarity with Kantian "transcendental" idealism and theories concerning a priori laws governing observation and imposing order on sentient experience. She also admired the work

of the nineteenth-century artist Corot. A monograph on this art-
ist is discernible in bookshelves in the background of a photo-
graph of her taken in her studio on April 28, 1928.[35] During the *Background and*
period of her study at the Art Students League, Corot's work was *Early Philosophical*
extremely popular, and his significance to the development of *Readings*
modernism in America was confirmed by a major exhibition of
his work which opened in October 1930 at the year-old Museum
of Modern Art. Alfred A. Barr, Jr., the director of the museum,
explained:

> *Since the war there has been an extraordinary preoccupation with*
> *the classical spirit and the classical tradition. Corot was the most*
> *complete nineteenth century representative of this tradition. Since*
> *the war there has been a marked revival of interest in the texture*
> *and quality of "fine painting" of which Corot was also a perfect*
> *master. . . . Corot's art is quiet, balanced, held at arm's length,*
> *complete in itself and unconcerned with the immediate emotions*
> *of living—in the best sense classical.*[36]

Pereira's interest in idealist theory was reinforced by her read-
ing of the immensely popular English translation of Oswald
Spengler's *The Decline of the West,* which she acquired in 1928.[37]
Spengler, a German historian who sought to effect a revolution
in twentieth-century thought rivaling that of Copernicus in the

FIGURE 6

Still Life #2, 1934,
25 × 30 in. Location
unknown. The
Schlesinger Library,
Radcliffe College.

sixteenth century,[38] proposed a morphological history of civiliza-
tion based upon perceived cycles of cultures rather than any linear
structure. He regarded history as "an organism of rigorous struc-
ture," with an "inner necessity" or "soul," that "does not suddenly
dissolve into a formless and ambiguous future when it reaches the
accidental present of the observer."[39] All history, whether human,
biological, geological, or cosmic, was endowed with an intrinsic
design, a "memory-picture," somewhat analogous to the geneti-
cally predetermined growth of an oak from an acorn. This inner
structure, also referred to as the "prime form," may not be readily
detected due to historical focus on apparently random, singular
events, but, as Spengler wrote, "through this seeming anarchy,
the keener glance can detect those pure forms which underlie all
human becoming, penetrate their cloud-mantle, and bring them
unwillingly to unveil."[40]

Spengler, of course, thought himself blessed with that "keener
glance," but he also challenged others to contribute to the solu-
tion of the "great problem" of the twentieth century: carefully
exploring "the inner structure of the organic units through and in
which world-history fulfils itself, to separate the morphologically
necessary from the accidental, and, by seizing the *purport* of
events, to ascertain the language in which they speak."[41] To that
end, he identified several self-contained cultures which spontane-
ously emerged, grew, flowered, and declined, following identical
life-cycles with stages corresponding to the passage of the seasons.
For him, the modern Western world was part of the Faustian cul-
ture, now in the winter of its existence, at a point in its life-cycle
corresponding to that of Hellenistic Greece. In Spengler's eyes,
entropy, defined as an irreversible process signifying the "world's
end as completion of an inwardly necessary evolution," was symp-
tomatic of culture's downward trajectory.[42] Thus, Faustian cul-
ture, like all those preceding it, was doomed to extinction, and
individual agency might have no effect upon its course.

Because he theorized that the prime forms of cultures mani-
fested themselves in all aspects of life, Spengler also believed that
all individuals living in a particular time and place "are connected
by a common world-feeling," a collective soul, from which emerges
or is projected a "common world-form." This form is revealed as
a symbol, and, according to the historian, "thenceforth this sym-
bol is and remains the *prime symbol* of that life, imparting to it its
specific style and the historical form in which it progressively ac-
tualizes its inward possibilities."[43] The prime symbol of a culture,
through which the world is rendered comprehensible, is how it
perceives space, and this concept is the paradigm which informs

the structure "of the state, the religious myths and cults, the ethi-cal ideals, the forms of painting and music and poetry, the fun-damental notions of each science."[44] For Spengler, as for Pereira after him, the prime symbol for the modern Western soul is infi-nite space.[45]

H. Stuart Hughes, in his critical study of Spengler's *Decline of the West,* noted that "in the late 1920s and early 1930s Spengler's theories had become a fashionable topic for semi-intellectual con-versation."[46] Testament to its popularity, the book was serialized in *Dial* in 1924 and 1925 before it was published in English. Edwin Berry Burgum, a professor at New York University, included an excerpt from the first volume in his book on aesthetics, titled *The New Criticism,* published in 1930. Even those who criticized Spen-gler's book for being too mystical often praised the author for his insight. Lewis Mumford, for example, admitted that the book's originality outweighed its defects, although he found the histori-an's theory of prime forms "a piece of fantastic platonism that no modern man can swallow." He also complained that Spengler had based his work upon "snatches of knowledge grabbed from en-cyclopedias and similar works of reference . . . [and on] unreliable texts," and that "the actual historic facts are often carelessly used—or spurned—or hacked apart in queer shapes to fit his particular need at the moment."[47] This last was not a drawback for Ameri-can author Henry Miller, however, for, as he wrote to novelist and future diarist Anaïs Nin in 1933, "Spengler's great panoramic review of the past is again full of life and meaning for me. The actual events always left me cold."[48] Nin herself called Spengler "the visionary who fires the imagination."[49]

Most readers knew Spengler as a prophet of the inevitable de-cline of Western civilization, a fact borne out by comments made by Pereira's friend and classmate, Dorothy Dehner. Dehner re-called that the German historian's message of doom was shared by the group of students in Matulka's class, for they all thought Western culture was coming to an end. His book was so impor-tant to Dehner that she took her copy with her when she and David Smith made their Gauguinesque escape to the Virgin Is-lands in 1931.[50] Similarly affected, Joseph Campbell, author of *The Hero with a Thousand Faces,* which Pereira later owned, described the effect Spengler's work had on him in his book *Myths to Live By.* He wrote, "I can remember how we used to sit around and discuss this looming prospect, trying to imagine how it might be beaten back, and trying to guess what the *positive* features might be of this period of crisis."[51]

Pereira left no written statement from this period regarding the

book's impact on her life, although she was sufficiently impressed by what Spengler wrote to return to this work twenty years later, following a revival of the book's popularity during the 1940s.[52] *The Decline of the West* influenced the formation of her own philosophical ideas in the 1950s and 1960s. What she published during these later years paralleled Spengler's philosophic model closely enough that Joseph Campbell wrote to her in 1966 that his enthusiasm for Spengler helped him to appreciate the force and scope of her work.[53]

Apart from his prophecies of doom, some of the idealist concepts that Spengler presented had already found currency during the 1920s and 1930s, a fact which may, in part, account for the acceptance of his overall thesis by many of his readers. Certainly he was not alone in seeking to find patterns underlying human history. Most of the contemporary work in the new field of sociology was based upon comparative examination of cultures, particularly those considered by American scholars of European descent to be "primitive" or "barbaric," such as the Native American or the native inhabitants of Africa. Much of this work assumed certain commonalities in development, despite obvious surface differences. This method was also applied to art forms. Attempting to discover the "cosmic order" or the "spirit of the forms," identified as lines of force passing throughout history, French art historian Elie Faure, author of the classic five-volume *History of Art,* completed in 1930, was a major proponent of this comparative method.[54] The same was true of Emanuel M. Benson, whose articles appeared regularly in the *Magazine of Art* during the 1930s. In 1935, he compared examples of primitive, archaic Greek, and early medieval art to modern products and justified this exercise by stating, "If the primitive approach has become an integral part of the modern artist's creative repertoire, it is perhaps because there are elements in modern society that can be expressed most effectively through this form of art."[55]

Spengler's Platonic views also reinforced contemporary interest in classical order and the modernists' search for universal forms underlying human creative expression. For example, in 1935, art historian Raphael Petrucci wrote, "No matter how varied the outward appearances due to differences of race and civilization the fundamentals of art are the same everywhere and pertain to the same mental attitudes."[56] In his *L'Art décoratif d'aujourd'hui,* published in 1925, Le Corbusier wrote that the geometry, precision, and polished steel of machines arouse our senses and, in Edwin Avery Park's translation, "unconsciously revive race memories of

the discs and spheres of the Gods of Egypt and of the Congo.
Geometry and the Gods seated together!"[57] One further example
of the pervasiveness of this argument was presented by James M.
Richards in an article on modern design. In arguing that furniture
should be produced according to the same aesthetic that applies
to the airplane, Richards explained, "It must reflect the real, essen-
tial world of scientific order that underlies our civilization: the
'world men carry in their heads,' of which the aeroplane is a typi-
cal inhabitant."[58]

Spengler's assumption that all aspects of life—its art, science,
philosophy, religious beliefs, and politics—were manifestations of
the same "soul" or world-view was also widely shared. According
to this viewpoint, all products of civilization were broadly cul-
ture- and period-specific, a fact accepted by those who celebrated
the revolutionary "neotechnic" or machine age of the twentieth
century.[59] During the 1930s, the idea was even narrowed to refer
to the products of an individual city. The authors of *New York
Panorama,* members of the Federal Writers' Project of New York
City, suggested that there was a unity of shared consciousness
beneath the apparent chaos of contemporary life in that city:

> *In this shared consciousness—generated by a look, a grin, an anec-
> dote, as cabalistic to outsiders as the shop talk of mathematicians—
> the complex of the metropolis finds its organizing principle, deeper
> than civic pride and more basic than the domination of mass or
> power. To the degree that this principle, this wise geolatry, can be
> instrumented by the forms and processes appropriate to it, New
> York will emerge in greatness from the paradox of its confusions.*[60]

Of singular importance to Pereira, Spengler specified that the
prime symbol of a culture was its concept of space. Yet the belief
that such concepts evolved over time was also widely shared.
There were numerous contemporary investigations by psycholo-
gists and art historians into the spatial perceptions of "primitive"
peoples and of children, each of whom was theorized to be unaf-
fected by learned codes of "modern" behavior and thus provided
models for the study of the origins of "civilized" culture and psy-
chology. In line with this thinking, many avant-garde artists and
contemporary critics justified the rejection of linear perspective in
art as being the product of the Renaissance period and no longer
relevant to the needs of a more advanced twentieth-century West-
ern culture.

One of the leading authorities on "primitive" African societies

during the 1920s and 1930s was another highly prominent German cultural historian, Leo Frobenius, founder of the Research Institute for the Morphology of Civilization (Forschungsinstitut für Kultur-morphologie) in 1923. Remembered by Joseph Campbell as a major influence on the period, he, like Spengler, conceived of culture "in morphological terms as a kind of organic, unfolding process of irreversible inevitability."[61] In contrast to Spengler's pessimism, Frobenius, whose theories were recognized by Robert Goldwater in 1938 as being closely tied to German expansionist and imperialist efforts,[62] saw the twentieth century as the dawn of a new age of a united world culture, guided and supported by the Western science and technology.

Frobenius, whose name, according to artist Charmion von Wiegand, "conjured up African jungles and tribes, strange rituals and ante diluvian wonders," led numerous expeditions into Africa, still popularly regarded by many in the West as a "dark continent."[63] The explorer-ethnologist assembled facsimiles of prehistoric art for exhibition at the Museum of Modern Art in May 1937, the year before his death. This was the first exhibition in the United States of the results of his twelve expeditions between 1904 and 1935. Pereira obtained a copy of the accompanying catalogue, *Prehistoric Rock Pictures in Europe and Africa; From Material in the Archives of the Research for the Morphology of Civilization, Frankfort-on-Main,* written by Frobenius and Douglas C. Fox, with a preface by Alfred H. Barr, Jr. The exhibition included comparative paintings by Klee, Arp, Masson, Lebedev, and Larionov, as well as reproductions of pictographs painted by Native Americans and copied in facsimile by workers on the Federal Art Project.[64] The explorer's celebrity status and the public interest in African art were documented in 1935 by Emanuel M. Benson, who wrote, "Today, Dr. Leo Frobenius's expeditions to South Africa are reported on the front page of the *London Illustrated News* and his finds reproduced in four colors!"[65]

Frobenius wrote articles on "primitive" myths and beliefs, some of which appeared during the 1930s in Eugene Jolas' periodical *transition.* He also contributed articles on "primitive" art, particularly that found in South Africa, to *Cahiers d'Art,* the publication that kept many American artists informed on the latest developments in avant-garde European art. His article "L'Art de la silhouette" appeared in volume 4, number 8–9, of 1929, one of two issues of *Cahiers d'Art* that Pereira kept until her death.

The other issue of *Cahiers d'Art* that Pereira saved was the second number from 1930. This issue contained nothing by Froben-

ius, but it did include an article devoted to prehistoric art, the first
of five installments of Hans Mühlestein's "Des origines de l'art et
de la culture." Rather than the expected formula piece about pre-
historic art, however, the reader discovers, in the second install-
ment, appearing in the next issue with the subtitle "Cosmogenie
et préhistoire," that this author linked human culture to "le grand
rythme cosmique." Like Spengler, he proposed a synthetic view
of culture, in this case uniting the evolution of humankind, as
both a rational and intuitional species, to cataclysmic terrestrial
and cosmic events. Citing both Plato and Kant in support of his
theories, the author viewed humans as beings who both perceive
order and require it to give form to their existence. Mühlestein's
acknowledged source of inspiration was the cosmogony of Aus-
trian engineer Hanns Hörbiger, whose *Glazialcosmogonie,* origi-
nally published in 1912, appeared in a second German edition in
1926. Hörbiger's Glacial Cosmology, or Cosmic Ice Theory, re-
sembling in some respects Madame (Helena) Blavatsky's Theoso-
phy, combined pseudo-scientific ideas with a metaphysics that in-
cluded a Platonic World Soul.[66]

Pereira's interest in "primitive" art is demonstrated further in
her possession of a copy of Paul Guillaume and Thomas Munro's
Primitive Negro Sculpture, published in 1926. She was influenced
by Matulka, who had studied the cave paintings in southern
France in 1922 and had also collected African tribal sculpture.[67]
However, more important than any stylistic interest in African art
was her life-long obsession with theories concerning so-called
primitive consciousness and spatial awareness, a fact that is con-
firmed by even a cursory inspection of passages marked in the
books in her library. A typical example is the following, written
by C. Howard Hinton, in his book *The Fourth Dimension,* first
published in 1904, wherein the author theorized that "civilised
man has discovered a depth in his existence, which makes him feel
that that which appears all to the savage is a mere externality and
appurtenage to his true being."[68]

Clearly, many of the passages Pereira noted in her books, like
the one quoted above, are racially biased and based upon an evo-
lutionary model that privileges the accomplishments of Euro-
American peoples. It is beyond the scope of this study to expose
or critique further the racist and imperialist assumptions under-
lying these theories, but the reader is advised to consult the litera-
ture related to this issue, which is now quite extensive.[69] Despite
the bias underlying the theories that Pereira endorsed, she herself
harbored no apparent prejudice against her African-American con-

temporaries. In fact, she maintained several long-lasting relationships with African-American friends and associates met through her 1938 one-artist exhibition at Howard University in Washington, D.C. In addition, from 1947 until 1960, she was represented by the Barnett-Aden Gallery in Washington, D.C. Called "the most important contemporary gallery south of New York City" by artist Therese Schwartz, it was founded in 1943 by James Vernon Herring and Alonzo J. Aden, formerly the chair of the art department and curator of the art gallery at Howard University, who considered Pereira "family."[70] That these affections were reciprocated is made clear by her published tribute to Aden in 1960.[71]

Pereira's interest in what Hinton had termed the "depth" of human experience undoubtedly owed much to the popularization of the "depth psychologies" of Sigmund Freud and Carl G. Jung. She may have become aware of the latter's work through John Graham, whom she came to know through Matulka and her classmates at the Art Students League. Graham, whom Dorothy Dehner recalled as having an enormous impact on everyone he met, stimulated the students' interests in African, Oceanic, and Greek art. In the foreword to the 1971 annotated edition of Graham's *System and Dialectics of Art,* first published in 1937, Dehner wrote,

> *David Smith and I were studying at the Art Students League
> in New York when we first met John and his wife Elinor in 1929.
> Graham came into our lives at exactly the right moment. He was
> a mature artist, and we were still students, members of the group
> of young artists whom he characteristically accepted as his peers,
> and we were immensely stimulated by him. He brought the
> excitement of the French art world to us, a world he knew well
> from having lived and painted in Paris. He told us many things
> about that scene, in brief sharp comments. What he said was very
> much to the point, profound, flavored with a caustic humor. He
> showed us copies of* Cahiers d'Art *and other French art publi-
> cations of which we had been unaware. He knew the painters of
> that time, and the writers Eluard, Breton, Gide, and others were
> his friends.[72]*

Graham also introduced this circle of students to Stuart Davis, Arshile Gorky, and Frederick Kiesler, with whom Pereira maintained friendships for many years.[73]

In 1931, Matulka was asked to leave the Art Students League because his enrollment did not meet minimum requirements. His

students rallied to his support and found studio space on West
Fourteenth Street, between Seventh and Eighth avenues, where
he conducted private classes.[74] As Dehner termed it, Pereira was
one of the "chief movers and shakers" in locating this space.[75] The
group provided their own tables and collected items for still-life
paintings, including boxes of soap powder, canned goods, a fruit
dish, and a white plaster head of Voltaire.[76] Matulka taught here
through the summer months.

An informal sketch class also met regularly in the apartment
belonging to Lucille Corcos and Edgar Levy, the couple with the
largest space, which happened to be located in the same building
as Adolph Gottlieb's. Each member of the class contributed to
a model's fee, and, after the sessions, Pereira was sometimes es-
corted to the subway by Levy, whose portrait etching of Corcos
she kept until her death.[77]

Although some individuals continued to study with Matulka
through the fall, the core group of students who had studied with
him since 1929 began to disintegrate at the end of the summer of
1931. Dehner and Smith traveled to the Virgin Islands, and Pereira
also left the country. Seeking to be close to the source of the ex-
citing, revolutionary ideas emanating from France, she embarked
for Paris.

According to John I. H. Baur's 1953 biographical essay, based
upon interviews with the artist, Pereira studied at the Académie
Moderne in Paris with Amédée Ozenfant, who was giving criti-
cism in Léger's absence. Baur reported that she was disappointed
in the school's conventional insistence on working from the
model.[78] Surprisingly, she claimed in 1968 that she had only vis-
ited the school and had never studied with Ozenfant at all. Infor-
mation to the contrary was, as she termed it, "a mistake in my
biography; somewhere it got into the records."[79] Yet the clear
source for the original "mistake" was Pereira herself. In 1934, in
one of the earliest reviews of her work, critic Emily Genauer
wrote that the artist had spent "considerable time studying at the
Academie Moderne."[80] Thumbnail résumés of her career, printed
in 1937, before much published information about her was readily
available, indicate not only that she had studied at the school but,
in one surprising example, that she had studied with Léger, who
was, in fact, in the United States while Pereira was in Paris.[81]
While the reference to studying with Léger does not recur, her
attendance at the Académie Moderne appears in virtually all pub-
lished summaries of her training, both prior and subsequent to

the publication of Baur's essay, although the artist did begin, in 1968 or 1969, to edit this and other information in her own copies of these accounts.[82]

The question remains: Did Pereira study with Ozenfant at the Académie Moderne, or did she not? While any answer would be speculative, it is logical to assume that the eager young artist visited the Académie Moderne during her stay in Paris and, despite her disappointment with its program, embellished the fact of her visit to enhance her professional credentials upon her return to New York. Such embroidering of details may have proven embarrassing to her after Ozenfant moved to New York in 1939, at which point the information may also have been difficult to expunge from the public record. Late in life, as she attempted to bolster her historical importance by repeatedly denying the impact of any artist, it is understandable that she chose to distance herself from Ozenfant.

The souvenirs Pereira kept from her trip abroad indicate that she remained in Paris for a month, and not the four years she claimed in 1968.[83] If she did study with Ozenfant, albeit briefly, his instruction assuredly reinforced the idealistic concept that the artist's responsibility was to search for universal forms underlying the chaotic surface details of human experience. His positive attitude toward the products of technology and industry might also have fueled a nascent interest in machine forms, documented by sketches of ship ventilators, anchors, and lifeboats she made en route to France aboard the S.S. *Pennland*. She began to paint these subjects a few months after her return home.[84]

That Pereira was heavily indebted to the idealist theories endorsed by Spengler, Ozenfant, and the numerous writers cited above is evidenced by the contents of her first published statement on art. Written in 1934, when her semiabstract paintings contained recognizable imagery, her essay "The Indulgent Be Pleased" presented her views on the relationship of abstract art to society, to history, and to nature. Although her writing style renders some of her points unclear, the reader may determine her general meaning from the following excerpt:

> *That art still exists and has a place today may be news to the skeptic standpatter, nevertheless it rises with, and in spite of our tremendous structures, machines et cetera. This is only a machine age to those who have not grown with it and therefore are offended by the metamorphosis. Art being useful and serving its eternal purpose merely conveys a new phase of a world old message. Its garb*

*may be slightly altered but neither do we array ourselves as we did
only a few years ago.*

 *Among the various manifestations of aesthetics, the abstract has
always been the most disturbing element, and that it has actually
come to serve a simple one when aware of its functions. One
employs the abstract as a means of understanding nature more
profoundly, and more sincerely; incorporating its movements, its
functions and its relations into an intellectual comprehension, a
more sensitized emotion, manifested through the instrument of a
more distilled consciousness. Of course using the abstract always
as a basis upon which to build structures, harmonies, rhythms,
relations, etc., and as a means of reaching the very core, the
essence, the interpretation of things, the artist is then capable
of bridling the music of nature as a medium for creating and
composing. . . . The inquisition of geometric forms, plastic
structures, values and dimensions should certainly be a means to
better feel and understand nature. With the obvious embroideries
eliminated, it is more simple to see things as a whole, study them
and to create without the interference of the superfluous. One
departs from life, only to again revert to it with more clarity
and insight. . . . The artist today is a healthy, alert, intelligent
individual with an universal message to convey, whether it be in
abstract forms or more readily comprehensible matter; a message
of himself, yourself, and the universe itself.*[85]

Here, Pereira clearly identified herself with that cadre of artists
and intellectuals seeking essential forms in nature, whom she per-
ceived as being advanced, and not with those "standpatters" who
saw only the surface details. In fact, her first sentence may have
been prompted by one she underlined in the paragraph immedi-
ately preceding the *New York Times* review of her first one-artist
show. Here, reporter Thomas C. Linn, covering André Masson's
first solo show in this country, cautioned, "It may be recom-
mended to those interested in the new; standpatters are likely to
object."[86]

Similarly, the analogy Pereira drew between art and fashion
was a common one made by those who wished to explain modern
art to the general public. For example, in *New Backgrounds for a
New Age,* Edwin Avery Park wrote, "Much of the problem of dis-
cerning beauty in the art of our new age lies in learning to rec-
ognize old friends in a new raiment. There are but a half dozen
laws at most which govern design and if we look, we will discover
all of these to have been obeyed in whatever object may possess

beauty."[87] The assumption here is that the superficial characteristics of style may be stripped away at will, like outdated fashions, to reveal the essential "body" beneath, and it is that more timeless, underlying form that we recognize as being beautiful. To carry the analogy further, Peter Wollen has shown in his article "Fashion/Orientalism/The Body," published in 1987, that the elimination of ornament in modernist art can be linked to what John Carl Flugel had termed in 1930 the Great Masculine Renunciation of sartorial display, with its goal an ascetic functionalism in male clothing.[88] Man, as Thorstein Veblen had written in *The Theory of the Leisure Class,* with his "sense of the merit of serviceability or efficiency and the demerit of futility, waste, or incapacity," renounced the "womanliness" of women's apparel, its "hindrance to useful exertion" and the apparent fact of "the wearer's abstinence from productive employment."[89] Thus, artists seeking to eliminate what Pereira called above the "obvious embroideries" and the "superfluous" from art were, in effect, calling for a "masculinization" of art out of a fear of their work's being too "decorative," too "feminine," hence, expendable. This point was driven home and made to serve ethnic, nationalistic, and expansionist causes as well in the writings of anthropologist Leo Frobenius, who distanced himself from what he called the "feminine French" and called for a "simplification," a "return to naturalness" in German art.[90]

In her efforts to explain abstract art in her brief essay, then, Pereira allied herself with what she perceived to be the most advanced trends in painting in the so-called machine age. With almost missionary zeal, she also sided with those promoting a more "masculine" style, at odds with what was constructed as stereotypically "feminine," to an audience of intransigent "standpatters." Certainly, she had already placed her faith in an idealistic outlook that privileged intellect, stereotypically viewed as a "masculine" attribute, over the senses, seen as "feminine." Because the stylistic and aesthetic concepts she embraced had become gendered over time, Pereira was again forced, in a sense, to renounce her own identity as a woman, as she had with her professional signature, in order to participate in this discourse. As she did accept as essential those characteristics constructed as "masculine" and "feminine," a fact that is borne out in some of her later writings,[91] she always sought to compensate for the apparent imbalance of the chosen "masculine" features in her oeuvre with something "feminine," whether this manifested itself in some stylistic flourish, overt subject matter, or, more significantly, the meaning hidden in her later abstractions.

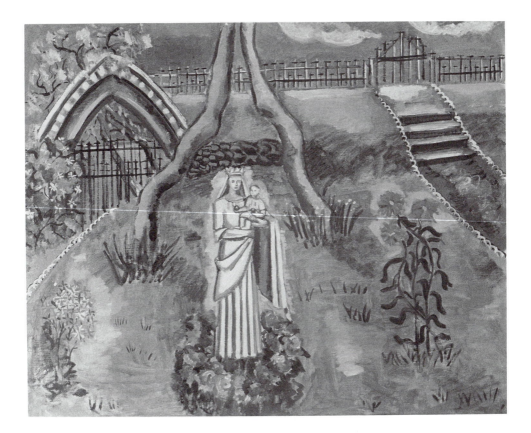

To find early examples of Pereira's attempt to insert her expe-
riences as a woman into art forms already encoded with meaning
by patriarchal systems, we must return to the period of her first
trip to Europe. Despite her avowed interest in discovering the
underlying laws in nature in 1934, her paintings prior to this date
were essentially descriptive. While in France in October 1931, she
visited Cluny, where she made a sketch, now lost, of a sculpture
of the Madonna and Child standing in an enclosed garden. She
returned to this sketch for the painting *Cluny Garden,* also titled
Garden Madonna (Figure 7), of 1934. Here, rather than determin-
ing the underlying forms in nature, she tried to force landscape
elements to conform to a preconceived compositional structure
based upon strong verticals, horizontals, and diagonals. Clumsily
composed and crudely drawn, the work is, nevertheless, closer in
spirit to the work of Henri Matisse or Raoul Dufy than to Ma-
tulka's work or that of the Cubists. Eager to embrace all that was
"new" in France, she tried unsuccessfully to fuse the former art-
ists' lyricism to a classical structure.

FIGURE 7

*Garden Madonna
(Cluny Garden),*
1934. Location
unknown.
The Schlesinger
Library, Radcliffe
College.

FIGURE 8

Brooklyn Heights,
c. 1935, oil on
canvas, 40 × 30 in.
Michael Rosenfeld
Gallery, New York,
New York.

Apart from this attempt to "gender-balance" her style, how-
ever, it is important to note that Pereira made the painting of the
Madonna, the Christian symbol of ideal womanhood,[92] at a time
when her most acclaimed paintings were devoted to the machine.
Only one other reference to motherhood appears in her known
oeuvre, and that takes the form of a woman pushing a baby car-
riage past a fallen fountain in the cityscape *Brooklyn Heights* (Fig-
ure 8), first exhibited in 1935. The fountain is a traditional symbol
of the mother-source of life, a metaphorical reading reinforced by
the presence of the baby carriage. However, the fact that the foun-
tain has been overturned suggests in a fairly heavy-handed way

that this life-source has been severed. It is known that Pereira had a hysterectomy sometime during the 1930s, although the date and reason for this surgery remain undetermined. Knowing this and yet holding open the possibility of other interpretations, one might see the sequence of this pair of paintings as a reference to a terminated pregnancy that required concurrent surgical removal of the womb. Despite the artist's continued references to the "feminine" throughout her painting career, she never returned to this subject. Furthermore, the *Garden Madonna* is unique in that the artist painted no other images of the Virgin Mary, although she used the work's compositional format of a centrally placed sculpture in an enclosed space in a series of illustrations for her book *The Lapis* in the 1950s.

In November 1931 Pereira left Paris for Italy. A painting *Roof Tops Geneva,* of 1932, was based upon sketches made during her stopover in Switzerland.[93] She spent a month in Italy, where she traveled from Milan to Florence, to Venice, and finally to Rome. In a diary entry dated October 19, 1963, she recalled that she had been particularly impressed by Milan, where she visited the Duomo, the Galleria, and the Brera. Venice left her "enraptured."[94] Already conditioned to reject Renaissance linear perspective as a result of her studies, she admired instead the color and light of what she termed "pre-Renaissance" Italian painting, such as Bellini and Botticelli, and not the work of later artists, such as Raphael or Titian.[95] This fact is borne out by the bright pinks and blues and oranges in many of the paintings she made soon after her return home.

In Venice, Pereira made a small watercolor-and-ink drawing of a canal and three gondolas. This work, exhibited under the title *Venice* in 1934,[96] was a preparatory study for a painting of the same title. In this version, the forms were first drawn in pen and ink. Then the artist added color in thin washes, and, finally, she loosely retraced the ink outlines with heavier ink, now applied with brush. The overall effect is one of a lively play of line, color, and form in a flat, decorative composition. Much of that spirit is lost in the subsequent painting (Figure 9), which, although identical in organization, lacks the drawing's fluidity of line and spontaneity.

These two versions of *Venice* document Pereira's then customary practice of reworking a theme in multiple versions. On occasion, her purpose was to reexamine her organization of forms. In most cases, however, the compositions in the various versions are virtually identical. Her interest was in materials, a fact confirmed by critic Emily Genauer in a 1934 review of Pereira's work:

There is an illusion of extreme spontaneity about the sketches of I. Rice Pereira. . . . It is a spontaneity particularly surprising when one learns that each of these sketches is one of a series of a great many which go into the making of one oil.

They are what Miss Pereira herself terms "preliminary material," since she never paints a subject in oil until she has thoroughly familiarized herself with it by incessant study in other mediums.[97]

Already Pereira demonstrated a predisposition toward systematically exploring the properties of materials, although at this point her choices were entirely conventional: pencil, charcoal, ink, gouache, and oil.

According to the story she often told to interviewers, Pereira intended to travel to Baghdad and Damascus after her travels in Italy. However, on the advice of a clerk in the American Express office in Rome, who convinced her that she was too young to

travel alone to the Middle East, she decided to go to North Af-
rica.[98] Her sister Nita, however, was already in Algeria, where she
had chosen to stay after aborting her own trip to Paris.[99] Buying
a ticket in Rome, Pereira sailed for Algeria, Tunisia, Morocco, and
the Sahara from Palermo on December 8, 1931. She arrived in Tu-
nis the next day and then traveled to Constantine and Biskra, Al-
geria. Touring with the vice-president of the French Line and his
wife, whom she met either on the ship to Tunis or in Biskra,
depending upon which account one reads, she went as far as
Ouargla, Algeria, which she later termed the "last outpost" in the
Sahara.[100] Photographs show her engaging in typical tourist ac-
tivities, including riding camels, standing, high-heeled, in the
sands of the Sahara, and posing with Algerian residents. Ironi-
cally, Pereira never made contact with Juanita, for, as her nephew
Djelloul Marbrook explained, "a kind of surreal ballet took place
across Algeria—she arriving in a town only to find her sister had
just left."[101] Pereira returned to New York in January, but her
sister, having fallen in love with a marabout, remained in Africa
until 1935.[102] Although Pereira would later cite this trip to the Sa-
hara as being of great importance to her study of light and in-
finity, it had no immediate impact upon her painting.

A year after her return to New York, Pereira enrolled in Hans
Hofmann's class at the Art Students League for one month, al-
though her study was so brief that Harry Holtzman, Hofmann's
teaching assistant between 1932 and 1935, had no recollection of
her attendance.[103] Yet her nephew recalled that she once said of
Hofmann's instruction that it was best to ignore what he said and
just watch.[104] Precisely what she meant by this remark is un-
known, and his instruction apparently had little impact on her.
No discussion of his work or theories appears in surviving papers.

Exploring the Relationship between Artist and Society

Irene Pereira's 1934 endorsement of the "machine age" aesthetic suggests that, at the time, she regarded technology as a benign force transforming civilization. Fascinated by the machine and attempting to capitalize on its popularity among American modernists, she embraced the subject and made it the central focus of her work between 1932 and 1938, although she also produced Cubist still lifes, Dufylike landscapes, portraits, and social realist subjects during this period. Ironically, in 1936, at the time she became associated with the Bauhaus-inspired Design Laboratory of the Works Progress Administration Federal Art Project (WPA/FAP) and began teaching students to design products for mass production (discussed in detail in the next chapter), her optimism toward the machine gave way to pessimism and, in 1938, to Dadalike satire or ambivalence. That from 1936 to 1938 she could balance seemingly opposing viewpoints with respect to machine technology is, perhaps, no more surprising than her ability to support both the procapitalist views of the administration at the Design Laboratory, where she worked, and the more Marxist views of the liberal artists' organizations she joined and actively participated in. It is further indicative of the complexity of the time and the individual that she, like so many of her artist colleagues, could adopt what Hal Foster has called the "guise" of the "proletarian role of the artist" while yet seeking to "elevate" the artistic tastes of the "masses."[1] One questions whether these positions seemed so antipodean at the time or whether it is due to the polarizing tendencies of modernist art history, which seek to locate artists and ideas into discreet, opposing factions, that we have failed to consider

potentially overlapping concerns. Nevertheless, any apparent inconsistencies with respect to her interest in the machine may be attributed in part to the fact that during this period of zealous experimentation, Pereira was desperately ambitious and desired to leave her imprint on history. She attempted in the juvenilia of her career not only to share in the limelight cast on painters of the machine but to contribute her own voice to the subject's interpretation. Once the machine-as-subject was no longer efficacious, she abandoned it and, in 1938, wholeheartedly embraced in its stead the clean-lined, Bauhaus-indebted abstraction that would become the hallmark of her career.

Pereira's depiction of machine forms was essentially naturalistic during the early 1930s, although she arranged belts-and-pulleys, generators, gears, gratings, ropes, and wharf paraphernalia in these compositions like the telephones, gin bottles, cheese graters, water faucets, and rolling pins in her contemporary still lifes. While there are affinities in structure and palette between her machine paintings and still lifes, the subject of the former, traditionally associated with the activities and working environment of men, was quite different from that of the latter, which evoked domestic interiors and cooking. Although mechanical devices appear in each series, they fall into categories identified by Reyner Banham as those belonging to the "First Machine Age" (power mains and generators), which he claimed to have spawned International Style architecture, and the so-called woman-controlled machinery of the "Second Machine Age" (telephones and vacuum cleaners).[2] Furthermore, the machine paintings (as broadly conceived to include her nautical subjects) were viewed quite differently by critics, particularly when her mask was removed and the "I" in her professional signature was revealed to stand for "Irene." For example, a *New York Times* critic pointed out that, while these paintings lacked subtlety, they were full of "dash and sureness" and possessed the "force and strength and forthrightness usually associated with the term 'masculine painting,'" while a *New York World Telegram* critic commented on her "virile strength and directness."[3] Robert Ulrich Godsoe-Kohn, reporting for the Flushing, New York, *News,* observed that, in contrast to her animated paintings of the circus and other exotic locales, "it is in the personal field of her marine abstractions that this inventive artist gets away to a really imposing expression. Here she thinks in terms of aggressive, positively delineated forms, eliminating nuance and attending a masculinely devised linear and formal decor, bold in its contrasts and never overworked."[4] Thus, a pattern was estab-

lished by which the more "masculine" her paintings appeared, the more praise Pereira received from critics.

Although not abstract, her work was considered "modern" by most American critics. As she became increasingly enamored of Cubism and more confident in her sense of design, she began to disassemble ship ventilators, anchors, masts, and capstans and rearrange their parts such that the resulting abstracted forms bore little resemblance to their original selves. Yet despite the platonic rhetoric ubiquitously applied to machines and their representation during this period, Pereira exploited the rhythm of gently curving surfaces and loosely coiled ropes (to the extent that one critic advised her to hold in check her "natural inclination to undulance"[5]) and demonstrated little interest in discovering any underlying cubes, cones, and spheres.

As her paintings became increasingly abstract, Pereira became more and more interested in discovering the appropriate role of the artist in modern society. Ironically, the artist is always represented in her paintings and referred to in her writings as male. Despite the fact that there is little documentation of her opinions from this period, it is clear from the progression evident in her work that she came to reject the determinism of Spengler's theories and to see the artist not as a passive observer recording nature but as an active participant in life, capable of reordering nature. In this, she was heavily influenced by the doctrines of liberal artists' organizations of the 1930s, such as the American Artists Congress[6] and the United American Artists, which sought a radical restructuring of society and the role of the artist within it. She was also affected by dramatic and literary characterizations of the artist in pursuit of transcendental goals, particularly those depictions informed by the German romantic model of the *Künstlerroman*. By the time recognizable imagery began to disappear from her work, she perceived the artist as an inspired collaborator with the industrialist, the studio as a laboratory. In place of the machine as subject, she used the latest products of technology as materials in her abstractions. While consistently privileging her own role, she believed that only through the unity of the artist and industrialist in society could a better world be achieved. The machine had become too malignant a force to be allowed to exist untended.

Prior to 1935, Pereira's machine paintings, like her still lifes, were closely related to contemporary works by her former teacher, Jan Matulka. Basing her paintings on sketches from life, she grafted component shapes to an underlying structure of parallel lines and

right triangles. In general, her compositions were brightly colored, with flattened, often interlocking forms clustered in the center of her canvases.

According to the artist, her interest in ships began with her voyage to France aboard the S.S. *Pennland* in 1931, when she recorded the steamship's features. Surviving sketches of a ship's deck and ventilators, although undated, may be those mentioned. However, she did not begin to paint marine subjects until the summer of 1932, when she visited Provincetown on Cape Cod.[7] Her earliest painting of ship paraphernalia was *Anchor* of 1932 (Figure 10), which was exhibited in her first one-artist show at the American Contemporary Arts (ACA) Gallery in New York in January 1933. Pereira painted the stockless, double-fluked anchor, seen from above, with bold, outlined contours and loosely applied brushwork, a style she called "expressionism."[8]

Like the Russian artist Natalia Goncharova, who was fascinated by engines and electrical equipment during the early 1910s and may have been the first modernist to paint a dynamo,[9] Pereira painted *Generator,* originally exhibited as *Generation,* of 1932 (Figure 11). Surrounded by metal gratings and electrical cables, the foreshortened generator is silhouetted against a rear wall on which hangs a gauge, with the word "generation" printed beneath its dial. Electrical power was an important symbol of the "machine age" and, on one level, one might interpret Pereira's use of this label as a romantic statement concerning the source of modern energy and the positive impact of the machine on society. Additionally, her concurrent interest in masts and sails, the means by which sailing vessels convert the force of the wind into movement, may have led to her interest in this analogous harnessing of natural forces. Her only recorded comment regarding this painting, appearing in "Eastward Journey," is characteristically romantic and ambiguous in meaning: "I seemed to have to generate my own energy in order to understand energy—the dynamo—the dynamics of energy."[10]

"Generation" also suggests propagation, and one is tempted to seek sexual metaphors in this work, although, apart from the word "generation" itself, there is nothing to suggest such an interpretation here. As there is no evidence that Pereira was familiar with "New York Dada" prior to 1936, it is unlikely that she intended in *Generator* any procreative puns reminiscent of Francis Picabia's "daughter born without a mother" theme.[11] However, one cannot rule out the possibility that the generator is a metaphor for the libido, the alleged source of artistic creativity, according to contemporary psychoanalytic theories. As such, the generator

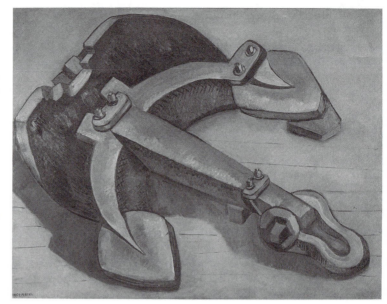

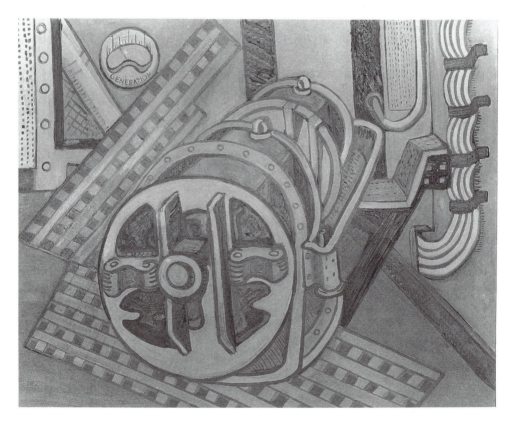

FIGURE 12

The Ship, 1934,
oil on canvas,
42⅛ × 34 in.
The Lowe Art
Museum,
The University of
Miami. Gift of
John V. Christie.
Photo, Karen A.
Bearor.

might also be seen as a metaphor for Jung's "feminine uncon-
scious," an interpretation that would be in keeping with the ar-
tist's better-documented beliefs later in the decade, discussed in
more detail in chapter six of this study.

Pereira's first major sale was *The Ship,* of 1935, purchased in the
late 1930s by Marjorie Falk of New York. This work was, in fact,
the third version of a subject first painted in 1934. The first paint-
ing, also called *The Ship* (Figure 12), is vertical in format, with
a large capstan[12] on an elevated corner of a wharf in the fore-
ground. In the midground is the deck of a ship with two flanking
staircases (called "ladders" by naval personnel) and beyond that a
steamer flying two flags sails on the sea. As though standing near
the capstan, the viewer looks down on three pails, an inverted
double-fluked anchor, and other paraphernalia on the deck below.
The three prominently displayed pails, arranged in a row before
the anchor, itself unusual in its inversion, were obviously intended

FIGURE 13

The Ship, 1935.
Location unknown.
The Schlesinger
Library, Radcliffe
College.

as symbols. They may refer to the Christian trinity, an interpretation that is supported by the presence of the anchor, a traditional symbol for the cross, hope, and salvation. Apart from this Christian interpretation, however, another meaning may be posited. In numerology, three is the number associated with the soul,[13] which, in turn, is often associated with water. An inverted anchor sometimes denotes its mystic nature.[14] The ship itself, in its cradling aspect, is a traditional symbol of the feminine, particularly feminine transformation. In sum, spiritual transformation is suggested, an interpretation augmented by the two staircases for ascent.

The second version of *The Ship,* of 1934, in contrast to the first, is horizontal in format, with the three levels in the first painting telescoped to the extent that the inverted anchor takes on greater formal significance.[15] The three pails from the first painting are gone, and, in their place, the artist introduced a small sailboat in the center. The final version (Figure 13), dated 1935, is like the second, only more tightly organized. Reminiscing about this

painting in her manuscript "Eastward Journey," Pereira wrote: "Unconsciously I wrote 'Bye-Bye' on the flags; but one flag points East and the other one West. Also the ropes were blowing in the wind in both directions; one to the East and the other one to the West. . . . Somehow it seemed right to me that since the earth was round, if you kept travelling East you would end up in the West and vice versa."[16] Despite the above explanation concerning the flags, photographs of the painting reveal clearly that both flags fly in the same direction. Thus, one is reminded again that the artist's romantic recollections should be accepted with caution.

In 1932 Pereira began a series of paintings of ship ventilators based upon two sketches presumably made on board the S.S. *Pennland* in 1931. Fascinated by the shape of these structures and their neighboring funnels, she reworked the theme at least three more times, in a polychromatic ink drawing, a gouache painting, and an oil. Works titled *Funnels* and *Ventilators* were shown in her first show at the ACA Gallery in 1933, and a photograph in her archive of an early painting based directly upon one of the two pencil sketches is identified as *Ventilators,* of 1932. The ink drawing, different in composition, is also dated 1932, although the date was obviously added later and is suspect. The gouache painting, which, according to her pattern, succeeded the ink drawing, is undated. The final version, an oil painting originally titled *Ventilators* (Figure 14), identical in composition to the ink and gouache compositions, was painted in 1936, although someone, presumably the artist herself, subsequently altered the date to read "33."[17]

Ventilators is what Pereira called a "composite," a work with parts taken from different sources, in contrast to her wharf "constructions," which are based upon a rearrangement of objects logically associated in nature. One work called a *Composite* was exhibited in her first show at the ACA Gallery. This was undoubtedly the painting titled *Boat Composite* (Figure 15), dated 1932, a photograph of which was included in her manuscript "Eastward Journey."[18] *Boat Composite* preceded *Ventilators* in Pereira's memory, and there are elements in *Ventilators* that are clearly based upon forms in the other painting. For example, the davit[19] (the prominent upright with the vaguely ducklike "head") in *Ventilators* is a slightly abstracted mirror image of one appearing in *Boat Composite*.

While John I. H. Baur associated the soft grays and blues and Pereira's greater precision of line and shape in *Ventilators* with the paintings of Precisionist painters Charles Sheeler and Charles De-

Ventilators, 1936, oil on canvas, 34 × 42 in. The Lowe Art Museum, The University of Miami. Gift of John V. Christie. Photo, Karen A. Bearor.

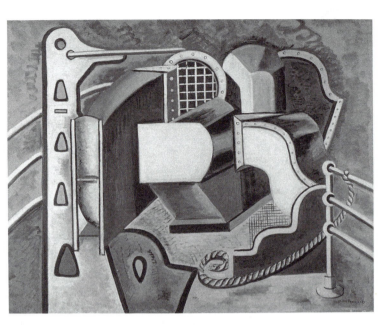

Boat Composite, 1932. Location unknown. The Schlesinger Library, Radcliffe College.

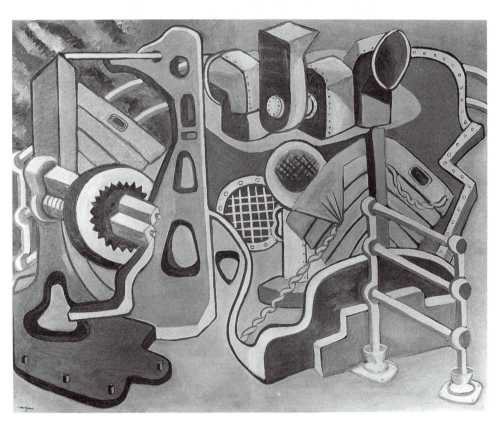

muth, she denied having known of their work at the time.[20] Certainly, her choice of subject may be related to Sheeler's *Upper Deck,* of 1929, Demuth's *Paquebot, Paris,* of 1921–22, or even Gerald Murphy's *Boatdeck,* of 1923. Peter Blume, musing on the sources for the ventilators appearing in his more surreal painting *Parade,* dated 1930, which served as the centerpiece for his first one-artist show at the Daniel Gallery the same year, recalled, "I'd been walking around the waterfront and going aboard the steamships and looking and sketching. The great air ventilators suddenly became a popular subject. I don't remember just how, but Demuth had painted one, and Sheeler was doing one, and here I was doing the same."[21] Pereira's vigorous handling of paint and dynamic arrangement of forms had little in common with these earlier paintings, however, and, in its final form, her *Ventilators* was far removed from the Precisionist aesthetic.

Her most abstract painting to date, *Ventilators* reveals Pereira's growing concern with the use of form and color to create the illusion of depth. Missing is the underlying structure of parallel lines and similar triangles so characteristic of her earlier work, although objects are still clustered in the center of the composition. While some colored areas are confined within heavy black outlines, other forms are liberated from such confinement. In particular, the two unbounded white shapes forming the sides of the ventilators virtually disengage from the objects they define and advance optically toward the viewer. This use of white represents a significant milestone in her development, and the ventilator's angular S-shaped profile continued to fascinate Pereira. She eventually abstracted and elongated this form to achieve the periscope-like motifs characteristic of her late works.

Pereira's machine paintings brought her more acclaim than her other work, and, although she continued to exhibit a variety of subjects throughout the 1930s, she chose *Wharf Construction* (Figure 16), of 1934, to represent her work when she was invited to participate in the Whitney Museum's Second Biennial in 1934.[22] She also included ventilators and wharf constructions in her first one-artist shows at the ACA Gallery in 1933 and 1934, about the earlier of which *New York Times* critic Thomas C. Linn wrote: "Unmistakable abstractions are to be found at the A.C.A. Gallery, where I. Rice Pereira is having her first one-man show. Here is a young artist who paints boldly and effectively in her large canvases, and with interesting color and whimsical humor in her smaller pictures. Although the marine subjects that Miss Pereira chooses for her abstractions may not interest all, many will recognize her skill."[23]

*Irene
Rice
Pereira*

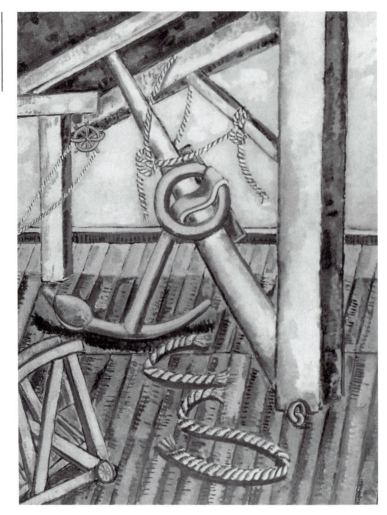

In 1936, however, Pereira became much more skeptical about
the beneficence of technology, and her concerns were shared by
many in society. Despite the popularity of the machine-age aes-
thetic during the 1930s, numerous writers sounded alarms about
the country's increasing dependence upon the industrial sciences
and its relative disinterest in the humanities. Not surprisingly,
some of the most vocal of the doomsday prophets worked within
the arts, and they warned of the consequences of this imbalance
or schism between industry and culture, machine and art. For
example, in the foreword to the catalogue accompanying the Mu-
seum of Modern Art's 1934 Machine Art exhibition, Alfred H.
Barr, Jr., remarked that America's romantic attitude toward the

machine had peaked with the Machine-Age Exhibition of 1927. Acknowledging the beauty in the geometry and rhythm of machine forms, he nevertheless cautioned:

> *It is in part through the aesthetic appreciation of natural forms that man has carried on his spiritual conquest of nature's hostile chaos. Today man is lost in the far more treacherous wilderness of industrial and commercial civilization. On every hand machines literally multiply our difficulties and point our doom. If, to use L. P. Jack's phrase, we are to "end the divorce" between our industry and our culture we must assimilate the machine aesthetically as well as economically. Not only must we bind Frankenstein—but we must make him beautiful.[24]*

Thus, despite public faith in science and technology, Barr and many other people associated with the arts characterized the relationship between human and machine as adversarial, as a kind of Darwinian struggle for power and survival. They viewed the machine as something to be conquered, to be bound and beautified. Left untended or incompetently managed, this mindless creation, evocative of the Golem of Jewish legend, might run amok and, in its uncontrolled state, create chaos, like the feeding machine in Charlie Chaplin's 1936 film *Modern Times*.

In theater as well, the struggle between human and machine was given literal expression. In the first scene of William Saroyan's *The Time of Your Life*, the character Willie, described as "the last of the American pioneers," is pitted against the unbeatable pinball machine, for he has "nothing more to fight." Like Barr, Saroyan employed the romantic metaphor of the indomitable spirit of the frontiersman setting out to conquer the wilderness and its native inhabitants. Seemingly having no other worthy enemies, the underdog Willies of America, with their invigorated pioneer spirit, must rally to defend their culture against this last foe. However, in order for the machine to become a credible enemy—to lend validity to the metaphor—writers had to breathe life into this "Tin Man," to endow "him" with autonomy and purpose but little innate intelligence (and certainly not a heart), to absolve "his" creators of blame or responsibility for the problems in culture attributed to this mechanical alien in our midst. In other words, the machine must be given the same features as the "wild Indian" of western lore—a foe European-Americans already knew they could "manage."

Willie, of course, beats the pinball machine in the last act. A

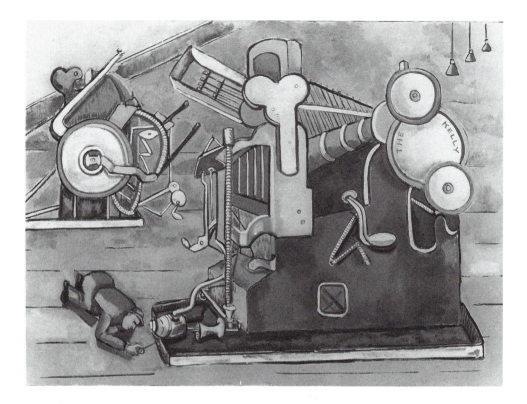

hero is made. Order is maintained. But, in reality, the fate of humanity pitted against the proliferation of standardized technology did not seem so assured in the 1930s. Many feared the loss of individualism in standardized mass production, a fate that at some point became so upsetting to Pereira that she destroyed an early work, *The Presses* (Figure 17), of 1933, because the man she painted oiling a large hinge press, described by John Baur as looking like a Rube Goldberg machine, seemed so insignificant with respect to the size of the press.[25] This fear was also addressed by former government economist Stuart Chase in his highly popular book *Men and Machines,* condensed and serialized in five articles in the *New Republic* (May–April 1929) before its publication in 1929 and reissued in 1935 after several printings. Lewis Mumford, a major critic of contemporary technological culture, remembered using Chase's book in preparing his evening course at Columbia University called "The Machine Age in America," which he taught from 1932 through 1935. He recalled that, at the time, apart from Harold Rugg's *The Great Technology,* it was the only introduction to the topic available in English. In addition, Chase's book was

recommended by Sheldon and Martha Candler Cheney in their 1936 publication *Art and the Machine*.[26]

In *Men and Machines*, Chase examined technology's impact on society. Tallying both its positive and negative contributions, the economist prepared a "balance sheet" from which he concluded that the machine itself should not be blamed for the problems of industrialized society. Management was the issue. Machines had been enslaved by humanity, he observed, rather than the reverse, but, like unruly children, society had failed to direct them with reason and a firm hand. Borrowing a metaphor often used by psychoanalysts who theorized that the conscious mind should control the unconscious for mental health, he called for humanity to bridle the machine through intelligence and spirit as one tamed and disciplined wild horses.[27]

If the author saw hope for reining in his spirited mechanical steed, the book's illustrator, Walter Tandy Murch, was more pessimistic. Evoking medieval manuscript illuminations showing angels turning cranks to move the heavenly spheres, his frontispiece portrays a universe set in motion by a colossal gear-and-belt-driven machine. An insignificant male nude, dwarfed by the gigantic gears rotating the moon and the stars, stands helplessly nearby, unable to affect the course of his future in this mechanistic universe.

Perhaps more disturbing in the book is Murch's depiction of three anonymous factory employees, with identical faces and robotlike bodies, who are handcuffed to the belt-driven machines of the assembly line they tend. One might interpret this image as a metaphor for the enslavement of humanity to the machine. However, in truth, the illustration accompanies Chase's factual report of punching-machine attendants chained to levers at an automobile manufacturing plant, an account rendered more chilling by the author's uncritical defense of the practice, implemented to prevent the periodic loss of body parts to the down-thrust of the punch. Reality could be more appalling than the visions of filmmakers and playwrights in the famous worker sequences in Fritz Lang's *Metropolis* and Karel Čapek's *R.U.R. (Rossum's Universal Robots)*.

Evoking the title of Chase's recently reissued book, Pereira's major work of the middle of this decade was *Man and Machine,* of 1936, a painting in two versions (Figures 18 and 19). In the first version, three male figures struggle against the weight of their mechanical burdens, driven by the relentless belts and pulleys of modern factories. One man carries a heavy blue sphere, which

*Irene
Rice
Pereira*

FIGURE 18

Man and Machine I,
1936, oil on canvas,
35⅞ × 48 in. The
Lowe Art Museum,
The University of
Miami. Gift of
John V. Christie.
Photo, Karen A.
Bearor.

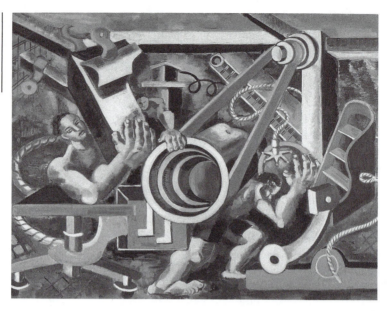

FIGURE 19

Man and Machine II,
1936, oil, 36 × 48 in.
University of
Arizona
Museum of Art.
Gift of Edward J.
Gallagher, Jr.

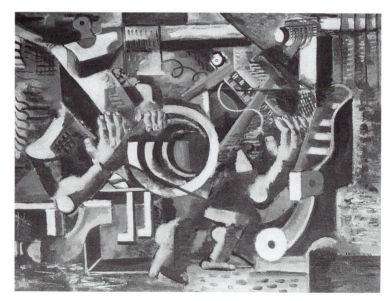

alternately suggests an ocean-filled globe borne by a laboring Atlas or the metallic surface of a bomb with its as yet unlit "fuse" snaking around a nearby conveyer belt and platform ladder. In the second version, the male figures, with only vaguely discernible heads and torsos, become faceless robots hardly distinguishable from the machines they tend. Ensnared in the complex network of mechanical parts, they, like Murch's automatons, have become enslaved to their mechanical masters. Parallel upraised arms with enlarged hands, vestigial reminders of Diego Rivera–like workers, bend at knobbed elbows that echo the circular hinge of a prominently positioned lever. Clearly these men have lost the Darwinian struggle. By rendering the second version of *Man and Machine* less literal in its depiction of the factory attendants, Pereira created a work more ominous in its implications.

While there is no evidence to prove that Pereira was familiar with Chase's book, it would be surprising, considering the book's popularity and availability, to discover that she had not seen it. Furthermore, not only did Chase work closely with at least one liberal artists' organization during the mid-1930s, but another of his books, *Nemesis of American Business,* published in 1931, appears on the general reading list of the Design Laboratory, where she had recently begun to teach.[28] However, whether *Men and Machines,* or perhaps her copy of Mumford's *Technics and Civilization,* published in 1934, contributed to her pessimism is purely academic, as these paintings reflected widely held fears concerning the dehumanizing effect of factory labor.

The machine forms appearing in each version of *Man and Machine* were inspired by objects from her own environment. The prominent, centrally placed pulley system appearing in each work, a motif relatively rare in the hundreds of machine paintings produced by American artists during the 1920s and 1930s, was based upon the belt-driven power lathes and saws in the workshops of the Design Laboratory. (One can imagine her own sense of frustration and dehumanization as she had to master some of these power tools virtually overnight in order to teach adult students how to operate them.) For other forms she mined previous paintings. Discussing the two versions of this painting in her manuscript "Eastward Journey," Pereira remembered that the composition of the first was assembled from parts of previous wharf paintings:

In fact, this is the main horizontal and vertical construction. The sea is in the upper right and I used a chimney for generating heat

instead of funnels. On the left, under the man's elbow, are parts abstracted from my own drawing board. The picture as it was being constructed was to me somewhat like the furnace room of a ship. I suppose I was no longer afraid of the machine and had started to make the machine larger and larger in this painting. But as I painted "Man and Machine," I became more and more aware of the difficulty of making man strong enough to control it.

I thought I would try again and did "Man and Machine No. 2." What I really felt I did not want to record, so I reduced everything to movement leaving only the strong hands as a sign of defiance.[29]

Apart from this statement, which she repeated in lectures during the 1950s, the artist made only one other surviving comment regarding this work. On the back of the photograph of the second version of the painting submitted to the Whitney Museum for reproduction in the catalogue of her retrospective in 1953, she wrote, "The machine as an anti-social force."[30]

Man and Machine (presumably the second, more familiar version) was exhibited at the Julien Levy Gallery in February 1939. While one attending critic wrote that the painting reflected romanticism toward the machine age, Howard Devree of the *New York Times* thought it successfully made a biting comment on civilization.[31] Years later, John I. H. Baur offered the following interpretation of the second version: "In one sense the machine triumphed; yet in another, man through the artist, was victorious. The more abstract design, the more disciplined organization of forms in parallel planes and subdued but rich harmony of earth colors with a few reds and blues combine to rob the machine of its terror by translating it completely into art." Yet it was the content—Pereira's "senseless assembly of wheels, rods, levers and gears from which disembodied hands and legs protrude at tortured angles"—and not merely her organization of forms that led Baur to select this painting as the work most representative of the "temper" of the 1930s in his survey of "The Machine in American Art" in 1963.[32]

Repeatedly, the second version of *Man and Machine* has been compared to the work of Fernand Léger. Having claimed to have studied at the Académie Moderne, Pereira was certainly familiar with his work, and she undoubtedly saw his paintings when she attended the exhibition Cubism and Abstract Art at the Museum of Modern Art in 1936. The flattened, cylindrical pulley in the center of each *Man and Machine* evokes Léger's *Les Disques* of 1918, although similar devices appear in Pereira's *Presses,* based

upon a sketch made from life. The machine aesthetic was so pervasive and the scope of Léger's influence so broad by the mid-1930s that to say Pereira was influenced by this artist is to be saying nothing of real consequence. Rather than placing Pereira's early work under the shadow cast by the impressive figure of Léger, it is more productive to view *Man and Machine* as both the culmination of Pereira's experimentation with machine forms and her recognition of the communicative power of abstraction.

With *Man and Machine,* Pereira seemed to reach a temporary dead end with respect to the machine. Although she continued to assemble hinges and levers and gears into semiabstract compositions, the human figure never again appeared overtly in her machine compositions, and other changes occur in the late 1930s. *Script for a Scenario (Belts and Wheels)*, *Washington* (alternately titled *Greek Twilight* and *Monument No. 1*), and *Congress (Monument No. 2)*, each completed in 1938, and *The Embryo*, of 1938–39,[33] reflect the impact of both Dada and Surrealism, the result of which was a fresh, though brief, outlook on the subject of the machine.

In both *Washington* (Figure 20) and the closely related *Congress*,

FIGURE 20

Washington (Monument No. 1), 1938, oil on canvas, 30 × 36 in. Michael Rosenfeld Gallery, New York, New York.

Pereira painted a façade of a classical temple, inspired, no doubt, by government buildings in Washington, D.C., where she had gone in March 1938 to attend the opening of her one-artist show at Howard University, held under the auspices of the WPA/FAP. Each edifice functions as the backdrop for machinelike forms which, particularly in *Congress,* took on anthropomorphic qualities. They brought to mind filibustering congressmen in the opinion of *New York Times* critic Howard Devree, who wrote, "In 'Congress' she taps a vein of humor with suggestions of pontifical figures and microphones."[34] However, her wit here is not that of an artist childishly writing "Bye-Bye" on the flags of a ship, but of a more mature artist intent upon exposing the foibles of humankind through mechanomorphic forms. This more Dadalike approach to her subject was undoubtedly a result of her exposure to the anthropomorphic machines painted by Picabia and Duchamp, on view at the Cubism and Abstract Art and Fantastic Art, Dada, Surrealism exhibitions at the Museum of Modern Art in 1936, the catalogues of which she saved. Yet the juxtaposition of the classical temple, symbol of reason and order, and the farcical "figures," representative of fallibility and chaos, is evocative of the pairing of the temple and the bestial women in the vision of Hans Castorp, a character in Thomas Mann's *Bildungsroman, Magic Mountain,* published in 1927. Psychological opposites—"thinking" and "feeling," or "spirit" and "nature"—are united compositionally. Although not as overtly indicated as in her depiction of the artist reaching for the sun in the earlier *Struggling* (Figure 22), of 1937, discussed in detail later in this chapter, both *Washington* and *Congress* could be interpreted as visual shorthand for the *Bildungsroman,* a literary genre in which Pereira demonstrated much interest. Such a reading is reinforced by the elevated position of the temple façades and the inclusion of staircases for ascent in each painting.

The Embryo (Figure 21), first exhibited at the Julien Levy Gallery in February 1939, represents a radical break from Pereira's earlier machine paintings. Only vestiges of machines appear. Positioned on an underlying grid structure, their identities and functions are unclear. All verticals and horizontals in the painting are in balance; rectilinear and organic shapes are also in equilibrium. If *Man and Machine* had depicted humanity lost in the struggle against the unchecked power of machines, the force of the machine here is held in check, its precision offset by ambiguity. The title of the painting refers to a prominent fetuslike figure, with a large "head," dark circular "eye," and undefined "limbs,"

FIGURE 21

The Embryo,
1938–1939, oil on
canvas, 38 × 30 in.
Location unknown.

reminiscent of motifs seen in many Surrealist paintings.[35] The contours of the limbs of this biomorph are echoed in another organic shape opposite it, on which Pereira painted a small square and rectangle. Unclear in meaning, these prominent symbols, evoking plus-and-minus indicators of electrical charge in circuit diagrams, suggest polarities held in balance. The form above them, resembling the cross section of an automotive piston housing, may be similarly interpreted. Here, two rings are held in equipoised opposition by a discontinuous larger ring. In style and content, all potentially conflicting forces in this painting are equalized and synthesized into a harmonious whole.

Pereira's union of geometric and organic shapes in *The Embryo,* like the juxtaposition of the classical temple and the anthropo-

morphic machines in *Congress,* may be seen metaphorically as a synthesis of rationality and irrationality. In a passage she underlined in the catalogue to the exhibition Cubism and Abstract Art, Alfred H. Barr, Jr., identified "two main traditions of abstract art": first, that which was "intellectual, structural, architectonic, geometrical, rectilinear and classical in its austerity," which had descended from Cézanne through Cubism and Constructivism; and second, that which was intuitional, emotional, organic or biomorphic, curvilinear, romantic, spontaneous, and irrational, which he associated with Surrealism. Observing that these two currents occasionally intermingled and might appear in the work of one artist, Barr further declared, "The shape of the square confronts the silhouette of the amoeba."[36] In Pereira's painting, the amorphous silhouette of the embryo both confronts and embraces a square.

Although no contemporary statement by Pereira concerning her machine paintings survives, an indirect quotation may be found in a press release from the Department of Information, WPA/FAP, concerning her exhibition at Howard University in Washington, D.C. Dated February 25, 1938, the press release reports that her "chief concern as an artist is with instruments that have created the 'Machine Age.' These she uses symbolically, and although she does not attempt to reproduce definite machines in her paintings, her concept of form and her invention of 'motifs' are derived from an understanding of the functions and social influence of the machine in modern life."[37]

The bankruptcy of her inventive yet essentially descriptive representations of machine parts was becoming increasingly evident, as Pereira cast about for new forms of expression. Years later, following her immersion in Jungian thought, she said that in her last machine paintings, those containing colonnaded temple façades, she was burying the machine in classical Greece, its ancient home of pure logic.[38] While one is tempted initially to interpret this statement as a rejection of the machine aesthetic, in fact it refers to her returning to the psychological source of these forms, that region of the mind theorized to contain the buried experiences of ancient cultures (the memories of discs and spheres invoked by Le Corbusier), the collective unconscious and its archetypal forms. She repeatedly claimed to find there the source of the geometric motifs she would find more useful in conveying the concept of the union of rationality and irrationality, "thinking" and "feeling."

In 1938, Pereira harbored no doubt that she was part of a revo-

lutionary movement bringing to the world a new culture. This feeling had been nurtured by her association with left-wing artists' galleries and organizations throughout the 1930s. Although generally remembered as promoting social realist or social protest art, these groups also provided a network of support for artists working in an abstract idiom. An examination of Pereira's interaction with these groups, despite scanty extant evidence regarding her political beliefs, provides some insight into subsequent choices she made regarding her life and her work.

As noted above, Pereira was given her first one-artist show at the ACA Gallery, in its original location at 1269 Madison Avenue, in January 1933. Founded by Herman Baron and financed in part by his work as an editor and contributor for a monthly trade paper called *Glass Digest* (originally *Glazier's Journal*) the small street-level gallery had opened the previous August during what one reporter called "the nadir of the New York art season."[39] Baron's idealistic goal was to create a "people's art gallery" to bring to the community the work of young, unknown, perhaps even unpopular artists practicing any style.[40] Considering ignorance of the fine arts as disastrous to culture as illiteracy and innumeracy, he felt such a gallery might help teach the community to appreciate art and thus stimulate a desire for further contributions by artists. The director of such a gallery, he felt, should accept this responsibility for the love of art and the good of the community, not for financial gain.[41] While such liberal sentiments were not uncommon during the Depression years, they were revolutionary coming from a gallery owner.

With the opening of the John Reed Club's exhibition in November 1932, the ACA Gallery established itself as a showplace for social protest art and earned its associates reputations as Communist sympathizers.[42] Although Baron felt that social realism was a universal language of human experience, he also believed that any style of painting, even abstraction, was legitimate, so long as it served a social function.[43] In keeping with this policy, the ACA Gallery gave one-artist shows to artists as politically and stylistically diverse as Joe Jones (1935), William Gropper (1936–1944), Philip Evergood (1938), John Heartfield (1938), Robert Gwathmey (1941), and Joseph Stella (1943), in addition to later one-artist shows for Pereira in 1946 and 1949, after her paintings had become totally abstract.

The ACA Gallery was also quick to respond to the needs of the oppressed and disadvantaged. In March 1935, to support the Costigan-Wagner Anti-Lynching Bill, it sponsored a show "For

Negro Rights." During May 1937 it exhibited the works of seventy-nine artists dismissed from the WPA Federal Art Project during massive government cutbacks in Pink Slip over Culture, sponsored by John Dewey, Lillian Hellman, Rockwell Kent, Lewis Mumford, Edna St. Vincent Millay, and Van Wyck Brooks, among others. Two additional exhibitions, one in August 1937 and another in September 1938, grew out of problems within the WPA which were dramatized by the demonstrations of the Artists Union. A William Randolph Hearst editorial on August 15, 1939, prompted a show titled Free Speech for Artists the following September. In 1940, to strike out against fascism, the gallery showed graphic works by Chinese and Soviet artists. In addition, beginning in November 1938, with its We Like America exhibition, the gallery provided space annually for exhibitions sponsored by *New Masses,* until that magazine suspended publication.[44]

In April 1934 the ACA Gallery moved from Madison Avenue to a Greenwich Village loft, above the Village Barn, at 52 West Eighth Street, only a few doors away from the Whitney Museum of American Art. It was here, in the fall of 1935, that the organizational meeting for the American Artists Congress was held. Critic Elizabeth McCausland, an art reporter for the Springfield (Massachusetts) *Republican,* in New York to work for the WPA's department of public information, participated. She recalled this as her first visit to the gallery.[45]

The motto of the American Artists Congress was "For Peace, For Democracy, For Cultural Progress." Excerpts from Lynd Ward's foreword to the catalogue of the first members' exhibition provides insight into the problems artists shared during the Depression and their reasons for organizing:

The artist has learned . . . that those who control the state and boast themselves the guardians of civilization have, in the final analysis, no real concern for him; that if left to their own devices and programs they will cast him off to starve, and ask only that he do it without protest. . . . But the artist has learned . . . that if he wants the world of art to live, he must work actively for those physical conditions that are basic necessities for any art activity. . . . Hence the artist seeks new relationships, federal projects and patronage, new uses for art, new places for pictures, new audiences, wider audiences. . . . The artist must have complete freedom of expression, freedom to deal with any aspect of life without hindrance. He must be free to bring his work before people without the barriers that rise from official censorship, attacks by hoodlums

*and vigilantes, or prohibitive costs of materials and display space.
He must have an audience that is in its turn free, not bound
down by taboos and superstitions or kept from contact with art
by barriers of another sort, lack of education, lack of leisure,
lack of money to buy and to own. . . . Because alone he can do
nothing, . . . the American Artists' Congress was formed . . . [to
join together] artists of all races and aesthetic creeds in common
action whose goal is the creation of those conditions that art must
have if it is to live and grow. In the larger sense, this common
action means complete and passionate opposition to those forces in
the world about us that are moving toward another war, that seek
to repeat the bitter formula wherein lust for power and privilege
and desire for business profits work bloody havoc with the lives of
millions.*[46]

Despite her association with the ACA and her sympathies with
the goals of the American Artists Congress, Pereira was appar-
ently not present at its founding, and it is not known whether she
attended its first convention held at New York's Town Hall on Feb-
ruary 14, 1936. She was not among the 378 signatories of "The Call,"
published in the catalogue of its first exhibition, held at the ACA
Gallery, although the names of many of her friends and profes-
sional acquaintances, such as Jan Matulka, Stuart Davis, C. Adolph
Glassgold, Herman Baron, and David Smith, appear there.[47] Yet
in April 1937 she submitted *Machine Composition* to its First An-
nual Membership exhibition in the Mezzanine Galleries of the
International Building in Rockefeller Center, ironically located
next to the Italian consulate with its large brass sculpture of Mus-
solini in front. The *Daily Worker* applauded the efforts of the con-
gress and noted that "every type of aesthetic direction is repre-
sented in the exhibition. And when artists are willing to forget
artistic feuds there must be a pretty large common denominator
holding them together."[48]

Pereira endorsed, and benefited from, the stylistic diversity
promoted by Baron and the American Artists Congress, and she
participated in their pursuits of liberal ideals. Late in life she re-
membered the prewar years as a time when artists had highly
moral goals and worked to create a climate of freedom for the
emergence of new ideas, to lead the society forward. For her, "art
has to remain free if a society is to be great. And unless you have
the greatest minds in the field of action all the time the whole
society is going to go under. You suppress one genius and the
society loses a tremendous amount of energy."[49] Her lifelong

commitment to cultural progress stemmed from her association with the artists and supporters of the ACA Gallery and the liberal artists' organizations of the 1930s.

So influenced was Pereira by the goals of these groups that she began to paint and exhibit social realist works of her own. Beginning in 1935, she worked on several gouache paintings with subjects related to the theme of how to organize relief work for the poor. One of these works, *Home Relief,* dated 1935, shows a three-level dormitory inhabited by dejected, unemployed, otherwise homeless anonymous figures.[50] Another painting of the same year, included in the ACA Gallery's exhibition The Social Scene, in April 1935, elicited the following comment from a *New York Post* critic: "I. Rice Pereira's 'Subway,' with its corps of men patiently (or not) washing down the walls, . . . registers decidedly on the credit side of the ledger."[51] Although seemingly innocuous and apolitical, *Subway,* in fact, would have been provocative in 1935, amid discussions of the cleaning up and unification of the subway system and the first rumblings of the controversy concerning the "un-American" decoration of New York's subway stations.[52]

Pereira's most ambitious and impressive painting in a social realist style was *Struggling,* or *The Artist* (Figure 22), completed in 1937. Here a supine, barefooted, and bare-chested male figure, shackled like the workers in *Man and Machine,* is virtually crushed beneath the feet of unseen oppressors. He reaches out for the sun, like Oswald Alving, the artist who struggled against puritanical repressiveness in Ibsen's *Ghosts,* a play which Pereira subsequently identified as having great meaning for her as a young artist.[53] Surrounding this foreshortened figure are three manacled, supplicating men, with massive upraised hands, one of which reaches for a cross. Near the center of the canvas is a disembodied hand, also cuffed, supporting an orb. The "artists" here are both painters, symbolized by an easel, and writers, represented by a scroll. While it is curious that Pereira included no female figures among the group, her message is obvious: the downtrodden artist, who upholds civilization, must break free from the bondage of earthly concerns and seek the total enlightenment and transcendental freedom represented by the sun.[54] In effect, this painting is a visual analog to the literary genre made popular during the period of German Romanticism, the *Bildungsroman,* or, more specifically here, the *Künstlerroman,* a novel detailing how the hero transcends earthly concerns to become a true artist or poet celebrating the spirit.

In 1937 Pereira also painted *Against War and Fascism,* the title
of which was taken from that of the American Artists Congress'
inaugural exhibition in April 1936. Its name was abbreviated to
Fascism for the Congress' An Exhibition in Defense of World De-
mocracy, Dedicated to the Peoples of Spain and China, in Decem-
ber 1937, one of several political shows in which she participated.[55]
According to Henry Glintenkamp, writing in the exhibition cata-
logue, the show was originally planned as a response to Musso-
lini's and Hitler's threats of intervention in the civil war in Spain
and the aggression of Imperial Japan against China. However, he
noted that the theme was broadened to include "curtailment of
civil liberties, strikes, police brutalities, etc., . . . [or] any work
depicting undemocratic procedure and the exploitation or enslave-
ment of labor."[56] Elizabeth McCausland, writing under the pseud-
onym Elizabeth Noble in *New Masses,* saw this nonjuried, uncen-
sored exhibition as "a significant landmark in the evolution of our
native culture," demonstrating a "deep and passionate awareness

FIGURE 22

*Struggling
(The Artist),* 1937,
oil on canvas,
50 × 42 in. The
Lowe Art Museum,
The University of
Miami. Gift of
John V. Christie.
Photo, Karen A.
Bearor.

of the artist's oneness with society." While approving the decision to include diverse styles of painting, she argued that no "forward-looking" artist could remain untouched by social realism, for

> [*Art*] *is made for society, for the world, for the widest possible audience. Moreover, it wants to deal with relevant facts and experiences, not with pseudo-classical or mythological allegories, but with the life the artist knows and daily lives. . . . Yet because the artist, looking outward on the world, is a far different person from the artist looking inward to the depths of his own psyche, he will use whatever is his inherited tradition—realistic, abstractionist, or what—with new implications. New problems, technical and aesthetic, inevitably will arise, it is unthinkable, therefore, that his style will remain the same as he had before he sought to put the new wine of social content into the old bottles.[57]*

That abstraction, like social realism, was deemed appropriate for an exhibition directed against international fascism and other "undemocratic" procedures is a fact amply documented in the writings of the liberal artists' groups and their supporters and recently the focus of Cecile Whiting's book *Anti-Fascism,* published in 1989. But it is also important to note in the above quotation McCausland's apparent assumption that abstraction was the result of the artist's looking inward to the depth of his or her psyche, language that was fairly commonplace in explanations of abstraction by sympathetic (if not always enthusiastic) writers.

During the course of this exhibition, the American Artists Congress held its second national convention on December 17, 1937, at Carnegie Hall, and it is probable that Pereira was among the audience of "some 400 U.S. artists and six times as many followers of the arts."[58] The well-publicized program, chaired by Ralph M. Pearson, was to include a transatlantic telephone call from Picasso in Paris and a speech by New York mayor Fiorelo H. LaGuardia. LaGuardia canceled at the last moment, and, as the artist had become ill, Picasso's message, urging artists not to remain indifferent to the Spanish people's struggle for democracy, had to be read.[59] Erika Mann delivered a statement written by her father, Thomas Mann, which also encouraged artists to fight against fascism. The elder Mann, author of widely read novels such as *Death in Venice,* published in English in 1925, which focused upon psychological studies of the artist's relationship to the world, was in exile after having been deprived of his German citi-

zenship by the Nazis.[60] The remainder of the program included

speeches by Max Weber, George Biddle, Martha Graham, Philip
Evergood, and Yasuo Kuniyoshi, among others.

During the McCarthy era Pereira downplayed her association
with the congress; in fact, she became an increasingly active par-
ticipant in the organization in 1938. Not only did she exhibit *Black
Squares* (Figure 25), misidentified as *Block Squares,* in the non-
juried Second Annual Membership exhibition, but she also de-
signed the invitation card for the event. Open to any member on
payment of a small entry fee, the exhibition was held in the fifth-
floor galleries of Wanamaker's department store, rather than in a
gallery, to reach a broader audience. Both Pereira and Baron
served on the exhibition committee, chaired by Victor Candell.[61]
The critic for the *New York Post* singled out her *Black Squares* as
the "most inventive" of the abstract paintings shown.[62] The fol-
lowing February she contributed an abstract painting to the con-
gress's third annual exhibition, Art in a Skyscraper, whose "demo-
cratic" mixture of styles continued to merit comment by critics.
For example, Elizabeth McCausland wrote that, while all the
works included might not be of the highest quality, the show was
based upon a more "progressive" premise, that of uniting artists
working "for peace and for a social environment which permits
human beings to live happily and to do their work without
censorship. . . . As in our democratic structures of government,
all shades of opinion are to be found, so in this exhibition all
schools of esthetic thought are represented."[63]

Apparently defecting from the organization after her disillu-
sionment with politics following the signing of the Hitler-Stalin
nonaggression pact of August 1939,[64] Pereira did not exhibit again
with the congress. During the period of her association with this
group, however, she also participated in nonjuried exhibitions
sponsored by other nonprofit organizations and government
agencies. The nonjuried show, vitally important in the 1930s, pro-
vided visibility to artists without prior exhibition or sales records.
Such exhibitions were intended to fill the void created by the
more risk-free practices of commercial galleries promoting the
work of "master" European artists with established reputations,
most of whom were long dead. For example, in January 1936
Mayor LaGuardia's Municipal Art Committee began to operate
the Municipal Art Gallery, located in a remodeled, city-owned
brownstone on West 53rd Street, providing New York artists a
place to show their work without incurring entry fees, the biases

of a jury, or the deduction of commissions from sales. Deemed more important than any arbitrary standards of quality was the public exposure given to emerging artists, like Pereira, who exhibited here in 1936 and 1937. In theory, the public benefited as a result, for, as critic Emily Genauer explained, "here, for the first time in the history of American art, was presented a truly representative picture of the art expression of a particular time and environment."[65]

Although she was not invited to join An American Group, Incorporated,[66] Pereira contributed an abstract collage, titled *Home Sweet Home,* to its exhibition Roofs for Forty Million, held in April 1938 in seventh-floor galleries at Rockefeller Center.[67] A broadsheet inviting artists to submit works appropriate to its "housing" theme listed possible subjects: fire escape outlooks, families of six in two rooms, sordid interiors, dilapidated stairs, rural slums, and so forth. More positive alternatives included showing solutions to the housing problem, such as the Williamsburg Housing Project. Artists still at a loss for ideas were advised to attend the Federal Theatre Project's production of *One Third of a Nation,* a play about the housing problem, at the Adelphi Theatre.[68]

Pereira's collage *Home Sweet Home* included a scrap of sheet music bearing the title of the famous melody. Although she later claimed that she intended no social comment, despite the work's inclusion in this exhibition,[69] such a position seems unlikely when one considers her participation in contemporary shows with overtly political themes. Furthermore, the subject of housing was so politically charged during this decade that her friend Philip Evergood was arrested in New Jersey, allegedly for making sketches of a tenement district preparatory to painting the work he intended to submit to this exhibition.[70] At the very least, Pereira would have appreciated the irony of her title, which elicited comment in the *Daily Worker.*[71]

Among the other artists' organizations that Pereira joined during this decade was the United American Artists. Originally the Unemployed Artists Group, a few artists meeting informally in 1933 at the John Reed Club, it was renamed the Artists Union in 1934, when it expanded to become a trade union of painters, sculptors, printmakers, and allied artists, under the presidency of painter Balcomb Greene, with whom Pereira would have a joint show at the Museum of Non-Objective Painting in 1940.[72]

Pereira may have been a member of the Artists Union, although the evidence supporting such an assertion is inconclusive.

In her files, she kept articles on tempera and gesso painting writ-
ten by Stefan Hirsh and published in *Art Front,* the union's offi-
cial organ for three years, beginning in November 1934, the man-
aging editor of which was Herman Baron.[73] Like the American
Artists Congress, a majority of the members of the Artists Union
were social realists. Although other styles were tolerated, there
were heated debates about abstraction, which some members con-
sidered elitist. Such arguments were reflected in the pages of *Art
Front,* itself the focus of periodic attack because of the scholarly
tone of articles written by such notables as Meyer Shapiro, Isamu
Noguchi, Louis Aragon, Lynd Ward, Frederick Kiesler, Berenice
Abbott, and Elizabeth McCausland. As Gerald M. Monroe has
written, "*Art Front* was, in effect, an esthetic dialogue on the left.
American Scene artists and the academicians were roundly con-
demned, but a lively debate evolved among the social realists, the
expressionists, the surrealists, and the abstractionists."[74]

Whether Pereira obtained the *Art Front* articles through mem-
bership in the Artists Union or other access cannot be determined
without corroborative evidence. However, in January 1938 the or-
ganization became the United American Artists, Local 60 of the
United Office and Professional Workers of America (UOPWA).
Pereira was a member by October of that year and ultimately be-
came chair of its easel division.[75] Recognized by *New York Post*
critic Jerome Klein as "the mainstay of organized support for
WPA art," the organization fought to secure permanent govern-
ment patronage for artists.[76] In an attempt to unite artists in this
struggle, the UAA exhibited both realist and abstract work. In
1940, in a special issue of its publication, the *New York Artist,* an
editorial made it clear that both styles were essential to the sur-
vival of the arts in society. Responding to a *New York Times* article
that predicted that the war would force artists back into their
"ivory towers," one of the editors naïvely forecasted the following:

> The ivory tower is an image of a past that will never rise
> again. . . . The artist will never forget that it was the confluence
> of the political, trade union, and the unemployment forces of the
> country that created arts projects and other government sponsored
> art efforts. And war or no war the artist is compelled in the
> interests of his economic and cultural existence to fight for the
> continuance of these projects. . . . In a period of brutality loosed
> upon the earth by those who seek to divide it for their profit, all
> artists—abstract, surrealist, romantic or social realist—all those
> who stir the imagination or the emotions, our sense of order or

*social responsibility—are laying up a human barrier against
brutality, lies, hatred, ignorance, and vulgarity.*[77]

This issue of the *New York Artist* contains a checklist and re-
productions of selected works shown in the UAA's annual exhi-
bition held at 50 Rockefeller Center from May 25 to June 9, 1940.
Pereira's painting *The Diagonal* (Figure 28), 1938, was one of the
abstractions reproduced. The exhibition followed a series of five
forums on contemporary art sponsored by the UAA. Although
ostensibly planned to provoke discussion of contemporary aes-
thetic issues, the organizers of the series hoped participants would
find common ground, for they feared fragmentation and its po-
tentially disastrous consequences. The following statement by
Max Weber, appearing on the printed announcements for the se-
ries of lectures, makes this point quite clear: "It is absolutely es-
sential and urgent particularly at this time, to create harmony and
understanding between the several existing 'Schools.' Reaction
thrives on just such division and diversion, and unwittingly the
artist like all workers—being more or less unconscious victims of
the competitive 'philosophy' of our environment—play right into
the hands of those who are ready to divide and destroy them."[78]

Held at the Labor Stage at 39th Street and Sixth Avenue, the
series began December 7, 1939, and ran through March 7, 1940.
Devoting itself to a selected theme, such as "Social Realism,"
"American Romanticism," "Surrealism, Expressionism," "Abstract
Art in America," and "Contemporary Sculpture," each forum was
moderated by Elizabeth McCausland and consisted of lectures by
artists and discussions from the floor. On February 15 Pereira ap-
peared with fellow panelists Stuart Davis and David Smith and
spoke on the topic "How Abstract Artists Work."[79] Here Pereira
discussed the sources of abstraction, which she divided into three
categories, recorded by John I. H. Baur as the following: "The
first was 'representational,' meaning that it broke down objects
in nature to obtain their essence. The second was 'intuitional,' or
shapes drawn from the subconscious. The third, obviously her own
kind, was 'the pure scientific or geometric system of esthetics,'
which, she said, seeks 'to find plastic equivalents for the revolu-
tionary discoveries in mathematics, physics, biochemistry and ra-
dioactivity.'"[80] These definitions of abstractions are those that she
formulated in 1937 while working on the WPA.[81]

Pereira was still a member of the UAA when it combined with
the American Artists Congress to become the Artists' League of
America in March 1942.[82] She exhibited a painting in the Artists'

League exhibition Artists in the War held at the ACA Gallery in the summer of 1942. Titled *Air Raid,* the work was described by Elizabeth McCausland as "an interesting fusion of abstract esthetic theories with content of real experience."[83] On March 19, 1945, she spoke on a panel sponsored jointly by the Artists' League and the Young Men's Hebrew Association and chaired by artist Robert Gwathmey. Pereira and fellow panelists Philip Evergood and Nat Werner addressed the session theme "Some Trends in American Art."[84]

Pereira continued to support liberal causes throughout the 1940s and 1950s. In 1941, she submitted a painting to the Art for China Exhibition and Sale, part of a national relief effort in support of China.[85] She exhibited in aid of Russian relief at the André Seligmann Gallery in 1942. Her name appeared along with those of friends Lucille Corcos, Edgar Levy, Philip Evergood, and numerous other artists who contributed works to an auction to benefit *New Masses* in April 1942.[86] In August 1945 she signed a petition for raising the minimum wage circulated in association with an exhibition of works by members of the National Maritime Union at the ACA Gallery. In connection with this event, a photograph of her, with photographer Berenice Abbott and artist Elizabeth Olds, appeared in the NMU publication the *Pilot.*[87] In 1946 she donated a work, title unknown, to the New York Citizens Emergency Committee to Aid Strikers' Families, and she also contributed work to an auction held jointly at the Sidney Janis and Betty Parsons galleries in February 1949 to benefit the United Art-workshops of Brooklyn Neighborhood Houses.[88] In 1959 she assisted American Friends of Spartan Children, Inc., of Highland Park, Michigan.[89] She also worked to improve the conditions under which artists created through her active membership in Artists' Equity in New York for several years.[90]

Pereira's connection with liberal artists' organizations caused her some distress. Throughout the 1930s, artists working with abstraction were particularly vulnerable to attack from the conservative press and its supporters among artists working in traditional academic styles. The Hearst Press, in particular, seemed to delight in skewering abstractionists. For example, an editorial appearing in the August 15, 1939, issue of Hearst's *New York Journal American* charged modern artists with sedition and misrepresentation and suggested "they should be prosecuted like anyone else who commits that offense."[91] However, little attention was directed toward Pereira in particular until 1946, when her work was included in the State Department's ill-fated exhibition Ad-

vancing American Art, which circulated briefly abroad before being brought ignominiously back home.[92] The painter made two statements to the press critical of the cancellation of the tour[93] before she, like each of those artists whose works had been selected by J. Leroy Davidson for inclusion in this exhibition, was subsequently investigated by the House Committee on Un-American Activities. This committee labeled many of these artists as Communists, and its findings were submitted to Congress by Representative Fred E. Busbey of Illinois in May 1947 in support of his charges that the government was using taxpayers' money to support Communism. The damning evidence against Pereira was that she had contributed to the Third New Masses Art Auction in April 1942.[94]

Two years later, the artist was again labeled a Communist as a result of her participation in the Gallery on Wheels exhibition for disabled war veterans held at the United States Naval Hospital, St. Albans, New York, for two weeks, beginning January 17, 1949. On March 11, 1949, Representative George A. Dondero of Michigan called the abstractions in this exhibition "Communist art." In addition, he found fault with Pereira's association with the "American Artists Congress; ACA; Artists Gallery, and Artists League of America; Protestant magazine auction; State Department show."[95] She was also a member of Artists' Equity Association, which Dondero cited as a Communist front organization.[96] Although she later denied any participation, her name appeared in the *New York Times* that same month as a sponsor of a peace conference at the Waldorf Astoria, a meeting vilified by opponents as a front for spreading Communist propaganda.[97] In an interview with critic Emily Genauer, one of Pereira's friends and life-long supporters, Dondero cited this conference as a Communist front as well. In fact, he told Genauer that it was the responsibility of the art critic to police the painter of abstractions, for any such artist is automatically under suspicion of being disloyal. When asked how this might be accomplished, Dondero responded that critics should carry "lists": the names of those artists who were included in the State Department show, those who sent their works to St. Alban's, those who sponsored the conference at the Waldorf, and those who were associated with any group named in the government's "Citations," a booklet listing organizations and publications cited by any government agency or committee as "communist or communist front."[98]

Unfortunately, despite the fact that there is no evidence to suggest that Pereira was ever a member of the Communist party, her

name, or those of the galleries and organizations with which she was associated, appeared on each of the lists named. In retrospect, one can take solace only in Dondero's incompetence as a self-appointed critic of modern art, best revealed by the following often-quoted statement, made on August 16, 1949: "Abstraction-ism aims to destroy by the creation of brainstorms."[99]

The Design Laboratory and Pereira's Introduction to Bauhaus Theories

Irene Rice Pereira's association with the Design Laboratory of the WPA/FAP, beginning in 1936, was critical to both her professional development and reputation. To this point she had been successful in getting her work into exhibitions, but she had yet to find a style of painting that sustained her interest. She abandoned her Dufylike cityscapes in 1935, and her more naturalistic figural subjects, the most successful of which include her portraits of Dorothy Rice (Figure 23) and Byron Browne (Figure 24), were generally panned by critics. Her Cubist compositions of mid-decade were most promising in terms of her abilities, but her concurrent experiments in social realism suggest that she found this semi-abstract style politically limiting.[1] However, at the Design Laboratory, an industrial arts school in New York City with instruction based on the pedagogic theories of John Dewey and the Dessau Bauhaus, she was exposed to a new socially relevant abstraction based upon a synthesis of avant-garde aesthetic theories and functionalism. This holistic approach to art and life integrated the dual aspects of the artist's persona as skilled professional and responsible citizen while also blurring traditional distinctions between the production of fine art and utilitarian objects.

Pereira's teaching position at the Design Laboratory provided her with new credentials and increased visibility within the New York art world. Like other artists employed by the WPA, she profited from the opportunity to paint full time, to develop her skills and techniques, and to associate with other arts professionals. While many historians have remarked on the uniqueness of such support for American artists, only a few scholars have examined

this relief program in terms of its impact on the lives of women

artists, even if those it served were primarily of European descent, with middle-class backgrounds and education.[2] Bureaucratic time-keeping and oath-taking procedures often humbled or humiliated those individuals seeking relief, but, for women artists, such obstacles were offset by the opportunity to maintain professional identities, to exhibit their work, and to compete on equal footing with men for government commissions. As a result of such public exposure, those rare critics willing to suspend belief in stereotypes could see that women were capable of working successfully with a wide range of materials in a variety of styles and techniques. Talented women could also be seen as representing a significant portion of the artistic community, not merely an elite group of "exceptions" (although individually, many of these artists, like Pereira, were reluctant or unwilling to surrender the illusion of being "special").[3] Even though these privileges largely evaporated with the end of the WPA, the impact of government-sponsored art programs on the lives of women must be further explored to determine the extent to which their experiences differed or dovetailed with those of their male counterparts.

In Pereira's case, her faculty position at the Design Laboratory allowed her to take advantage of resources otherwise inaccessible to her. Through her post she became associated with the glamorous new field of industrial design (which had already received institutional approval in New York through exhibitions at the Museum of Modern Art and the Metropolitan Museum of Art) and met internationally famous designers and architects. Because the school's program of instruction was inspired by that at the Bauhaus, which had employed women instructors[4] and made the teaching of "crafts" an integral component of the curriculum, Pereira could see herself as a collaborator in a new educational experiment promising women more active involvement in the shaping of mainstream culture. Looking back on this time, she recalled feeling respected as an innovator and free to work in any style she wished without bureaucratic interference.[5] That she was respected by her contemporaries is evidenced by the options that became available to her. Provided the opportunity to clarify her aesthetic opinions through course preparation, teaching, and interaction with colleagues, she began to lecture publicly and to participate in panel discussions—sometimes for radio broadcast—on current issues in painting and art theory. Finally, her income from the FAP made her self-sufficient, a fact which may have been acutely important, for her marriage to Humberto Pereira, foundering at

Irene
Rice
Pereira

FIGURE 23

Dorothy, c. 1933.
Location unknown.
The Schlesinger
Library, Radcliffe
College.

the time of her appointment, ended in divorce before the end of her tenure.[6] The financial security gained from her employment at the Design Laboratory unquestionably contributed to her freedom to make choices regarding her personal life and career.[7]

The WPA Federal Art Project was established in August 1935 under the national direction of Holger Cahill. Frances M. Pollak, director of art teaching for the project, is generally credited with the original concept of the Design Laboratory, which was founded the following month. This school for industrial design training had only two predecessors: the Bauhaus, closed by Hitler's forces in 1933, and a four-year degree program established in 1935 by the Carnegie Institute of Technology at Pittsburgh.[8] The well-known New Bauhaus in Chicago, directed by László Moholy-Nagy, did not open until October 1937. Not only was the Design Laboratory

FIGURE 24

*Braz (Portrait of
Byron Browne)*,
1933, oil on canvas,
42 × 34 in. The
Lowe Art Museum,
The University of
Miami. Gift of
John V. Christie.
Photo, Karen A.
Bearor.

the only school in New York to provide coordinated instruction in industrial design but, as part of the FAP, it also offered retraining to large numbers of unemployed craftspersons and designers displaced by technological change.

Of the twenty-four original faculty, four were women. Pereira, who had worked briefly for the Treasury Department's defunct Public Works of Art Project (PWAP) in 1934, claimed to be one of the founders of the school, although her name does not appear as such in any documents. In fact, she was a last-minute addition to the teaching staff. She was not listed in the school's first publicity brochure, the source for the faculty roster appearing in the *New York Times* on December 2, 1935, the date registration began. However, she did join Nathaniel Dirk and Hans Foy as instructors of painting when classes began for more than two hundred

students on January 13, 1936, in one floor of the building at 10 East 39th Street.[9] The other women instructors were textile designers Anna W. Franke and Ruth Reeves (who left immediately to become a technical adviser to the Index of American Design and may not have actually taught a class) and product designer Hilde Reiss. A fifth woman, interior designer Lila Ulrich, was hired in the winter of 1936. In addition, the following members of the original faculty (listed with their dates of matriculation) had been Bauhaus students: Hilde Reiss, winter 1930–31; Lila Ulrich, winter 1931–32; and William Priestly, winter 1932–33.[10]

Because the WPA/FAP itself was a temporary relief organization, the Design Laboratory had no assurance of prolonged government sponsorship. Consequently, during its first months there was no defined curriculum, and, to critics of the New Deal, its instructional programs may have seemed to be little more than "boondoggling."[11] However, despite the tentative nature of its existence, the school was ambitious in its offerings. Open only to underprivileged students unable to attend private art institutions, the Design Laboratory offered free instruction in industrial design, graphic arts, and fine arts, including painting, sculpture, photography, and ceramics. Although admission requirements became more restrictive for the fall term, the school originally accepted all applicants, regardless of their training or demonstrated aptitude for the arts. According to one journalist's account, this open enrollment policy resulted in a student body composed of persons of "almost every race and nationality" ranging in age from sixteen to sixty years.[12]

Despite federal cutbacks and persistent rumors of the school's impending demise, co-directors Gilbert Rohde and Josiah P. Marvel publicly discussed transforming their institution into an advanced technical and professional school, and they implemented a new three-year curriculum in the fall of 1936 with that in mind. A seven-week summer session, intended as both a vocational orientation for prospective students and a means to weed out those who were unpromising, had just been completed. Beginning with the fall session, students were required to demonstrate some professional potential to gain entrance. Once admitted, all students took unspecialized foundation design courses. For advanced students, four majors were defined: industrial design, textile design, advertising, and photography. Although facilities were not expanded to accommodate the increased enrollment of 350, instruction was now based upon a sixteen-week semester system, with duplicate classes available for day and evening students. New

courses were offered in architecture, three-dimensional abstract design, and store planning. During the spring term, guest speakers participated in a series of lectures on "Design Analysis," individual topics of which included "Architecture," by William Lescaze, "Art and the Machine," by Meyer Schapiro, "Designing for the Theatre," by Lee Simonson, "Architecture and the Interior," by Percival Goodman, "Merchandising," by Alfred Auerbach, and an untitled presentation by Frederick Kiesler. Pereira spoke on "Art in Industry" in February. Intended to benefit students, most of these lectures were closed to the public. The school also produced a series of "bulletins" written by members of the faculty to augment classroom instruction and to document the ongoing research required for their continued employment. Collectively, these reports were to form the core of what became an unrealized textbook on industrial design. In April 1937 Pereira contributed short bulletins on "Design Elements," "Revolutionary Schools of Painting: Effect on Industry," and "Definitions and Terminology (Painting)," texts of the last two of which survive.[13]

By the end of the spring term of 1937, fourteen students had received positions in commercial advertising, industrial photography, store planning, and industrial design, based upon the technical training they had received at the Design Laboratory.[14] Yet despite these achievements and the praise of such arts professionals as Alfred Barr, Jr., Frederick Kiesler, William Lescaze, Ralph Pearson, and Philip Youtz, the school lost all federal support during the massive WPA layoffs in June 1937. To protest government cutbacks and to underscore the value of these educational programs to the community, the ACA Gallery held an exhibition of student works during the summer.[15] For most of the faculty, however, there was no noticeable break in employment following the end of the spring semester, for on July 1 the school merged with the Federation Technical School operated by the Federation of Architects, Engineers, Chemists and Technicians (FAECT), a CIO union, and began registration for summer classes. Having opened in January 1936, the nonprofit FAECT school had quickly earned the respect of professionals, and its curriculum had already exceeded its original purpose, that of preparing students for licensing exams in architecture and engineering. Organizers had been planning to expand into the area of industrial design when the FAP school lost its support. Administratively self-contained within the FAECT school, the Design Laboratory, under the direction of Milton Lowenthal, became the Laboratory School of Industrial Design, although, for the sake of continuity, it continued to use

its former name in publicity materials. Pereira remained on the faculty until her resignation in October 1939.[16] Meanwhile, she was also able to transfer to the Easel Painting division of the WPA/FAP.[17]

The basic composition of the faculty and instructional programs at the Design Laboratory remained essentially the same following this shift in sponsorship, although women faculty lost ground, at least symbolically, in terms of their stature within the program. Before the merger, Pereira taught painting, a historically privileged medium. Afterward, however, she and the other women instructors were assigned foundation courses, such as design synthesis, laboratory workshops, or classes in areas traditionally associated with women, such as textile and interior design. Theoretical courses in industrial design and social studies were taught by men.

The new school's advisory board continued to include some of the most significant names in the arts, such as Frank Lloyd Wright, internationally known "Prairie School" architect; R. Buckminster Fuller, architect of the novel Dymaxion house; Josiah P. Marvel, former co-director of the Design Laboratory; Audrey McMahon, former director of the College Art Association, editor of *Parnassus,* and regional director of the FAP in New York from 1935 until its liquidation in 1943; Frances M. Pollak, former director of art teaching of the FAP in New York; Frederick Kiesler, director of the Laboratory for Design Correlation, School of Architecture, Columbia University; and Alfred Auerbach, editor of the professional journal *Retailing, Home Furnishings Edition,* contributor of editorial assistance to Kiesler's book *Contemporary Art Applied to the Store and Its Display,* and, of significance for this study, one of Pereira's early patrons.[18]

The Design Laboratory's already progressive image was reinforced by its new sponsorship, for the CIO was then a militant organization, which *New Masses* equated with popular front movements in France, China, Spain, and the U.S.S.R.[19] Sympathetic art critics, such as Elizabeth McCausland, who wrote several of the press releases for the Design Laboratory, failed to comment on the political significance of the merger. Nevertheless, one liberal champion characterized the new school as "one of the first practical steps toward the creation of a Labor University, based on the needs and interests of the American working class."[20] Unfortunately, that portion of the underemployed "working class" actually served by the new Design Laboratory was reduced, as the

most immediate effect of the merger was more restricted access to design education. A major tenet upon which the original school had been founded—that of providing vocational art training to those talented individuals least able to pay—was abandoned. The new school charged tuition ($40 per term, raised to $60 per term in 1938) and registration fees, although administrators did solicit donations for a scholarship fund.[21]

The first class held in the school's new quarters on the ninth floor of 114 East 16th Street was the experimental "Materials Laboratory," offered during the eight-week summer session beginning July 12, 1937, and required of all incoming students. While the entire faculty contributed to the teaching of the course, Pereira and Hilde Reiss supervised the laboratory sessions in which students experimented with various materials and power tools.[22] An expanded four-year course of study, including eight sixteen-week terms of a required twelve credit hours each, was implemented in the fall semester, beginning September 27. Four majors were offered: product design, textile design, display design, and interior design. During their first term, students were required to take materials laboratories, design synthesis, drafting, industrial science, and weekly "conferences" with faculty. The second term included three hours of advanced design synthesis, a course in industrial science (chemistry and physics of materials, mechanics, and electricity), and a course in social science (survey of economics, science, technology, architecture, and allied arts) as well as six hours in the student's major. Social science continued to be stressed in the third and fourth years. Other advanced offerings included a history of technological developments, culture as literature, the fine arts and their social implications, and a history of American labor.[23]

Despite the changes in sponsorship and its increasingly prescribed course of study, the Design Laboratory changed little in its philosophy of teaching during the three years of Pereira's association. From its inception, the faculty determined school policy, curriculum, and pedagogical methods. They collectively outlined the syllabi, studio assignments, and reading lists for each course, although some individual freedom in instruction was apparently allowed in more specialized courses. The faculty based their curriculum on that at the Bauhaus, particularly as it existed after 1923, the year Walter Gropius delivered his famous lecture on "Art and Technology, a New Unity" at the Weimar Bauhaus exhibition, and the year that László Moholy-Nagy took over Johannes Itten's

preliminary course. It was Moholy-Nagy's machine-oriented design principles that prevailed at the Bauhaus when it moved to Dessau in 1925.

The Dessau Bauhaus was specified as the model for the Design Laboratory in a self-study prepared in September 1937. This distinction was apparently intended to prevent association with the earlier, more craft-oriented Weimar Bauhaus,[24] for, as a publicity brochure pointed out, the school "seeks to train designers, not specialized craftsmen" by coordinating instruction in the general principles of design and fine arts with shop practice. Through this integration of theory and practice, analogous to "the experimental procedure of a research laboratory," students were expected to develop "ingenuity and esthetic judgment in the use of materials"—including wood, metal, ceramics, glass, plastics, and textiles. They were guided in their research by a faculty that "includes well known and successful practitioners who bring to the classes their daily problems in the manufacturing field."[25]

The emphasis on functionalism, new materials, and a clean-lined machine aesthetic at the Dessau Bauhaus was widely seen as modern and fashionable, in contrast to the more ornamented designs of the nineteenth century.[26] Thus, in the Design Laboratory workshops, faculty stressed the use of the latest materials available and encouraged students to find those forms most suitable for mass production. As one journalist recorded, "The basic theory is that articles of modern use, from lighting fixtures to houses, should be the logical outgrowth of the new materials and methods of the machine age."[27] So-called arbitrary ornament, that with no "genetic connection" to the functional and mechanical properties of the object, was discouraged, as it "tends to obscure major design problems in the untrained mind." "Organic" ornament, that which was "logical" and derived from the functional and mechanical properties of the object, was allowed.[28]

As outdated design principles were assumed to be unacceptable for new materials, the student needed modern aesthetic criteria by which the suitability of the design might be assessed. To satisfy this need, support classes in abstract painting and sculpture were included in the curriculum. According to a press release, "pure form, color and line educate anew the eye of students who have grown up in a world which, from the standpoint of its technics, belongs to the 20th century, but which is about two centuries behind with its applied arts."[29]

Design Laboratory publications repeatedly stressed that "no one designer or no one school of design is to be exalted above the

surroundings. The organism brings with it through its own struc-
ture, native and acquired, forces that play a part in the interaction.
The self acts as well as undergoes."[40] By extension, artists, no less
than any other biological "organisms," were viewed as both prod-
ucts of and active participants in their society. Dewey's concept of
the reflexive interaction and interdependence of organism and en-
vironment underlies Cahill's belief in the indispensable contribu-
tion of the artist to society. As a result, he saw artists as workers
deserving of federal relief regardless of their skill or the style of
their work. Convinced that an enlightened audience would readily
comprehend the products made by fellow workers, he sought in
turn to educate the public to the necessity of art through the na-
tionwide WPA/FAP art programs.

To dismantle the barriers between artist and public, Cahill
sought to strip from the artist the concept of "genius," a notion
perpetuated by museums and galleries to increase the commodity
value of art objects. In this he could also find support in Dewey's
Art as Experience, wherein the philosopher wrote that, as art lost
its indigenous status, art objects became mere "specimens of fine
art," "insignia of taste and certificates of special culture," function-
ing "in isolation from the conditions of their origin." Artists, too,
are less integrated in "the normal flow of social services." As a
result, they exhibit "a peculiar esthetic 'individualism'" as they
"feel obliged to exaggerate their separateness to the point of ec-
centricity. Consequently artistic products take on to a still greater
degree the air of something independent and esoteric."[41] Since
the Renaissance, artistic "eccentricity" has become virtually syn-
onymous with "genius," and it is this aura projected onto artists,
isolating them from society, that both Dewey and Cahill sought
to remedy.[42]

To some extent Design Laboratory director Gilbert Rohde
agreed with this revised view of the artist in society. In an article
written about the school during its first year, he stressed that the
faculty were not intent upon discovering or producing geniuses.
Instead, he argued, each instructor was motivated by the desire to
provide all students with training which would allow them to be
integrated into modern industrialized society. Rohde explained,

*The industrial designer need not be a Michelangelo nor a [George]
Stephenson, for only a modicum of art and engineering abilities are
required. It is the combination that is important. Men and women
possessed of the necessary talents are not isolated phenomena. . . .
Find an opportunity . . . [for each to] exercise both the manipulative*

and aesthetic impulses and you have a well-adjusted individual—
a joy to himself and of value to society, and incidentally to industry.[43]

There is a troubling aspect to Rohde's argument as developed
in this article, however, particularly in his inconsistency with re-
spect to this notion of genius. His writing betrays a belief in a
hierarchy of designers: those with the creative ideas, in which
category he saw himself, over the skilled laborers who carried out
the work, that station for which most of his Design Laboratory
students were apparently destined. While arguing that he did not
share the picture of industrial designers drawn by some magazines
as "a handful of super-men who are revolutionizing everything
from hairpins to locomotives at a fabulous price," he nevertheless
indicated that "design as art" offered "opportunities to men pos-
sessed of higher abilities." Although he acknowledged that there
were common skills required of both designers for machine pro-
duction (factory site) and those for hand production (domestic
site), he made clear his belief that "the designer for industry is
commonly supposed to possess another sense that the craftsman
had no need for—something uncanny which enables him to make
things that have 'sales appeal.'" Clearly, Rohde intended women
to make up some part of the overall industrial design equation,
for he (or the publicity arm of the FAP) went to great lengths to
indicate their presence at the Design Laboratory. Photographs ac-
companying this and similar articles about the school showed fe-
male students operating power tools, shearing aluminum, boring
designs into wood, and sculpting with hammer and chisel, tasks
the average reader would not readily associate with women. Cer-
tainly the novelty of such pictures attracted the reader's eye. Yet
ostensibly these images were included here to illustrate Rohde's
point that, at his school, women were required to take machine
shop courses, for they "have as good a sense of construction as
the men" (if not, by implication, their "higher abilities" as design-
ers nor their "uncanny" merchandising skills).[44]

Rohde apparently worked under a widely held assumption, re-
cently challenged by Cheryl Buckley, that certain design abilities
are suited to women's skills, but those involving creative imagi-
nation or aggressive marketing skills are inherently male.[45] Fur-
thermore, he consistently championed the designer, working for
the industrialized American marketplace, over the artisan, associ-
ated with cottage industries and domestic consumption. Not only
did he thus distinguish his program from the craft-based regional
and community art centers vying for the same federal relief dol-

lars, he also implicitly privileged the traditional locus of male activity over that of the woman. The inevitable result of such bias was that, while the Design Laboratory promised to provide students with the skills necessary to work successfully within the glamorous new field of industrial design, opportunities and expectations for women were clearly more limited due to the impress of stereotypical beliefs regarding nature and ability.

So powerful was the premise that the artist must be reunified with society that, even if it had been acknowledged that women, or any of Western society's "others," were differently integrated into industrialized society, it is doubtful that this assumption would have been shaken. This concept of unity, so fundamental to the pedagogy of the Design Laboratory, had roots extending beyond the philosophies of the Bauhaus and Dewey to a broader holistic movement occurring in postwar United States and Europe.[46] Many adherents of this movement believed overspecialization would lead to continued fragmentation of society, further war, and, ultimately, the death of modern culture. Readers of popular literature were constantly confronted by pleas for the unification of conflicting forces in society, for example, industry and culture, machine and art, or science and philosophy.

For artists in particular, such interest in "wholes" was reinforced by Gestalt psychology, introduced in Germany in 1912 by Max Wertheimer, Wolfgang Köhler, and Kurt Koffka. Briefly, this is a theory of perception concerned with the allegedly innate tendency of the human mind to organize multiple objects into groups or wholes. Gestalt psychologists considered the individual as existing in a psychophysical environment, or field, somewhat analogous to a magnetic field, all contents of which are governed by certain intrinsic laws. Events taking place in one part of the field affect those occurring in all others in ways "determined by the inner structural laws of the whole [field]," as Wertheimer stated in 1924.[47] Thus, according to theory, it would be a mistake to draw conclusions based upon an analysis of individual incidents or even cumulative studies of isolated occurrences. The relationships between these events, their configuration, must be considered. Analogously, within a visual field, forms are interrelated and governed by laws, called "requiredness" by Koffka, who, of the three founders, was perhaps most responsible for introducing the concepts of Gestalt psychology into aesthetics. For him requiredness was a "force" intrinsic to the art object that held the compositional elements in equilibrium analogously to the system of forces maintaining planets in orbit around the sun.

Another important aspect of Gestalt theory is its principle of isomorphism, which seeks to establish a relationship between the structural order of an object or occurrence and the organization of the sensory and psychological responses to it. For clarification of this concept, authors Vernon J. Nordby and Calvin S. Hall provided the following useful illustration: "A chalk circle on the blackboard is different in substance from the pattern of light waves reflected from the chalk circle. The image formed on the retina is a different substance from the light waves, and so is the experience of a circle. But they are all alike in having the form of a circle."[48] Thus the perceived organization of phenomena, not the phenomena themselves, is most significant, and any experience of form is dependent upon some physiological or neurological isomorphism. However, echoing the relativity physicists to whose theories they were indebted, Gestalt psychologists emphasized that there can be no universal frame of reference with regard to perception, as any response to an object or occurrence is conditioned, or limited, by individual experience. Hence total comprehension may be impossible.

Interest in Gestalt psychology in the United States during the 1930s was kindled by the immigration of its three founders. Wertheimer came to New York during the early 1930s and joined the faculty of the New School for Social Research, which became a leading center for the study of Gestalt psychology, and remained there until his death in 1943.[49] Köhler arrived in 1935 and was professor of psychology at Swarthmore College until his retirement in 1953, while Koffka was a professor of psychology at Smith College from 1932 until his death in 1941. That their theories had far-reaching implications beyond the empirical study of visual perceptions is evidenced by the work of anthropologist Ruth Benedict, the title of whose most recognized work, *Patterns of Culture,* indicated her own debt to Gestalt method. Others, such as Gardner Murphy, a Columbia University professor of psychology, considered what the "Gestalters" had done "to be of astounding significance" to all science and philosophy. In his article "The Geometry of the Mind," he asserted: "This is no mere revolution in psychology; we can be content with nothing less than a new metaphysics, in which the part-whole relationship shall be irrevocably banished. . . . We shall have to say, as relativity says, that the nature of any alleged part depends upon the place it holds, and that modes of relationship are the only absolutes which we can hope to know."[50]

While Gestalt psychology failed to generate the great revolu-

tion in philosophy and the sciences that this last writer anticipated, the fact is that, for a time, it did inspire much excitement in academic circles, particularly in the visual arts. Such enthusiasm is evident in the preface to the published papers of the 1939 interdisciplinary symposium on art held at Bryn Mawr College at which Koffka lectured on "Problems in the Psychology of Art." The author of these statements explained that "the whole attack of experimental psychology on artistic phenomena is so recent, so much in its tentative stages, . . . [yet] it may ultimately prove to be the most fruitful, the most revolutionary, and the most effective contribution of modern thought to a field of speculation as old as Plato."[51]

For many artists and designers working with abstract imagery or seeking theoretical justification for abstraction, both the Gestalt concept of a visual field and its principle of isomorphism were of interest. As designer-architect Rutherford Boyd explained, artists, though long concerned with composition, had been unaware of any "control" over design. He believed that through a new understanding of the interrelationship of design elements artists might free themselves of "preconceived ideas" and "sentimental value in design" to approach an "abstract purity of Shape" and to "compose a new music of Space."[52] Implicit in his remarks is the belief that artists might be freed from slavish copying of superficial, transient effects and be allowed to focus instead upon the essential structures of what they observed.

Echoing Boyd was Ralph M. Pearson, a designer and educator whom Pereira met during the late 1930s. Pearson's school, the Design Workshop, which had opened in 1924, was incorporated into the program of the New School for Social Research during the 1930s. Undoubtedly coming under Wertheimer's influence there, he believed that design was an active force that "controls the choice and placing of objects in the picture field." Extending Gestalt theory into the realm of metaphysics, he also wrote that design "crystallizes a specific order out of the confusion of the physical and mental environment and so contacts the cosmic order of the universe." As late as the 1950s, he continued to believe that design was an "inborn sensitivity," "the primary power itself," and "the least common denominator of all the arts. It, like the symbol, is part of man's universal language. . . . It implies the organizing sensitivity within man himself regardless of time and place."[53]

Other artists, inspired perhaps by the principle of isomorphism, believed that the evocative power of a work of art was related to the amount of congruence between its shapes and cer-

tain innate organic forms that govern the organization of human experience. Thus form in art might be considered a reflection of organic nature.[54] Several of these artists became interested in morphology, the science of which, according to Rudolf Arnheim, shared common philosophical roots with Gestalt psychology. In the opening paragraph of his classic article "Gestalt and Art," published in 1943, this noted film and art critic and former student of Wertheimer's characterized the birth of Gestalt psychology as "the scientific expression of a new wave of *naturphilosophie* and romanticism in Germany, which revived in a strongly emotional way the feeling of the wonderful secrets of the organism, the creative powers of natural forces as opposed to the detrimental effects of . . . rationalism. . . . Gestalt theory has a kinship to certain poets and thinkers of the past, the nearest in time being Goethe."[55]

In considering the sociohistorical context of Gestalt psychology and its impact upon modernist art in the United States, one should also note its appeal to persons interested in then-accepted anthropological theories concerning so-called primitive cultures, both prehistoric and contemporary. Some persons seeking ancient antecedents for twentieth-century abstraction were attracted to Gestalt theories because of the belief, recorded by Hans and Shulamith Kreitler, that regardless of culture "the perception of gestalts . . . [resolves] the tensions of disorientation evoked by chaos. The striving for organization is . . . an 'effort after meaning' which provides for the perception of the most meaningful forms that circumstances allow," examples of which may include, but are not restricted to, "simple geometrical figures."[56] Abstract painter and filmmaker Dwinell Grant, later one of Pereira's close friends and author of a 1942 article about her use of parchment, recalled his concurrent interests in Gestalt psychology and prehistoric art:

> In 1935, after twelve years of portrait, landscape, and still-life painting, a . . . change [to geometric abstraction] resulted from a peaking of interest in very early prehistoric forms of communication and in Gestalt psychology. The main objective in both seemed to be awareness of and communication of relationships. It was very satisfying to feel that it was possible to carry forward the aims of the earliest communicators in their attempts to demonstrate relationships not experienced before. . . .
>
> The anthropologists thus gave the why. Gestalt gave the how. Three Gestalt concepts seemed especially applicable. First, the whole is always greater than the sum of its parts. Second, each element of

*a pattern, through a dynamic participation, alters its individuality
in becoming a constituent of the whole. Third, there is a dynamic
attribute of self-fulfillment in all structural wholes which allows
gaps to be disregarded. This last was interpreted to refer to the
recognition of spatial or other relationships between forms and
colors not actually connected to each other. . . . The paper, the
canvas, the film frame, the time sequence are all fields with almost
unlimited potentials. The possibilities for organizing forms, colors,
and movements within these fields are endless, and the variety
depends only on the experience and imagination of the artist.*[57]

Although specific references to Gestalt psychology have not
surfaced in surviving documents from the Design Laboratory,
there are several references to psychology in general,[58] and its im-
pact was obviously felt there. Not only were some of the most
progressive designers in the country concerned with its principles,
but its doctrines had also been studied at the Bauhaus during its
last years.[59] Furthermore, Gilbert Rohde noted that the coordi-
nation of the Design Laboratory's fine and technical arts courses
was "a case in which the whole is greater than the sum of the
parts," a phrase indicating at least superficial awareness of Gestalt
theories of perception.[60] The most convincing evidence of its im-
pact on the school are the telltale references in its publicity re-
leases to "good design," recognition of which was incumbent
upon the sensitive and intelligent student. However, examination
of the syllabi and notes from which Pereira taught during her
three-year tenure there yields further confirmation.

Surviving documents include Pereira's outlines for a painting
and composition course for an unspecified term from the 1936–37
school year, for the materials laboratories taught during the 1937
summer and fall semesters, and for Design Synthesis I and II, also
taught that fall.[61] In addition, miscellaneous assignment or ex-
periment guidelines, apparently meant for the instructor and not
for distribution to students, are extant.[62] How much Pereira con-
tributed to the collective preparation of these materials probably
varied. For example, her copies of syllabi for the materials labo-
ratory and Design Synthesis Ia (presumably the laboratory section
for Design Synthesis I) taught during the fall term, 1937, indicate
that she replaced Jack Kufeld as instructor. As his substitute, she
probably exerted less individual control over planning this class
than she did over her portions of Design Synthesis I and II, which
she team-taught with Vladimir Yoffe. These latter courses were
each divided into two halves, with Pereira instructing in the use

of two-dimensional media in Design Synthesis I from September 27 through November 15, and in Design Synthesis II from December 2 through January 27. Yoffe taught three-dimensional media in the alternate halves of each course.[63]

Materials Laboratory I was a prerequisite for Design Synthesis I, and both courses stressed unhampered exploration of the structural and tactile properties of paper, wood, metal, clay, plastics, glass, yarns, and fabrics. However, it is in the surviving documents for Design Synthesis where one can best determine those principles of design fundamental to Pereira's teaching. For example, one major concern in Pereira's classes was the creation of the illusion of space. Repeatedly the outlines and assignments by which she taught emphasized the exploration of spatial relationships between forms, created through their relative placement or through what she called the "progressive-recessive" properties of color. Experimentation also involved the "exploration of materials, kinetics, constructions, tactile evaluation, texture, [and] collage."[64]

Either directly or indirectly influenced by Gestalt theories of perception, Pereira guided her design synthesis students toward discovery of the "tension paths or underlying abstract order stabilizing [the] construction of composition" of the two-dimensional surface. Students studied what she termed the "control" or "energies" that maintained the balanced relationships of forms. Students might work in an abstract or figurative style, but if they adopted the latter, she expected them to analyze the relationships of objects within the pictorial field in terms of their "geometric equivalents."[65]

It is in the experimental emphasis on texture and tactility, the purpose of which was "to arouse and enrich desire for sensation and expression,"[66] that the dependence of the Design Laboratory foundation courses on the prototypical *Vorkurs*, or Preliminary Course, at the Bauhaus becomes most evident. Originally developed by Johannes Itten and later taken over by László Moholy-Nagy and Josef Albers, the *Vorkurs* was the Bauhaus student's introduction to design and aesthetics. Instruction focused on stimulating the senses, allegedly underdeveloped through years of scholastic emphasis on exercising the intellect. In a review of Moholy-Nagy's book *The New Vision*, published in English in 1930 and required reading at the Design Laboratory,[67] Herbert Read summarized the philosophic assumptions underlying education in the *Vorkurs:* "The individual is . . . an organism with five senses, all crying for development, and art will only be secure if it is a

function of the whole organism. The present system of produc-
tion destroys this wholeness by creating a monster with a special-
ized calling, a man with perhaps one beautiful muscle on an oth-
erwise wretched body. . . . For health, for beauty, we need the
whole man, harmoniously developed."[68] For this development,
students experimented with various materials, to explore and dis-
cover for themselves the visual and tactile properties inherent in
each. Sight was stimulated by refraction or transparency. Touch
was stimulated by contact with variously textured surfaces, often
gathered and arranged in "tactile charts," several of which were
illustrated in *The New Vision* and in Moholy-Nagy's later book
Vision in Motion, published posthumously in 1946. Proposing the
adaptation of his exercises for the rehabilitation of disabled veter-
ans, the author described the use of tactile charts and related ex-
ercises in a 1943 article in which he wrote:

> *The exercises start with the skill of the fingers, the hands, the eye,*
> *and the ear, and their co-ordination. This is accomplished through*
> *so-called tactile charts composed of textures, the purpose of which is*
> *to permit emotional experience to be gained from their organized*
> *relationships; through hand sculptures carved out of wood, to be*
> *held in the hands and manipulated; through machine woodcuts,*
> *which make lumber as elastic as rubber; through paper cuts*
> *which, if skillfully handled, lead to the understanding of basic*
> *structures—folding, cutting, rolling, scoring, and weaving.*[69]

Of course, the Bauhaus artists were not the first modernists to
explore texture, and the subject was common in contemporary
literature on the arts. For example, in *Art and the Machine,* Shel-
don and Martha Candler Cheney discussed the texture studies ini-
tiated by Picasso, Archipenko, and the Neoplasticists, by which
"every possible material has been subjected to experiment with
regard to tactile and visual potentialities."[70] Pereira had received
ample exposure to these artists' work through her studies with
Jan Matulka, as well as through books she acquired, including the
1919 edition of Arthur Jerome Eddy's classic *Cubists and Post-
Impressionism* and an English translation of Hans Hildebrand's
monograph on Archipenko, originally published in France in 1923.
She also attended the 1936 exhibition Cubism and Abstract Art
at the Museum of Modern Art, the catalogue of which contained
a discussion of texture in Cubist collage. Here she saw examples
of Cubism, Futurism, Constructivism, Neoplasticism, and the
Bauhaus and witnessed the application of their concepts to ar-

chitecture, furniture, theater, film, and photography. Numerous underlined passages and handwritten notes placed between the leaves of her copy of the catalogue, which she subsequently used to prepare her bulletin on revolutionary schools of painting, confirm the exhibition's impact on her.[71]

Yet the major source of inspiration for Pereira's classroom exercises in texture and tactility remains Moholy-Nagy's *The New Vision,* the first pages of which were devoted to a discussion of the tactile exercises at the Bauhaus. A translation of *Von Material zu Architektur,* one of the *Bauhausbücher* series, *The New Vision* was essentially an instructional manual presenting a summary of the Preliminary Course. As mentioned above, the 1930 English edition of this book was required reading at the Design Laboratory until the publication of the 1938 revised and enlarged edition, a copy of which Pereira purchased for her personal library.

Most of the exercises assigned in Pereira's classes were described in Moholy-Nagy's book. Not only did her students make tactile charts, but they also made pressure and vibration scales, Bauhaus prototypes of which were reproduced in *The New Vision.* Similar to tactile charts, these scales were constructed of corrugated materials, or materials suspended on spring-constructed bridges, that would vibrate as the fingers were drawn rapidly over them. In her Materials Laboratory I, she asked students to manipulate paper surfaces by means of folding, cutting, and using various tools, an exercise described in *The New Vision,* where the suggested tools included needles, tweezers, or knives to prick, press, rub, file, or bore the surface. In Design Synthesis I students built up the surfaces of their two-dimensional designs with sand, sawdust, wood shavings, and even ready-made objects. Her students also made "scales" (analogous to value scales appearing in most art appreciation texts) with materials arranged from smooth to rough, soft to hard, thin to thick, and so forth. These exercises and others Pereira copied from *The New Vision* in typed and handwritten notes which were then incorporated into the syllabi for her courses.[72]

Advanced exercises in each of Pereira's classes included the making of constructions from paper or other soft, pliable materials, such as straw or textiles. The more advanced sections worked with "hard" materials. Apart from traditional concerns with space, plane, volume, and texture in design, students learned about the "natural frequency of material (sound)" and optical effects, such as refraction and reflection. According to the syllabi, these problems were analyzed from the point of view of function,

precision and clarity in execution, and aesthetic and psychological judgments.[73]

Pereira's syllabi indicate further congruences with Bauhaus practice in having her advanced classes make two-dimensional interpretations of their three-dimensional constructions. Students recreated as closely as possible the textural and structural elements of the construction in graphic media as a "check-up" on the conception. Termed "optical translations" by Moholy-Nagy, two examples of this exercise appear in *The New Vision,* with the original in each case reproduced next to its copy.[74] Pereira would also find this exercise useful in her own work.

Corresponding to her own interests in abstraction by the 1937–38 school year, Pereira required students in her advanced course in design synthesis to solve one studio problem with "rectilinear" abstraction, in shapes "either geometric or intuitional."[75] Her use of the word "rectilinear" in the context of her syllabus is somewhat eccentric and ambiguous, particularly when she refers to a "rectilinear problem of curve [*sic.*]" However, her definition of "intuitional" abstraction, clearly based upon some knowledge of archetypal theory, may be found in her 1937 bulletin on terminology: "the interpretation of organic or inorganic shapes or forms manifested from intuition or the subconscious" (with a handwritten change to "unconscious" on her copy). Somewhat surprisingly, she did not include Surrealism in this category, a fact confirmed by the text of a lecture she presented at the Brooklyn Art Center in 1940, in which she provided as examples of "intuitional" abstraction the paintings of Kandinsky and "non-objective" representations of "moods."[76] Clearly, geometric abstraction might fall into this category as readily as it might into "pure" abstraction, defined as "a scientific or geometric system of aesthetics," in support of which she cited a passage from C. Howard Hinton's *Fourth Dimension* and the often-quoted lines from Plato's *Philebus,* section 51c.[77] Her students were not encouraged here to work in the third type of abstraction identified in the bulletin as "representational," the "breaking down of elements in order to obtain an essence or summary—a sensitized comprehension of the thing itself."[78]

Pereira's association with the Design Laboratory and the former members of the Bauhaus on its faculty proved catalytic in her development, for it stimulated her to put into practice those theories she espoused in her classes. Retaining motifs from her machine paintings, she began to experiment with new materials and to explore the spatial and optical effects their textures would gen-

erate. While she may have tried working in collage as early as 1936, she made no serious attempts to work in that medium until the fall of 1937, concurrent with its inclusion in her classroom exercises.[79]

Pereira's opinions regarding the Bauhaus and abstraction have been preserved in the script for her lecture on "New Materials and the Artist," presented in March 1939 at Columbia University. After citing Futurism, Cubism, De Stijl, and Constructivism as its historical forebears, she celebrated the Bauhaus as having "exerted the greatest influence on our entire social order." She characterized its coordination of the efforts of artist, architect, and designer in transforming art into "living things—utilitarian things—things of every day use—such as our cooking utensils—our homes—our entire environments" as the most successful means of "educating on a mass scale," since exhibitions, books, and lectures "reach a limited audience." Encouraging fellow artists to break with the past, she argued, "It is not necessary to limit ourselves to paint or stone because . . . our Aesthetic problem today concerns everything in our daily life from spiritual gratification to our Architecture . . . and all these fields [*sic*] are dependent on the experimentation of the artist." Distinguishing between the roles played by the artist and designer, and privileging the former, Pereira noted that the "artist is free in his experimentation," while "industrial designers must work with the disadvantage of certain specifications and certain requirements." Not surprisingly, she implied that artists working with abstraction were the lynchpins upon which this entire vision of culture depended, for they were the least encumbered in their experimentation. As she stated, "The importance of abstract art lies in the fact that it is an experimental art—These artists are not concerned with literary documentation—but experimentation which conveys its influences to our architecture—our typography—photography—industrial design—It is an art which performs a definite social function."[80]

Art's "social function" remains undefined here apart from its alleged ability to "educate" the public through redesigned utilitarian objects. Yet it is clear that Pereira believed that she and the designers with whom she cooperated had not only the right but the responsibility to impose their standards upon others. She presumed the superiority of artists' judgments and tastes over popular ones, and, despite liberal stances she took on other issues, she remained convinced of this superiority throughout her life. She would have been in agreement with Reyner Banham's statement that it was upper-middle-class homes "that tend to breed archi-

tects, painters, poets, journalists, the creators of the myths and symbols by which a culture recognises itself."[81] In fact, late in life she claimed that, even if one considered art a commodity for the wealthy and intellectual elite, it was still the central defining factor for a culture.[82]

Pereira's suggestion in her lecture that abstraction transcends "literary documentation" appears to signal a rejection of the artist's conventional dependence upon translating stories from literature or history into visual form, as in mythological or history painting. It is clear, however, in this lecture and in her definitions of abstraction in her 1937 "bulletin" that she did not intend to strip abstraction of meaning or purpose. On the contrary, abstraction symbolized for her the freedom to experiment, to break with outdated traditions in all aspects of contemporary culture.

Pereira's close association with designers and architects was acknowledged in "The Abstract in Art," published in the December 1937 issue of *Interior Design and Decoration,* the first article about her to appear in a magazine directed toward these professionals. The anonymous author wrote, "Miss Perira's [*sic*] experience with interior designers and architects, by whom she has been commissioned to execute paintings for interiors in the Modern style, has resulted in a thorough comprehension of the value of color, pattern and texture in paintings and their relation to the decor of the interior."[83] Despite these associations, however, Pereira's paintings should not be casually dismissed as being derivative of Bauhaus-inspired work. Such a view fails to account fully for her unique and innovative glass paintings of the 1940s, nor does it provide a basis for understanding the philosophical writings of the 1950s and 1960s which serve to explain the imagery in her late canvases. Even the author of "The Abstract in Art" noted that there was something more to Pereira's paintings than mere stylistic harmony with interior decor. In the sentence following the one quoted above, this writer remarked, "Clients who appreciate original compositions rich with esoteric symbolism will find here the work of one who paints with knowledge and with enjoyment."[84]

To what "esoteric symbolism" does this reviewer refer? The article is illustrated with two of the artist's machine compositions: the first version of *Man and Machine* and the third version of *The Ship,* neither of which appears to contain anything particularly esoteric. Nor is either abstract by today's definition of the word. Pereira's first abstractions, exhibited at the East River Gallery in New York in November 1937, were apparently so recent as to be

too late for publication deadlines, although the author of the article does refer to Pereira's work as "abstract." Our only insight into this writer's meaning is gained from a discussion of modern art wherein the reader is told that it is only in this century that anyone attempted "to paint an *idea* in the abstract." Furthermore, such forms of expression, intended for "only a few discerning artists, patrons and critics," was filled with "psychological complexities." The "province [of abstract art] is that of the mind, not the factual world. . . . The abstract in art . . . [is] a somewhat heightened projection of the mental force and a subjection of the emotions when viewing a painting."[85]

One assumes that the journalist here was attempting to come to grips with what he or she considered "esoteric," and that the idealist concepts reported in this article, presumably derived from conversations with the artist, reflect Pereira's thinking at the time. Certainly the references to abstract art's psychological complexities and its dependence upon a projected mental "force" are in keeping with the painter's definitions of "intuitional" and "pure" abstraction and would seem to confirm the importance of these ideas for her own work. Thus the propitious appearance of "The Abstract in Art" within days of the exhibition of her first abstractions provides a crucial link between Pereira's researches into the origins of abstract imagery and her own work.

The painting which Pereira claimed to be her first abstraction was *Black Squares* (Figure 25), exhibited later as *Six Black Squares,* the latter title being the one that she came to prefer. She recorded in "Eastward Journey" that the painting was based upon the machine composition *Pendulum* (Figure 26), a 1937 collage, a photograph of which was included with the manuscript.[86] A hinged machine joint, with two arms forming a forty-five-degree angle extending laterally, dominates the center of the composition, and at the right is a large C-shaped form resembling the body of a vise clamp. Beneath the latter is a double step, a motif appearing in several of Pereira's marine and machine compositions. Each of these elements recurs in *Black Squares,* but here the machine forms are "transparent." A broken grid design in the background resembles the pattern in Mondrian's *Composition* of 1915, included in the exhibition Cubism and Abstract Art. In fact, Pereira underlined the following sentence concerning Mondrian's painting in her catalogue of the show: "This apparently abstract 'plus-and-minus' pattern is based upon memories of the beach at Scheveningen; the graduated lines of the waves move toward the shore at

FIGURE 25

Black Squares (Six Black Squares), 1937, oil on canvas, 25 × 30 in. Sid Deutsch Gallery, New York.

FIGURE 26

Pendulum, 1937. Location unknown. The Schlesinger Library, Radcliffe College.

the bottom of the picture and break about the predominantly vertical lines of the pier in the center."[87] She also underlined a passage concerning an earlier painting by the same artist that indicated that his abstract grid pattern was "based upon a seaport with masts and rigging."[88] Pereira must have been pleased to discover that Mondrian's reticulated pattern was based upon marine forms. Like steps and ladders, grids appeared frequently in her work.

Curiously, the artist covered half the painting with a pattern of pseudo-Chinese ideograms.[89] In her romantic account of her painting of this work, recorded in "Eastward Journey," she explained,

> *I then went back to the "Pendulum" and reorganized it. It was
> now just a swinging linear construction painted over a pattern.
> At this time, I had a feeling of leaving the west and going back
> to the east. I started to paint something that seemed to me like a*
> transfer ticket *in white and blue; and then started to write on
> it in Chinese character, which I made up as I went along. Each
> hieroglyph was accompanied by a song with the feeling I was
> writing my own* ticket, *even if I could not understand the symbols
> I was making. The painting is called "Six Black Squares."*[90]

This passage, perhaps, reveals more about Pereira in the 1950s than it does about the artist who created the work in 1937. Nevertheless, what she failed to mention was that *Black Squares* was a painted "interpretation," or "optical translation," of yet another collage, title unknown, assembled after she made *Pendulum*. For this intermediary work, she cut bits of paper to form a ground upon which she drew in dark ink the outlines of the principal shapes in *Pendulum*.[91] As she had instructed her Design Synthesis students to do, she then chose painting media and techniques to simulate the structure, texture, and surface effects of the collage. *Black Squares*, Pereira's first abstract painting, was thus a product of her experimentation with design exercises proposed in Moholy-Nagy's *The New Vision*.

The question remains as to why Pereira chose to include Chinese ideograms in *Black Squares*. China may have held some exotic fascination for her at this time, but her interest was undoubtedly stimulated by news headlines and tabloid photo essays reporting the growing tensions between China and Japan. At the height of her participation in artists' unions whose members were antifascist in political stance and suspicious of anything mystical,[92] it is unlikely that she would have envisioned herself then as a conduit

to a spiritual world enabling her to write in an ancient language unknown to her. To include ideograms in a work at this time would be to invite political interpretation, particularly in the work of an artist associated with leftist causes. Familiar as she was with the German artists who had emigrated to escape Hitler's tyranny, she was sympathetic with the struggles of other people for freedom from repression. One is reminded that Pereira contributed the painting *Fascism* to an Exhibition in Defense of World Democracy; Dedicated to the Peoples of Spain and China, held in December 1937. In January 1938, the American Artists Congress and Artists' International Association sponsored an exhibition of contemporary Chinese graphic art, held at the ACA Gallery. The show was the first in the United States devoted to social themes by contemporary Chinese artists,[93] and Pereira would have been aware of plans for this exhibition while assembling her collage. Further confirmation of her political sympathies is found in her 1941 donation of a painting to the Art for China Exhibition and Sale, sponsored by the China Aid Council, New York, participating in the United China Relief.[94]

A second abstraction from 1937, with no apparent political content, retained outlined fragments of machines drawn in white on a brightly colored ground. *Ascending Scale* (Figure 27) is obviously based upon a collage, although the latter's location is unknown. Pereira simulated the weave of fabrics with interconnecting lines scratched into the paint surface. In the center of the composition, she also painted an illusionistic "fringe" based upon a cut-paper original similar to those appearing in other collages. Colored planes, loosely brushed, melt into one another yet maintain a compact, gridlike structure in the center of the canvas. Resembling scales common in design classes, color values shift from dark at the bottom to light at the top, a clue to the title's meaning.

More clearly here than in any of her previous works, Pereira revealed an interest in space, light, and transparency. Anticipating later glass paintings, *Ascending Scale* "reads" as a transparent plane, on which the white lines are drawn, superimposed over a ground. The ground, however, is not flat but has subtle planar shifts suggested by contrasts in color, value, and texture. In places, two layers of paint have been applied in such a way that the upper layer becomes a semitransparent veil partially concealing the lower layer. The artist used a comb, twirled around a point, and other simple tools to alter the texture of the paint to create shimmering reflections of light.

The steps, ladders, and metal ship railings appearing in earlier

FIGURE 27

Ascending Scale,
1937, oil on canvas,
27 × 22 in. The
Lowe Art Museum,
The University of
Miami. Gift of
John V. Christie.
Photo, Karen A.
Bearor.

machine compositions become schematic ladders positioned parallel to the picture plane, suggesting ascent, in keeping with the title of the painting. Formally, they both assert their respective planes and render these planes transparent. This effect may have been suggested by a photograph of ship ladders reproduced in *The New Vision.* Looking down the stairwell of a steamship, the camera reveals a mazelike pattern of metal gratings forming catwalks along the walls. Allowing hot air from the boilers to rise to exhaust shafts (ventilators) above, the gratings appear to define receding transparent planes, superimposed over one another, through which light (appearing to generate from the center of the photograph) reaches the viewer.

During the early months of 1938, Pereira painted *Script for a Scenario, Washington,* and *Congress.* About the same time, she

FIGURE 28

The Diagonal, 1938,
oil on canvas,
34 × 28 in. Sid
Deutsch Gallery,
New York.

made another collage which borrowed the shape of the vertical
machine form appearing on the left-hand side of each of the three
machine compositions mentioned. This 1938 collage, *The Diago-
nal*, was the basis for a painting of the same title (Figure 28). Most
of the collage elements are in browns, dark blue, grays, black, and
white, with the outlines of the machine superimposed in black.
Cut-paper fringe added to the surface mimics the fringed edges
of scraps of burlap. Two lines of color, one blue, one red, cut
through the upper half of the composition at sharp angles. A
small white square at the center brings the movement of these
lines to a halt, like a period at the end of a sentence. A bus transfer
for the 23rd Street line in New York for a Sunday in August, with
midnight punched, echoes metaphorically the changing direc-
tions of the colored lines.

The unsigned and undated painting based upon this collage has been exhibited and reproduced with various dates assigned to it. However, Pereira noted that it was painted following the completion of her last machine paintings.[95] Given the confirmed date of 1938 for the collage and the fact that the painting was first exhibited in February 1939 at Pereira's one-artist show at the Julien Levy Gallery, its probable date is 1938. The artist made only minor refinements in this second *Diagonal*. The bus transfer appears without text, with only the geometric divisions of the ticket remaining. She also gave each shape and line greater definition and clarity than in the collage. This resulted in a greater harmony of parts, if also a certain rigidity in structure.

Pereira remembered *The Diagonal* as stimulating further research in the spatial relationships of forms within a composition. In "Eastward Journey," she recalled,

> *I do remember now that when the painting was completed, I was very preoccupied with the white area in the center. Instead of white projecting from the canvas as is usual, it receded. I also realized that the shapes moving in and out of the picture plane of the canvas possessed independent qualities of motion. They projected or receded on the flat surface, depending on the pictorial construction. Although a clock moves in a circular motion, defining a two-dimensional space, the progressive and recessive shapes were inscribing a depth backward and forward on the flat surface independent of color or texture.*[96]

An examination of a painting from later in 1938 confirms these interests. In this painting, *White Rectangle No. 1* (Figure 29), dark forms abstracted from the ship ventilators seen in her machine compositions are silhouetted against lighter areas. This is the first appearance of the periscope-shaped motifs that would become her trademark two decades later. In addition, a central white shape appears as a window to a light source behind the surface. Surface patterns incised through the top coats of paint allow pale underlayers to shine through like sunlight through the weave of a straw hat on a bright summer's day. Although it would be many years before Pereira developed her philosophy of light, it is apparent that it was in 1938 that she made the first explorations toward that end.

About the same time that Pereira created the collage *The Diagonal*, she assembled an untitled collage (Figure 30) that includes a transfer for the 75th Street–Ridge Parkway–Stillwell Avenue route, dated June 5, 1937.[97] Along the right edge of the collage, a

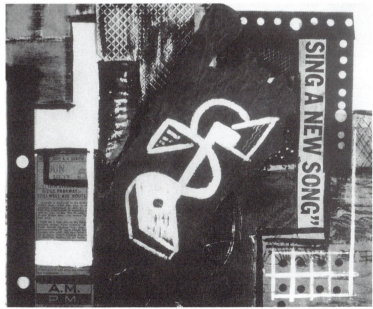

FIGURE 29

White Rectangle No. 1,
1938, oil on canvas,
25 × 27 in. The
Lowe Art Museum,
The University of
Miami. Gift of
John V. Christie.
Photo, Karen A.
Bearor.

FIGURE 30

*Untitled (Sing a
New Song),* 1938,
collage, 10¼ × 13
in. Collection
Herrick Jackson,
Wilton, Connecticut.

fragment of a title from a magazine article triumphantly proclaims "sing a new song."[98] In the center of the composition, the artist painted a white musical note. Sensing, perhaps, that this image was too clichéd, she altered the form such that it appears to rest upon a white base and painted an S-curve and winglike triangles over the stem. A dark spot on the note is echoed by irregularly spaced holes punched through black strips of construction paper with perforated edges.

Reproduced in the January 1959 issue of *Print,* this collage is accompanied by a caption suggesting obliquely that it had been included in an exhibition featuring collages by Pereira and poetry by David Sortor.[99] This one-evening event, one of a series of "gala nights," was held at the East River Gallery on March 24, 1938. Pereira collaborated with Sortor and, as the caption in *Print* noted, "in many instances, she made the poetry an integral part of the collage."[100] Pereira confirmed this fact in "Eastward Journey" in a discussion of an unknown collage based upon the forms in *Script for a Scenario.*[101]

At least two of the works exhibited in the Pereira-Sortor show were mobile collages. As neither these works nor photographs of them survive, one is left to speculate as to what form they might have taken. John I. H. Baur recorded that "a typical one consisted of a wheel bearing a poem and turned by a crank which protruded through a hole in the glass," but no further description exists.[102] Possibly they resembled Duchamp's rotoreliefs, which she could have seen at the exhibition Cubism and Abstract Art, or the rotating verses seen in his 1926 film *Anémic Cinéma,* made in collaboration with Man Ray. Perhaps they resembled the tachistoscopes of the Gestalt psychologists, which tested the perceptions of individuals by flashing word fragments for fractions of seconds.[103] Another possible prototype is the rotating tactile chart, with scraps of materials attached at intervals to a rotating drum, which appeared in *The New Vision.*

Whatever their form, Pereira's collages demonstrate a new interest in kinetics, with forms that change in time and space. This, coupled with her new explorations of texture and light, reflect the continued impact of the Bauhaus. In particular, her ideas closely parallel the contemporary interests of Moholy-Nagy and the circle of architects and designers who helped guide the program at the Laboratory School of Industrial Design. Pereira's involvement with these figures and the steps that led to her first use of glass are discussed in the next chapter.

The "Glass Age" and Pereira's
First Paintings on Glass

Prior to 1936, Pereira had worked only with traditional painting media, yet a clue to her early interest in modern materials is found in a clipping from the *New York Times* dated January 22, 1933, preserved in her scrapbook. Here, she underlined the passage immediately following the review of her first one-artist show:

> To advance from the machine as portrayed in these [Pereira's] abstractions to the machine age in actuality one need only go down to the Art Centre, where the National Alliance of Art and Industry is holding an industrial exhibition, "New Materials, New Products and New Uses," organized "to stimulate earlier consumer acceptance for new products and processes." Although this exhibition may not appeal to the audience interested primarily in pictures, it is important to those interested in art in industry.[1]

Pereira's own advance from "the machine as portrayed" to "the machine age in actuality" was facilitated not only by her association with the Design Laboratory but also by support services within the WPA. It was in the technical laboratory for artists established by the FAP and headed by Raphael Doktor that she learned to work with various non-traditional materials, including glyptal resin and magnesite. She was assisted in her work by Jack Kufeld, the colleague whose classes at the Design Laboratory she took over in 1937.[2] Called the Restoration, Installation and Technical Division, this section of the FAP maintained laboratory facilities to test the reliability and durability of various materials,

primarily those used in outdoor murals. Their successes were published in numerous brochures on technical processes, distributed at no cost to artists and public schools on request, several of which Pereira retained in her files. An anonymous author outlined the potential value of this technical laboratory to artists, particularly those unprepared for the demands of industry or large-scale public works, in an article in the November 1940 issue of *Design*:

> *The Technical Division of the New York City WPA Art Project has relieved the artist almost entirely of the necessity of choosing, preparing and testing materials for the execution of painting and sculpture . . . and in the process has made some discoveries of new media and new uses of old media which constitute a major contribution to the field. . . . Its findings are available not only to Project Artists but to the public generally, and have thus become a valuable contribution to the profession as a whole.[3]*

New painting mediums, the testing and developing of which were described in the above article, included casein resin emulsion, developed for mural painting and tested for use in James Brooks' mural for the rotunda of the Municipal Airport, LaGuardia Field. Casein resin emulsion was preferred over natural resins, such as damar and mastic, which artists had used for years, because of its water resistance and matte finish.[4] Another product evaluated by the technical laboratory was glyptal, a synthetic resin used with casein. After 1939, Pereira often applied a coat of the thick casein-glyptal mixture to the surface of her canvas or panel, and she would scratch lines through this layer to the support beneath to generate luminous effects. Appreciating its matte surface and sometimes using the substance as a varnish, the artist extolled the following virtues of glyptal to Elizabeth McCausland:

> *Perhaps the most interesting of the materials I have worked with is glyptal resin—used to paint battleships as well as pictures.*
> *Glyptal resin dries very hard. Being water soluble, it can be mixed with casein to form an emulsion which in turn can be used as the medium for pigment, either oil paint or dry color. This emulsion will also bind a filler (such as marble dust or silex) with oil paint and bind them without affecting the color itself. Thus I can get a deep semi-relief impasto, as well as the actual three-dimensional light and color relations of the various planes of these paintings.[5]*

Another product tested in the Technical Division's laboratories was magnesia cement, or magnesite (also spelled "magnasite"), a popular flooring material during World War II which was the subject of a technical bulletin distributed in 1941. Used to make cast stone with a much finer aggregate than cement, magnesite was also substituted for Venetian glass and fine mosaic stones in WPA murals when these imported materials became unavailable during the war. Ordinary dry pigments could also be mixed with this substance without loss of their original brilliance once the compound hardened.[6] Appreciating its flexibility, Pereira performed a variety of experiments with this medium, and her handwritten formula for its mixture remains with her papers.[7] Although she noted in correspondence that one might apply the cement to a surface in thin layers or cast in relief, she preferred using it as a binder in which she mixed marble dust, sand, or silex to build up the surface of her paintings.[8] In describing Pereira's use of magnesite, critic Elizabeth McCausland explained that it might be "molded, worked with sculptor's cutting tools, cast into abstract shapes to be incorporated in flat or relief mosaic-like paintings or sculptures, polished, given surface textures of various kinds, etc."[9] Precisely such a technique must have been used by the artist in an unlocated work *Cast Magnasite Set in Magnasite Cement,* of 1941, exhibited at the fifth annual exhibition of the American Abstract Artists.

Another unconventional material Pereira learned to use in the technical laboratories of the WPA was porcelain cement, which, in addition to mixing well with pigments, was resistant to acid, water, and corrosive fumes. For slick surfaces, she also worked with ceramic fluid, which had been developed for the manufacturers of laboratory test-tube labels, from whom she obtained her supplies.[10] Stimulated by the researches taking place in the technical services division, Pereira also experimented with parchment, a more traditional but long-neglected painting support, and, later, with the highly dangerous, radioactive substances used to paint luminous dials for watches.

Apart from the parchment and radioactive paint, Pereira may have learned to use all these new and unconventional materials in hopes of obtaining one of the more than two hundred mural commissions approved by the WPA during the second half of the decade. The odds were somewhat in her favor, despite the fact that she was not employed by the New York mural division, for a former classmate, Burgoyne Diller, was supervisor of this section.

Dedicated to promoting abstraction in public art, Diller was in-strumental in obtaining commissions for their mutual friends, Stuart Davis and Arshile Gorky, and former teacher, Jan Matulka. He was also the liaison between the FAP and the organizers of the New York World's Fair, who planned several murals for fair-ground buildings.[11]

Pereira did make a preparatory drawing for an unrealized mu-ral, although it is unclear what occasioned this effort. The draw-ing was displayed in July 1939 at the Berkshire Museum in her childhood home, Pittsfield, Massachusetts, in the exhibition the World of Today. Organizer Elizabeth McCausland wrote:

> *Abstract artists, in renouncing realistic subject matter, do not renounce an obligation to be socially useful. Utilization of space, line, form, volume, color and texture to create psychologically pleasing and functional effects is a major tenet of their creed. Applications to industrial design, typography and architecture are among their objectives. In her first idea for a mural, I. Rice Pereira has filled the given proportions with an organization of areas varied in color and surface treatment. Luminosity is to be the chief quality of the mural, which yet must be kept within the two dimensional convention.*[12]

A commission for Pereira did not materialize, however. Two years later, on McCausland's recommendation, she wrote to Inslee Hop-per, of the Treasury Department's Section of Fine Art, Public Buildings Administration, in a fruitless attempt to secure patron-age from his division.[13]

Pereira's experimentation with nontraditional materials indi-cated a willing alliance with designers and architects, although she never ceased to believe in the traditional function of painting as an independent object placed upon a wall. Yet in theory, the wall itself must now be considered, and the painting had to be har-monious in style and materials with its environment. The artist's role in society and means of support appeared to be moving away from dependence upon the fickle tastes of rich collectors and to-ward a more secure position working with architects and indus-trial designers to create a new social environment. Pereira was not alone in seeking this alliance, as is evidenced during this period by the attempts of the American Abstract Artists to cultivate closer ties with modern architects, whom the group's membership saw as sympathetic to their ideas.[14]

Pereira's work was respected by leading architects and design-

ers, whose names appear as contributors of statements to catalogues of her exhibitions and as patrons. One of these was William Lescaze, whom she met through her work at the Design Laboratory. One of the featured architects in the Museum of Modern Art's 1932 exhibition International Modern Architecture, Lescaze was also a designer of numerous domestic furnishings, including light fixtures, furniture, and other utilitarian objects.[15] More recently, he had been the architect in charge of New York's Williamsburg Housing Project, which included abstract murals by Stuart Davis, Paul Kelpe, Albert Swinden, and others. He also designed the Aviation Building for the New York World's Fair. One measure of Pereira's stature within the design community is the fact that Lescaze wrote the introduction to the catalogue of her one-artist show at the Julien Levy Gallery which opened in February 1939. His statement read:

> *The interdependence of all human beings has become increasingly clear to all of us. It always existed, but few recognized it. Now most of us are conscious of it and welcome it as a manifest sign of a better and more orderly society.*
>
> *The welfare of a city depends on the crops of the farmer. The welfare of a rural community depends on the products of the factory.*
>
> *Similarly each form of art is not a separate and fenced off domain: In this little drawer, literature; in this other one, architecture; in that one painting; no. Rather each one is dependent on the other, and all of them are parts of the whole.*
>
> *The paintings of I. Rice Pereira show precisely such an understanding. New forms and new surfaces are suggested not only for what they convey on the canvas but also for their relation to surrounding surfaces and forms; and to other parts of art.[16]*

Pereira's work also came to the attention of Edgar Kaufmann, Jr., who purchased a painting from her in December 1938.[17] Having studied with Frank Lloyd Wright at Taliesen, he had persuaded his father, head of the Pittsburgh-based Kaufmann Department Stores, to hire the architect to design the house Fallingwater in Bear Run, Pennsylvania. When the house was featured in an exhibition at the Museum of Modern Art earlier in the year, Kaufmann *fils* met John McAndrew, the museum's new curator of architecture. Kaufmann had also been instrumental in arranging for the exhibition of numerous items in the museum's show Useful Household Objects under $5.00, which had opened in September

1938. He later became curator of design at the museum and was responsible for the Good Design series of exhibitions in the early 1950s.[18]

The extent to which Pereira viewed her art as part of a total environment may be determined not only by the style of her paintings but also by her designs for rugs and textiles during the 1940s and early 1950s. Perhaps through Kaufmann's influence, she was invited to design a rug to be included in a circulating exhibition, New Rugs by American Artists, which opened at the Museum of Modern Art in July 1942.[19] Comparable in style to textile patterns created by Bauhaus artists, such as Anni Albers, Pereira's abstract design was built upon a complex network of rectangles of contrasting textures and colors. Her primary interest was in suggesting depth, a fact verified by the "shadows" woven into the composition. However, the spatial illusion worked best with the piece hung on a vertical surface, rather than on the floor, so this is how it was displayed. Titled *Abstract Design with Emphasis on Textures,* her accent rug design, like those submitted by other artists in the exhibition, including Stuart Davis, Arshile Gorky, George L. K. Morris, and Loren MacIver, was executed by Stanislav V'Soske.[20]

In 1954 Pereira designed another rug, *Eastwind* (also known as *Eastward*), executed by Gloria Finn and shown at the Grace Borgenicht Gallery in New York, with those designed by Anni Albers, Milton Avery, Jimmy Ernst, and others.[21] Pereira's interest in textiles dated back to her student years in Brooklyn, but it was not until 1948 that one of her designs was adapted for wearing apparel. In that year, her painting *Rectangular Rhythm* was transformed into a Contempora silk scarf which sold for $6.95 at both Gimbels and Stern Brothers department stores.[22] The scarf was subsequently featured in the Museum of Modern Art's June 1950 exhibition, the Artist and the Decorative Arts, organized by Kaufmann.

As a result of her collaboration with architects and designers, Pereira was invited to present the lecture "New Materials and the Artist" at Columbia University in March 1939, the substance of which was discussed in the previous chapter. In terms of securing prestige within the art community, her talk at Columbia was decisive, for it cemented her connection, already established at the Design Laboratory, with the most progressive movement in education and design. Not only was Dewey still professor emeritus of philosophy in residence there, but during the 1938–39 academic year, the school had a particularly ambitious extension program in drawing, painting, sculpture, and commercial art. In related

publicity, the university provided the following "Point of View" with respect to this program:

> *In the contemporary order of society individuals are becoming increasingly aware of the greater significance of aesthetic training. Improvement in human environment is being encouraged and art study is becoming a definite part of well-balanced personal development. . . . It is to meet this growing demand for art training as an integral part of general education that a "clearing house" for artistic thought, discussion and experiment is established. Art education can be vital only when related to the social and economic conditions of the present time.[23]*

The list of visiting artists and critics for this program was impressive. In addition to Pereira, the following were advertised: Philip Evergood, former president of the Artists Union; Emily Genauer, graduate of the Columbia University School of Journalism and art critic for the *New York World Telegram;* Frederick J. Kiesler, architect, scenic designer, and director of the Laboratory for Design Correlation, School of Architecture, Columbia University; Paul Manship, sculptor; Burgoyne Diller, head of the Mural Painting Division of the Federal Art Project; Katherine S. Dreier, founder of Société Anonyme; Talbot Faulkner Hamlin, lecturer in the School of Architecture, Columbia University; J. B. Neumann, director of the New Art Circle, New York and formerly director of the Berliner Sezession; and Ralph M. Pearson, founder and director of the Design Workshop and author.

Of this list of distinguished arts professionals, several individuals were either friends or long-term professional acquaintances. For Philip Evergood, her friend and associate at the ACA Gallery, she designed the catalogue accompanying his retrospective at that gallery in 1946.[24] Emily Genauer became a life-long friend and promoter of Pereira's work through her columns. Burgoyne Diller, her former classmate, was a fellow member of the American Abstract Artists.

Ralph M. Pearson had been program chairman for the second annual national convention of the American Artists Congress and had written the foreword to the catalogue of the Congress' Exhibition in Defense of World Democracy. An influential teacher of design and the founder of the Design Workshop in 1924, he developed a laboratory approach to instruction that was incorporated into the curriculum of the New School for Social Research during the 1930s. He also wrote the column "A Modern View,"

which ran in *Art Digest* from January 1945 to August 1953, as well as several books on design education, including *The New Art Education* published in 1941. Pereira possessed a copy of his loose-leaf book *Critical Appreciation Course II,* a mail-order text in art appreciation published in 1950. Pearson discussed her career and reproduced five of her paintings in his *Modern Renaissance in American Art,* published in 1954, and the two corresponded until 1955.[25]

Of the participants in the program at Columbia University, the person most important to Pereira's early development was Frederick Kiesler. The Viennese architect and scenic designer, a former member of De Stijl, had come to the United States with his wife, Stefanie (Steffi),[26] to become director of the International Theatre Exposition held in February and March 1926. By 1929 he was director of the American Union of Decorative Artists and Craftsmen, the first professional industrial arts organization in the United States.[27]

Kiesler was another of the major figures in New York during the 1930s who promoted a holistic view of life. His philosophy was closely related to the teachings of the Bauhaus, which was itself indebted to the De Stijl aesthetic. Although he was never formally associated with the Bauhaus, his ties to its leaders were strong. He knew Moholy-Nagy in Berlin in the early 1920s, and the two men made contact again in the United States after the Hungarian artist settled in Chicago in 1937.[28] Kiesler's Space Stage, constructed for the International Exhibition of New Theatre Technique in Vienna in 1924, was also the setting for a program of light orchestrated by Ludwig Hirschfeld-Mack, who had experimented with reflected and projected light at the Bauhaus theater.[29]

Kiesler was an early proponent of a school that would teach the arts with an approach similar to that of the Bauhaus. He advocated coordinated instruction in architecture, painting, sculpture, and the industrial arts, which he considered the link between daily life and the fine arts.[30] Cognizant of the continuous interaction of people with their environment, the architect recommended the complementary study of psychology, history, and philosophy.[31] He also made numerous attempts to interest others in a school based upon such principles, his earliest endeavor in the United States being his ill-fated International Theatre Arts Institute, dedicated in 1926 "to crystalliz[ing] the beauty of the present age." Although never fully realized, the institute was to have been a laboratory school for the theater arts, with studies divided into three major areas: psychology, headed by Princess

Matchabelli (the actor Maria Carmi); science, supervised by Bess Mensendieck; and art, directed by Kiesler. Required courses of study were to have included history, drawing, and art theory, and Mensendieck's class in "body education," a study of the movement of the body in accordance with "natural laws" and related to the bio-mechanics of Russian director Vsevelod Meyerhold.[32] Despite Kiesler's preparation, which included his procurement of a building and initial funding and the publication of a course catalogue, the project failed.

Following this venture, Kiesler prepared architectural plans for a proposed Institute of Art and Industrial Design which were used to illustrate Emanuel M. Benson's article "Wanted: An American Bauhaus," published in the *American Magazine of Art* in June 1934.[33] Like its predecessor, this institute failed to be realized, although, as mentioned previously, Kiesler did become an advisory-board member of the Design Laboratory in 1935. However, his most significant contribution to coordinated instruction in architecture and its allied arts was his founding of the Laboratory for Design Correlation within the School of Architecture at Columbia University in 1936.[34]

Pereira undoubtedly met Kiesler earlier in the decade about the time that her close friends and classmates, Dorothy Dehner and David Smith, were introduced to him by John Graham. The earliest documentation of their acquaintance occurred in 1940, however, when, on Kiesler's advice, she wrote to Cecil C. Briggs at Pratt Institute in connection with her search for a teaching position.[35] Kiesler was also an early collector of her work, and he contributed a preface to the catalogue of her one-artist show at the Art of This Century Gallery in January 1944.[36]

Years later, in a letter written to her third husband, Irish poet George Reavey, Pereira referred to Kiesler as a genius and claimed that each had great admiration for the other's work. She described the model of the architect's Endless House, first shown in America at the Kootz Gallery in 1950 and subsequently exhibited with Buckminster Fuller's dome structures in the Museum of Modern Art's exhibition Two Houses in 1952. Pereira mentioned feature articles written about the Endless House, including one, "The Endless House and Its Psychological Lighting," published in the November 1950 issue of *Interiors*. Although the artist was out of the country at the time of its publication, this article had nevertheless made a deep impression on her, and she enthusiastically described how one could tell the time of day from the prismatic color of sunlight as it passed through the faceted crystal aperture at one end of the

structure. Significantly, within weeks of this letter, written on August 11, 1951, Pereira made the notes that would form the core of "Light and the New Reality," her first philosophical work.[37]

Pereira owned an uninscribed, first-edition copy of Kiesler's *Contemporary Art Applied to the Store and Its Display,* published in 1930, a book dedicated to "a sound cooperation between public, artist and industry." Kiesler's revolutionary thesis was that it was the department store that had brought modern art to the public, not galleries or museums. He wrote,

> *The department store at home was the true introducer of modernism to the public at large. It revealed contemporary art to American commerce.*
>
> *First, as a new style in textile design for woman's fashions.*
> *Second, as a means of show window decoration.*
> *Third, in store decoration and expositions.*
>
> *And finally, entering the home through interior decoration, modern art is becoming a lasting contribution to a new outlook on life.*
>
> *The department store acted as the interpreter for the populace of a new spirit in art.*[38]

Kiesler's project was to create a market for modernism by hailing it as "new," like the latest vacuum cleaner, something a grateful public could no longer afford to live without. His unabashedly commercial theory was based upon his observation of how *art moderne* had been promoted at the Exposition of Modern Decorative and Industrial Arts in Paris in 1925 and had reached a broad public in Europe and the United States. French department stores, followed by their American counterparts, such as Saks–Fifth Avenue, had performed a vital role in the dissemination of this style during the late 1920s,[39] and he, like all promoters, believed that this trend could only increase. As he explained, "The store's role is expanding. . . . It is beginning to exercise a social and cultural influence. Department stores are rapidly becoming social centers; and there are signs that their cultural force will become stronger."[40] In fact, these commercial institutions were more responsive to current trends in art (and, hence, living artists) than most contemporary New York galleries. Thus, perhaps it did not seem so ironic at the time that some liberal artists' organizations, theoretically representing the views of "the masses," shared Kiesler's beliefs concerning department stores and endorsed his marketing strategies. For example, to reach a wider

audience, the American Artists Congress held its annual exhibition in 1938 in Wanamaker's.[41]

To bring modern art to the public, the audience whom it was theoretically intended to benefit, the department store needed a new means of communication, one consistent with the tempo of modern life. The show window was the most efficient means to bring New York City's consumers into contact with new merchandise, and Kiesler demonstrated its inherent possibilities when, in 1928, he redesigned the street-front displays at Saks–Fifth Avenue. He ripped out all partitions between windows and replaced the standard expensive wood paneling with a white background panel, against which one or two items were dramatically highlighted.[42]

For maximum effectiveness in capturing the attention of the pedestrians, Kiesler advocated the use of large glass show windows. Glass was both the transparent partition and the link between interior and exterior spaces, the means by which the "wall" between merchandise and moving spectator might be made penetrable.[43] The glass window also provided dual specular surfaces on which the reflected images of viewer and object were co-mingled, such that the pausing passerby was literally united with the object of his or her desire.

Yet to understand further the significance of glass to Kiesler and to other architects and designers in the 1930s and to understand why Pereira herself chose to work with this material, one must go back to the Deutscher Werkbund Exhibition in Cologne in 1914. There, two approaches to its use were represented in the architecture of Bruno Taut and Walter Gropius. Taut, one of the architects associated with the postwar Berlin Glass Chain group, had a romantic vision of a new glass culture, with jewellike buildings of colored glass and ceramic tiling. His pavilion, representing the German glass industry, was dedicated to Expressionist poet-author Paul Scheerbart, whose book *Glasarchitektur* had been published in Berlin the same year under the *Der Sturm* imprint.[44] The building consisted of a double-glazed dome resting on a glass-and-concrete drum whose inner walls and staircase were constructed of Luxfer prisms backed with sheets of colored glass. The dreamlike interior, saturated with colored light, was seemingly emblematic of the light mysticism of the poet, whose dedicatory mottoes—"Glass brings us the new age, Brick culture does us only harm" and "Colored glass destroys hatred"—were inscribed around the stringcourse of Taut's building. Although the technology was not available during his lifetime, Scheerbart also had prophetic visions

of buildings of glass, equipped with concealed light fixtures, that would appear to float when illuminated against the backdrop of the night sky.[45]

Although affected by the romantic visions of Scheerbart and Taut, Walter Gropius, in contrast, promoted a more pragmatic approach to materials and design in his model factory at the Werkbund Exhibition. Here the revolutionary glass-enclosed stairwells were constructed such that the glass "skin" revealed the load-bearing steel core of the staircases within. Interior and exterior spaces were fused. Following the war, when Germany needed a large number of working-class dwellings constructed as economically as possible, Gropius used glass in a similar manner, as in his housing scheme at Berlin-Siemenstadt, where glass walls relieved the claustrophobic effect of living in tiny, box-like apartments. Thus, glass became associated with this new architectural style, which, in turn, was associated with the rebirth of German culture and the creation of ideal living communities—planned, organized environments—built for working-class people, by whose toil this new civilization was being constructed. The Expressionists' utopian visions became fused with Gropius' functionalist architecture, and, in the end, glass became the romantic symbol of progress for a new twentieth-century culture born amid the embers of its past.[46]

During the 1920s, glass architecture dominated the plans of Berlin architects, such as those of Mies van der Rohe, whose famous German Pavilion at the International Exhibition at Barcelona in 1929 was featured in Kiesler's *Contemporary Art Applied to the Store and Its Display*. This building's non-load-bearing glass and onyx walls functioned as partitions to create a free and flowing interior space continuous with the exterior. In 1929, another Berlin architect, Arthur Korn, published a book on glass architecture in which he wrote:

A new glass age has begun, which is equal in beauty to the old one of Gothic windows. . . . In the situation now, the outside wall is no longer the first impression one gets of a building. It is the interior, the spaces in depth and the structural frame which delineates them, that one begins to notice through the glass wall. . . . The new characteristic of glass is evident only when it opens up views deep into the inside of the building, thus exploiting its peculiar property through its position.[47]

Although Korn's book was not available in English until the 1960s, the ideas he espoused were certainly not confined to Eu-

ropean shores. New industrial developments in the United States led contemporary periodicals to proclaim that glass was "the structural material of tomorrow" and that we had entered a "New Age of Glass." This was particularly true following the Century of Progress Exposition in Chicago in 1933, where visitors saw an innovative glass building erected by the Owens-Illinois Glass Company as part of the Home and Industrial Arts section of the exposition. Fairgoers might circulate within the walls of glass blocks, through which sunlight filtered, creating an effect similar to that of Taut's glass pavilion two decades earlier. As in Germany, glass was associated with progress and the rebirth of culture, only here it was the United States that was struggling to overcome the economic devastation of the Depression.

Despite the long history of glassmaking, new production methods in the 1930s made glass fashionably modern, readily available, and affordable. It was advertised as clean, attractive, durable, fire-resistant, and transparent. A new tempered glass, invented in 1934, was featured in illustrated articles in various popular magazines in which its resilience and strength were variously tested under the weights of female models, new automobiles, and even an elephant. Glass that transmitted ultraviolet rays, believed to be germicidal and healthful to the body, was used in hospitals for its hygienic properties. Semiopaque varieties were used in sanatoria, for many health professionals thought bright light caused nervous ailments. Inexpensive, oven-proof, boro-silicate (Pyrex) glassware emerged from chemistry laboratories for domestic use, and contact lenses were invented. Glass could even be spun into threads—Fiberglas—which were woven into fabrics and insulation.[48] Virtually all these new wonders were on display at the New York World's Fair, which opened in May 1939 in Flushing Meadows on a site formerly occupied, appropriately enough, by materials-testing laboratories.[49]

Celebrating the 150th anniversary of the inauguration of George Washington in New York City, the fair exalted and glorified democracy and the ingenuity of American citizens. The official theme of the fair was "building the world of tomorrow," and, as the *Official Guide Book* stated, "The plain American citizen will be able to see here what he could attain for his community and himself by intelligent coordinated effort and will be made to realize the interdependence of every contributing form of life and work."[50] In celebration of the unity of commerce, labor, and art, each exhibit at the fair stressed the new materials of tomorrow and the new possibilities for labor. This was symbolized by the Theme Center, consisting of the seven hundred–foot, three-sided

obelisk, the Trylon, and the adjacent hollow globe, the Perisphere, which housed Henry Dreyfuss' famous "Democracity." Architects Wallace K. Harrison and J. André Fouilhoux selected the triangle and sphere as the basis for their constructions because these shapes represented geometry's simplest and most fundamental forms. Their choice also resulted from their determination to "strike a new note" in design, and advance publicity indicated that the Trylon symbolized the finite, and the Perisphere, the infinite.[51] According to a guide to the architecture at the fair, a "selective Baedeker of sights not to be missed," published by the Design Laboratory, the architects selected these forms "to symbolize the design of tomorrow; symbols that are easily reproduced and recognized anywhere."[52]

Colored light was also a design element in the Theme Center. Although the Trylon was not illuminated at night, the lights projected onto the Perisphere made "a revolving, vari-colored screen of the huge white globe, creating mobile marbled patterns heretofore limited to the [Thomas] Wilfred clavilux or color organ," as it was reported in the WPA publication *New York Panorama*.[53] The result of this orchestration of light was to create the "floating quality" prophesied by Scheerbart, a phenomenon described in the fair's *Guide Book*:

> *Here is the magnificent spectacle of a luminous world, apparently suspended in space by gushing fountains of liquid reds and blues and greens, over which clings a strange ethereal mist. An ingenious arrangement of mirror casings on which eight groups of fountains continuously play make the supporting columns invisible; while at night powerful lights project cloud patterns on the globe, and wreathing it in color mist, create the startling illusion that it is revolving like a great planet on its axis.*[54]

The entire history of glass and glassmaking was made available to visitors at the Glass Center, sponsored by Corning Glass Works, Owens-Illinois Glass Company, and Pittsburgh Plate Glass Company. As the modern equivalent to Taut's pavilion at the Werkbund Exhibition, the building was described in one fair publication as an "enchanted palace." Furthermore, "its commanding tower of glass blocks with fins of blue plate glass is magic, and particularly so at night when it appears like nothing so much as a dream out of Bagdad."[55]

Indicating the persistence of Scheerbart's utopian beliefs, Gerald Wendt, the director of the fair's Department of Science, ar-

FIGURE 31

World's Fair, 1939, pencil, 22 × 30 in. Permanent Collection, Howard University Gallery of Art, Washington, D.C. Photo, Jarvis Grant © 1989.

gued in *Science for the World of Tomorrow,* the guidebook to scientific features of the fair, that glass architecture was beneficial both to society and to the psyche of the individual. Reasoning that people living in glass houses would become more outwardly directed, he wrote that the increased use of glass "is likely to become a major event in human history by releasing men from their four walls, from their restricted and artificial environment, and to turn their attention to nature and natural beauty."[56]

For Pereira, the architecture and design at the New York World's Fair must have confirmed that her own work was in line with the most advanced aesthetic trends in this country. Although no recorded statement by her regarding the fair survives, her art documents its impact on her career. She registered her impressions of the fairground in a drawing and virtually identical painting, each titled *World's Fair.*[57] Yet more important, it was while the fair was in progress that she made her first painting on glass, a fact which seems substantially more than mere coincidence, considering the prominence and signification of this material there.

Pereira was so caught up in the preopening excitement surrounding the fair that, in her drawing *World's Fair* (Figure 31), she

depicted the Trylon and Perisphere, not with their reflective white surfaces intact, but as they appeared under construction. She captured the essence of the complex network of underlying steel girders, which stood in striking contrast to the pared-down geometry of the completed architecture. Elsewhere in the composition she included the colonnaded portico similar to the one appearing in *Congress*. Gone, however, are any references to machines as such. Her juxtaposition of a "classical" motif with the incomplete Theme Center suggests not only her equation of these two epochs architecturally but also, because she was so closely associated with contemporary architects, an awareness of her part in "building the world of tomorrow."

Related to *World's Fair* in style and theme is *The Embryo*. Looking again at the heart of that painting, one notices the artist's inclusion of a tiny colonnaded building with a heavy, blocklike superstructure, resembling that of the Brazilian Pavilion at the fair. Above this, she painted a cogged wheel and the ring described earlier, each a virtual "quotation" from Henry Billings' animated mural in the Ford Building, which included an exploded view of a V-8 engine. Apart from the lure of the machine parts, however, Billings' work may also have appealed to Pereira in its use of glass and polarized light. As Helen A. Harrison has described it,

> *During the day, the mural appeared as a translucent glass panel containing the abstract forms of a streamlined automobile, a comet with flaring tail, a diagrammatic drawing of an internal combustion engine, a star containing a gear symbol, and a planet form with a symbolic speedometer. When lighted, however, it became a mobile pattern of shifting prismatic color, which was effected by means of rotating discs of wrinkled cellophane and polarizing plastic and a stationary polarizing disc.*[58]

When in 1946 Pereira herself worked with polarized light, she credited Billings with suggesting the material.[59]

Although the formal affinities between the images in *The Embryo* and the cited examples of art serve to strengthen the circumstantial case for the fair's impact upon Pereira, the significance of this painting does not depend entirely upon this correlation. What is more important is the broader interpretation—Pereira's linking of the embryo to modern architecture and, as discussed before, to avant-garde painting. Here, as in the *World's Fair,* that

FIGURE 32

Irene Rice Pereira
with painting *Curves
and Angles* (1937),
in 1940. Photo,
Photographic
division, Federal
Arts Project,
Works Progress
Administration.

which is new—represented by the incomplete Theme Center in
one painting and the embryo in the other—is just taking shape.

Like other painters and sculptors in New York, Pereira un-
doubtedly anticipated the opportunity to exhibit her work at the
fair, although, for some time, there were no plans to allow artists
that opportunity. However, when a public furor erupted over this
issue, fair organizers amended their plans, and two buildings, the
Masterpieces of Art and the Contemporary Art buildings, were
dedicated to that purpose.[60] Pereira was ultimately given the op-
portunity to exhibit at the fair in May 1940, when her painting
Curves and Angles, of 1937, was included in an exhibition of WPA
art.[61] An unknown WPA photographer captured the artist stand-
ing by this work, whose composition is dominated by the C-
shaped body of a micrometer (Figure 32). Also painted here is a
spiraling line resembling schematic diagrams of the loose coupler
in a radio receiver or the coiled grid of a triode (vacuum tube), a
receiver or transmitter of what one period encyclopedia called

"undampt ether waves."[62] The transparent glass tube of a separate triode, a familiar furnishing in the laboratories of Hollywood's "mad" scientists of the 1930s, appears at the top.

If contemporary trends were any indication, traditional easel painting appeared to have limited usefulness in the world of the future. Certainly, the difficulties artists encountered in trying to convince fair officials to hold exhibitions of painting and sculpture suggested that the country's most influential designers—seeking to unify the arts with architecture—held independently conceived easel art in low regard. Frederick Kiesler, among others, felt that the natural beauty of the materials used in architecture rendered any other decoration nonessential. Reminiscent of Flugel's "Great Masculine Renunciation" of sartorial display, he wrote, "There is no line of demarcation between architecture and decoration. Decoration, . . . such as painted ornaments, printed wall papers, carved cornices, hanging draperies, has been ruled out as superfluous by contemporary architecture."[63] For public architecture, at least, all traces of "feminine" touches were to be eliminated. Furthermore, speaking of architecture, he saw individual styles as inimical to the modern spirit, which must have a unified expression, an international style. According to him, individualism led to insularity.[64]

Some artists adopting the aesthetics of Constructivism and De Stijl, which had coalesced at the Bauhaus, were in agreement concerning individual styles in painting. For example, looking back on this period, Balcomb Greene, first president of the American Abstract Artists, stated, "I never believed in personal style. In the Thirties I wanted to be impersonal. Didn't sign my work, didn't like the artistic ego."[65]

This renunciation of the "ego" was all well and good for male artists working in an "impersonal" yet "masculine" style. It was something else again for women artists, who had already been rendered virtually silent and invisible in the history of art. Nevertheless, having already eliminated "Irene" from her professional signature, Pereira began to eliminate any overt traces of a "feminine" hand in her work. In 1938 and 1939 her paintings became increasingly abstract and rectilinear in structure as she purged her work of references to Picasso or Dufy. She had now fully embraced the Bauhaus aesthetic and its faith in the unity of artist and industrialist. She subordinated her "ego" to the concept of the whole represented by the pared-down forms of a "masculinized" architecture. Ironically, this renunciation of characteristics that might be seen as stereotypically "feminine" allowed her to explore

options presented to her in the so-called decorative arts with less fear of being marginalized. As a consequence, she sought out different avenues of expression, such as the rug and textile designs discussed above.

For an artist seeking to work in harmony with architecture, another possibility to explore was stained glass. Considering the importance of glass in the architecture of the fair, stained glass must have seemed an attractive and viable option for the modern artist. Furthermore, there had been a stained glass section on the WPA/FAP offering technical assistance to New York artists, such as Balcomb Greene, who received commissions to design windows in public architecture. That her first glass painting was in fact a stained glass design suggests that Pereira saw this medium as a promising alternative to traditional easel painting. This untitled work, painted in 1939–40, represents a major milestone in her career, for her innovative use of glass would soon catapult her to international prominence.[66]

In style, Pereira's painting closely resembled Josef Albers' abstract *Colored Window in Red,* of 1923, shown at the Weimar Bauhaus Exhibition of 1923 and reproduced in the German-language catalogue of that exhibition, a copy of which she obtained sometime during the 1930s. Albers' work was clearly intended to fulfill a traditional role within an architectural environment—as a window. This may have been Pereira's original plan as well, although the resulting abstraction was not composed of individual segments linked by lead cames but was painted on the reverse surface of a single pane of glass.

Pereira enclosed her painted glass in a shadow-box frame, which transformed the work into a "picture" rather than an architectural element. To some extent, this would appear to link her work with Marcel Duchamp's famous *The Bride Stripped Bare by Her Bachelors, Even,* alternately known as *The Large Glass.* Instead, her work is closer in spirit to Frederick Kiesler's *interpretation* of Duchamp's glass painting. The architect featured *The Large Glass* in his article "Design-Correlation," published in the *Architectural Record* in May 1937, in which he wrote, "Architecture is control of space. An Easel-painting is illusion of Space-Reality. Duchamp's Glass is the first x-ray painting of space."[67] In other words, like shadows cast upon a wall, the images in Duchamp's *Glass* were two-dimensional projections of three-dimensional forms. Just days before this publication was released, Pereira had quoted the following passage from C. Howard Hinton's *Fourth Dimension* to support her definition of "pure" abstraction as being just such a

projection: "As a shadow is to a solid object, so is the solid object to the reality."[68] Hinton, of course, derived this notion from the shadows cast on the wall in Plato's famous allegory of the cave, the summary of which Pereira marked in her copy of the *Fourth Dimension*,[69] and other artists at the time were similarly inspired.[70]

For Kiesler, however, Duchamp's painting represented even more, for it also incorporated a psychological component, such that the work "is nothing short of being the masterpiece of the first quarter of twentieth-century painting. It is architecture, sculpture and painting in ONE. To create such an X-ray painting of space, materiae [*sic*] and psychic, one needs as a lens (a) oneself, well focused and dusted off, (b) the subconscious as camera obscura, (c) a super-consciousness as sensitizer, and (d) the clash of this trinity to illuminate the scene."[71]

In Kiesler's photographic metaphor, the lens (glass) representing the intellect functioned to focus the projected image of space-reality onto the "superconscious"-sensitized surface of the wall of the darkened chamber of the subconscious. (He had been interested in cast images as early as 1922, when he used projected slides and motion pictures in the set for *R.U.R.* in Berlin.)[72] Significantly, the metaphoric lens was situated between, and also linked, external reality and the inner self. This lens was analogous to the glass show windows which both separated and linked the exterior spaces of the street and the interior spaces of the store. In his discussion of Duchamp's painting, he reiterated this concept:

> *Translucent material such as glass being used more and more in contemporary building finds its manufacturing not for commercial but spiritual reasons. . . . Glass is the only material in the building industry which expresses surface-and-space at the same time. Neither brick nor stone, nor steel, nor wood can convey both simultaneously. It satisfies what we need as contemporary designers and builders: an inclosure* [sic] *that is space in itself, an inclosure that divides and at the same time links.*[73]

In Pereira's glass painting, the transparent surface also physically differentiates, yet visually synthesizes, exterior and interior spaces. The view it provides is not that of an illusionistic three-dimensional reality but an actual space, that void between the glass and the rear panel of the box frame. Furthermore, her work functions analogously to Kiesler's projected-image art or the shadows in Plato's allegory. The forms of the rectilinear design on the surface are cast in colored shadows against the white surface

of the panel. In effect, this white panel becomes a blank surface on which virtual images, geometric equivalents to the insubstantial figures of actors on a motion picture screen, are "painted" by light.

Kiesler had predicted the widespread use of light "painting" in his *Contemporary Art Applied to the Store and Its Display.*[74] In 1936 Sheldon and Martha Chandler Cheney noted that Donald Deskey had built "an instrument to project moving patterns of color upon a white wall" but felt that, in general, the use of "mobile light" in interior design had failed to live up to its earlier promise.[75] However, the most dramatic use of "light painting" occurred at the New York World's Fair in the projection of colored lights and images on the interior and exterior surfaces of the Perisphere. Significantly, architects at the fair also considered the virtual images created by cast shadows as part of the decoration of their buildings. The *Official Guide Book* stated that the buildings at the fair "were constructed with large blank wall surfaces and without the superposition of meaningless architectural forms. The barren aspect of the blank surfaces was overcome through the application of sculpture, murals, and shadows cast by vines and tree groups arranged appropriately near the buildings."[76]

The shadows on the walls of fair buildings, of course, changed form and position with the movement of the sun. Thus the shadow imagery was related to the passage of time. The concept of time was incorporated into the theme of the fair, and everywhere on the grounds visitors were reminded of their position relative to the past, present, and future. Each of the exhibits emphasized how far our civilization had progressed or what possibilities lay ahead. Although confronted with strange sights, like talking robots or "black lights" and fluorescent paints in "Democracity," visitors were comforted by the recognition of their place within the continuity of history.

In addition, fairgoers were reminded of their place within the cosmos, both in terms of the infinitely large and the infinitely small realms.[77] For example, on the curved façade of the Business Systems and Insurance Building, a wall facing the Rose Court, Joseph Kiselewski's allegorical figure of "Day" fell through the heavens toward the sun, which was sinking on a horizon flush with the physical ground. This figure was superimposed on a large sundial, on whose radiating bands appeared the signs of the zodiac. Reminded of the microscopic order of nature as well, visitors in the center of Bowling Green found Waylande Gregory's group sculpture titled the *Fountain of the Atom*. Here, eight ce-

ramic figures of children encircled four large adult figures and a thirty-foot shaft of glass brick. The group's placement was based upon the octet theory of the atom.[78] Yet nowhere was the individual's relationship to the order of the cosmos more simply or directly expressed than by the cast shadows on the walls of the architecture—the same means by which ancient civilizations had recorded the passage of time and their relationship with the heavens.

Pereira's glass work also uses "light painting" to record the passage of time, although on a more human than cosmic level. Standing directly in front of the construction, as one would a more traditional painting, the viewer gains little understanding of the whole work. In order to see the cast shadows, indeed, to cause them to "move" on the white recessed surface, the individual must pass from one side to another. With each new viewpoint, the patterns of light and shadow change. Thus to gauge the shifting perspectives of interior spaces, the individual must cross in front of the painting, like the pedestrians peering through Kiesler's store windows. Space and time are shaped into a continuum.

While Kiesler's theories on the use of glass and light had a profound effect on Pereira, his article on Duchamp's *The Large Glass* itself, predating her first use of glass by more than two years, is an unlikely catalyst for this new direction. Duchamp's work was certainly a modern predecessor for glass-as-easel-painting, and it had been discussed in the catalogue to the exhibition Cubism and Abstract Art, where other examples of Duchamp's glass paintings were reproduced. However, Pereira made no markings in relevant passages in her copy of the catalogue, and, despite the historical prominence given to Duchamp's glass painting, it apparently had no direct impact on her.

Like Duchamp's painting, however, Pereira's glass was painted on the reverse surface. Thus both works are related to a long glass-painting tradition called reverse painting on glass, or, as it is called in German folk arts, *Hinterglasmalerei*. Wassily Kandinsky and Gabriele Munter, artists associated with *Der Blaue Reiter,* both experimented with the technique and collected examples of Bavarian *Hinterglasmalerei*. Swiss artist Paul Klee experimented with glass as early as 1905, and both he and Kandinsky went on to become teachers at the Bauhaus.[79] There were American precedents for reverse-painting on glass as well, some of which were included in the Index of American Design, Holger Cahill's pet project on the WPA/FAP. Pereira had some contact with the people working on the index, particularly C. Adolph Glassgold,

FIGURE 33

*Shadows with
Painting,* 1940,
outer surface, oil on
glass, 1¼ in.
in front of inner
surface, goache
on cardboard,
15 × 12⅛ in.
Collection, The
Museum of
Modern Art,
New York. Gift of
Mrs. Marjorie Falk.

national coordinator of the index, who wrote the foreword to the catalogue of her one-artist exhibition at Howard University in 1938. Glassgold, formerly curator of education at the Whitney Museum, also claimed responsibility for alerting that institution to Pereira's work for its Second Biennial in 1935.[80]

Pereira's glass painting with its shadow-box frame most closely resembles contemporary work by Moholy-Nagy, however, and his work may be seen as the most direct antecedent for her own. During the 1930s he wrote several articles on incorporating light in art, including "Light Painting," appearing in *Circle: International Survey of Constructive Art,* which Pereira obtained in 1937, and "An Academy for the Study of Light," published the same year in *transition.* He also included a section on light and its potential

uses in art in the expanded 1938 edition of *The New Vision,* which she also owned. He explored the different uses of light in photography, especially in his photograms, and his efforts in part inspired Pereira's own limited experiments in this medium.[81] However, Moholy-Nagy's series of *Space Modulators* had the greatest impact upon Pereira's work. He initiated this series in London in 1936 with a painting on a sheet of transparent plastic (rhodoid) mounted two inches in front of a white plywood panel.[82] One of these constructions, which he continued to make until his death in 1946, illustrated his article "Light: A New Medium of Expression," published in *Architectural Forum* in May 1939.

It appears, however, that there is no single apocalyptic event, no towering individual, no charismatic "master" whose inspiration may account for Pereira's decision to work with glass. Rather, it was her assimilation of all the factors discussed in this chapter that must be seen as her ultimate motivation. To suggest otherwise is to deny her the intelligence to process this information and reach her own conclusions and to privilege the work of another, presumably more capable individual. While Pereira, certainly a product of her times, was indebted to many prevailing currents of thought, she quickly became one of the most innovative artists using glass. For example, in her third glass painting, *Shadows with Painting,* of 1940 (Figure 33), which the artist considered her first successful effort, the gridlike pattern on the surface pane resembled that in her first one. However, in this case she went beyond Moholy-Nagy's precedent in that she also painted rectilinear shapes in gouache on the recessed cardboard ground. Thus virtual images, those shadows cast on this back plane by the reticulated forms suspended before it, set up a dynamic interplay with "real" images. In future works these interweaving forms, shadows, and internal reflections would become increasingly complex and, in comparison with the simple visual melodies of Moholy-Nagy's *Space Modulators,* would become fugues of light and color.

Pereira's Study of Perception: Hildebrand, Worringer, Hinton, and Giedion

As much as Pereira's work and outlook during the late 1930s and early 1940s were dependent upon Bauhaus philosophy and the related interests of architects and designers, contemporary theories of perception and psychology played equally important roles in her thinking. Her interest in the unconscious at the time of her first abstractions is documented in her writings for the Design Laboratory. Her general interest in theories of perception may be confirmed through an examination of three books she obtained during her first months at the Design Laboratory: Adolf von Hildebrand's *The Problem of Form in Painting and Sculpture* (1907), Wilhelm Worringer's *Form Problems of the Gothic* (ca. 1927), and C. Howard Hinton's *The Fourth Dimension* (1904). Each heavily marked volume from her library is inscribed with Pereira's signature and the date 1936, and each had an enormous impact upon her thinking. Furthermore, each title appears on the bibliography for the "fine arts" section of the Design Laboratory, with Hildebrand's volume weighted most heavily of all the books listed.[1] The artist's subsequent discovery of Siegfried Giedion's *Space, Time and Architecture* led her to see how aspects of these authors' thoughts might be integrated with the interests of architects, designers, and painters, as Giedion's words became, quite literally, the source of inspiration for her lectures and a published essay during the mid-1940s.

Perhaps because of the importance attached to Hildebrand's work at the Design Laboratory, it was his book, of the three mentioned above, that ultimately had the most visible impact upon Pereira's paintings, particularly those completed during the early

1940s. Hildebrand, a sculptor, complained that contemporary art seldom transcended imitation. Consequently, artists must seek to raise their work to a "higher plane" through an "architectonic method," by which "the piece-work of perception [is combined] into an ideal whole."[2] In a paragraph that attracted Pereira's attention, he explained, "Material acquired through a direct study of Nature is, by the architectonic process, transformed into an artistic unity . . . [and] sculpture and painting emerge from the sphere of mere naturalism into the realm of true art."[3]

Hildebrand's architectonic method had some affinities with Gestalt theories of perception, particularly in its emphasis on wholes and in stressing that the order artists were to impose upon nature was based upon an understanding of the interrelationship of forms. The impact of these concepts is visible in the changes that occur in Pereira's machine compositions in 1936, the year she began to teach at the Design Laboratory. For example, one might compare the compositional unity and adroit orchestration of forms in *Man and Machine* with the more awkwardly structured painting *The Ship*. However, in terms of its lasting impact on her, the author's discussion of pictorial space was even more significant.

For Hildebrand, like Spengler, our conception of space and our perception of spatial form are the most important factors in our apprehension of reality.[4] Thus it is imperative that artists exploit in their work those means by which the sensation of space is aroused in the viewer. According to the author, "the more emphatically the artist demonstrates in his picture the volume of space, and the more positive the spatial suggestions contained in its perception, the more living and vivid is the illusion which the picture affords."[5] Yet because his theories were based primarily on his study of relief sculpture and architecture, his ideas regarding space were much different from those based ultimately upon linear perspective.

Hildebrand believed that space, a continuity extending in three dimensions, was analogous to "a body of water into which we may sink certain vessels, and thus be able to define individual volumes of the water without, however, destroying the idea of a continuous mass of water enveloping all."[6] Any volume of space is defined by that which contains it and is contained within it, such that "the boundaries of the objects also limit the volumes of air which lie between them,"[7] a concept echoed in *The New Vision* by Moholy-Nagy, who claimed to have found in physics his definition of space as "the relation between the position of bodies."[8]

The illusion of such a space in a two-dimensional painting thus depends upon the interrelationship of individual forms, for, as Hildebrand wrote, these shapes "have no meaning in themselves alone, but gain their significance only through that peculiar connection which constitutes their total unity."[9] To orient the viewer, the artist must establish a fixed frontal plane against which objects in depth may be measured. Space is conceived as visual penetration commencing with the frontal plane, and, to be convincing, such a system must be established with respect to a single viewing position.[10]

Hildebrand's method of defining space on a two-dimensional surface was, in part, the basis for Pereira's conception of space during the early and mid-1940s. To some extent, she relied upon his book in her class instruction as she had Moholy-Nagy's *The New Vision* at the Design Laboratory. This fact is confirmed in her lecture notes for a design class at the Pratt Institute of Design during the fall of 1942. Here Pereira identified three types of planes to define space: spatial (or measuring), directional, and tangential. Spatial planes, sometimes "transparent," lie parallel to the surface, and, like the frontal planes described by Hildebrand, their sole function is to establish a reference or point of orientation for the viewer.[11] Directional planes are trapezoidal shapes that appear illusionistically as orthogonal rectangles receding into the depths of the painting.[12] In overlapping sequence or through intersection, these trapezoidal forms establish a directional flow. According to Pereira's notes, undepicted, imaginary tangential planes connect edges and corners of spatial and directional planes to establish "vertical and horizontal proportions" with respect to the position of an "observer."[13] Not necessarily coexistent with the actual viewer of the painting, this fictional figure's stance is implied by the placement of the so-called spatial planes at right angles to his or her line of vision (see Figure 34). Consequently, for any given composition, a single point of view for the privileged "observer" is established, and, in theory, the actual viewer, in godlike transcendence, may stand outside that system altogether. Thus the system of viewing itself, the relativity of perception based upon position (as opposed to more recent discussions of the relativity of perception based upon gender, race, class, or age), becomes, in effect, the subject of such paintings as *Oblique Progression,* of 1948 (Figure 35). Her work anticipated by several years a sentence she found to be most significant in her copy of the 1950 revised edition of Lincoln Barnett's *The Universe and Dr. Einstein:* "Least of all does he [man] understand his noblest

and most mysterious faculty: the ability to transcend himself and perceive himself in the act of perception."[14]

Pereira's spatial system, based upon a frame of reference dictated by a spatial or frontal plane, is strikingly similar to that described by Hildebrand. However, she was further indebted to his book, for he raised questions regarding the perception of space that were to become central issues in Pereira's own publications. In the course of his discussion of space, Hildebrand described examples of ways to represent the recession of objects. In one example, he suggested placing a form defining the frontal plane in the center of the composition, with other shapes, each partially overlapping the next, extending laterally from it in a V-shaped fashion. In the second, he inverted this arrangement such that there was a convergence of elements toward a distant central object.[15]

In describing the visual effect of the first arrangement, Hildebrand noted that such a representation was in agreement with "our normal mode of looking at Nature as it spreads out with increasing distance." In other words, through this expansion of vision, marked by the V-shaped progression of objects, the viewer's "feeling for space" is "incited to infinite stretches." In contrast, in the second example, the convergence of objects toward a distant point in the middle of the composition (analogous in construction to a one-point perspective system) "opposes our true and normal relation to Nature" and curtails the "feeling for space."[16]

In her Pratt notes, Pereira used diagrams based upon these examples to indicate that the first means of graphic representation allowed for infinite expansion, whereas the second created a tunnel effect (see Figure 36). However, she also encountered here what she saw as the contradiction between space as it is experienced and space as it is represented graphically. According to her notes, space has an expanding quality with respect to the human eye due to the so-called cone of vision. A standard text on perspective, George Adolphus Storey's *The Theory and Practice of Perspective*, first published in 1910, provides the following explanation of this concept:

> *We perceive objects by means of the visual rays, which are imaginary straight lines drawn from the eye to the various points of the thing we are looking at. As those rays proceed from the pupil of the eye, which is a circular opening, they form themselves into a cone called*

A B

FIGURE 36

Diagram demon-
strating *(a)* infinite
expansion and *(b)*
tunneling effect,
based upon diagrams
and notations in
Irene Rice Pereira's
lecture notes for
classes at the Pratt
Institute of Design,
Fall term, 1942.
© Karen A. Bearor.

the optic cone, *the base of which increases in proportion to its distance from the eye, so that the larger the view which we wish to take in, the farther must we be removed from it.*[17]

However, what Pereira called "academic perception," or "ordinary" perspective, her terms for linear perspective, has a contracting quality based upon the convergence and ultimate meeting of parallel lines at a vanishing point on the horizon. Although such a graphic representation "satisfies the eye," she noted, it is nevertheless at odds with human experience.[18]

The problem was an old one made new again in light of twentieth-century rejections of linear perspective, and, in 1938, it became part of the focus of William Ivins' essay "On the Rationalization of Sight," published by the Metropolitan Museum of Art:

> *The underlying tactile assumptions of Euclidean geometry are excellently exhibited in its basic postulate about parallel lines. If we get our awareness of parallelism through touch, as by running our fingers along a simple molding, there is no question of the sensuous return that parallel lines do not meet. If, however, we get our awareness of parallelism through sight, as when we look down a long colonnade, there is no doubt about the sensuous return that parallel lines do converge and will meet if they are far enough extended.*[19]

The debate concerning the visual convergence of parallel lines that the mind knows do not meet became a major focus of Pereira's attention after her tenure at the Design Laboratory. Privileging

the operations of the mind over those of the senses, she rejected linear perspective as being too dependent upon that which "satisfies" the eye. Employing some of the methods that Hildebrand had proposed, she sought to suggest depth in her abstractions through the interrelationship of planes. Thus she hoped to reconcile the apparent disjunctions between what is perceived and what is known about space by avoiding altogether the systematic use of horizon lines and vanishing points.[20]

Worringer's *Form Problems of the Gothic* was equally significant for Pereira's work in that this book provided her with a theoretical and psychological justification for geometric abstraction. Worringer proposed that one look at the history of art not as a history of artistic ability but as a history of artistic will. Just as changes in myths, religions, philosophical systems, and world-views reflected the adjustment of humans to their outer world, for him variations in style in art were also dependent upon changes in the spiritual and mental makeup of a people and period. Accordingly, he advocated that art be part of broader investigations into the history of the human psyche and its various forms of expression, in part because the study of human artistic activities had not yet undergone the revolution

> *which the science of the mental activity of man owes to Kant's criticism of knowledge. The great shifting of emphasis in investigation from the objects of perception to perception itself would correspond in the sphere of the scientific study of art to a method which treats all the facts of art merely as arrangements of certain* a priori *categories of artistic, or rather, of general psychic sensibility and to a method by which these form-creating categories of the soul are the real problem to be investigated.*[21]

For Worringer, geometric abstraction was evidence of a maladjustment between the human beings and their environment, an imbalance between instinct and reason. Echoing opinions sometimes expressed by Gestalt psychologists, as discussed earlier, he felt humanity took refuge in absolute geometric forms when the chaos of the phenomenal world became overwhelming. During a decade in which an imbalance between instinct and reason was often taken for granted and when the world appeared to be on a collision course toward war, it is hardly surprising that Worringer's ideas found response. His theory that fearful "primitive" peoples used geometry to explain what they did not comprehend was often discussed, if not always endorsed, in art circles.[22] Yet

despite what Robert Goldwater cited in 1938 as the "obvious ex-tra-ethnological bias" of Worringer (and Leo Frobenius),[23] the German's theory of "primitive" art was a major source of inspira-tion for Pereira and, therefore, the following lengthy passage from *Form Problems of the Gothic* deserves quotation:

> *If, from the sum total of the conceptions to which we cling, we deduct the enormous number of inherited and acquired experiences; . . . if we dismantle to its very foundations the marvelously delicate fabric of the unbroken chain of transmitted characters, we are left with a creature who confronts the outer world as helplessly and incoherently as a dumbfounded animal, a creature who only receives shifting and unreliable* perceptual *images of the phenomenal world, and who will only by slow stages of progressive and consolidated experience remodel such perceptions into* conceptual *images, using these as guides for finding his way, step by step as it were, in the chaos of the phenomenal world. . . . Confused by the arbitrariness and the incoherence of appearances, primitive man lives in a relationship of gloomy spiritual fear to the outer world, . . . [and] the dregs of these primal deep-seated experiences remain in man as a vague memory, in the form of* instinct. *For thus we define that secret undercurrent in our nature, . . . the great irrational substratum beneath the illusory surface of the senses and intellect, to which we descend in the hours of deepest and most anguished insight, as Faust descended to the witches. . . . Out of this relationship of fear which is man's attitude towards the phenomenal world, there cannot but arise as the strongest mental and spiritual need the urge to absolute values, which deliver him from the chaotic confusion of mental and visual impressions. He must therefore endeavor to recast the incomprehensible relativity of the phenomenal world into constant absolute values. . . . In untrammelled spiritual activity primitive man creates for himself symbols of the absolute in geometric or stereometric forms.*[24]

In sum, Worringer believed the mind had two layers: the sur-face layer of the senses and intellect, and the substratum contain-ing vaguely remembered accumulated experiences of the past. From this substratum of instinct emerges the geometric symbols by which later humans, in periods of fear of the phenomenal world, will seek to "recast" the incomprehensible.

Although Pereira was silent concerning Worringer's impact upon her thinking, she did mention her debt to Hinton's *The*

Fourth Dimension.[25] She was rereading this book during the pe-
riod of her interviews with John I. H. Baur for the catalogue of
her Whitney retrospective. Baur, grasping at any clue to the
sources of the artist's philosophy, recorded Hinton's name in his
essay and, as a result, this bit of information has taken on undue
prominence in her standard biography.[26] Nevertheless, the book
was an important one for her. Although she told her biographer
that she had read the book several times during the early 1930s,
she did not obtain her own copy until 1936.[27] Her first references
to Hinton's work are two passages she quoted in her Design
Laboratory bulletin on terminology dated April 1937. The differ-
ent colors of pencil and ink she used in her notations throughout
the book's first nine chapters (some markings overlapping earlier
ones) suggest that she read these pages several times during the
course of her lifetime.[28] Her notations indicate that Hinton's last-
ing value for her lay in those paragraphs devoted to perception
and order. She had no interest at all in the last third of the book,
the tenth through fourteenth chapters, devoted to the geometric
representations of four-dimensional figures.

A former mathematics professor at Princeton University and a
U.S. Patent Office employee at the time of his death in 1907, Hin-
ton was the first writer to develop the philosophical implications
of a possible fourth dimension of space.[29] His book presented, in
some respects, a synthesis of ideas concerning perception articu-
lated by Hildebrand and Worringer, and it is in that light that we
might determine its early impact upon Pereira.

For Hinton, true knowledge of any "natural object" cannot be
deduced from a single observation with respect to space and
time.[30] To the contrary, such knowledge also requires experience
accumulated through the ages. With evolution, humans discover
higher dimensional existence, with respect to both the scientific
conceptions of the external world and the related recognition of
the depths of the soul.[31] Thus perceptions change. Hinton also
noted discrepancies between what is known and what is sensed;
and, in this connection, he included a discussion of Euclid's
postulate concerning parallel lines and attempts by mathemati-
cians through history to prove or disprove it.[32] Furthermore, he
claimed that the non-Euclidean geometries of Bolyai and Lobat-
chewsky had freed humankind from the limitations of the senses
and indirectly contributed to the recognition of higher dimen-
sions.[33] Arguing that what we see around us is conditioned by
our spatial perceptions, he made those spatial perceptions them-
selves the focus of his study, and, in a passage that may have had

some impact upon Pereira's "observer" diagrams, he wrote: "We can predicate nothing about nature, only about the way in which we can apprehend nature. All that we can say is that all that which experience gives us will be conditioned as spatial, subject to our logic. Thus, in exploring the facts of geometry from the simplest logical relations to the properties of space of any number of dimensions, we are merely observing ourselves, becoming aware of the conditions under which we must perceive."[34]

Within his discussion of higher dimensionality, Hinton wrote, "Thinkers become accustomed to deal with the geometry of higher space—it was Kant, says Veronese, who first used the expression of 'different spaces.'"[35] Pereira copied this sentence in her notes, dog-eared the page, and placed a bookmark at this point in the book, all of which indicate the importance of this passage for her. It appears that it was Hinton's debt to Kant, in addition to his discussion of higher dimensions of space and the soul, that attracted the artist to his work.

Hinton devoted an entire chapter to demonstrating the application of his theories of the fourth dimension to Kant's theory of experience. Explicitly acknowledging his debt to Kant's "transcendental analytic,"[36] he was attracted to the philosopher's distinctions between forms of sensibility and concepts of reason:

> *A dream in which everything happens at haphazard would be*
> *an experience subject to the form of sensibility and only partially*
> *subject to the concepts of reason. It is partially subject to the*
> *concepts of reason because, although there is no order of sequence,*
> *still at any given time there is order. Perception of a thing as in*
> *space is a form of sensibility, the perception of an order is a concept*
> *of reason.*[37] [*The last sentence was underlined by Pereira.*]

Hinton's association of Kant's epistemological theories with his own concept of the fourth dimension is important in that it signals the philosopher's impact on general studies of perception during the early decades of the twentieth century. When British astronomer Arthur Stanley Eddington's expedition "proved" Einstein's relativity theories by observing during the solar eclipse of 1919 that gravity altered the course of light, the apparent rupture between traditional beliefs and scientific evidence led to some public confusion.[38] News about the quantum theory during the late 1920s led to more. As a result of publications concerning Werner Heisenberg's uncertainty principle and Niels Bohr's complementarity principle, the public found to its dismay that it is not

possible to describe an object or phenomenon with precision, for some of the processes required for gaining data are contradictory or even mutually exclusive. Furthermore, the very act of observing might affect test results. The classic example appearing in popular literature was the case of an electron, whose position and velocity together could not be determined, for the process of obtaining information about one aspect alters the second.[39]

These revolutionary theories prompted physicists, philosophers, and artists alike to raise questions about how we perceive objects in space and time and what we can know about those objects given the limitations of our senses and experience. Many of these professionals turned to Kant for a philosophical model. For example, Cyril E. M. Joad, in his often-reprinted *Guide to Philosophy,* first published in 1936, addressed Kant's importance to contemporary science:

> *Kant's thought, moreover, has a peculiar appositeness at the present time, since, of all metaphysical positions, that which he adopts is most favourable to the view of the physical world suggested by modern science. . . . As the commonsense notion of a world of things separated by space and time whose motions are governed by laws which are independent of any observer grows increasingly difficult to maintain, it is inevitable that some other conception should be substituted. . . . It is not without reason that modern scientists should affirm that Kant's metaphysical views afford a more hospitable structure than those of any other philosopher for the accommodation of the conclusions to which increasingly they find themselves driven, or that J. B. S. Haldane, devoting a chapter to Kant in his book of popular scientific essays,* Possible Worlds, *should insist that modern scientific developments make Kant's views "more important now than when Kant arrived at them a hundred years ago."[40]*

Although there is some question as to when Pereira obtained her copy of Joad's book, it was to be a primary reference for philosophical thought.[41] Throughout her life, most of her knowledge of philosophy was obtained from secondary sources, such as Joad's book, Alexander Koyre's *From the Closed World to the Infinite Universe,* or reference books such as Dagobert Runes' *The Dictionary of Philosophy* and *Treasury of Philosophy.* Yet she did possess a copy of Kant's *Critique of Pure Reason.* The character of her notations and markings in this volume suggest that they were made during the 1950s, when she began to write her own philo-

sophical works. However, they do confirm the impact on her of Kant's thought concerning the perception of space and time, for it is the philosopher's metaphysical expositions on space and time appearing early in the volume that received her greatest attention. Yet the single passage she marked with most emphasis appears later in the volume:

> *For laws do not exist in the phenomena any more than the phenomena exist as things in themselves. Laws do not exist except by relation to the subject in which the phenomena inhere, in so far as it possesses understanding, just as phenomena have no existence except by relating to the same existing subject in so far as it has senses. To things as things in themselves, conformability to law must necessarily belong independently of an understanding to cognize them. But phenomena are only representations of things which are utterly unknown in respect to what they are in themselves. But as mere representations, they stand under no law of conjunction except that which the conjoining faculty prescribes.*[42]

According to Kant, without the ability to sense a phenomenon, a subject has no awareness of its existence. Hinton linked this concept to the apprehension of spatial dimensions and, in turn, to the evolution of consciousness, a concept having enormous impact upon Pereira in the 1950s. Assuming "the more space that is experienced, the greater the space becomes,"[43] she came to believe, like Hinton, that it was the accumulated perceptions of ages past that enabled twentieth-century individuals to become aware of higher spatial dimensions (although the fourth spatial dimension she recognized was "space-time"). According to her evolutionary model, earlier generations, lacking this wealth of experience, were unable to comprehend anything more than a three-dimensional reality.[44] Also like Hinton, Pereira believed that there was a four-dimensional "depth" to inner experience, corresponding to that of the "outer reality," that likewise expanded and allowed for "the mind's capacity for dimensionality and extension."[45] Since any awareness of the dimensionality of the universe was first dependent upon the mind's ability to apprehend it, her usage of the words "fourth dimension" most often refers to this privileged inner realm. This fact is confirmed by the definition she provided in the 1960s, that the fourth dimension is that aspect of the mind that gives structural form to thought.[46]

Hinton's evolutionary approach to the apprehension of space, like Spengler's, became a model for Pereira to follow in her own

writings. However, her philosophical essays, first appearing in the 1950s, were actually delayed entries into the melee of publications seeking to provide "new" philosophical frameworks for a culture shaped by "relativity." Alan J. Friedman and Carol C. Donley de- scribed this phenomenon in *Einstein as Myth and Muse,* published in 1985:

> *Because science and technology were making such a remarkable difference in people's lives, they attracted a great deal of public interest. . . . Science had opened up a Pandora's box of new world views whose contents required entirely new approaches and attitudes. Public discussion began to wrestle with the new concepts of relativity, of indeterminism, of an expanding universe, of the hypothetical—rather than absolute—nature of scientific laws. These revolutionary ideas pervaded the western world as part of the daily fare of newspapers. . . .*
>
> *Physicists explaining their own positions in articles and books usually achieved the most accurate interpretations of the actual physical theories, although their explanations were not always accessible to the general public. A few scientists turned spontaneously into philosophers (often rather poor ones) who published their metaphysical, epistemological, and ethical interpretations. . . . Some popularizers gave excellent explanations of the new physics, but others felt inspired to construct whole ethical systems, to support dialectical materialism, or to give scientific justifications of spiritualism—all on the basis of the new ideas.[47]*

One of the popular responses to this new Einsteinian world was Siegfried Giedion's 1941 publication *Space, Time and Architecture,* a text synthesizing many of the ideas put forward by Hildebrand, Worringer, and Hinton with Bauhaus-inspired theories concerning architecture and industrial design. Pereira obtained her uninscribed first-edition copy of Giedion's book, based upon his lectures as Charles Eliot Norton professor at Harvard in 1938–39, fairly soon after its publication. Evidence supporting this contention includes three undated sheets of handwritten notes, headed "Notes Summary, Perspective vs Space" and kept with her Pratt papers, which do not, in fact, offer the expected summation of preceding notes.[48] Instead, these sheets contain bits of information taken from pages 14 through 34 of Giedion's book, although no source is credited. Apart from this, a bookmark, torn from a page of the *New York Post* printed with an application for War Ration Book #2, issued between January and May 1943, pro-

vides a clue as to when she may have first read the book and re-corded her notes.[49] Based upon the date of the bookmark and the association of the pages of notes with her Pratt lecture materials, it is reasonably safe to conclude that she read Giedion's book dur-ing the period of her recuperation from a right lateral radical mas-tectomy. The discovery of her breast cancer that January, little more than a year after her sister Dorothy's death from the same disease, had forced her resignation from Pratt six classes into the spring term of 1943.[50]

Giedion's name may have been a familiar one to Pereira prior to 1943, for the architectural and cultural historian had been one of Moholy-Nagy's close friends for many years. After opening the New Bauhaus in Chicago in 1937, Moholy-Nagy had planned to establish an Institute of Design Research next door, with Giedion as its director. Unfortunately, the New Bauhaus closed before the institute was realized.[51] Giedion had also contributed articles to *Cahiers d'Art,* including one on Walter Gropius and German ar-chitecture, appearing in the 1930 issue Pereira saved.[52] His article on Robert Maillart, the Swiss engineer, appeared in *Circle: Inter-national Survey of Constructive Art,* edited by John Legat Martin, Ben Nicholson, and Naum Gabo and published in London in July 1937, a copy of which Pereira owned as well. Furthermore, at some point prior to 1946, Giedion purchased her first parchment paint-ing, *Red Squares,* of 1941.[53]

Giedion had studied in Munich with Heinrich Wölfflin, when the latter's widely read *Kunstgeschichtlich Grundbegriffe,* translated into English in 1932 as *Principles of Art History,* was first published in 1915. Wölfflin saw style in art as an externalization of a world-view to which artists subconsciously conformed, and he sought to re-examine the history of art through what he called a "psycho-logical interpretation of historical development."[54] In *Space, Time and Architecture,* Giedion acknowledged his debt to his teacher's comparative approach to history, which he thought was useful in revealing "how our epoch had been formed, where the roots of present-day thought lay buried."[55] Pereira, too, embraced this method in a lecture on "Perspective vs. Space-Time," which she presented in Oliver Larkin's summer course at Smith College in August 1944. A substantial portion of her lecture was published under the title "An Abstract Painter on Abstract Art" in the ACA Gallery's publication *American Contemporary Art* the following October.

In her opening to both the lecture and the essay, she drew parallels between the revolutionary impact of science on the Ital-

ian Renaissance and the modern periods. For her, these epochs differed in terms of the theories by which their people perceived space. She explained that "the arena of action for the artist today is the space-time continuum; the area of action for the artist of the Renaissance was space. The concepts are at opposite ends of the cone of vision, as it were, Renaissance theory expressing by means of linear perspective a contraction of vision, whereas modern art seeks to express expansion of vision."[56]

Clearly, this opening statement is indebted to Hinton's theory of the evolution of consciousness and Hildebrand's discussion of the expansion and contraction of vision, with its corresponding "feeling of space." However, to understand more fully Pereira's debt to Giedion's book, one must analyze the following three paragraphs from her essay:

> In Florence at the dawn of the fifteenth century, a new system of two-dimensional pictorial art was created by the invention of linear perspective. In this system symbolization of visual material is achieved by depicting objects on a plane surface without reference to their absolute shapes or relations. This system was a complete revolution from the inefficiency of previous painting where no picture could be exactly duplicated and where there was no rule or grammatical scheme for obtaining logical relations in a system of pictorial symbols. Artists and scientists elaborated the new theory, and Uccello cried, "How sweet is perspective!" Linear perspective came as an entirely new invention and one in complete accord with its age. It was not the discovery of a single individual but the expression of an epoch, as space-time in our period has developed with no one inventor but in response to the ideas of our age. In the evolution of both perspective and the space-time esthetic, art and science have cooperated.
>
> The substitution of visual for tactile space may be credited to Alberti who, in 1436, proposed a simple scheme for pictorial representation. His system not only brought parallel lines together at a logically measurable vanishing point but also provided a theoretical basis for that hitherto missing grammar, which would provide logical relations within the system of symbols employed and supply a two-way, reciprocal correspondence between the pictorial representation of shapes of objects and their locations in space. Alberti wrote: "The rays from the eye to the outward boundaries of the field of vision make what is called the pyramid of vision, and when a painter makes a picture of something he sees, it is as if his picture were of transparent glass cutting across the pyramid

of vision at a given distance from the eye, and, because of this, whoever looks at a picture looks at a cross-section of a pyramid of vision."

This static, mathematical conception of space is a far cry from the other end of the cone of vision —the fluid, ever-changing space-time continuum of modern theory. In 1908 the mathematician Minkowitz [sic], quoted by Siegfried Giedion in "Space, Time and Architecture," declared: "Henceforth space alone or time alone is doomed to fade into a mere shadow; only a kind of union of both will preserve their existence."⁵⁷

The contents of the three paragraphs just quoted are virtually copied from two sources: Giedion's *Space, Time and Architecture* and William M. Ivins' essays "On the Rationalization of Sight" and "Three Renaissance Texts on Perspective," which were published together by the Metropolitan Museum of Art in 1938. To determine the extent of her dependence upon these uncredited sources, compare the following composite of original passages with Pereira's first paragraph above:

In the Renaissance the dominant space conceptions found their proper frame in perspective while in our period the conception of space-time leads the artist to adopt very different means.⁵⁸ At the start of the fifteenth century, in Florence, . . . [a new conception of space] was translated into artistic terms through the discovery of perspective.⁵⁹ [At the beginning of human history] picturemaking long remained a most inefficient sort of symbolization. There were two great reasons for this inefficiency: one, that no picture could be exactly duplicated, and the other, that there was no rule or grammatical scheme for securing either logical relations within the system of pictorial symbols or a logical two-way, or reciprocal, correspondence between the pictorial representations of the shapes of objects and the locations of those objects in space.⁶⁰ Artists and scientists elaborated its [perspective's] secrets with a readily understandable excitement and pride. Their feeling toward it appears in the enthusiastic exclamation of the painter Paolo Uccello, "How sweet is perspective!" Perspective was not the discovery of any one person; it was the expression of the whole era. . . . [With Cubism], too, we shall find a whole movement arising in response to the new space conception developed in our time, rather than a single inventor. In both cases the significant thing is the mixture of art with science, but the two worked together far more closely in the development of perspective.⁶¹

Pereira's paragraph concerning Alberti was no less dependent upon two paragraphs written by Ivins.[62] Ironically, in the single passage for which the artist acknowledged her source, she misquoted the original. Giedion had quoted Hermann Minkowski twice in *Space, Time and Architecture,* although the second occurrence was merely a differently translated restatement of the first. Pereira's source was the second version, but her misspelling of the mathematician's name was a mistake she had first made when taking notes from the book in 1943. As her habit was to work from her own notes rather than to return to the original text, she continuously cited "Minkowitz" in subsequent lectures and writings. She remained oblivious to her error until the late 1950s, when an acquaintance gave her an anthology of essays concerning relativity physics, including the seminal one by Minkowski.[63]

In what is perhaps the most original passage in her essay, a portion of which she had presented earlier in a lecture for the UAA in 1940, Pereira stated:

In abstract art, space-time is the dominant concept. In science, space is measured by elaborate and intricate calculations. The electron, for example, is not visible, but actual. To the artist in the modern world, these intellectual interests are compelling. Equipped with a new theory, space-time, knowing the world to be fluid and changing rather than static and fixed, the modern artist cannot accept old usages. Rather, the abstract artist seeks, by utilizing contemporary knowledge, to create new forms to express the new age. Space-time is his medium, and substances of modern science the material with which he works. Much of his search has taken place, as it were, in the laboratory, and experiment is its keynote. . . . In its own right, abstract art seeks plastic equivalents for the revolutionary discoveries in mathematics, physics, biochemistry, radio-activity and a thousand related fields.[64]

Einstein had shown that light exhibited properties of both waves and particles, and, during the 1920s, French physicist Louis de Broglie and Austrian physicist Erwin Schrödinger each proposed that matter also exhibited wave and particle properties. Although these wave theories were symbolic means to describe the behaviors of elementary particles, they led some writers to a revived interest in the concept of a universal ether. Scientists believing in the ether were in a minority, for Einstein had effectively laid that theory to rest. Yet some popular sources of information about the sciences—including those that were potentially major

resources in public schools—perpetuated the belief in the ether. For example, the 1928 edition of the World Book Encyclopedia declared that "ether is the substance that fills the immeasurable spaces of the universe which separate the heavenly bodies and . . . it permeates even the smallest particles into which matter can be divided."[65] One *New York Times* journalist, troubled by the increasing rapidity by which certain theories come and go, summed up the situation: "You have on the one hand X-rays identified as showers of particles and atomic particles conjectured as rays or waves. The ether, which has gone out of fashion in recent years, is now apparently by way of being rehabilitated."[66]

These wave theories were in part the basis for Pereira's reference to the fluid and changing universe in her paper. Her use of corrugated and textured glasses during the 1940s created wavelike images that were metaphors for the "medium" of space-time. Furthermore, in physics, the wave nature of electrons was demonstrated through diffraction experiments with crystals, and such tests had become standard procedure in science laboratories. The number of Pereira's glass paintings containing the word *diffraction* in their titles suggests that analogous experiments made up some of her own practices as well. In fact, the title of at least one of her paintings was based upon the diffraction rating of the glass— *Diffraction A3.*

Pereira's dependence upon Giedion's book is evident throughout the remainder of her lecture/essay on space and perspective. Like him, she discussed the stroboscopic photographs made by Harold E. Edgerton at MIT. Furthermore, she was attracted to the historian's discussion of Picasso's *Guernica,* a painting she admired for its inclusion of fragments of the real world as symbols "to express the deepest human experience of our time," even if, as she quoted Thomas Mann, the painting represented "a universal feast of death."[67] Giedion had linked the shape of the elongated head of the lamp-bearing female figure in *Guernica* with the stroboscopic images created by Edgerton.[68] Although not explicitly making the same connection in the published version of her text, Pereira did argue the same point in her lecture to Larkin's class. The idea apparently had some currency in the mid-1940s, as it was subsequently expressed by Ad Reinhardt as well.[69]

According to Giedion, one of the guiding principles underlying his analysis of architecture was to discover the degree to which the equilibrium of an epoch is determined by the coincidence of its methods of "thinking and feeling."[70] He believed that only through such unity of thought and feeling could the "disintegrat-

ing forces in our period" be countered.[71] Like Worringer and
Wölfflin, he saw each period in history as having a personality.
However, just as in the individual, a period might have a "split
personality" based upon an imbalance between thought and feel-
ing. For him, the nineteenth century had exhibited such an im-
balance, and this legacy lingered in Western culture. In *Space,
Time and Architecture*, he wrote,

> *Throughout the nineteenth century the natural sciences went
> splendidly ahead, impelled by the great tradition which the
> previous two hundred years had established, and sustained by
> problems which had a direction and momentum of their own. The
> real spirit of the age came out in these researches—in the realm
> of thinking, that is. But these achievements were regarded as
> emotionally neutral, as having no relation to the realm of feeling.
> Feeling could not keep up with the swift advances made in science
> and the techniques. The century's genuine strength and special
> accomplishments remained largely irrelevant to man's inner life.*
>
> *This orientation of the vital energies of the period is reflected in
> the make-up of the man of today. Scarcely anyone can escape the
> unbalanced development which it encourages. The split personality,
> the unevenly adjusted man, is symptomatic of our period.*[72]

If the root of the world's difficulties indeed lay in the mal-
adjusted "man," and by metaphoric and stereotypic extension "so-
ciety," then one could do no better than to turn to psychoanalysis
for a solution. Psychic imbalance, on both the individual and so-
cietal levels, was Carl G. Jung's interest as well. Despite what
many now see as the sexism and reliance upon essentialist stereo-
types inherent in his theories, Jung's writings provided Pereira
with a history, even if that history was largely peopled with
mythological figures, and access to a symbolic language that she
hoped would lead to her empowerment within the discourse of
modernism.

The Impact of Jung, Alchemy, and Tales of Transformation on Pereira's Abstract Symbolism

The first dated evidence of Pereira's interest in the unconscious is found in her terminology list compiled at the Design Laboratory in April 1937, not only in her definition for "intuitional" abstraction, discussed earlier, but also in her definition of *symbolism:* "Interpretation of objects, qualities, by means of Rhythms, sentiments, emotions, colors or personal qualities manifested from subconscious [later changed to "unconscious" in her copy]."[1] While it may be merely coincidental, Pereira prepared these definitions almost immediately after having work exhibited at the East River Gallery in January 1937. Gallery owner Marian Willard had attended lectures by Jung in Zurich in 1935, when she was the guest of Carola and Siegfried Giedion, and would do so again in 1937.[2] Pereira maintained contact with Willard throughout this year, for her first abstractions were subsequently exhibited at the East River Gallery in November 1937.

Whatever impact Willard may have had in stimulating the artist's interest in archetypal theory, Pereira could hardly have avoided the widespread discussions of Jung's theories in New York in 1936 and 1937, when he was teaching in and near that city. Nor could she have been oblivious to a general interest in psychoanalysis within the WPA/FAP. For example, the project sponsored an exhibition of work produced by Bellevue patients in classes conducted by the Art Teaching Division and supervised by psychiatrist Lauretta Bender. Called "Art and Psychopathology," the show was held at the Harlem Community Art Center in October 1938.[3] The project also joined forces with the Bellevue Psychiatric Division to sponsor an exhibition at the meeting of the American Orthopsychiatric Association, held at the Hotel Commodore in February 1939.[4]

In fact, the "therapeutic" benefits of abstraction for the viewer were commonly discussed during this period by artists and designers creating art for public spaces, just as the salutary effects of light and glass were debated. For example, George L. George argued that nonobjective abstraction—the "Art of Tomorrow"—had "positive therapeutic virtues" in home decorating which could be appreciated not by just "a few snobbish esthetes" but by those who put themselves into a "beatific state of euphoria" by emptying their minds of preconceived attitudes regarding art.[5] In part, the "proof" that abstraction was beneficial stemmed from pseudo-scientific "researches" by artists on the WPA who were commissioned to paint murals for psychiatric wards in hospitals and asylums. A case in point is artist Esther Levine's FAP report, "A Mural in a Mental Hospital Created with Therapeutic Consideration," dated September 18, 1940, concerning her four-part, semi-abstract mural *History of Man's Struggle with Fears,* designed for patients who had "regressed to a primitive mode of experience."[6] In this report, she argued that any therapeutic approach to painting for the mentally ill must involve the basic principle of "bringing forward of the patient's mental material" by appealing to the unconscious mind. Abstraction was appropriate for such an undertaking because "all so called primitive types of experience show evidence of a larger use of symbolic thinking which originates from the collective unconscious." She continued, "The artist's endeavor should be to transmute in a particular direction the emotions arising from primordial conflicts and express them in a pure aesthetic form. In art the subconscious deals with subject matter which sets up the release symbols for projection, identification, free-association."[7]

Pereira's concurrent interest in these same issues suggests that concerns with the contents of the unconscious were shared by many more artists during this period than the more celebrated few who went on to become Abstract Expressionists. Furthermore, the archetypal imagery believed to emanate from the depths of the psyche was as likely to be geometric in appearance, in accordance with Worringer's theories, as it was to resemble the automatism or the dream and mythopoetic imagery of the Surrealists. This point is essential to keep in mind, for, although Pereira's geometric abstractions, particularly her glass paintings, did not look like the paintings of the Surrealists nor that of their recognized aesthetic beneficiaries, the Abstract Expressionists, the works were nevertheless dependent upon many of the same theories.

It is impossible to determine when Pereira acquired her first volume of Jung's works. However, her marked interest in passages

referring to machines in her uninscribed copy of his *Contributions to Analytical Psychology,* published in 1928, suggests that she possessed this book by the mid-1930s, at the height of her interest in that subject. Her second-hand copy of his *Psychology of the Unconscious,* inscribed only with the name of the previous owner, was a 1922 edition. Through the course of her lifetime, she collected seven additional volumes of his writings, each issued in 1948 or afterward, as well as Richard Wilhelm's *The Secret of the Golden Flower,* with Jung's commentary. She also acquired books written by avowed followers, including Jolande Jacobi and Erich Neumann, and popularizers, such as Joseph Campbell. Although in 1958 Pereira denied knowing Jung's work well[8] (perhaps the most mendacious disavowal of her career), there is sufficient evidence to conclude that his archetypal theories formed the core of her philosophical beliefs from at least as early as 1937 until her death.

Yet what is of greater importance than any speculation concerning when Pereira first became aware of Jung's theories is how she used them once that knowledge is obvious. Why, for example, had she little use for Freud's theories instead? Although at some point she did acquire a 1938 revised edition of the latter's *A General Introduction to Psychoanalysis,* it was about 1941 that she advised her friend Dwinell Grant that Freudian analysis would ruin him as an artist.[9] Although she did not explain her comment further, it is likely, particularly in light of what we know about her later writings, that she held beliefs similar to those expressed by Nicolas Calas in 1942 regarding Freud and poets: "Freud's patients are merely victims; the poet, by the sole fact that he creates, is a *hero,* a hero . . . who has discovered a world he can explore and conquer, a world, moreover, of high social significance, and cannot be degraded to the rank of patient."[10] In contrast to Freud's characterization of artists as essentially neurotic, Jungianism contributed to the overall romance of the artist, for, as Frederick J. Hoffman wrote in 1957, Jung "serves artists by rescuing them from an unflattering Freudian diagnosis and giving them the role of seer, prophetic bard, guardian of the temple, neighbor of the mystic. . . . Jung's elaborate system has tried, therefore, to satisfy a great hunger for transcendence."[11]

More than this, Jung's writings appeared to hold open the possibility for women to empower themselves in contemporary society. Many feminists now argue that, in his simplistic dependence upon stereotypical, essentialist notions of what constitutes the "feminine," he merely reinforced the limitations placed upon women in patriarchal society rather than offering them any real

liberation. Nevertheless, Pereira was attracted to remarks he made concerning modern women's natures in his essay on "Woman in Europe," included in his *Contributions*. Underlining both his positive and negative characterizations as though they were all in accord with her own thinking, the artist also singled out the following: "Therefore the modern woman longs for greater consciousness, for meaning, and the power of naming her goal in order to escape from the blind dynamism of nature. She seeks it in theosophy and in every other possible unreality. . . . The modern woman stands before a great cultural task which means, perhaps, the beginning of a new era."[12] The power of naming one's own goal, to be a pioneer carving out a new culture for a new age—what heady stuff for a Depression-era woman, even if the psychoanalyst had scornfully limited her resources to theosophy and other "unrealities."

During the time Jung was in the United States, he was exploring the theoretical parallels between the dream imagery of his patients and the symbols associated with the mysterious practices of the medieval alchemists. His work served to sensitize artists to the possibilities inherent in esoteric symbolism, the means by which individuals might gain a better understanding of individual and collective behavior. Although these symbols had lost much of their arcane significance once freed from the secret laboratories of adepts, Jung considered them, in their original manifestations, as archetypes, those forms universally present in the collective unconscious. In particular, they were of the class of archetypes he called "archetypes of transformation."[13] He had initially become aware of their potential value to psychoanalysis in 1928, when Richard Wilhelm sent him a copy of a thousand-year-old Taoist-alchemical tract, *The Secret of the Golden Flower,* with a request that he provide a psychological commentary on it.[14] For Jung, this tract provided the key to understanding individual striving for psychological wholeness, as well as the significance of the mandalas that he had begun to draw in 1918 while he was stationed at Château-d'Oex.[15]

Jung's commentary, published in the original German edition of the tract in 1929 and translated into English in 1931, represented his first formulation of the relationship between alchemy and psychoanalysis. (Herbert Silberer of Vienna had already made the connection between alchemy and psychoanalysis in his book *Problems of Mysticism and Its Symbolism,* published in New York in 1917; and the connection was well established enough by the late 1920s that "alchemy" was cross-referenced with "psycho-analysis" in the

1928 edition of *The World Book* encyclopedia.) [16] Excerpts from this commentary were published in Eugene Jolas' *transition* in March 1932.[17] Jung developed his concepts further in his lectures "Traumsymbole des Individuationsprozesses" and "Die Erlosungsvorstellungen in der Alchemie," published in *Eranos-Jahrbuch 1935* and *Eranos-Jahrbuch 1936,* respectively. These lectures were expanded, translated, and published in English in *The Integration of the Personality* in 1939.[18] In September 1936, following his participation in the Harvard Tercentenary, Jung gave a seminar on "Dream Symbols of the Individuation Process" to members of the Analytical Psychology Club of New York.[19] He held additional seminars on the subject in September 1936 at Bailey Island, Maine, and again in New York in October 1937.[20] Also in 1937 he theorized the relationship between Christianity and alchemy in talks at Yale University, presented as the fifteenth series of "Lectures on Religion in the Light of Science and Philosophy," sponsored by the Dwight Harrington Terry Foundation. Jung's lectures were collectively published in English under the title *Psychology and Religion* in March 1938.[21]

Jung's writings concerning "archetypes of transformation," as well as his lending scientific credibility and authority to occult literature, would certainly have found a receptive audience in Pereira, with her demonstrated interest in witchcraft and exoticism. These interests appear to have been encouraged by her first husband, Humberto, who gave her a copy of John Anster's translation of Goethe's *Faust*. Illustrated by Harry Clarke, this numbered collector's edition of Part I, published in conjunction with the centenary of the poet's death in 1932, contains the following inscription, translated here from the original Spanish: "To Irene as Margarete, I hope that the divine love for the precious Margarete that reigned in Faust's heart will be symbolic of my love for you even with the diabolical interventions of the devil Mephistopheles. Your Faust, Humberto."[22]

How Pereira responded to this declaration of love is unknown. To some women, it would hardly seem a compliment to be cast as the tragic Margarete (Gretchen), the innocent, uncomplicated, long-suffering but willing victim of Faust's abuse, abandonment, and unfaithfulness, a woman powerless to inspire in her lover the courage to resist the devil's magnetic entreaties, driven insane by imprisonment. In fact, their marriage was not a happy one, as indicated by Irene's accusations written in pencil on the backs of ten torn photo-postcards of herself, still with her papers. According to her, Humberto was distant, unloving, and indifferent

to her unnamed sacrifices and suffering. While she quoted him as charging her with being selfish, she indicated that she had stayed in the marriage out of love for him and the faint hope that once again that love might be reciprocated, despite his desire to leave her.[23] Nevertheless, Irene subsequently claimed that it was Humberto who had put her in the right "channel,"[24] a possible reference to her introduction to the Faustian cycle of spiritual transformation.

Pereira maintained an interest in the Faust legend for many years. She marked many passages referring to it or to Goethe in her books and also acquired Thomas Mann's *Doctor Faustus* in 1948.[25] Based upon the nature of the passages she highlighted, what she found compelling about the tale was the eponymous character's romantic quest for knowledge, perfection, the goal of all human striving, identified by Goethe in the final lines of the play as the Eternal Feminine, the source of the perpetual renewal of life and art. In tracing his degradation, his chthonic descent, Goethe has Mephistopheles lead the scholar through the "witch's kitchen" and then to the Harz Mountains on "Walpurgis Night" for a satanic orgy. In Part II, Faust and Mephistopheles are guided to the Thessalian witches' "Classical Walpurgis Night" by Homunculus, the artificial little man created in the laboratory by Faust's famulus, Wagner. Ultimately, the quest ends in heaven with the union of opposites—the intellectual male, Faust, with the emotional female, Gretchen.

While in the witch's kitchen, Faust drinks a potion to remove thirty years from his age and symbolically regresses toward the more primitive world and baser instincts of his ancestors. Precisely such a "reversal of the whole personality" was detailed by Jung in *The Integration of the Personality* in his discussion of the possibility of the shadow (representing the contents of the unconscious) assimilating the ego, causing the latter to become more "infantile and primitive."[26] This regression accompanies what Jung and others called "introversion," the psychic exploration of the depths of the unconscious, when the balance between the unconscious and the conscious is disturbed. As Silberer explained in 1917, "Introversion . . . is accompanied by a desire for symbolic form of expression . . . and causes the infantile images to revive."[27] While Worringer identified these symbols as geometric, Silberer noted that they were chiefly symbols of the mother (womb), for example, earth, hole, sea, belly of the fish, and so forth.[28]

For Jung, a temporary period of introversion was necessary for psychological health. Psychoanalysis was the process of individua-

tion, by which he meant self-realization, the process of making the human being "whole" through an awareness and conjunction of the conscious and unconscious aspects of the mind. Individuation requires individuals to develop all levels of the psyche, thus they must descend metaphorically to the depths of the unconscious and bring to the surface the information buried there. According to Jung, the unconscious has two levels: the personal unconscious, that region just beneath the surface containing experiences that have been repressed, forgotten, or ignored; and the collective unconscious, the deepest spaces of the mind holding universal and inherited impulses, like the instincts of animals, including all the evolutionary material humans have accumulated since creation. This information is encoded in archetypes, engrams created by the constant repetition of certain experiences throughout time. The sun god, based upon the daily observation of the sun's rising and setting, is one such archetype. Archetypes might manifest themselves in graphic symbols, or they may take form in myths and legends.

The archetypal myth that had the greatest importance to Germans and Americans between the World Wars was the story of Faust, particularly as recorded by Goethe. Against the emphasis on the positivistic world of senses identified with the nineteenth century, many viewed the twentieth century as the century of inner exploration. Herein lies the significance of Spengler's identification of the modern world as the Faustian age. Faust's descent was identified by Jung, Silberer, and others as a symbol of introversion.[29] His subsequent salvation in the second part of Goethe's play was, for Jung and his followers, a metaphor for the completion of the individuation process. For example, in 1930, Mark van Doren wrote that Goethe's version of the legend, in particular, "showed how the story of *Faust* is rooted in the consciousness of man."[30] Looking back on Goethe's impact on the formative years of psychoanalysis, Juliet Mitchell noted in 1974 that Goethe's conception of the Eternal Feminine "found its apotheosis in Jung's works."[31]

However, more than this, between the World Wars, the interest in Goethe's *Faust* was symbolic of a period of inquiry into the relationship of humanity to the world and to the very nature of our species itself. As has been noted on several occasions in this study, it was widely conceded that humankind had emphasized the intellect at the expense of the intuition and that this critical imbalance had led to the problems in the world. Mourning this presumed loss of totality and longing nostalgically for its restora-

tion, many believed that what was needed was a worldwide individuation, so to speak, and Faust became a figure symbolic of that quest for both individual and society.[32] Even Goethe's life itself was mythologized and became emblematic of the age. In the foreword to her translation of *Faust,* Alice Raphael wrote, "Goethe is so important to modern man because he struggled consciously and ceaselessly throughout his life to integrate the manifold aspects of his richly endowed personality under the hierarchy of his will; his conflicts were the struggles which lead to self-mastery, his aim the development of his possibilities, and his goal the conquest of his own nature."[33]

In *The Integration of the Personality,* Jung called *Faust* an *opus alchymicum,*[34] the "last magnificent link in 'Homer's golden chain,'" and, simultaneously, the introduction of individuation to "a new, psychologically minded age."[35] The reference to "Homer's golden chain" is an acknowledgment of Goethe's debt to alchemy,[36] whose symbolism Jung recognized in *Faust.* For him, alchemy was the "medieval exemplar of this concept of individuation,"[37] and the writings of the alchemists verified that the true purpose of their work was the perfection of the soul through the search for knowledge. However, Jung's views linking Goethe, alchemy, and individuation were not published until after Humberto Pereira gave his wife her copy of *Faust.* Although Goethe's interest in alchemy had been discussed in print since the early years of the twentieth century, none of these sources would have been readily available to Pereira.[38] Lacking other documentation, it is difficult to determine whether she was aware of all these connections at that time. However, during the early 1930s, Pereira would have had some familiarity with alchemy itself, for the transmutation of metals was headline news between 1924 and 1936.

There were two developments in Germany in 1924 that made alchemy and the transmutation of elements so commonplace in the news that the *Reader's Guide to Periodical Literature* reinstituted a category for "transmutation" from 1925 through the 1930s.[39] In Munich, Franz Tausend, a plumber-turned-alchemist, won fame with "gold-making" demonstrations during which he allegedly transformed lead into gold by placing the original substance in fire. Becoming a cult leader, he fleeced people of their money until he was jailed later in the decade.[40] In July 1924 persons identified as Professor Miethe and Dr. Stammreich of the Berlin Technische Hochschule published a paper in *Die Naturwissenschaften* concerning their transmutation of mercury into gold using an electric discharge of 170 volts between the electrodes of a special type of

mercury vapor lamp. Their results were allegedly confirmed in 1925 by a Professor Nagaoka of the Institute of Physical and Chemical Research of Tokyo. A photograph of Nagaoka's equipment, including his high-voltage generator, appeared in the *Literary Digest* issue of February 6, 1926. With the accompanying caption, "A Modern Alchemist's Furnace," this photograph bears a striking resemblance to Pereira's painting *Generator* six years later.[41]

Although American scientists were unable to confirm the German or Japanese experiments, these attempts were widely reported in the United States. Yet the key to unlocking the mystery of transmutation lay in the atom's interior—a microcosmic frontier into which pioneer scientists were making inroads. In that spirit in 1930, Bernard Jaffe wrote "The Human Crucible," an article celebrating "the romance of heroic men working to push back the frontiers of knowledge . . . struggling to frame the laws of nature, . . . leading intellectual revolutions and fighting decisive battles in obscure laboratories."[42] The article, which won Jaffe a $7,500 award for the "Humanizing of Knowledge," was about alchemy.

Americans searching for a scientist-hero found one in Ernest O. Lawrence, a physicist at the University of California Radiation Laboratory. Popular interest in his work had been building since he began his experiments in 1932. Noted physicist William Francis Gray Swann, then associated with the Bartol Research Foundation, Franklin Institute, helped fuel the fire with his 1934 publication, *The Architecture of the Universe*. He explained that scientists, freed "from the shackles of mysticism," had thought the possibility of the "transmutation of the elements" to be "beyond our wildest hopes" until the recent fashioning of "weapons to pierce the very heart of the atom." With these, Ernest Lawrence and others "are disintegrating atoms in ever increasing amounts, so that while even yet transmutation in large quantities is a distant hope, it is a hope which is at least on the horizon of our scientific vision."[43]

In February 1936 Lawrence produced unstable Radium E from stable bismuth with a "frying pan"–shaped "atom-smashing machine," achieving what a *News-Week* (later *Newsweek*) journalist called "the goal of all alchemists: the transmutation of an element."[44] Within weeks, he had also changed lithium into gaseous helium. By May 1936 he had artificially produced gold, the alchemists' dream, although the quantity was so minute and the cost so great, it represented no boon to metallurgists.

There was so much popular interest in alchemy by the mid-1930s, with the developments in science and Jung's interest in the subject, one need have no interest in the occult to believe that the medieval alchemists may have been correct all along. But for an artist who already had an interest in the occult, who saw herself as a "scientist" working in a laboratory environment exploring the innate qualities of materials and who was interested in psychology, such a belief would appear to offer a grand synthesis of all these aspects of her life. Furthermore, analogies between the researches and goals of alchemists and artists had already been established by André Breton in his call for the "occultization" of Surrealism in his second manifesto of 1929. Whether or not Pereira was aware of Breton's writings or the growing interest in Goethe as an alchemist, it would take little imagination for her to see all seekers of knowledge—in science, psychology, or art—as romantic heroes in one grand accord. Thus it is not surprising, particularly when one factors in her own Germanic heritage, that she became caught up in the general interest in German Romanticism ushered in by America's fascination with the work of Einstein, Freud, Jung, Goethe, Kant, the Gestalt psychologists, Spengler, Marx, Hildebrand, Worringer, and the Bauhaus artists. It is equally unsurprising to discover alchemical symbolism in her paintings by 1938, if not earlier.

Although not necessarily indicating any knowledge of alchemy this early in the decade, symbols of transformation occur in Pereira's paintings by 1932, when she painted *Generator,* a machine to convert electrical energy into a usable form. As mentioned earlier, the generator may be a metaphor for what Freud and Jung called "the transformation of the libido," wherein sexual energies are channeled into other uses, such as artistic creativity. In discussing this concept, Jung wrote in his *Contributions to Analytical Psychology* that it is "a process corresponding to the so-called transformation of energy; for example, in the steam engines the conversion of heat into the pressure of steam, and then into the energy of motion. Similarly the energy of certain psychological phenomena are transformed by suitable means into other dynamisms." On the following page, in a passage that Pereira underlined at some undetermined time, Jung continued, "Just as it has been possible for man to discover the turbine, and, by leading a river to it, to convert the latter's energy of motion into electricity capable of manifold applications, so it has been possible for him to convert, through the aid of a machine, natural energies that would otherwise flow away without accomplishing work into

other dynamic forms productive of work." (Is it mere coincidence that Jung also mentions a power station in this connection and the artist painted a *Power House* in 1937?) [45] Yet significantly he also linked the transformation of energy to alchemical symbolism and electricity to magic. [46] Pereira, whose marginal notations accompanying this discussion include "instinctive energy = magic" and "magic the mother of science," underlined these passages as well.

Ships and ladders are also frequent cross-cultural symbols of transformation. Having already considered Pereira's marine imagery within the context of the male-dominated interest in the machine, that context in which most critics and art historians have viewed it, one should also consider these forms within complementary traditions in women's art and literature. Despite the fact that her best-known works lack any overt stylistic affinities with Surrealism, it is within that theoretical framework that much of her work might be more appropriately evaluated. More to the point, it is against the art created by the women Surrealists, their literary associates and aesthetic descendants, celebrated in the ground-breaking writings of Gloria Orenstein and Whitney Chadwick, that her work should be compared thematically. Sharing their male colleagues' quest for total knowledge but not their objectification of the woman's body, some of these women selected the metaphorical language of marine imagery to convey what Carol Christ has called their "diving deep and surfacing." [47] In Pereira's ship paintings the focus is upon the surface and ascent rather than the sea and descent. Yet her insistent association of stair steps ("ladders") with these vessels might be likened to Adrienne Rich's ladder at the side of the schooner—the one that is always there, appearing to be sundry equipment to some, but full of meaning to those who have used it—a central metaphor in the poem "Diving into the Wreck." [48]

Other images in Pereira's oeuvre have possible correspondences with alchemical symbolism. In "Eastward Journey" Pereira included a photograph of a painting of an unidentified man seated in a wooden chair (Figure 37). [49] Seen from an elevated, Philip Pearlstein–like vantage, the seated figure assumes the brooding pose of Melancholia, with his open left hand supporting the weight of his downturned head. The figure of Melancholia is often used as a symbol of male artistic genius, and that may be the extent of its meaning here. Yet this pose is also associated with the frustrated seeker of the philosopher's stone during the first stage of the Great Work seen, for example, in Dürer's famous engraving *Melencolia I.* Unlike Dürer's work, however, Pereira's

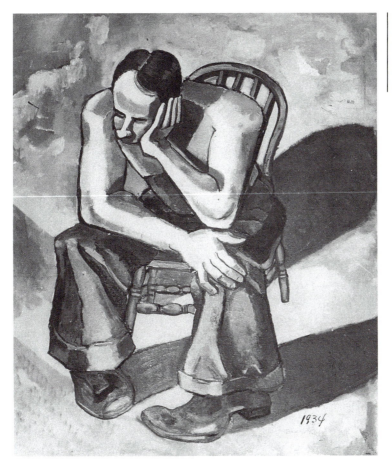

FIGURE 37

Portrait of a Man,
1933 or 1934.
Location unknown.
The Schlesinger
Library, Radcliffe
College.

painting contains no other symbols of any kind. Lacking further evidence, the question of interpretation remains open.

There is also at least one work whose cryptic title can be linked to occult or pseudo-scientific practices popularized during this decade. This is *Pendulum* of 1937, the collage on which Pereira's first abstraction, *Black Squares,* was based. There is no recognizable pendulum among the mechanical forms represented in the collage, thus the title presumably refers to the pendular motion of some machine parts. The potential metaphoric value of such rhythmic motion would appear to be consistent with the artist's interest in "rhythms" emanating from the unconscious in her definition of *symbolism* in her Design Laboratory bulletin of April 1937. Yet considering her interest in the occult, it is worth mentioning contemporary fascination with pallomancy or dows-

ing (divination with a pendulum) and radiesthesia (sensitivity to radiation supposedly detectable by a pendulum due to magnetic forces surrounding the human body). For members of some secret societies, such as the Hermetic Order of the Golden Dawn, pallomancy was a means by which one might increase one's sensitivity to "vibrations."[50] The alleged properties of radiesthesia were tested by doctors and engineers in several countries, and a number of societies and journals devoted to its study were formed in Europe during the 1930s. In 1936 the war departments in Germany and Italy even considered its potential wartime applications.[51]

Unquestionably, however, the collage bearing the words "sing a new song" of 1938 contains references to alchemy, and it bears reexamination in that light. The central motif was originally painted as a musical eighth note around the stem of which the artist painted a spiraling line. The resulting image resembles a snake on a pole, evoking illustrations of Moses' brazen serpent.[52] Because of its ability to shed its skin, the snake also has a long cross-cultural history as a symbol of transformation, and, in alchemical literature, it may bring things to maturity and perfection.[53] Yet added to Pereira's configuration are two opposing triangles, resembling abstracted, outstretched wings, whose apices meet at the flag of the note. In alchemy, the serpent and bird are opposites; their appearance together represents the union of opposites. Combined, they are also symbols of Mercurius (Hermes), as in his attribute, the caduceus, and this fact provides a clue to the entire motif's meaning. In alchemical symbolism, Mercurius may represent the feminine principle or the hermaphrodite (androgyne), depending upon context. As the hermaphrodite, Mercurius is also the figural symbol of the philosopher's stone, or lapis.

If one accepts the upper half of the central motif as representing Mercurius and thus the alchemical process itself, the oval note, virtually disappearing against the added "base," suggests the vessel, often called the "egg," in which the transmutation of elements occurs. The dark spot within the oval would thus correspond to the dark matrix, the *prima materia,* that chaotic mixture of primary ingredients that gives birth to the lapis. (The spot within the oval also evokes the chemical symbol for gold, a dot within a circle.) The box-shaped base itself, whose form envelops the note, might thus be seen as representing the furnace that provides the heat necessary for transmutation to occur.

The central motif in this collage, itself physically transformed,

is thus only a slightly disguised symbol of alchemical transformation. As such, it reinforces metaphorically the meaning attached to this work earlier in this study. Yet there may be additional significance to the work. Alchemy was often described as a musical art because, like music, it required measure, as intervals of space (extension) or as time (duration).[54] Music was also seen as having a salutary effect upon the transmutation process or as an antidote to alchemical melancholy.[55] Therefore, Pereira's inclusion of the words "sing a new song," evoking change or transformation, might be seen as a reference to alchemy, the musical art itself. (The painting *Ascending Scale* might also have such allusions.) Perhaps the words have a more literal meaning, however, for it has often been noted that while she painted Pereira sang or chanted—incantatory rhythms—just like medieval alchemists in their laboratories.[56]

Pereira's interest in alchemy becomes much easier to document after the date of this collage. One might look again at the fetal shape in *The Embryo* and consider the possible connection between it and the homunculus, the artificially generated figure, the creation of which was one of the principal goals of the medieval alchemists.[57] The most famous homunculus of legend, the well-known inspiration for the monster in Mary Shelley's *Frankenstein,* was that created by the sixteenth-century alchemist Paracelsus. As such, an embryo often appears in alchemical literature as the product of the conjunction of opposites, another symbol of the transmutation process.

More significantly, Pereira began to paint on parchment in 1941.[58] Parchment was recommended in the medieval grimoires, or magical textbooks, as the proper material on which to inscribe magical symbols and talismans.[59] Critics might dismiss this connection as pure coincidence if it were not for the fact that upon these surfaces the artist affixed gold, silver, and copper leaf. Certainly, she desired of these materials the same reflective qualities as that of the marble dust she sometimes used,[60] yet each of these metals also plays a role in the alchemical process. Furthermore, in 1946 she created *Polarized Painting* (alternately titled *Polaroid Painting*), a glass painting in which she used sheets of Polaroid to cause the colors in the work to change depending upon the location of the viewer.[61] The colors change due to the polarization of light, which occurs when light passes through or is reflected off certain crystals, glasses, or even dewdrops. Because of this transformative property, polarized light was used to treat the alchemists' base mixture in the Great Work.[62]

Pereira's interest in psychoanalytical theories and in alchemical symbolism was less overtly demonstrated in her glass paintings of the 1940s. Yet here, more readily than through her use of symbols, one may understand that her interest was in the individuation process and the relationship between the inner self and the outer world. The inner region of the glass paintings, the area behind the transparent surface plane, represents, to borrow Worringer's words, "the great irrational substratum beneath the illusory surface of the senses and intellect, to which we descend in the hours of deepest and most anguished insight, as Faust descended to the witches."[63] In the process of viewing these works, the viewer's eye "descends" beyond the surface into the inner realm of the painting and returns again to the solid yet immaterial glass surface. The viewer probes not the symbolic depths of Pereira's unconscious but the metaphorical depths of the collective unconscious, which is, by theory, commonly shared by artist and viewer, each of whose faces is reflected in the specular surface. As Jung wrote, "The man who looks into the mirror of the waters does, indeed, see his own face first of all. Whoever goes to himself risks a confrontation with himself. . . . The meeting with oneself is the meeting with one's own shadow."[64] In peering into the depths of Pereira's glass paintings, the viewer becomes the active protagonist of his or her own quest, or, to borrow the words of Anaïs Nin, "proceed[s] to the other side of the mirror and into a metaphysical journey."[65]

Creating greater visual complexity, Pereira often used hammered or corrugated glass so that the underlying forms appear free-flowing and everchanging. On the one hand, this creates the illusion of the fluid continuum she associated with space-time in her Giedion-influenced Smith College paper. Alternately, as the most common symbol of the unconscious is water,[66] the inconstant forms also suggest archetypal imagery surfacing from the aqueous depths of the unconscious, an analysis that reinforces the psychological reading of the paintings.

Water, however, is also symbolic of the Hermetic Stream in which sulfur (masculine principle) and mercury (feminine principle) are conjoined.[67] In alchemical symbolism, Mercurius is sometimes represented as water or fluid (quicksilver). In Pereira's glass paintings, the glass becomes a "container" for the fluid, the alchemical vessel, whose contents are the living, semiorganic mixture of the four elements (earth, air, fire, water) from which the lapis will emerge. This mixture is the *prima materia* containing the base minerals and primitive bio- and zoomorphic forms of

creation. That this interpretation is precisely what the artist in-
tended is verified by one painting cunningly titled *Aquarium,* of
1943. A *New York Herald Tribune* reviewer described the work as
"an interesting departure towards naturalism. . . . The two planes
enable her to show a water-like surface—and with pleasant ef-
fect—also the acquatic [*sic*] forms underneath."[68] In addition,
Rosamund Frost, a critic for *Art News,* equated the experience of
looking into such glass paintings with that of "a diver plunging
ever deeper into a mysterious submarine realm."[69]

In 1945 Pereira began to construct multiplanar paintings in
which there are two panes of glass superimposed over a recessed
ground (Figure 38). The interplay of forms painted now on
three levels becomes more complex, and visual penetration to the
ground layer becomes more difficult. Yet the metaphorical read-
ing of these multiplanar works becomes more accurate with re-
spect to Jung's stratiform structure of the psyche, as there are two

FIGURE 38

Transversion, 1946,
ceramic fluid and
porcelain cement on
two panes of glass,
oil on masonite,
13½ × 15¼ in.
© The Phillips
Collection,
Washington, D.C.

inner planes corresponding to the personal and collective uncon-
scious. Each painted surface is clearly differentiated physically and
yet, due to the transparency of the glass, fully integrated optically.
As Pereira repeatedly remarked, she constructed these multiplanar
paintings so that the internal reflections would give the illusion
that light originated within the painting. (She incorporated light
bulbs in *Polarized Painting,* but this was never repeated. She also
used radioactive paint, such as that used at the time for lumines-
cent watch dials, in *Radium Diagonals,* of 1945, which caused the
work to glow in the dark.)[70] Through the interplay of reflections
within these works, the exterior light is seemingly multiplied,
generated, not absorbed, and radiated back out to the viewer.
Metaphorically, this light suggests the light of the mind, yet it also
suggests the Mercurial vessel of light.[71]

Should there be any question remaining concerning the inter-
pretation of these works, an analysis of one other painting should
prove conclusive. Although not a glass painting, it nevertheless
provides insight into Pereira's interests at the time. The only
known shaped work by Pereira, this trapezoidal parchment paint-
ing (Figure 39) was exhibited as a self-portrait at the Art of This
Century Gallery in 1943. A reviewer for the *New York Times* un-
derstood the imagery immediately and described the work as
"very subconscious."[72]

The central motif is a full-length winged female figure whose
right foot, as in conventional representations of Fortuna or
Dürer's famous winged Nemesis, rests on a sphere, here rolling
up a spiral pathway. In the lower right corner, a dragon with a
gaping mouth emerges from a fiery ball. At the top, a foreshort-
ened, somewhat androgynous nude female figure, seen as through
a transparent floor, fully extends her left arm at shoulder level.
The subject of this "self-portrait" is surely Pereira's ascent from
her Faustian journey into the chthonic depths of the unconscious,
her quest for total knowledge.

The winged figure is clearly a personification of Mercurius atop
the sphere that represents chaos, the *prima materia.* In this per-
sonification, Mercurius is the *anima mundi,* or World-Soul, which,
according to Jung, is immanent in everything that exists. The fig-
ure traverses the helix, which Jung called the "circumambulation,"
toward its goal. As he wrote, this pathway "is not straight but
appears to go round in circles. More accurate knowledge has
proved it to go in spirals."[73]

Surrounding the winged figure are wavy lines indicating that
the environment is the sea of the unconscious, inhabited by

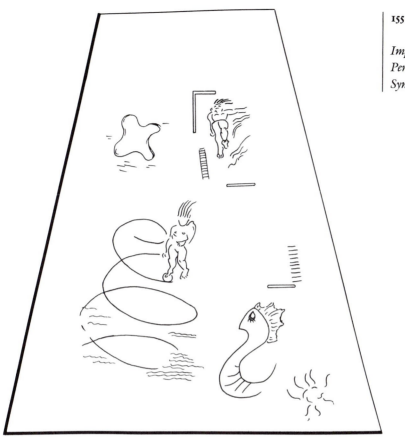

amoeba-shaped aquatic creatures. As Jung wrote, "The sea is the symbol of the collective unconscious, because unfathomed depths lie concealed beneath its reflecting surface."[74] The winged figure of the *anima mundi* is female because the anima is the female principle of the psyche, the feminine archetype, according to Jung. Further, as he wrote, "Just as the father represents collective consciousness, the traditional spirit, so the mother stands for the collective unconscious, the source of the water of life."[75]

In the metaphoric language of Jungianism, the dragon, as an inhabitant of the dark, primordial waters, represents the *prima materia*.[76] It is the Chaldean Tiamat, the feminine personification of chaos, which the sun god Marduk must slay in the archetypal battle of light and darkness. Associated with these depths, it is also a symbol of the *anima mundi*.[77] With its large fins, it combines the earth principle of the serpent and the air principle of the

FIGURE 39

Diagram after
I. Rice Pereira's
Self-Portrait, 1943.
Location unknown.
© Karen A. Bearor.

bird.[78] It is the guardian of the treasure, at the portal of esoteric knowledge. It is the monster against whom heroes, like Saint George, must fight. The dragon also symbolizes the vision of the alchemist, who works in the laboratory seeking the key that opens the door to the secret of the Great Work.[79] However, the source of life is fire; thus the dragon appears in Pereira's painting to emerge from the fiery ball in the lower right corner. Again, one may turn to Jung for explanation: "The all-dissolving *aqua nostra* is an essential ingredient in the production of the *lapis*. But the source is underground and therefore the way leads underneath; only down below can we find the fiery source of life. These depths constitute the natural history of man, his causal link with the world of instinct. Unless this link be rediscovered no *lapis* and no self can come into being."[80]

The shape of Pereira's canvas must be understood with respect to her concept of directional planes, as outlined in her Pratt lecture notes. The viewer is to understand the base of the trapezoid as being not only the lowest but also the nearest point, and the physical convergence of the painting's sides indicates ascent, as though they themselves are graphic parallel lines in orthogonal projection toward some distant point above. Thus the foreshortened figure in the upper right corner is meant to be seen as from below, for it is understood to be soaring above the viewer. This figure represents the spirit of Mercurius, whose extended arm appears to calm the waters below, to render order from chaos. The figure is in ascent, an interpretation reinforced by the ladders that appear near her. Because she is seen from below, she is understood to be on or near the transparent surface—the level of the conscious. In essence, the figure soars over the depths, for, as Jung wrote, "spirit means highest freedom, a soaring over depths, a deliverance from the prison of the chthonian element."[81] She is nearer the goal, the perfection, the spiritual gold of individuation. The Great Work, the *opus alchymicum,* is near completion. Thus, Pereira has identified herself in this self-portrait with three personifications of Mercurius—the dragon, *anima mundi,* and spirit— ascending from the realm of the collective unconscious, through the middle region of the personal unconscious, to emerge fully integrated at the conscious level of the "surface."

Pereira's painting is almost a visual equivalent, with gender adjustment, to the following description from *The Integration of the Personality,* which she underlined and re-emphasized with the marginal notation "Mercury":

The alchemists declare again and again that the opus *emerges from one thing and leads back again to the One; it is thus in a certain sense a circle like a dragon that bites itself in the tail. . . . Mercury stands at the beginning and the end of the work. He is the* materia prima, *. . . as the dragon he devours himself, and as the dragon he dies and is resurrected in the form of the* lapis. *. . . He is the hermaphrodite of the incipient being who divides into two in the classic dualism of brother-sister, and unites in the* conjunctio, *to appear again at the end in the radiant form of the* lumen novum, *the stone. He is metal and yet fluid, matter and yet spirit, cold but fiery, poison but also the healing draught— a symbol that unites the opposites.*[82]

Pereira was not alone in her interest in the hermaphroditic Mercurius. As Gloria Orenstein has written, "The ideal of the restitution of the Primordial Androgyne was also espoused by the Surrealists, for it represented the desire to return to a primitive unity or harmony of opposites, which was . . . an essential element of their search for totality."[83] However, despite whatever commonalities she had with these artists and her interest in totality, there is added significance to Pereira's representations of Mercurius. She exhibited the work as a self-portrait, and one might better understand her identification with this figure with the knowledge that the artist was bisexual.[84] Furthermore, as she had recently had a mastectomy, her own body closely resembled illustrations of the hermaphrodite, particularly those in which half a man's body and half a woman's are joined axially. While this is not the representation that she painted, it is certainly possible that she made a positive association with such depictions of Mercurius at a time when she was adjusting psychologically to her own surgically altered body.

While Pereira was certainly romantic in her general outlook, her early interest in alchemy was less for its mystical or spiritual aspects than for the promise of the psychological wholeness, the healing reconciliation, that Jung's interpretation of it held out to individuals and, by extension, to the world. There is no evidence to suggest that she read any books on mysticism during this period or that she favored any symbolic renunciation of the world for a more spiritual realm. In fact, the available evidence points to the opposite conclusion. Pereira's admiration for *Guernica* and Picasso's use of symbols "to express the deepest human experiences of our time," as documented earlier, is indicative of the role

she wanted her own art to play. While her utopianism does not exclude spiritual beliefs from consideration, such interests are only one part of the equation. Since her beliefs were clearly indebted to Jung's work, one might again turn to his writings for some insight.

Although Jung linked concepts of Eastern mysticism, along with alchemy, to the process of psychoanalysis, his interest in these subjects was allegedly analytical. He sought to find what relevance these belief systems held for twentieth-century life, and he had little patience with Westerners who became cult-followers of the East. Although he made his position quite clear, Cary F. Baynes, in the translator's preface to *The Secret of the Golden Flower,* stated it more concisely:

> *Millions of people are included in [fields of "occult thought"]* . . . *and Eastern ideas dominate all of them. Since there is nowhere any sign of a psychological understanding of the phenomena on which the ideas are based, they undergo a complete twisting and are a real menace in our world.* . . .
>
> *This is the point of view established in* The Secret of the Golden Flower. *Through the combined efforts of Wilhelm and Jung we have for the first time a way of understanding and appreciating Eastern wisdom which satisfies all sides of our minds. It has been taken out of metaphysics and placed in psychological experience. We approach it with an entirely new tool, and are protected from the perversion the East undergoes at the hands of the cult-mongers of the West.* . . . *[Jung considered Theosophy the best example of this.]*[85]
>
> *[I]t is precisely the need of understanding himself in terms of change and renewal which most grips the imagination of modern man. Having seen the world of matter disappear before his scientific eye and reappear as a world of energy, he comes to ask himself a bold question; does he not contain within his psyche a store of unexplored forces, which, if rightly understood, would give him a new vision of himself and help safeguard the future for him?*[86]

Claiming that his beliefs did not involve "metaphysics in the ordinary sense," Jung related them to Kant's concept of "das Ding an sich." He regarded statements concerning the transcendental to be the product of a human mind unconscious of its limitation and wrote, "When God or *Tao* is spoken of as a stirring of, or a condition of, the soul, something has been said about the know-

able only, but nothing about the unknowable. Of the latter, nothing can be determined."[87]

Jung's almost secularized, psychological approach to the unknown paralleled the beliefs of many of the members of the American Abstract Artists. Although it is unclear when she was admitted to membership, Pereira exhibited work under its auspices at the Riverside Museum (formerly the Roerich Museum) in March 1939.[88] During its early years, acceptance into the group was dependent upon the vote of the membership. According to the minutes of the meetings, Pereira was initially denied membership in March 1937.[89] Rosalind Bengelsdorf Browne suggested that her rejection may have been due in part to a fear that "Reds" were trying to take over the organization.[90] However, since other members had similarly belonged to left-wing organizations, this objection seems unlikely. The more plausible explanation for Pereira's rejection is that her work at that time was not totally abstract.

Although Pereira exhibited with the American Abstract Artists group for several years, she was not particularly active in its governing or functioning. Apart from membership rosters and exhibitions catalogues, her name appears only once more in the group's extant papers. Yet the very fact of her membership suggests that at the time her beliefs concerning abstraction were neither mystic nor spiritual, despite the assumptions made by numerous writers familiar only with statements she made during the last two decades of her life. During the late 1930s and early 1940s, esoteric beliefs of the sort found in Pereira's philosophical writings would have been highly unusual and unwelcome within the organization, which had a markedly secular, at times pragmatic, cast to it.[91] In fact, she stopped exhibiting with this group at the very time she began to assign her paintings the poetic, cryptic, mystical titles associated with her late works.

The organization's views concerning the sources of abstraction were highlighted during the rift between some of its members and Baroness Hilla Rebay. In June 1937 the Solomon R. Guggenheim Foundation was chartered, and Rebay was appointed as its curator. A supporter of the work of Rudolf Bauer and Wassily Kandinsky, she promoted a spiritualistic interpretation of modern art. However, the views she held concerning the purpose and implications of "nonobjective" art at that time angered seven members of the AAA, who wrote a letter directed against her to the editor of *Art Front*. Published in the October 1937 issue, the letter was signed by Pereira's former teacher Jan Matulka and classmate

George McNeil, among others. Feeling that Rebay's narrow beliefs concerning abstraction represented a detachment from life, they wrote:

> *It is our very definite belief that abstract art forms are not separated from life, but on the contrary are great realities, manifestations of a search into the world about one's self, having basis in living actuality, made by artists who walk the earth, who see colors (which are realities), squares (which are realities, not some spiritual mystery), tactile surfaces, resistant materials, movement. . . .*
>
> *Einstein is as "pure" a scientist as can be found. . . . In fact, he is an "abstractionist." Yet his theories are realities, they are based upon certain life-forms, and they help us to understand the world we live in. They are themselves a new form, which we can enjoy, just as abstract art. His theories are not valuable to us as an aid in escaping into purity trances. . . .*
>
> *Abstract art . . . has brought a profound change in our environment and in our lives. The modern esthetic has accompanied modern science in a quest for knowledge and recognition of materials in search for a logical combination of art and life.*[92]

The opinions recorded here are consistent with those Pereira expressed publicly from the late 1930s through the 1940s. Nevertheless, despite the rift between the American Abstract Artists and Rebay and any aesthetic differences she and Pereira may have had, Rebay gave her much professional, financial, and personal support from January 1940 through September 1942. In June 1939 the Guggenheim Foundation had opened the Museum of Non-Objective Painting, patterned after Bauer's museum in Berlin, with Rebay as its first director. The following January the museum launched its first exhibition of work by American artists. The show was devoted to the works of Balcomb Greene, Gertrude Greene, and Pereira.

The foundation charter stipulated that deserving artists be given financial support, and, as the WPA/FAP programs dissolved, Rebay provided stipends to many artists working in abstraction who turned to the Museum of Non-Objective Painting for help. Some were hired as guards, others as maintenance workers, secretaries, hostesses, and so forth. On October 15, 1940, Pereira wrote to Rebay to request work, for she was to lose her job with the project's Easel Division within weeks.[93] Hired as museum assistant at the rate of $30 per week, beginning December 1, 1940, she greeted guests and kept records of attendance and

catalogue sales. One of her museum reports, for the period of June 17–22, 1941, included among visitors the names of André Breton, André Masson, Yves Tanguy, Gordon Onslow Ford, and Howard Putzel.[94] Her artist co-workers included Dwinell Grant and Marie Menken.[95]

By all accounts, Rebay was short-tempered and difficult to work with.[96] In July 1942 she asked for Pereira's resignation because the artist missed two and a half days' work without notifying the director. Pereira was out for a tooth extraction, a fact confirmed by Elizabeth McCausland, who had taken her to the dentist.[97] However, the absence was apparently the last straw for Rebay, whose correspondence and personal notes concerning the incident reveal deep-seated resentments. She felt that Pereira lacked respect for the director and Guggenheim, who had not only hired the artist but had also advanced her money at the time of her sister's illness and death. Rebay accused her employee of using the museum for self-serving purposes and being disloyal. The most telling criticisms, reflecting the two women's aesthetic differences, were that Pereira did not like Bauer's work, that she thought the Museum of Modern Art might help her more than the Museum of Non-Objective Painting, that she was too concerned with materials in her work, and that she was less interested in "our" work than in that of the American Abstract Artists.[98]

Rebay did not like some of Pereira's early abstractions, and the correspondence between the two women indicates that she and Guggenheim often rejected the artist's work, which was uneven in quality as a result of her experimentation with materials. Yet they included Pereira's work in several group shows at the museum. Her last exhibition there, a joint show with Moholy-Nagy, opened in August 1942, despite the bitterness occasioned by Pereira's absence from work only days before. Rebay allowed Pereira to stay on at the museum through September, at which time she left to take a teaching position at the Pratt Institute.[99]

On September 26, 1942, Pereira married George Wellington Brown, a Boston-born marine engineer whom she had known for about ten years[100] and with whom she may have traveled in Italy in 1931.[101] They may also have traveled together to Germany during the 1930s, where Brown's interest in the design and construction of submarines had taken him. Preparing to go on active duty at the time of the wedding, Brown commuted to Hoboken, New Jersey, during the war, where, ironically, he taught naval recruits how to sink German U-boats.[102]

The following January Pereira began her two-year association with Peggy Guggenheim's Art of This Century Gallery, which

had opened in October 1942 in galleries designed by Kiesler. Although Gypsy Rose Lee's self-portrait collage garnered most press attention, Pereira's work captured most of the critics' eyes in the Exhibition of Thirty-One Women held there that month. André Breton, Max Ernst, James Johnson Sweeney, Marcel Duchamp, Howard Putzel, and Peggy Guggenheim made up the jury of the show.[103] Most of the works selected were Surrealist in style, which offered what Emily Genauer quipped was a "provocative peek at the artists' libidos." Noting that Pereira's two pieces seemed a little out of place stylistically, Genauer maintained, nevertheless, "Out of the lot I'll still take the Pereira abstractions. These new ones are as exquisite, as tasteful and as subtle as any she has ever done."[104] Peggy Guggenheim subsequently purchased one of these abstractions, the artist's 1942 parchment painting titled *View*, as a wedding gift for Lawrence Vail.[105]

The Art of This Century Gallery is, of course, best remembered for its support of European Surrealist artists and the emerging American talent that would become Abstract Expressionism. Pereira benefited from this association, for it was during this period that she created the self-portrait discussed above. Her contact with the other artists exploring the inner realms of the mind undoubtedly reinforced her own interests in this area. Guggenheim also wanted her gallery to be a "research laboratory for new ideas,"[106] a concept extending from Kiesler's innovative interiors to her choice of shows, including an exhibition of collages in April 1943, the first of its kind in the United States. Pereira's work was again included. Guggenheim also sponsored "spring salons" for artists "thirty-five and under." Even fibbing about her age, Pereira did not meet that entry requirement, although she did participate in 1943 and 1944. Some reviewers made note of her age, but they were nearly unanimous in their praise. For example, in a review of the first salon, the critic for the *Nation* remarked, "They are all promising, and some, like I. Rice Pereira, are more than that. Her Composition, No. 30, which gives the impression of one abstraction neatly painted over another and precisely complementing it, is the best thing here."[107]

In January 1944 Guggenheim gave Pereira a one-artist show.[108] Kiesler wrote the foreword to the catalogue. Elizabeth McCausland wrote the introduction, and some of her words are worth quoting for their insight:

> *I. Rice Pereira has evolved a discipline which embraces the double exploration of materials and space. . . . [She] is not content to solve problems of plane geometry but sets herself more elaborate*

propositions, which can only be described as belonging to the space-time continuum. . . . By the projection or the recession of non-representational shapes she controls the relation of planes and thus controls the space whose illusion she creates. . . . In the paintings made with transparent fore-plane and opaque rear-plane, the simultaneous visual perception of images on two separate physical surfaces produces spatial compositions. In this respect, I. Rice Pereira has sought to imbue painting with something of the psychological surprise of stereoscopic vision.[109]

McCausland's comments make an important contribution to an understanding of Pereira's works because, as a long-time friend, she based her understanding on more than the artist's written word. Pereira's recorded comments regarding her work during the 1940s are remarkably incomplete. For instance, in the statement she prepared on December 8, 1942, for publicity surrounding her one-artist show at the Art of This Century Gallery—the earliest extant comments by her concerning her glass and parchment paintings—she emphasized her laboratory experimentation with materials and omitted references to space or perception.[110] Clearly, there is greater complexity to Pereira's paintings than her own words indicate. Yet this statement formed the core of all she wrote about her work during the 1940s.

Pereira's most refined and expanded explanation of her work during this decade appeared in the catalogue of her ACA Gallery exhibition in February 1946, a reunion exhibition following her break with the Art of This Century Gallery and her brief association with Gallery 67, opened by Guggenheim's former assistant, Howard Putzel, ending with his death in August 1945. Again, her stated concerns, quoted here in their entirety, were primarily formal:

I have employed the abstract idiom in painting rather than more traditional forms of expression, since this offers a wider range for experimentation. In these pictures I have endeavored to explore the formal and design possibilities of painting, with special emphasis on constructional ways of expressing space and of experimenting with new materials and mediums. Aside from aesthetic considerations, it may be stated that this kind of investigation can make a contribution to painting in general in terms of:

1. Clarifying the structural problems concerning pictorial presentation.

2. Revitalizing technique in oil painting through experiments with new resins and vehicles for pigment.

3. Stimulating visual and tactile awareness of paint quality by re-exploring the possibilities of pigment as an integral part of painting.

4. Indicating the practicability of materials other than canvas as a painting support, such as parchment.

5. Utilizing other than the traditional materials, such as plastics, glass, etc.

Paintings on glass: These are executed in a number of planes in spatial opposition. In these paintings I have tried to produce an integrated picture with actual light as part of the painting.

Parchment: This material is of great durability, capable of creating luminosity, as well as retaining relief pattern. My research to date has been to determine the nature and reaction of the material to various kinds of binders and fillers added to the pigment, as well as to plastic resins, varnish, lacquer, emulsions, etc.

Canvas: In addition to expressing space relations on a two-dimensional surface, I have tried to develop a means of exploiting the possibilities of pigment to produce textural effects, vibrancy, luminosity, transparency, density of paint, the effect of light on incised and relief surfaces. I have tried to achieve results by developing a working process, using the medium itself rather than by creating an illusionistic interpretation.[111]

These paragraphs were quoted verbatim by McCausland in an article she wrote on Pereira in 1946. Again, however, one obtains greater insight into the artist's works from her responses to this critic's questions. Pereira said,

My work, as I see it, is a search to apply the concepts of our time to esthetics—for example, to find space relations appropriate to and expressive of modern life, and, also, of course, to use materials and methods which are a part of our age. . . . [The new materials] give new sensory stimuli and thereby new sensory perceptions and experiences, which are just as exciting in the primary stage of the esthetic process as the new concepts of space relations are in the theoretical. . . . New emotions are evoked in the spectator by the new materials and the new space relations of our age, which are quite unlike the psychological perceptions and experiences of older periods. This is actually a new content, as well as a new method, for contemporary painting.[112]

From these statements, one senses that Pereira felt that she must justify her work, not merely explain it, that she herself must

define her contribution to the history of painting. The sheer number of times she used the word *new* suggests a latent fear that her paintings were becoming too familiar or that her contributions were not being sufficiently recognized, despite the fact that she was creating the most innovative work of her career.

While revealing her thoughts concerning a Hintonlike evolutionary connection between the spectator's "psychological perceptions" and "space relations," the statements also indicate that experimentation was still an essential aspect of Pereira's work. However, in 1953 she made the provocative announcement that some of her talk of experimenting with materials had been a deception. In her manuscript "Eastward Journey" she explained, "Maybe I was frightened because I could not talk about what I was doing, except experimenting; experimenting with pictorial construction, experimenting with materials; experimenting with light. But I had a feeling of being at the bottom of the ocean on a very long journey in the black sea of night."[113] As this passage indicates, Pereria felt she had to deny herself in order to succeed; full disclosure of her purpose might make too clear her difference from other artists working in a similar manner. She desired to be singular, to be an "exceptional" woman artist, to gain notice, yet the Bauhaus-related style she had developed had already been rigidly delineated and encoded with meaning. Through her public endorsement and reinforcement of its aims, she herself had participated in its ossification. How might she publicly reinscribe herself in her work without foregrounding the bankruptcy of a painting style based upon endless technical experimentation? That she had not found a solution in the 1940s is clear by her silence, the elision of her self in her public statements as she had done in her professional signature.

McCausland continued to focus on the artist's experimental use of nontraditional materials in an article published in July 1947. There must be some significance to her title "Alchemy and the Artist," although on the surface, McCausland's association of Pereira's methods with those of medieval alchemists appears to be no more than a journalistic device. Yet at one point the critic revealed her own perplexity in noting that Pereira's symbols are "personal to the artist" and "problematic" in meaning.[114] After the insight her earlier writings on the artist had offered, McCausland's puzzlement invites speculation that Pereira was becoming increasingly interested in the more esoteric aspects of alchemy and more vocal about her sources. Certainly, the strains on the friendship caused by the women's diverging beliefs concerning the purpose

of art were beginning to show.[115] The critic's bias against abstraction is evident in the insertion of her own wistful aside: "Would our laboratory artists, engrossed in the alembics and crucibles of alchemy, find refreshment and nourishment by stating visual problems in other terms than the nonobjective? Problems of deep space or illusions of light and interlocking planes might offer more intricate enigmas if played out in visual images of nature. But that is another question."[116]

While one might speculate about Pereira's interest in the more arcane aspects of alchemy in 1947, the facts become irrefutable by 1949, the year she met George Reavey. Born May 1, 1907, in Vitebsk, Russia, to an Irish flax expert and his Polish wife, Reavey lived for a time in post-revolutionary Russia.[117] Nevertheless, he attended school in Belfast and London during the early 1920s and entered Cambridge later that decade. While there he met classmate and life-long friend Jacob Bronowski, the future poet, author, and mathematician, and also had poetry and prose published in the review *Experiment,* edited by Bronowski and Hugh Sykes. In 1928, while visiting Paris, Reavey met fellow Irish writers Samuel Beckett and James Joyce. It was also about this time that he met Stanley William Hayter, who had just established his graphic workshop Atelier 17.[118]

When Reavey settled in Paris in 1930, he became active in the Surrealist movement. An excerpt from his prose piece "Io Lo Sognai" was published, along with other selections from the Cambridge *Experiment,* in Eugene Jolas' *transition* in June 1930. His poem "Dismissing Progress and Its Progenitors" was printed in the tenth anniversary issue of the same periodical in November 1937.[119] Between these two appearances in *transition,* Reavey published four volumes of poetry: *Faust's Metamorphoses,* published in 1931 with illustrations by Hayter; *Nostradam,* in 1935; *Quixotic Perquisitions*; and *Signe d'Adieu,* published in 1935, with jacket illustration by Roger Vieillard, a printmaker associated with Atelier 17. In 1931 he was editor, with Bronowski, Samuel Putnam, and Maida Castelhun Darnton, of *The European Caravan: An Anthology of the New Spirit in European Literature.* He translated Paul Eluard's essay "Poetic Evidence" included in Herbert Read's *Surrealism,* published in 1937. He also translated and edited anthologies of Soviet literature and, in 1935, established Europa Press in London, which first published the plays of Beckett.

In 1936 Europa Press, with Stanley Nott, published Paul Eluard's selection of poems *Thorns of Thunder,* with a jacket illustration by Max Ernst and a frontispiece by Picasso. Reavey edited

the volume and was one of the translators, along with Beckett, Jolas, Denis Devlin, David Gasgoyne, Man Ray, and Ruthven Todd. Read provided a preface, and Reavey wrote a foreword in which he characterized Surrealist art as "essentially lyrical" due to its preoccupation with "investigating the psychological phenomena" that were "the very sources of creative activity." Rejecting both "conventional imagery" and "purely formal research (abstract art)," Reavey saw Surrealism as the culmination of a movement initiated by poets such as Nerval, Baudelaire, Rimbaud, and Lautreamont, "who sought to abolish the frontiers imposed upon the poetic intelligence and to achieve unity." [120]

One highlight of Reavey's involvement with the Surrealist movement was his participation in the International Surrealist Exhibition held in the New Burlington Galleries in London during the summer of 1936. On June 26, two weeks after Salvador Dalí's notorious attempt to present a lecture from within a diving suit and helmet and one week after Read spoke on "Art and the Unconscious" while standing on a spring sofa, Reavey, Gascoyne, and Humphrey Jennings read English Surrealist verse. The three shared the evening's bill with Eluard, who read selections from his own work. [121]

Reavey was also a participant in the so-called Irish Renaissance, the patriarchal leader of which was William Butler Yeats, Nobel Prize winner for literature in 1923. Yeats was also a former member of the Hermetic Order of the Golden Dawn, a secret society headquartered in London with another lodge in Edinburgh, active until the outbreak of World War II. British poet Kathleen Raine, who was a friend of Reavey's and wrote a two-volume study of William Blake as well as shorter pieces on Yeats and the Golden Dawn, indicated that the sources for Yeats' mystic poetry were eclectic, including Plato and Plotinus, the Hermetica and the alchemists. In addition, he helped MacGregor Mathers, one of the founders of the Golden Dawn, write the rituals for the order, which drew upon the Chaldean Oracles, the Egyptian Book of the Dead, the Cabala, and Blake's writings. Among Yeats' associates were Arthur Edward Waite, prolific author on the occult, Harold Bayley, whose book on symbolism, *The Lost Language of Symbolism,* published in 1912, was a major reference for Pereira, and Stephen MacKenna, translator of Plotinus' *Enneads.* [122]

When Pereira met Reavey in August 1949, he was on leave from London University and in the United States on a Rockefeller Fellowship for research on Maxim Gorky. He was also interested in the work of the Russian Symbolists, particularly Boris

Nikolaevich Berdiaev (pseudonym, Andrey Biely), a poet mentioned by John Graham in his *System and Dialectics of Art* as having produced great literature and destroyed the borderline between the real and unreal.[123] Arriving in the country on January 11, 1949, Reavey worked first at Columbia University and then at the Hoover Institute, Stanford University. He returned to New York during the summer and remained there until his departure for England on February 10, 1950.[124]

While in New York, Reavey stayed with Hayter,[125] who had moved his Atelier 17 to that city at the outbreak of World War II. A charismatic figure, the poet was quickly accepted into the celebrity echelon of New York literary and artistic circles. It was, of course, through these associations that he met Pereira just prior to her departure for Paris. Upon her return in November, the two fell passionately in love, although she was not the only woman with whom Reavey had an affair before his departure.[126]

Nevertheless, Pereira and Reavey clearly had more in common during their two-month New York courtship than mere physical attraction. Probably not coincidentally, they had the same analyst, Assia Abel, and, based upon examination of Pereira's works, letters, and manuscripts, it appears that Abel and Reavey were major figures in turning the artist toward a more mystical understanding of the psychoanalytic process. Pereira had met Abel late in 1948 in the waiting room of Max Jacobson, the "celebrity doctor" who also treated John F. Kennedy, Cecil B. DeMille, Lee Radziwill, Anaïs Nin, among others, for a variety of physical ailments.[127] Abel also knew Pereira's friends Holger Cahill and his wife, Dorothy Miller.[128] In 1948 the titles of Pereira's paintings changed in nature, a transition marked by the title that boldly announced *A New World A'Coming*. Even so, it was 1950 that the artist often indicated as the year in which she first understood the "real meaning" of her "journey," by which she meant the metaphorical journey to self-knowledge, the Faustian descent into the unconscious world and back.[129] Already versed in the language and tropes of Jungian psychology, she apparently derived greater insight into their sources and meanings through Reavey, whom she acknowledged at the time as understanding the "process" better than she.[130] Yet she was not alone in benefiting from his catalytic presence. Through his mesmerizing accounts linking the creative processes of artists to a spiritual realm beyond perception, he introduced several artists and writers to what is now called "channeling." Others came to him to learn about the "Great Tradition" (what Jung called Homer's golden chain) begun by Hermes Trismegistus.[131]

There was no single term in general use at the time to refer to channeling. As noted above, Pereira had used the word "rhythms" as early as 1937 to refer to emanations from the unconscious, and, in their early correspondence, she and Reavey identified the creative source that produced their work as "feeling rhythms."[132] In February 1950 she began to write verses that were close in style and content to his. Concurrently, her prose took on such a decidedly lyrical character—as though resonating with those inner vibrations—that Reavey compared her writing to Biely's.[133] In 1953, in explaining to a *Life* journalist that the same rhythms informed both her poetry and paintings, she said, "If I don't lose the rhythms, I won't make mistakes."[134] Yet after meeting Reavey, Pereira also believed herself to be a conduit, an "instrument" for creative energies, as she described herself in 1950.[135] In her 1953 manuscript "Eastward Journey" she wrote of herself as a "medium for communication," and she claimed to be a "translator for an inner voice" in 1954.[136]

For Pereira, one's contact with this realm beyond conscious perception came through dreams. In 1949 she began to keep a diary in which she recorded her dream imagery and analyzed its contents for their usefulness to the conscious mind. The creative process had become for her as Jung had described it in 1930: "These 'instincts' are vivified and send their images into the dreams of the individual as well as into the visions of the artists and seers, in order to re-establish in this way the psychic balance. The psychic need of the people is fulfilled in the work of the poet, . . . whether he be conscious of it or not. He is essentially the instrument."[137]

Reavey introduced Pereira to or encouraged her study of Early Christian mysticism and Neoplatonism, in which light played an important role. Neoplatonism, itself an eclectic philosophy combining ideas of Platonism, Aristotelianism, neo-Pythagoreanism, and Stoicism, had many parallels with early alchemy. There had been an upsurge of interest in this philosophy in England between the wars due in part to the publication of Stephen MacKenna's translation of Porphyry's *Life of Plotinus* and the *Enneads,* between 1917 and 1930. In addition, William R. Inge presented his Gifford Lectures on Plotinus in 1917 and 1918.[138] Its importance to the literary circle of which Reavey was a member might best be described by Eugene Jolas, who wrote in his article "Three Romantic-Mystic Texts," published in *transition* in July 1935: "It has frequently been pointed out that our age shows astonishing analogies with [the Early Christian period]. The gnostic-neoplatonic wave of thought that swept over the Byzantian regions, together

with the wave of mystic theology, as shown in the lives of the desert saints, has its analogy with the tendencies toward an expansion of consciousness today."[139]

Because of his own interest in Neoplatonic light mysticism, Reavey had a catalytic influence on Pereira's interest in the subject. His letters and poetry were filled with references to light and to the sun god.[140] He spoke to her of their guardian, Sunwake, perhaps their name for the Nordic god Heimdall, a god of the dawn's light, who presides over the chaos at the beginning of time and guards the rainbow bridge leading from the earth to the threshold of the world of the gods. (In fact, on occasion, Reavey addressed Pereira as "Sunwake," or, alternately, as the dawning light.)[141] "Sunwake" also suggests a possible association with the Hermetic Order of the Golden Dawn. Eager to share his enthusiasm for the mystical aspects of light, Reavey sent Pereira a prose piece and a poem, each titled "Ship of Light," in February 1950.[142] The ship, long associated with spiritual quests, is the vessel that carries dreamers on their "night sea journey," of which Jung wrote so often.[143] (Pereira used this phrase to title a painting in 1953.)

From Jolas' reference to the "desert saints" in the passage quoted above, it appears that Reavey's literary circle had interest in Persian mysticism as well as Gnostic-Neoplatonic thought. Reavey's references to the sun-god are probably related to the god Mithras, for it is this god that Pereira mentioned as such in *The Nature of Space*.[144] He may also have introduced Pereira to Sufism,[145] a Persian religion of light. According to Sufi literature, "the candidate for enlightenment in this Order represents a Traveller in search of Truth itself . . . the Divine Light, and so on to a knowledge of God."[146] Although her general interest in Arabian lore dated back to the 1920s, it was after meeting Reavey that Pereira began to characterize her experience in the desert, in Ouargla, as a mystical one.

On February 10, 1950, Reavey embarked on the *Ile de France* to return to England. His send-off party of six included Mark Rothko, but he had already said his good-byes to Pereira less publicly.[147] Although she had been separated from her second husband for some months, both she and Reavey were inconvenienced in their future wedding plans by current spouses. Each began divorce proceedings in February.[148] Their correspondence from February until June 1950 and from June until October 1951, when immigration problems temporarily prevented Reavey's reentry into the United States after his wife's return,[149] provides information crucial to understanding Pereira's growth during this critical period. One finds that the two believed that together they

were "One," a union of conscious and unconscious, the conjunction of opposites as in alchemy.[150] In fact, their correspondence is filled with alchemical symbolism.

Reavey received Pereira's first letter on February 17, 1950, and in this and her subsequent correspondence she addressed or referred to him by various terms, including "bridge," "white stallion," and "Mercury." (On some occasions, Reavey also called her "Mercury.")[151] She wrote of soaring the heights and swimming the depths, of making the dangerous voyage to the sun and back to earth again.[152] As a symbol of their union, Reavey bought her a glass crystal, subsequently made into a pendant necklace visible in many photographs of her. Pereira referred to it as a crystal "diamond," the diamond in the "center," the crystallized essence of light, the crystallized sun, the crystallized dewdrop.[153]

In explanation of her terminology, the bridge, apart from its use as a metaphor of sexual union, is a reconciling structure between the conscious (male) and unconscious (female). In the dream analyses that appear in Jung's books, the bridge is sometimes represented as a rainbow, and Pereira would subsequently use the symbol of the rainbow in this sense.[154] But in carrying out the metaphor, travel on the bridge is dangerous. The human intellect is lured by the seductive heights of the spirit and may be tempted to leave reality behind. This causes the "death" of the psyche. As Jung wrote, the danger occurs when "the ground slips from under his [man's] feet and he begins to speculate in the void."[155] In other words, one must return again to the realm of the conscious, for an equilibrium between both aspects of the mind is necessary for psychic health.

The "white stallion" may be interpreted on one level as a symbol of lust, which, like the beast, is uncontrolled by reason. Alternately, as M. Oldfied Howey proposed, "the horse or mare, like the serpent, is the symbol of intellect, and of the Sun, and therefore a fitting emblem of Mercury, the Great Mind, and the Sun-god."[156] A white horse draws Mithras' chariot, and the star-browed Dioscuri, the ancient mariners' guides figuring so prominently in Pereira's late ink drawings and gouache paintings, also rode white steeds.[157] The familiar outlines of the Iron Age White Horse of Uffington, cut into the chalk hills in England, were reproduced in Pereira's copy of Bayley's *The Lost Language of Symbolism,* and she placed a checkmark by its description in the text: "The mouth consists of the Two Rays of the Eternal Twins, and the Head and Eye form a point within a circle, the symbol of the Everlasting."[158] Like the English Surrealist artist Leonora Carrington, Reavey may have been raised on Celtic legends regarding

the goddess-protector of the dead, whose pale white mount carried her through the night.[159] Of course, for George Reavey, the most memorable white stallion of all would have been the one ridden by Saint George, patron saint of England.

Pereira's reference to soaring the heights and swimming the depths is, by now, self-explanatory. Her meaning in traveling to the sun and back again to earth is similar. The sun she refers to is not our star in the sky but the sun as symbol of the unity and divinity of the self, as Jung defined it.[160] The journey to the sun and back refers to the process of attaining enlightenment. The danger in the voyage is the same as that the traveler on the bridge faces—being lured to stay in the realm of the sun and failing to return to earth once more. One's journey describes a circular path that reflects not only the shape of the sun but its apparent path in its daily passage through the sky. This circle is traced in our collective unconscious in the form of the sun archetype. The journey also relates to the circumambulation of alchemy and traces the "line that runs back upon itself," sometimes symbolized by the tail-eating serpent, the uroboros.[161]

Pereira's talk of the diamond at the center is a reference to the "diamond body" of alchemy. During the alchemical process, small star-shaped crystals—diamond bodies—formed on the surface of the base mixture.[162] Jung wrote at length on their symbolism, but two passages provide sufficient explanation. In *Psychology and Alchemy* he wrote that the diamond body is "the attainment of immortality through physical transformation. The diamond is an excellent symbol because it is hard, fiery, and translucent. . . . [It is] the noble and blessed stone of the philosophers, on account of its hardness, transparency, and rubeous hue."[163] It is "the goal of the *opus magnum*," as he explained in *Psychology and Religion*.[164] The center, in alchemy, is also the goal, the location of the lapis, the point of unity. The diamond body is produced inside the "golden flower," both of which are symbols of the lapis, or philosopher's stone.[165] Thus "The Secret of the Golden Flower" is the secret of alchemy.

For Pereira, the diamond or crystal was a symbol of unity, for, despite its many facets, it is a whole.[166] It also represented crystallized light, or crystallized spirit, into which light transforms itself through circulation. This was the meaning of the crystal presented in *The Secret of the Golden Flower*, which Pereira read during this period.[167] Most often, her references are to its identity as crystallized dew. Dew is, of course, associated with the dawn, and, in notes she made about 1951, she characterized dew as "vapored essence of earth" and "vapored essence of the night sea

journey." These notes also record her memory of seeing the sun's light reflected in a dewdrop as a child in Great Barrington and realizing its significance as a revelation of God.[168] While this story is often repeated in Pereira's biography, there is no evidence of her having related it prior to her meeting Reavey. Nevertheless, its meaning is made clear when one consults her frequent reference, Harold Bayley's *The Lost Language of Symbolism*. Its author wrote that dew symbolizes "the cardinal doctrine of Mysticism that every man is a 'microcosmos' or world in miniature. In each dewdrop everything is reflected, from the Sun itself down to the minutest object. It was believed that God was in every individual according to his capacity for reflecting God, and that each in his degree reflected God's image according to the development and purity of his soul."[169]

In final confirmation of their union, Reavey and Pereira prepared a handwritten certificate of "marriage" dated July 30, 1950, six weeks before their legal wedding.[170] Their different scripts are recognizable, and, in two instances Pereira wrote the word *one,* beginning the word with ☉, the symbol for both gold and the sun, the most significant symbol in alchemical literature.

In her correspondence with Reavey, Pereira also discussed her sessions with her psychoanalyst. She believed that she had presented her analyst with the creative process in its essence or pure form.[171] She meant by this that she had direct access to the collective unconscious and that her imagery, having surfaced unmodified by the conscious, was archetypal in its purest sense. She believed that her creative energies existed in this pure, egoless, mathematical state on the conscious plane as geometric symbols of the structure of the psyche brought to consciousness as a whole.[172]

If the structure of the universe might be described in mathematical terms, why not the structure of the mind? That the universe might be described mathematically was a concept as old as Pythagoras and Plato. William Blake had depicted God (Urizen) as the Great Geometer in his *Ancient of Days,* and this image was the source for the figure in Lee Lawrie's sculpture *Genius, Which Interprets to the Human Race the Laws and Cycles of the Cosmic Forces of the Universe Making Cycles of Light and Sound,* of 1933, above the entrance to the RCA Building in Rockefeller Center.[173] Given contemporary modern theories in physics, wherein the structure and operation of the universe could be described by equations, the idea of a mathematical universe had been revived popularly, as Lawrie's sculpture attests. For further confirmation of this fact, one might turn to James Jeans' *The Mysterious Uni-*

verse, published in 1930. Jeans wrote that "nature seems very conversant with the rules of pure mathematics, as our mathematicians have formulated them in their studies, out of their own inner consciousness and without drawing to any appreciable extent on their experience of the outer world." A few pages later he wrote, "We discover that the universe shews evidence of a designing or controlling power that has something in common with our own individual minds—not, so far as we have discovered, emotion, morality, or aesthetic appreciation, but the tendency to think in the way which, for want of a better word, we describe as mathematical."[174]

When faced with a phenomenal universe indescribable by physical models, scientists had resorted to abstract means to represent it. The incomprehensible was made a graspable reality through symbolization. Scientists had been presented with the "chaotic confusion of mental and visual impressions" that Worringer had described. He would see the mathematical abstractions of science and the geometric abstractions of art as a refuge for modern humanity. Each was a means by which the incomprehensible was recast into absolute values. If the organization of the mind and the universe were based upon the same laws, as the Gestalt psychologists had believed, then mathematical equations or geometric symbols might as easily describe the structure of the psyche as the structure of the universe. The unfathomable depths of the unknown inner realm might be described symbolically in the same manner as the infinite universe, and the source for both symbols lay within the unconscious.

For Pereira, this was confirmed by her reading of *The Secret of the Golden Flower.* Here Richard Wilhelm summarized the philosophy contained within this Taoist-alchemical tract as follows:

> *This philosophy is . . . built on the premise that cosmos and man in the last analysis obey common laws; that man is a cosmos in miniature and is not divided from the great cosmos by any fixed limits. The same laws rule for the one as for the other, and from the one a way leads into the other. The psyche and the cosmos are related to each other like the inner and outer worlds. Therefore man participates by nature in all cosmic events, and is inwardly as well as outwardly interwoven with them.*[175]

That this passage was particularly meaningful for Pereira may be determined by the fact that she recopied it in her notes as late as 1962.[176]

According to Pereira, her complete psychoanalytical process had occurred in four dreams at the beginning of her work with her analyst, and there were four different rhythms in her creative process.[177] The number four is significant, for it is the number of unity or perfection in alchemy. Although the number of stages in the alchemical process varies with different authors, Jung alleged that the majority agreed that there were four stages, corresponding to the four colors of the process: black (occasionally blue), white, yellow, and red. There were also four elements: earth, wind, fire, and water. There were four cardinal points, and so forth.[178] The "squaring of the circle" is another reference to the alchemical process.

Pereira's use of the number four reveals an interest in numerology, an interest shared by Reavey, who believed the significant events in his life had occurred in "sevens," that is, every seven years.[179] From this time onward, she saw some significance in every figure, date, or number of letters in a name. For example, she found it significant that the number five (she was born on August 5) symbolized "light" to the Pythagoreans and was a number sacred to Apollo, god of light and reason,[180] and that five also symbolized the quintessence in alchemical writings. The artist avidly read books on numerology and marked passages referring to numbers in various other texts. In addition to rereading Spengler's chapter on the meaning of numbers, she purchased Tobias Dantzig's *Number: The Language of Science* during the 1960s.[181] During this last decade of her life, she also read Rosicrucian literature on Pythagorean number symbolism.[182]

Somewhat related to her interest in numbers was Pereira's belief in the Jungian concept of *synchronicity,* his term for meaningful coincidences of events separated in space and/or time.[183] She became acutely aware of coincidences of date. For example, she had written to President John F. Kennedy in November 1963 concerning his address at the dedication of the Robert Frost Library at Amherst College on October 26, 1963. In that address, the president had called the artist the "last champion of the individual mind and sensibility against an intrusive society and officious state."[184] She had written to indicate her support of this assessment. The reply from the president's staff was postmarked November 22, 1963, the date of his assassination. Pereira saw this coincidence of date as a portent with ominous implications for the artist.[185]

In addition to his other contributions to Pereira's development, Reavey also introduced her to a literary circle that included

Dylan Thomas and Oscar Williams, among others.[186] In terms of their writings, the most important member for Pereira, apart from her husband, was Reavey's late friend, James Joyce. Joyce had died in 1941, but his memory was kept alive in the many James Joyce Societies that sprang up in Europe and the United States soon afterward. Reavey and Pereira were both members of the New York chapter founded by Frances Steloff and meeting at her Gotham Book Mart. Each continued to attend meetings for years after their separation in 1956 and divorce in 1959.

Moholy-Nagy devoted several pages to Joyce in his last book, *Vision in Motion,* published posthumously in 1946. Because of Pereira's interest in Moholy-Nagy's work and in this book, with its reproduction of her *Radium Diagonals,* it is useful to look to his words for some assessment of Joyce's impact upon artists during this period. Of Joyce, Moholy-Nagy wrote, "He stood for a totality of existence, of sex and spirit, man and woman; for the universal against the specialized; for the union of intellect and emotional, for blending history with forecast, fairy tale with science. . . . He paved the way to a related, space-time thinking on a larger scale than any writer had done before." Further, Moholy-Nagy noted, "Joyce groped for a . . . law on the large scale of man's total existence and tried to decode the impulses which seek to establish the psychophysical balance in every situation."[187]

The "law" Joyce sought was for a continuity of experience in human history and relationships, some universal constant beneath the apparent surface differences in cultures. He "discovered" a cyclic pattern of recurrences much as Spengler had described,[188] an archetypal myth, a "monomyth," his term in *Finnegans Wake,* serialized in *transition* as "Work in Progress" and published in book form in 1939. According to Joseph Campbell, the "nuclear unit" of Joyce's monomyth is the saga of the *hero,* a central focus of his own thirty-eight-year teaching career at Sarah Lawrence. Pereira had been a visiting artist there in 1944,[189] the year Campbell coauthored *A Skeleton Key to Finnegans Wake,* cited in *Vision in Motion.* In trying to unravel the mysteries of Joyce's epic work, Campbell described *Finnegans Wake* as "a mighty allegory of the fall and resurrection of mankind," with a dreamlike structure that enabled the author "to compress all periods of history, all phases of individual and racial development, into a circular design, of which every part is beginning, middle, and end." He noted that Finnegan, the hod carrier, is identifiable with Ireland's ancient warrior-hero Finn, and "it is by Finn's coming again (Finnagain)—in other words, by the reappearance of the hero—that strength and hope are provided for mankind."[190]

In his *The Hero with a Thousand Faces,* Campbell described the essential events in the journey of the hero: "A hero ventures forth from the world of common day into a region of supernatural wonder; fabulous forces are there encountered and a decisive victory is won; the hero comes back from this mysterious adventure with the power to bestow boons on his fellow man." [191] The sequence is cyclic, for, although the hero renounces the world for the spiritual, he returns once more. Campbell's hero has, to use Pereira's words, gone to the sun and back. [192]

How might one represent the journey of the hero—a spiritual quest—in abstract visual terms? How might the temporal and spiritual duality of existence be reconciled in color, line, and form? This was the problem Pereira posed for herself as she sought to contribute something to the post–World War II period as important as a *Ulysses* or a *Finnegans Wake.* Drawing upon the models of heroic transformation she had found in her readings, she decided to write her own *Künstlerroman,* her unfinished "autobiography," in which she cast herself in the role of the fictional hero and told the story of her own personal and artistic transformation. The destination of her "Eastward Journey," the title of the manuscript she began to write in 1953, was her "modern Bagdad," her "Mecca" of divine light. [193] Like the path of the Sufi traveler, her eastward journey was her journey to the sun, in particular, the dawning sun. Furthermore, like Campbell's hero, she felt she had the power and obligation to "bestow boons" on her contemporaries. Through her philosophical writings and her paintings, she sought to demonstrate the means by which anyone could become the *hero.* It is as though she had been challenged by Campbell's concluding paragraph to *The Hero with a Thousand Faces,* a passage she recopied later in her notes: "The modern hero . . . [cannot] wait for his community to cast off its slough of pride, fear, rationalized avarice, and sanctified misunderstanding. . . . It is not society that is to guide and save the creative hero, but precisely the reverse. And so every one of us shares the supreme ordeal—carries the cross of the redeemer—not in the bright moments of his tribe's great victories, but in the silences of his personal despair." [194]

Reconciling the Inner-Outer Duality: Pereira's Philosophy of Space, Time, and Light

Since her years at the Design Laboratory and her experiments with various textures for their reflective and refractive qualities, Pereira had maintained an interest in light and its properties. Following Moholy-Nagy's lead, she had worked with "light painting" in her photograms and relief paintings on glass. In her multiplanar glass paintings, light jumped from pane to pane causing so many reflections that each work seemed to generate light from within. Yet until she met George Reavey she seemed to have had little interest in light mysticism. Afterward, she began reading broadly on the subject.

Launching her study was Wilhelm's translation of *The Secret of the Golden Flower,* containing previously secret writings fundamental to a Chinese religion of light. The Golden Flower is the symbol of light, as well as the Elixir of Life, according to these writings, and to learn its secret one must make light circulate. According to the text's eighth-century author, Lü Tzu, if light travels long enough in a circular path it crystallizes, and "all the powers of Heaven and Earth, of the Light and Dark, are crystallized." [1] Although the only extant notes from this book are dated 1962 and her copy of the book was a 1954 printing, a letter to Reavey dated March 9, 1950, confirms that Pereira was reading a copy she had borrowed from Holger Cahill. According to her letter, she was struck immediately by the circulation of light discussed within it. [2]

One is frustrated at this point, however, in attempting to follow Pereira's education further. When she joined Reavey in En-

gland during the summer of 1950, her letters naturally stopped, and there is an interruption in our knowledge about what she read or what she learned from him. Yet one might speculate that her interests led her to read further into the symbolic significance of light. Reavey's library undoubtedly reflected his interest in Russian Symbolist literature, Surrealism, and light mysticism. Furthermore, he probably had volumes on Neoplatonic philosophy, as well as more esoteric literature concerning mysticism. During the period he and Pereira lived together in Salford, downstairs from John Willett, then art critic for the *Manchester Guardian*,[3] Reavey was a professor of Russian literature and grammar at the University of Manchester. He was also writing a dissertation on Gorky. Thus Pereira had access not only to a scholar's library but to his example as well. As a result, she became more systematic in her own research, keeping notebooks with pages color-keyed by topic and duplicates of some notes cross-referenced and filed under different headings. She began to see herself as a poet-philosopher, perhaps like Goethe, and, already thinking in these terms by November 1950, she prepared a statement for the Whitney Museum that included the following: "My philosophy is the reality of space and light—an ever-flowing, never ceasing continuity, unfettered by man-made machinery, weight, and external likenesses."[4]

However, Pereira's days in England were not altogether happy ones. Once the excitement over her new marriage subsided, she was faced with the struggle of living in the postwar Manchester area, still bearing the physical scars of German bombs. Food continued to be rationed, with meat, eggs, and fresh fruit among those items most scarce and expensive. Although the couple received packages of food from Holger Cahill and Dorothy Miller during the winter, they suffered from malnourishment. In addition, Pereira, a heavy smoker, was subject to chronic respiratory difficulties exacerbated by the dense atmosphere of the perpetually foggy, industrialized region. She complained of the city's poor housing situation, the poverty, and the monotony of daily living, but what troubled her most during her winter in Salford was the absence of sunlight. Her letters from England in the early months of 1951 reflect her depression.[5]

Although she had turned down a teaching position at Black Mountain College to join Reavey,[6] Pereira accepted a position at Ball State Teacher's College in Muncie, Indiana, for which she returned to the United States in the summer of 1951. It was here

that she began to work out her own philosophy of light. At one point, she attributed the birth of this idea to the paintings she made while in Muncie,[7] although the issue of space dominated published excerpts from her interview with a Muncie journalist. She maintained that modern humanity seeks a universe beyond the boundaries of the finite earth and artists limiting themselves to recognizable objects were not expressing the contemporary mood. In her view, modern scientists had "conquered distance," such that now "we feel infinity."[8]

However, her contact with Frederick Kiesler in August and their discussion of the prismatic lighting in his Endless House were reaffirming. By mid-September, she was certain that the anxiety she had felt in England had been the result of the absence of the sun. She was certain that the sun existed in the unconscious as an archetype, and when there was an absence of the corresponding image in the sky, the creative person feels primitive emotions of anxiety and fear. Having moved back to New York, she felt greater equanimity.[9]

Suddenly, all that Pereira had read came together for her in a new way, and the timing of this synthesis coincided with the opening on October 1, 1951, of her one-artist show with her new gallery, Durlacher's, run by Kirk Askew and George Dix. In her first letter to Reavey following the opening, she announced that she had discovered a new pictorial system in which the "source" of light was internal, from the infinite reaches "beyond" the picture plane. Her ideas spilled forth in fragments linked together on the page by ellipses, although lacking any logical cohesion. With each succeeding letter, she embellished her theory, showing marked impatience for her husband's tardy response in the light of the importance of what she had already accomplished. Clearly excited by what she was developing, she had sent copies of her writing to various individuals, including Lloyd Goodrich and Andrew Carnduff Ritchie, by the 13th. However, already demonstrably jealous of the attention given to the Abstract Expressionists and fearing that they might unfairly profit from her ideas should they become aware of them, she cautioned her husband not to share her news with any artists. Although only a few notes from this period survive, she indicated that she had made copious notes documenting and rationalizing her theory.[10]

On October 14 Pereira sent a copy of some notes to her friend Holger Cahill. As he had loaned her *The Secret of the Golden Flower,* a primary source for her new pictorial system, she undoubtedly expected him to be enthusiastic. Significantly, in the

accompanying letter she cited in support of her ideas an article by an unidentified writer. Titled "The Continuity of Human Experience by Siegfried Giedion" and published in *Art News and Review* in February 1951, the author reviewed a paper presented by Giedion at the Institute of Contemporary Arts in London on January 8, 1951. Among the passages in the article Pereira found most meaningful, as underlined in her copy of the article and confirmed in her summary and excerpts sent to Cahill, are:

> *In* Space Time and Architecture *he [Giedion] was concerned with . . . why we are unable to restore the equilibrium between our inner and outer reality . . . [due to] the wide gap between thought and feeling. In* Mechanisation Takes Command *he had shown how this break had come about, by investigating the impact of mechanisation on human activities. . . . Now we need to know what aspects of man's nature and emotional outfit are constant throughout the ages and what are susceptible to change. . . . Certain of the dominant characteristics of modern art were present in primitive art—transparency, superimposition, simultaneity, abstraction, representation of movement, and they can all be summed up in one overall trend—the reawakening of symbolic expression. Symbolism is the most effective tool that man possesses for coming to terms with his environment. . . . From this human dimension, art, language, myth and science have grown.*

Giedion was also quoted as saying that "the artist was the optical specialist, the laboratory worker who develops space conceptions and certain methods of representation connected with them." Furthermore, he discussed the evolution of spatial conception from prehistoric art through Egyptian art to Cubism.[11]

Giedion's ideas must have resonated with truth for Pereira, for it was as though he was discussing her career itself and touching upon all issues of importance to her. In response to this article, she may have reexamined the historian's *Space, Time and Architecture,* for she mentioned in her letter of October 7 to her husband that her new pictorial system represented a synthesis between "inner" and "outer" analogous to that created by the new architecture.[12] She may also have had in mind her recent conversation with Kiesler concerning his Endless House, with its organic integration of inner and outer spaces and its use of the sun as a primary source of illumination.

In addition to the Giedion excerpts, Pereira sent Cahill a copy of a brief paper titled "Light and the New Reality: A Treatise on

the Metaphysics of Light with a New Aesthetic." The paper was divided into two sections. The first section, dated October 7, 1951, consisted of six paragraphs, which were essentially the same in content as her letter to Reavey of that date. This portion became the body of the essay when it was published under the title "Light and the New Reality" in the spring 1952 issue of the *Palette*. Edited by Alice Nichols, head of the art department at Ball State Teacher's College, where Pereira had taught the previous summer, the *Palette* was the official organ of Delta Phi Delta, an honorary art fraternity. The second section of Pereira's treatise, dated October 14, 1951, consisted of ten numbered paragraphs that formed the third, or "supporting facts," segment of the published version. An introductory section, not sent to Cahill, appeared in the *Palette* but was omitted from the version appearing otherwise unaltered under the title "Structural Core of an Aesthetic and Philosophy" in the July 1954 issue of *Mysindia*, a popular weekly published in Bangalore, India.

"Light and the New Reality" was Pereira's first attempt to synthesize a philosophy reconciling the temporal and spiritual realms of existence with a system of graphic representation consistent with her metaphysics. The whole of what she conceived was to be a twentieth-century counterpart, as a philosophical and aesthetic synthesis, to the religious art of Byzantium or medieval France.[13] Although bold in its conception, her approach was regrettably incomprehensible to the vast majority of readers who were not steeped in the same philosophical literature as she. Particularly frustrating for Pereira's readers were her unforecasted poetic shifts from discussions of the physical world to metaphor to pictorial symbolism within the same paragraph or, often, the same sentence. The fluidity of her style and her circumlocution might make her writing paradigmatic of *l'écriture féminine*,[14] but her text did not satisfy those persons accustomed to or desiring a more rigorous, academic style of argumentation.

Furthermore, Pereira seldom made any attempt to define her terms. For instance, she was once challenged on the perceived inconsistency in her usage of the word *space* in a later manuscript.[15] At no point in her writings did she clearly define what she meant by this term. However, in the margin to the opening page of a chapter on physical space in the revised 1950 edition of A. d'Abro's *The Evolution of Scientific Thought,* Pereira took issue with scientists over the distinctions they made between conceptual mathematical space and the physical space of experience. She wrote that there was no distinction, they were the same. She con-

sidered space to be an "absolute" with the same properties and qualities regardless of whether one was talking about that perceived in the physical world or that she sometimes called "abstract symbolic space."[16] Although she may not have understood Kant completely, she based her concept of space in part on a passage she underlined in his *Critique of Pure Reason* which reads:

> For in the first place, we can only represent to ourselves one space, and when we talk of divers spaces, we mean only parts of one and the same space. Moreover these parts cannot antecede this one all-embracing space, as the component parts from which the aggregate can be made up, but can be cogitated only as existing in it. Space is essentially one, and multiplicity in it, consequently the general notion of spaces, of this or that space, depends solely upon limitations. Hence it follows that an a priori *intuition (which is not empirical) lies at the root of all our conceptions of space.*[17]

Pereira's obfuscation of meaning throughout her various writings may have been intentional, however, for such a practice would have been consistent with the alchemical and Neoplatonic doctrines of secrecy. For example, Plotinus had written in the *Enneads*, "This is the purport of that rule of our Mysteries: Nothing Divulged to the Uninitiate: the Supreme is not to be made a common story, the holy things may not be uncovered to the stranger, to any that has not himself attained to see."[18]

Pereira's sources for "Light and the New Reality" are less clearly identifiable than those for her essay "An Abstract Painter on Abstract Art," in which she had virtually copied the words of Giedion and Ivins. Her paper on light is based upon an eclectic mixture of ideas borrowed from Hinton, Giedion, Worringer, Jung, Euclid, Plotinus, Kant, and others. Because this was the first of her philosophical writings and because it was the core for her future work, her treatise, with its introduction as published in the *Palette,* should be examined. The text begins:

> As a painter, I have been concerned with light for many years. As a result of my explorations I now feel I am able to clarify and define what is a new approach to the problem of light in relation to painting. . . . I am convinced that the light flow in painting is the key to a continuity of experience between Man and universe.
>
> Somehow, in our frantic tempo, rushing to express new ideas, we have forgotten the light and let it remain in the same position as the spectator—the position assigned to it when perspective was

promulgated. Light is constant and continuous in nature. Light is the missing link in pictorial construction which will make the synthesis between inner reality (what man feels about light) and outer reality (what man knows about light); otherwise he cannot sense dimensions in space and time. This discrepancy between FEELING and THINKING has prevented him from really experiencing infinite dimensions.[19]

In a very literal sense, light—from the sun, the stars, and, as cosmic rays, then recently discovered, interstellar space—fills the void between the earth and the universe and links them. Yet a metaphorical reading of the word *light* is also implied in Pereira's opening paragraph. As will become apparent, light, for her, is the principle by which the discrete elements in the universe are organized into a coherent whole.

Pereira's discussion of light with respect to the spectator must also be understood on multiple levels. On the one hand, taking her comments at face value, she took the position that, in graphic terms, the point-source of light and the position of the spectator are one and the same. She superimposed Renaissance perspective, Alberti's "pyramid of vision," upon Euclid's "cone of vision." While twentieth-century textbooks on perspective assumed the "rays" in the cone of vision to be imaginary lines, for Euclid light emanated from the eyes. Vision resulted from the contact of the rays with objects. In a related vein, as Gerald Holten explained in *Thematic Origins of Scientific Thought, Kepler to Einstein,* "Plato held that as long as the eye is open it emits an inner light. For the eye to perceive, however, there must be outside the eye a 'related other light,' that of the sun or some other source that allows rays to come from the objects."[20]

Pictorially, artists have sometimes found it useful to assume such a light source coincidental with the viewer's position. However, Pereira's contention that this position is "assigned" by perspective does not accord with even cursory observation. Clearly in those Renaissance paintings in which form is defined by chiaroscuro, the implied source of light is to the right or left of the viewer, not from the same position, and certainly not "assigned" by the geometry of relative subject-object positions defined by linear perspective.

Pereira's discussion of perspective must be understood, then, to be metaphorical for an anthropocentric view that privileges human orientation in physical reality rather than a spiritual view.

Her rejection of perspective and the source of light allegedly assigned by it is thus a rejection of the artist's traditional dependence upon observable reality, for that practice renounces the spiritual. As she confirmed in subsequent writings and painting titles, it was the "Absolute" with which she was concerned. This fact is also made clear in this treatise by her statements characterizing light as constant and continuous in nature. For her, light (divine light) exists without respect to the spatio-temporal existence of the individual. It is a saturating light that is infinite, without form or containment. As she wrote later in the treatise, "Light comes from beyond—beyond the horizon and permeates or saturates everything."[21] Compare this with a passage from the *Enneads* in which Plotinus wrote, "Light penetrates through and through, but nowhere coalesces; the light is the stable thing." [22]

Although there are no surviving notes from this period to document Pereira's reading of Plotinus, she was clearly indebted to his thought. Later she mentioned Neoplatonism in her book *The Nature of Space,* published in 1956, and in 1957 she titled a painting *Alone to the Alone.* The title refers to a passage in the *Enneads* that reads, in the MacKenna translation: "This is the life of gods and of the godlike and blessed among men, liberation from the alien that besets us here, a life taking no pleasure in the things of earth, the passing of solitary to solitary."[23]

In the remainder of the second paragraph of "Light and the New Reality" quoted above, Pereira returned to the old problem of perception versus conception with which she had been concerned since the late 1930s. In this case, she applied the problem to light. However, since both perception and conception were functions of the mind of the individual, the reconciliation between this duality must occur within the mind. For her, a metaphorical light binds together the inner realm of "feeling" and the outer realm of "thinking." Like the light of the Egyptian sun god, Ra, the light of reason illuminates the dark depths of the underworld, the unconscious.

For Pereira, without light one cannot sense dimensions in space and time. The "dimensions" she refers to are the higher dimensions conceivable in the mind. Consistently, her references to the linked concepts of "space and time" imply infinity. Her meaning is analogous to the Lockean concept of the "boundless Oceans of Eternity and Immensity," the "infinite Oceans of Duration and Space."[24] Scientists measure the distances between the earth and stars through the use of light. Because the speed of light

is constant, the vast distances are measured in light-years, a unit of measurement in which light, time, and space cohere. Until the scientific advances of the twentieth century, were there no light, there would have been no knowledge of the stars and, hence, no means to gauge the vast interstellar distances. Analogously, Pereira believed that the mind might contemplate higher dimensions despite the body's earthly limitations, but one needs an inner light to gauge these spaces as well.

Although Pereira did not explain the "New Reality" contained in the title of her paper, a page of notes from this period confirms that the "New Reality is Dual." It is a synthesis of "two realities": the inner world of feeling and the outer world of thinking. She linked thinking to temporal reality, which she defined as the known world available to the senses of sight and touch. She linked feeling to spiritual reality, the symbolic, unknown universe that may be "touched" through instinct and seen through the "inner eye."[25]

The next paragraph in Pereira's "Light and the New Reality" continues: "The circulation of light transports the perceptions, otherwise they become frozen from extension. When perceptions become frozen from extension, man loses his balance; he experiences panic, anxiety, chaos—'Nothing'—'End.' He feels 'Void.' The circulation of light transports the perceptions and insures their safe return to earth."[26]

Here the reader is presented with Pereira's first mention of the circulation of light. One is also presented with a fusion of Worringer's concept of humans overwhelmed by that which they cannot understand and Jung's reference to psychic imbalance created by the desire to stay within the realm of the spirit. Pereira agreed with Jung that this area is a "void" wherein one loses contact with the earth or reality and becomes "paralyzed" at being too long and too far within the realm of the unknown.[27] Jung asserted in his commentary to *The Secret of the Golden Flower* that the resulting psychic imbalance becomes "fixed as mental disturbances in the form of lunacies and hallucinations, thus destroying the unity of the personality."[28] Without a guardian (like Sunwake) to guide one to safety, one loses one's balance on that bridge between the earthly and spiritual realms.

Pereira used "perceptions," analogous to the perceptive soul of Neoplatonism, to refer to the probing aspect of the mind that seeks knowledge of the unknown. Her usage has nothing to do with those perceptions related to one's outer awareness. Further

evidence of this is found later in the treatise where she wrote, "Man, or the spectator is fixed; his movements are physical in terms of earth—gravity. He cannot leave earth except with the aid of machinery. But his PERCEPTIONS exist in time and space. He can sense, perceive, and experience dimensions beyond his physical limitations. That is the REALITY that links him with the Universe. Light exists in the depth of man's psyche. The translation of his perceptions out beyond—in space and time—infinity—are in reality." [29] That one's "perceptions" might exist in space and time may have been inspired by Pereira's reading of Hinton's interpretation of Kant's theory of experience. In *The Fourth Dimension*, Hinton had set out to apply Kant's theory to the perception of higher dimensions. He wrote that the problem is

> to represent that which Kant assumes not subject to any of our forms of thought, and then show some function which working on that makes it into a "nature" subject to law and order, in space and time. Such a function Kant calls the "Unity of Apperception"; i.e., that which makes our state of consciousness capable of being woven into a system with a self, an outer world, memory, law, cause, and order.
>
> The difficulty that meets us in discussing Kant's hypotheses is that everything we think of is in space and time—how then shall we represent in space an existence not in space, and in time an existence not in time? [30]

To resolve this difficulty, Hinton then went through an elaborate process by which he reduced "phases of consciousness" to their essences, which he called "posits." These posits he arranged symbolically as points on a geometric figure. Theoretically subject now to the rules of mathematics, these aspects of consciousness may exist in any conceptual space of any dimension. For Hinton, "Do any phenomena present themselves incapable of explanation under the assumption of the space we are dealing with, then we must habituate ourselves to the conception of a higher space, in order that our logic may be equal to the task before us." [31] Yet since any conceptual space is subject to the limitations of our mental processes, which are conditioned by the a priori forms of space and time, the "phases of consciousness" must also be subject to a priori forms. Thus, regardless how abstract a thought, it—

like Pereira's concept of "perceptions"—"exists" in space and time. Only that which one is prevented from knowing through the limitations of one's perceptions—the Kantian thing in itself—may exist outside of space and time.

In the introductory section of her essay, Pereira next discussed the light effects produced by her glass paintings. She noted that she had recently translated the experience of looking into their depths into a two-dimensional construction on canvas, such that the light was placed in its "proper position" in the depth of the picture plane. The experience one should get, according to her, is that produced by "pre-Renaissance" painting or by light filtering through stained glass. She concluded the introductory section with a paragraph that, with its first sentence elided, was also to open her manuscript "Eastward Journey":

> *I know you will ask me how I discovered this discrepancy between what we feel and what we think about light. All I can say is that for the most part one's work is a mysterious process. Its conscious reality may remain a secret for a long time; maybe forever. Every step is a real experience—the greatest joy—the profoundest anguish and sorrow. It is a lonely road, sometimes quite desolate. One must possess courage and strength to fulfil those inner experiences so they become living realities with a life of their own. Sometimes it is all darkness; one does not know where the last step ends and the new one begins. But the light within glows a path of dedication—you follow irrespective of the dangers encountered. The secret—the key—the treasure lies hidden in the darkness of creation—the black mass of white light.*[32]

Much of the body of Pereira's treatise, as well as the "supporting facts" appended to it, was a repetition of the material presented in the introductory section. However, in this middle section she did elaborate her pictorial construction further. She wrote,

> *In the new pictorial dimensions of space and time, there is no break between the spectator and infinity. IT is: SPECTATOR/ EARTH—Atmosphere/Ether/Space/Infinity—SUN and back again (earth). A whole or complete continuity. Therefore, [the] light source should come from [the] depth of [the] painting and extend into the picture plane, saturating it with light, thereby using the reality of light from its source.*[33]

Here is the circulation of light from the spectator to the sun and back again, with the area between identified as atmosphere, ether, space, or infinity. However, this is to be represented graphically, and she provided a diagram to make this circulation of light more meaningful. As this diagram applied to her paintings, the spectator is positioned in a central location in the "foreground" or bottom of the painting. The "light" of the spectator's "psyche" extends out (upward) toward the horizon and beyond. Simultaneously, light seems to emanate from within the depths of the painting. There is no beginning or end to this cycle. Metaphorically, inner and outer spaces flow into one another. Although Pereira applied this concept to her two-dimensional canvases, in principle it is analogous to the experience of gazing into the depths of her glass paintings.

The other major topic Pereira considered in the body of her essay concerned the object. For her, an object exists for the spectator because of the incidental light that defines it.[34] She then explained,

> The object is transitory, and only exists for a split second in space and time. Its meaning changes in time. Photography grasps the instant. The object does not have its own possibilities of transformation. It is neuter. But it can be reduced to a symbol, then it may have the possibility of becoming something else, because symbols have the possibility of change and dynamics. But in itself the object is static.[35]

The object, containing no life force, has meaning only at the moment it is sensed. Its purpose, function, usage, or location may change with time. The object might decay in time due to external forces, but with its "death" it has no possibility of rebirth or regeneration. This appears to be Pereira's meaning in the first portion of this paragraph. However, if represented by a symbol, the "life" of the object may be extended. For instance, a particular chair has meaning within a certain context, but symbolized by the word *chair* it may take on a multiplicity of meanings. The particular chair is static, but the word *chair* is dynamic in its extended applications.

Pereira provided an expanded discussion of the symbol in "Eastward Journey," where she wrote,

> The symbol has a psychic reality because it represents "Something." Symbol is dynamic. The symbol is a reality until its content is

known. When the unknown qualities become a reality, the symbol simultaneously becomes a new symbol representing some other unknown reality. Symbols are realities in space and time; and, like all living structures, have the possibility of transformation. . . . The symbol transforms what man perceives through his senses and makes contact with his subjective world of inner experience a reality in space and time. When man senses the unknown, only the symbol can define it.[36]

What Pereira spoke of here is analogous to the algebraic process whereby any unknown quantity might be represented by a symbol. Once the problem is solved and the quantity becomes known, that symbol is freed for use in another problem. Although in her writing "quantity" is replaced by "quality," the analogy holds. For her, a given symbol, such as "Z," may be used to represent different unknowns in different contexts and consequently has the possibility of "transformation."

In some cases, Pereira's sources are apparent because she borrowed so literally from them. In this case, it may be dangerous to attach too much significance to any particular author for Pereira's ideas concerning the transformation of the symbol. However, two might be mentioned. In 1944 Jacob Bronowski wrote a book on William Blake titled *A Man Without a Mask*. He and his wife, Rita, presented an inscribed copy of this book to Reavey and Pereira in June 1953, although Pereira would have had the opportunity to discuss Blake's work, or Bronowski's for that matter, when she lived in England during the winter of 1950–51. In his book, the author mentioned Blake's mysticism and the sources to which it was indebted, including Swedenborgianism, Jacob Boehme, the Gnostics, and the Cabala. On Blake's symbolism, he wrote,

Blake chose his prophetic symbols because he found them apt to what he was saying; but he changed their meanings, as the reason for their aptness changed. Nothing has hindered the understanding of Blake's prophetic books so much as the wish to fix their symbols singly and steadily. These symbols shift only within a well marked framework: nevertheless, they do shift, and they shift in order to remain apt to whatever actual Blake they had in mind.[37]

Blake, of course, was an artist-poet, a role model for Pereira.

Pereira also knew of Jung's discussion of the changing meaning of the symbol in *The Secret of the Golden Flower:*

As we know, activated unconscious contents always appear first as projections upon the outside world. In the course of mental development, consciousness gradually assimilates them and reshapes them into conscious ideas which then forfeit their originally autonomous and personal character. Some of the old gods, after serving as carrier of astrological projections, became mere descriptive attributes (martial, jovial, saturnine, erotic, logical, lunatic, etc.).[38]

In May 1955 Pereira went so far as to represent the role of the artist in symbolic terms. She formulated what she called an "equation": X—I—O. The "X" is the "Unknown," the "I" is the artist, and the "O" is "Idea." She explained,

In new dimensions of space and time, the artist/poet would be the one who is the mediator in space between the unknown symbolic space of his own inquiry [sic] mind (X) and the translations, or representation of the happening in his mind (o). Since he is in between the two (inner happening and the external representation) he is an inquirer into human experience as a mediator. The representation is his objective means for contemplation. . . . Since the picture is symbolic, it contains the dynamic for extending and transforming the spectator's consciousness.[39]

Although much more elaborately presented, Pereira's configuration is analogous to R. H. Wilenski's definition of classical art in his early text on modernism, *The Modern Movement in Art,* published in 1923: "Classical art assumes that art is greater than the artists, and that the artist is merely a link between the spectator and some universal order, which man, as such, is always seeking to discover."[40]

For Pereira, a painting should contain symbolism, rather than a realism based upon the external world, for realism is too specific and does not represent the multiplicity of experiences brought to the work by spectators. Appearances in the physical world are transitory. Like the object, a realist painting is static. With symbols, however, the painting may take on a multiplicity of meanings, changing with time and/or with spectator. Thus for her, paintings, like symbols, take on the qualities of life, capable of providing nourishment to the soul. Theoretically based upon archetypal symbols brought forth from the unconscious, where they have been etched by the accumulated experience of humanity

adapting to the physical world and its forces, the paintings are the symbolic embodiment of life itself. As she wrote in "Light and the New Reality," "We do not go back to old structures of reducing objects in nature to geometric equivalents; cylinder, cone, sphere, cubes, but we go back to nature itself—phenomena of nature—elements, forces."[41]

The third section of Pereira's treatise is made up of ten numbered paragraphs listed under the heading "Supporting Facts." However, the contents of these paragraphs are largely restatements or expansions of what she had already written. There is nothing factual here. She did include a handful of footnotes in this section, but their usage is specious. For example, in a paragraph discussing her "new light source" she wrote that its roots "lie in the new REALITY OF PERCEPTIONS." The sentence bears a footnoted reference to a passage in Lincoln Barnett's *The Universe and Dr. Einstein,* published in 1948. The quoted passage reads: "Much of the obscurity that has surrounded the Theory of Relativity stems from man's reluctance to recognize that sense of time, like sense of color, is a form of perception." Not only does this passage have little to do with Pereira's discussion, but the page number cited is grossly inaccurate.[42] Once again, Pereira's trail is hidden. The actual sources of her new philosophy remain veiled to the casual reader.

The most important information contained in the third section of "Light and the New Reality" concerns the use of the symbol of the sun. Pereira wrote, "*Light Symbol*—The sun is the reconciling symbol of all life. Although in darkness we say that we know we contain the essence of light within us, nevertheless without the symbol in reality, a great deal of energy is lost in terms of anxiety and panic when it is missing. I feel that the rhythm of internal and external adaptation is affected."[43]

This paragraph is clearly related to the feelings Pereira had regarding her experience in foggy Manchester, although her original inspiration was possibly Neoplatonic philosophy. For example, in the *Enneads* Plotinus wrote, "Material forms containing light incorporated in them need still a light apart from them that their own light may be manifest."[44] For Pereira, the body's internal rhythm, attuned to the cycle of night and day, is upset when the sun is not visible.

Pereira continued her discussion of the sun symbol:

*Man needs the reconciling symbol of the sun to restore his
EQUILIBRIUM to REALITY. He needs this symbol of all living*

*natural phenomena. The more man travels the unknown paths
of [the] milky way, constellation beyond constellation, "void,"
"Limbo," seething mass, gasses of unfathomable elements, the
more necessary the reconciling symbol becomes. It is his symbol of
continuity. It is his symbol of life. It is the symbol that transports
him from darkness and oblivion to light. It is his own natural
symbol of the incomprehensible forces of nature. As long as he feels
the sunrays, sun warmth, he feels continuity—regeneration. Man
must feel regeneration or his continuity of life is extinguished.
He must make a complete cycle with his reconciling symbol or he
will lose his continuity of regeneration. He must not be caught
in "void" or "Limbo" because generation of man's psyche is not
possible either in seething gasses or in emptiness. His psyche will
not allow him to make a continuity at that point. It is the point
where a transition is made from nothing to something: one panic/
anxiety—the other "SOMETHING." The symbol established
EQUILIBRIUM and psychic energy is regenerated. . . .*

*The reconciling symbol of the sun, which exists in man's psyche
as the symbol of regeneration, is the symbol that saves him from
complete destruction and prevents him from becoming victim of
"void"—darkness—madness.*[45]

Pereira's concept of traveling through the heavens from con-
stellation to constellation derives ultimately from Mithraism.
Mithras, the Persian sun god, the so-called sun behind the sun,
traveled through the constellations and ruled the world through
the zodiacal signs. Mithraism, in turn, had an impact upon the
thought of Marsilio Ficino, the leader of the Florentine Platonic
Academy during the days of the Medici. Ficino was commis-
sioned by Cosimo de' Medici to translate into Latin the works of
Plato and Plotinus. However, during this period, the *Corpus Her-
meticum* was rediscovered, and, in 1463, he completed a transla-
tion of this work for his patron as well.[46] According to Thomas
Moore, author of *The Planets Within: Marsilio Ficino's Astrological
Psychology,* Ficino claimed to follow the Arabian philosophers who
considered the sun to be the fundamental "human" planet. He
considered the ruling nature of the sun and the planets in his work
The Planets, written in 1489.[47] Pereira followed in this line of
thinking, for, apart from situating the reconciling symbol of the
sun in the human psyche in this treatise, she called the sun the
"center of man's constellation" in many of her publications, notes,
and letters.[48]

Pereira's use of "void" and "Limbo" was based upon the bridge

metaphor used by Jung. Just as the void was that area bordering on the realm of the spirit, Limbo bordered on the darkness of hell. For Pereira, the void is emptiness; Limbo is filled with seething gases. The point of balance between the two is the threshold between "nothing" and "something." That point, according to the artist, is marked by the reconciling symbol of the sun—the sun archetype.

The sun archetype may be represented graphically by the symbol "O," which reflects not only the circular shape of the sun but is also a symbol of unity. Its shape encompasses all. However, for Pereira, the "O" is also the numerical symbol zero, which is mathematically indivisible.[49] Despite the importance of the sun for her philosophy, there are no circular sun symbols in Pereira's paintings. Yet there was an ancient symbol of the sun that was compatible with the rectilinear structure of her canvases: the swastika. Following World War II, the swastika was an unlikely symbol for an American artist to display overtly. Nevertheless, Pereira obtained a booklet on the subject, and one may see traces of this sun symbol in the intersections of lines in such works as *Radiant Source of Spring,* of 1952 (frontispiece).

Pereira concluded her treatise on light with a paragraph that included the following passage: "The artist can pave the way for man's perceptions of a conscious reality of new universal ideas. He has the vision and can create the symbols. The artist can restore equilibrium so man can sense the universe without losing his balance."[50] As her sentences testify, Pereira saw the artist in a heroic, almost sacerdotal role. Attuned to the great mysteries of the universe, the artist for her had an obligation to pave the way for others in their own attainment of enlightenment. The artist was a mediator, a guardian-guide on the bridge between the spiritual and earthly realms. Like the priest, the painter or poet works with symbols to make the unknown comprehensible. As Plotinus had written at the end of the *Sixth Ennead,* "Things here are signs; they show therefore to the wiser teachers how the supreme God is known; the instructed priest reading the sign may enter the holy place and make real the vision of the inaccessible."[51]

Pereira took the role of the artist-hero quite seriously. Following the publication of her treatise on light and in the wake of her success in her Whitney retrospective, Pereira began to write and assemble a manuscript titled "Eastward Journey." Here she herself became the hero who must make an odyssey into the unknown and return again to familiar shores. She intended her account to

be autobiographical, retracing the progression of her paintings and offering some explanation for the sources of their imagery. Yet like the tales of many mythical figures, her story includes no record of her childhood nor does it provide details about her daily life, her family, her marriages and love affairs, her interactions with other artists, or her struggles for acceptance in the New York art community. Instead, she appears to emerge full-grown, like Athena from the head of Zeus, with a sense of purpose revealed to her incrementally by her own work. Excluding any mention of her early Cubist still lifes, for instance, she carefully selected the paintings discussed in this context to propel her narrative and to distance herself from outside influences. Fashioning a character concerned with matters transcending those of more earth-bound mortals, the artist told a story more fictional than factual. She assigned an orderliness to her past that denied life's intrusions or detours. As a result, "Eastward Journey" is more important as a source of insight into the way Pereira wanted to be perceived by posterity—as an inspired genius rising above all obstacles, the stereotype of the (male) artist—than about her life as it was. Its familiar storyline is found in countless tales of spiritual quest. Rather than crafting a new story of how a woman attained success in a male-dominated field through her own intelligence, skill, and hard work as well as the support of key people in the art world, she tried to enhance the significance of her life by grafting biographical details onto the preexisting model of the fictional male hero.

In a three-paragraph preface to the manuscript, Pereira outlined her purpose in writing:

Eastward Journey is the underlying symbolic experience, step by step or depth by depth of the paintings which after 20 years produced a philosophical system.

In the main, the metaphysic is a structural core of a continuity of experience in space-time. The text and paintings demonstrate that the apprehension of space and the development of dimensions as an attribute of consciousness are parallel.

Eastward Journey conveys to the reader the whole excursion of the mind through the dimensions of space. The symbol guides the reader as it guided me. The symbolic experience implicit in the paintings is the essence of this journey. It expresses a space-time concept in dimensions whereby plastic validity can be given to thought in time. The illuminative principle of the human mind

*is polarized in space free from the contradictions of the finite.
Perceptions become spatial. Thus the infinite becomes the
abundance and inexhaustibility of Reality.*[52]

According to this preface, Pereira's artistic and intellectual
journey was the underlying symbol of human evolution and the
ability to comprehend higher spatial dimensions. This metaphori-
cal connection between the individual's "journey" and that alleg-
edly traced by evolving civilization was made by Jung and his
followers.[53] However, while authors such as James Joyce might
elevate the fictional lives of common hod carriers to mythic pro-
portions, as in *Finnegans Wake,*[54] it is quite another matter to
elevate oneself to that level. Nevertheless, by doing so Pereira
clearly desired to extend and transform her life's meaning beyond
the spacio-temporal limitations of her physical existence, as well
as the cultural strictures imposed upon women artists at the time.
While once again she suppressed the truth of her own experience,
in this case to make her life conform to the fictional model of the
Künstlerroman, she claimed the power to define her own life. She
chose the active role of the hero-protagonist, champion, in her
mind, of her culture's right to progress; she was not the fair dam-
sel waiting helplessly far away from conflict for her hero's return.
Not only was her writing emancipatory in purpose, but through
it Pereira sought to secure immortality—to sip of the elixir of
life—one of the alchemists' goals.[55]

Although the manuscript remained "unfinished," Pereira left
herself with an unresolvable dilemma. Her narrative, in its origi-
nal form, concludes with her creation of the 1953 painting *Mecca,*
the symbolic attainment of her goal, her "eastward journey." Were
her life fiction, the story would have been complete. Heroes ride
off happily into the sunset; except in Hollywood sequels, we do
not follow their lives thereafter. But Pereira still had to paint, to
find galleries to market her work, and to interest publishers in her
writings.[56] She had to find an audience for both her art and writ-
ings in order to "bestow boons" on humanity, as Joseph Campbell
had described of the responsibility of the hero in *The Hero with a
Thousand Faces.* In her own story, Pereira unwittingly, yet pro-
phetically, rendered the remainder of her professional life anticli-
mactic. The year 1953 was the pinnacle of her career.

One of the more interesting things about "Eastward Journey"
is her discussion of her ship imagery of the 1930s. So well versed
in the metaphorical language of Jungianism, she looked back on

these paintings clearly thinking of the ship as the symbol of what Jung called the "Grand Peregrination" in his newly released volume *Psychology and Alchemy*. This book contained within it a reproduction of an engraving from the seventeenth-century *Viatorium, hoc est, De montibus planetarium septem seu metallorum* by Michael Maier. Above the ship in the illustration, two eagles fly away from one another. The caption beneath reads: "Two eagles fly round the earth in opposite directions, indicating that it is an odyssey in search of wholeness."[57] Given her dual interests in Jung and alchemy, Pereira must have purchased her copy of this volume immediately upon its release. When she wrote in "Eastward Journey" that the flags and ropes in her painting *The Ship* pointed in opposite directions, one east and one west, she must have had this caption in mind.

Given Pereira's comments on *The Ship*, one might speculate about the sources of a motif that begins to appear in Pereira's work about 1953 (halftitle). Looking like a squared ∪ with lateral projections, or "flags," at its terminals, this form recurs in her paintings through 1955. Each flagged ∪ is the geometric essence of a ship with flags blowing in opposite directions from the bow and stern. This is the symbol of the vessel of the hero's journey. Never inverted in her paintings, the ∪ is a container that, like the circle, can enclose all. These motifs are also reconciling symbols. Their bridgelike bases join the vertical poles like the male and female aspects of the hermaphroditic Mercurius. The poles themselves are capable of vertical extension, reconciling the spiritual void and the Limbo below. Thus this motif unites opposites into a single unity and, consequently, can be seen as a symbol of the One, the sun, the lapis—the goal of the alchemist.

This motif also resembles the Egyptian symbol of the Ka, the spirit of life that may enter and leave the mummy and tomb at will. Pereira was thoroughly familiar with Egyptian symbolism by this point, for alchemy was reputed to have originated here.[58] The Egyptian god of wisdom and magic, Thoth, had been identified with the Greek Hermes Trismegistus since the fifth century B.C. Since there are references to Egyptian symbolism in her notes at this time, she was undoubtedly familiar with the hieroglyph for the Ka.[59]

Oddly, the flagged-∪ symbol remains unidentified in Pereira's book *The Lapis*, which contains diagrams that allegedly provide the key to her geometric symbolism. Designed by David Way and published in 1957 by Thistle Press, *The Lapis* was sumptuously

illustrated with paintings and diagrams. The book is a record and self-analysis of two dreams, the first occurring on November 29, 1954. The second, a reprise of the first, as Winslow Ames called it,[60] occurred on Christmas Day—not coincidentally the date celebrated in Persia as the birthday of the sun god Mithras, a fact Pereira noted in her copy of Bayley's *The Lost Language of Symbolism.*[61] In these dreams, she saw an oval stone of lapis lazuli, like an ancient stela, standing on a circular island and surrounded by concentric rings representing a lake, trees, and the sky. Carved onto the visible face of the monolith of her dreams is a toga-clad, androgynous figure. Pereira identified this monument as the philosopher's stone, the lapis. Although the legendary lapis is traditionally red in color, the artist saw it as blue, the symbolic color of the hermaphrodite.[62] Although unidentified by the artist, the classical figure on the stone is, of course, Mercurius.[63]

The basic design of the lapis encircled by the island (Figure 40) is that of a labyrinth and as such is related to images like the seventeenth-century Dutch copper engraving of an alchemical hedge-labyrinth that appears in Jung's *Psychology and Alchemy.*[64] In the center of the labyrinth, the point of unity within the circle, is the sanctuary of the philosopher's stone. Traditionally, the labyrinth represents the difficulties of the work of alchemical transmutation. In Pereira's illustration, this work is accomplished in four stages, corresponding to the four circles.

The labyrinth is also related to mandalas. The English translation of *The Secret of the Golden Flower* included eleven black-and-white reproductions of mandalas. The frontispiece was a reproduction of a Lamaist mandala, Lamaism being a form of Buddhism in Tibet. The ten remaining mandalas were created by Jung and several of his patients. Jung was fascinated by mandalas. A significant portion of his *Integration of the Personality* was devoted to a discussion of mandala dreams, those dreams in which circles play some role. He believed mandalas were archetypes that surface through dreams. Given the extent of her interest in Jung's work, it is not surprising that Pereira would have mandala dreams of her own. However, her unconscious mind was considerably stimulated by Jung's discussion of the lapis in *The Integration of the Personality,* as her heavily marked copy of the book attests.

The problem presented in *The Lapis* is that of the death and birth of world-views symbolized by the death and birth of graphic representations of space. The discrepancy between what is seen and what is known becomes the focal point of the discussion. The

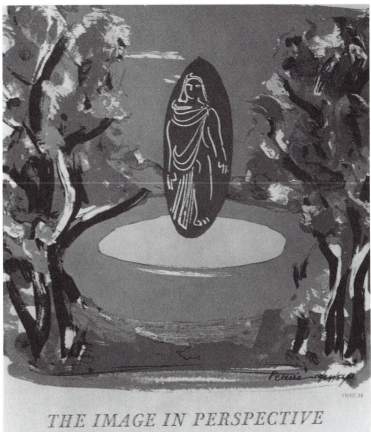

THE IMAGE IN PERSPECTIVE

FIGURE 40

"The Image in
Perspective," from
The Lapis. Photo,
Karen A. Bearor.

imagery in the author's dreams, by her account, presented itself
in a form consistent with a conventional view of external reality,
capable of being rendered graphically according to the rules of
linear perspective. Herein lies the problem for Pereira, because
when it is represented in a traditional landscape format, the island
upon which the lapis stands "looks" elliptical despite the fact that
the viewer knows that it is circular.

Through the text, Pereira described her experimentation with
alternative depictions of the subject. She manipulated the forms,
laying the lapis on its side, tilting the concentric circles upward
into a Kenneth Noland–like target formation, and so forth (Fig-
ure 41). She deemed each of her results unsatisfactory. Then,
without intermediary steps showing any transformation of the
circular terrestrial and supernal forms, she abruptly settled upon

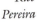

FIGURE 41

"The Lapis in a
Vertical Position,"
from *The Lapis*.
Photo, Karen A.
Bearor.

a rectilinear composition of symbols that, not surprisingly, re-sembled the style of the paintings she had been creating for years. What is missing for the reader is the fact that Pereira is "squaring the circle." In fact, the diagrams of the abstractions included in the book are perfect squares, although the paintings that resemble these diagrams in style are not necessarily square. The act of "squaring the circle" is symbolic of the alchemical process.

The two *Lapis* diagrams indicate a transformation of motifs that occurred in Pereira's paintings in the mid-1950s. The first (Figure 42) reveals a composition divided into two halves verti-cally. The upper portion contains the ether or cosmos, and the lower holds the symbols associated with the earth. Separating the

two regions is a horizontal band that represents the sun. Directly beneath this is the symbol designated as the lapis. In the upper half of the composition are free-floating rectangles, which the artist identified as "light penetrating space." The central flagged-U motif is unidentified. Yet this form unites all aspects of the diagram into a whole. The framing bands along the edges of the diagram represent the surrounding sky, or space, for, consistent with Pereira's theories, the symbols must be contained in space and time. Time here is symbolized by the "light" that appears to originate in the depth of the composition and saturates the whole. She explained in her book *The Nature of Space*, published in 1956, that "the sense of time would be perceived as light because both the inner sensation of light and the outer experience of the source of light have become synchronized in a continuous flow."[65]

The second diagram (Figure 43) is related to the first, but here the flagged-U motif has disappeared. Replacing it are periscope-shaped forms that emphasize far more dramatically the vertical axis of the composition. The text beneath the diagram tells the reader that "the vertical stimulates thinking and inquiry. It is the beginning of questioning in space." This new motif is also a reconciling symbol, although like the flagged-U motif it is given no definition in the diagram. Furthermore, like its predecessor, this new reconciling symbol is based upon the ship imagery of the 1930s in that it may be seen as the geometric essence of the ventilators Pereira drew in her first drawings of ship paraphernalia on the S.S. *Pennland* in 1931. With it, Pereira brought her painting career full circle—like the serpent biting its tail.

In this second diagram, Pereira noted that the symbol representing the surrounding space marks the "front plane." Here she is returning to ideas she outlined in her Pratt Institute lecture notes. Her intention is to construct the space to contain the symbol. In order to do so she must establish the spatial plane, parallel to the surface, as a point of reference against which symbols "beyond" may be compared. Unfortunately, the strict grid structure of these later paintings resists the illusion of depth that had been achieved in her earlier canvas paintings through the use of trapezoids and diagonals. The periscope-shaped motifs seem merely to be superimposed flatly upon an abstracted landscape background, although her text clearly indicates that these symbols were to appear to exist in depth.

Pereira's "front plane" establishes a point of reference for the viewer faced with the infinite expansion of space implied in the

Irene
Rice
Pereira

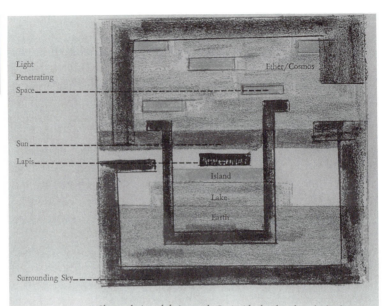

Light
Penetrating
Space

Ether/Cosmos

Sun

Lapis

Island

Lake

Earth

Surrounding Sky

FIGURE 42

Diagram illustrating "the sky enveloping whole image," from *The Lapis*. Photo, Karen A. Bearor.

Sky enveloping whole image; the Lapis, island and earth in depth of image surrounded by space.

FIGURE 43

Diagram illustrating "the correct interpretation to create depth and a spherical image," from *The Lapis*. Photo, Karen A. Bearor.

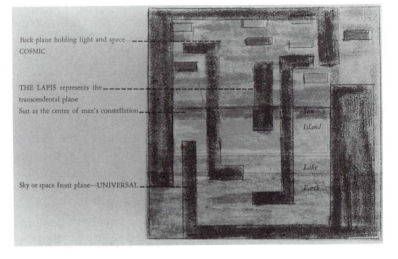

Back plane holding light and space
COSMIC

THE LAPIS represents the transcendental plane

Sun as the center of man's constellation

Sky or space front plane—UNIVERSAL

Sun

Island

Lake

Earth

background. As she wrote here, one's perceptions must be "held within boundaries of reference so that relationships can be formulated between man, the world and the universe." In fact, these symbols are guideposts to lead the viewer's "perceptions" back toward infinity, to render the unknown comprehensible by providing one with some reference to the "world." They are meant, as Pereira insisted, to prevent one's perceptions from becoming "frozen" in the "void." They are analogous to the "landmarks" John Locke described in his *Essays:*

> Time *in general is to* Duration, *as* Place *to* Expansion. *They are
> so much of those boundless Oceans of Eternity and Immensity, as is
> set out and distinguished from the rest, as it were by Landmarks;
> and so are made use of, to denote the Position of finite real Beings,
> in respect to one another, in those uniform infinite Oceans of
> Duration and Space. These rightly considered, are nothing but*
> Ideas *of determinate Distances, from certain known points fixed
> in distinguishable sensible things.*[66]

The periscope-shaped "landmarks" of the infinite expansion of the mind became Pereira's signature during the last fifteen years of her life (Figure 44). While the stem of this motif was reduced in thickness in her late paintings, there are no other changes in the symbols in her work. The only significant change in style that occurs subsequent to the publication of *The Lapis* is her introduction of a tripartite background about 1960. Somewhat related visually to the mature paintings by Rothko, this strict tripartite division represented the earth, the sky, and the "plain of infinity" between them. According to the artist, the plain of infinity allowed the illusion of light coming from beyond the horizon line of the earth.

In *The Lapis,* Pereira elaborated upon her fundamental assumption that society was evolving with respect to a higher spatial consciousness. If one might see its origins for her in the work of Hinton, some of her contemporaries were also working along similar lines in the early 1950s. One of these was Herbert Read, to whom she sent copies of her treatise "Light and the New Reality," the catalogue of her Whitney retrospective, and "Eastward Journey" in 1954. Seeking his advice concerning publication of her autobiographical manuscript, she confessed a long admiration for his work.[67] Pereira apparently met Read through her husband, George Reavey, with whom she attended the opening ceremonies

FIGURE 44

Sphering the Turn,
1962, oil on canvas,
50 × 40 in.
Courtesy, Andre
Zarre Gallery,
New York City.

of the Institute of Contemporary Art on December 12, 1950. Read, as chair of the institute, presented a lecture at those ceremonies, a copy of which Reavey kept. By reason of the British citizenship she acquired through marriage, Pereira had two paintings included in the inaugural exhibition at the institute titled 1950 Aspects of British Art, although one critic wryly commented that "she stands apart as a Yankee at the Court of King Arthur."[68] Subsequently, Pereira saw Read at the home of a mutual friend in New York, when he was in the United States as Charles Eliot Norton Lecturer at Harvard for 1953–54, and she spoke to him there of her philosophy.[69]

Pereira's decision to send Read her manuscript of "Eastward Journey" was prompted by an article about him appearing in *Newsweek* in the May 10, 1954, issue. The article contained excerpts from a lecture he had presented in New York concerning "Art and the Development of the Human Consciousness." Among the excerpts that Pereira underlined was the following:

> *In the life of man we distinguish and oppose two faculties: Intellect and sensibility. Intellect begins with the observation of nature, proceeds to memorize and classify the facts, and builds up that edifice of knowledge properly called science. Sensibility, on the other hand, is a direct and particular reaction to the separate and individual nature of things. It begins and ends with the apprehension of color, texture, and formal relations. . . . The reconciliation of intuition and intellect can only take place . . . creatively [ellipses in source]. It is only by projecting the two sides of our nature into a concrete construction that we can realize and contemplate the process of reconciliation. That is precisely the function of the work of art, and that has been its function throughout the ages.*[70]

Read had first presented the ideas upon which his Norton lectures were based in April 1951 in a lecture "Art and the Evolution of Man" presented at Conway Hall in London.[71] This lecture was published as a small book that year and subsequently appeared as an article "Art and the Evolution of Consciousness" in the *Journal of Aesthetics and Art Criticism* in December 1954.[72] The Norton lectures were published in 1955 as *Icon and Idea, the Function of Art in the Development of Human Consciousness*. One of the acknowledged major sources for Read's ideas was the work of the neo-Kantian philosopher Ernst Cassirer, particularly his *An Essay on Man: An Introduction to a Philosophy of Culture*. First published in

1944, this book was reissued in 1953 to coincide with the appearance of the first English translation of his major work, *The Philosophy of Symbolic Forms*. The first volume of this three-volume work, *Language,* was published in 1953, while volume two, *Mythical Thinking,* and volume three, *Phenomenology of Knowledge,* appeared in 1955 and 1957, respectively. Read had first encountered Cassirer's work, however, through the writing of the philosopher's most famous student, Susanne Langer.[73] Her *Philosophy in a New Key* had been published in 1942; her *Feeling and Form* was published in 1953.

Through personal contact with Read in 1954, Pereira may have learned of Cassirer and Langer, for it was in the summer of that year that she began to take notes from *An Essay on Man.*[74] Her personal copy of this book was a 1953 edition, as was her copy of Langer's *Philosophy in a New Key.* In all, she acquired five of Cassirer's books in the 1950s and 1960s, and her notes reveal her reading at least one other.[75] In terms of the number of volumes in her library, Cassirer's work was second only to Jung's in its importance to Pereira. Ironically, she never learned to spell his name correctly; throughout her notes, both typed and handwritten, she referred to him as "Cassiere."

Because Pereira discovered Cassirer's work so late in her professional development, its impact upon her thought is less clearly defined than other sources. To a large extent, his work merely confirmed or legitimized ideas in which she had already placed her faith. Yet after her discovery of his *An Essay on Man,* she began to broaden the scope of her interests. She began to write about the evolution of culture. She saw her own work as a synthesis of "biological, physiological, psychological, and optical investigations"[76] as his was a synthesis of language, myth, art, history, religion, and science. Since her association with the Design Laboratory, she had sought a synthetic approach to life and art, and Cassirer's work confirmed the legitimacy of that approach. Given her interest in the "center," she must have been struck by the passage in his preface in which he said that "all subjects dealt with in this book are, after all, only *one* subject. They are different roads leading to a common center—and, to my mind, it is for a philosophy of culture to find out and to determine this center."[77]

While Cassirer had faith in the methods of science, he thought over-reliance upon empirical data ignored the vital role of human reason in synthesizing this information into a comprehensible order. In *An Essay on Man,* he wrote,

No former age was ever in such a favorable position with regard to the sources of our knowledge of human nature. Psychology, ethnology, anthropology, and history have amassed an astoundingly rich and constantly increasing body of facts. Our technical instruments for observation and experimentation have been immensely improved, and our analyses have become sharper and more penetrating. We appear, nevertheless, not yet to have found a method for the mastery and organization of this material.[78]

Cassirer sought to investigate the forms by which knowledge was organized, for he saw the whole progress of human culture as based upon its symbolic thought and symbolic behavior.[79] Despite thinking that the appropriate form for his age had not yet been found, he believed, "No longer in a merely physical universe, man lives in a symbolic universe. Language, myth, art, and religion are parts of this universe. They are the varied threads which weave the symbolic net, and the tangled web of human experience. All human progress in thought and experience refines upon and strengthens this net."[80]

Pereira had been struck earlier by Siegfried Giedion's discussion of symbolism in his talk on "The Continuity of Human Experience," and Cassirer's work reinforced those concepts with which she was already familiar. Nevertheless, as several passages in her book *The Nature of Space* reveal, she was also indebted to Cassirer's idea that the symbol might contribute to the development of culture. Because his books cover several periods of Western civilization, they were a continued source of information for her with respect to the history of thought and the lives of individual philosophers. More than this, however, her reading of *An Essay on Man* contributed to the theme and structure of her book *The Nature of Space*, published in 1956, in which she saw the symbolic representation of space, reflecting changing world-views, as a thread of continuity running throughout history.[81]

As Pereira wrote in an epigraph to her book, the work is "a metaphysical and aesthetic inquiry. The study demonstrates that the apprehension of space and the development of dimensions as an attribute of consciousness are parallel and follow a cultural evolution dimension by dimension."[82] She divided her study into two parts. The first part is essentially a historical overview of the shifting emphasis between temporal and spiritual existence from period to period in Western civilization. Considering vertical extension to be a metaphor for a period with an emphasis upon

spiritual values and horizontal extension to be a metaphor for temporal ones, she drew a picture of history with a pulsating pattern of peaks and valleys. Within this progression of history, Pereira considered what she believed was the expanded apprehension of space, from the one-dimensional spatial conception of primitive society, the two-dimensional conception of the Greeks, the three-dimensional conception introduced at the end of the medieval period, to the four-dimensional spatial conception of the modern period. In the second part of *The Nature of Space,* Pereira discussed the structure of space and how that structure provided a frame of reference for humanity in its attempt to bring temporal existence into a cosmological continuum.

While it is beyond the purpose of this study to offer a lengthy critical analysis of Pereira's philosophy, some difficulties in her work should be noted. Apart from the frequent slipperiness of her argument, one problem, alluded to before, is her apparent inconsistency in using the words *space* and *space-time.* Her meaning becomes more clear if the reader understands that Pereira considered space and time as separate concepts that are joined together by light into a whole. Light becomes, for her, the "binding energy," analogous in its usage to the same term appearing in British physicist Oliver Lodge's book *Evolution and Creation,* published in 1926. Lodge, an experimenter in telepathy and mediumship and an early member of the Society for Psychical Research in London, described light, used synonymously with the words *radiation* and *ether,* as the energy binding together protons and electrons in the universe.[83] For Pereira, "space-time" refers to the realm beyond physical existence; it is the so-called plain of infinity existing "beyond the horizon." According to her hypothesis regarding the evolution of knowledge, space-time did not exist for primitive societies, for example, because they had no frame of reference by which to posit such existence.[84]

Another difficulty with Pereira's writing is that she presumed the truth of what she was saying, heedless of any need for consensus, verification, or documentation, and she derived conclusions based upon those "facts." She began with a hypothesis—that there is an evolution of spatial consciousness demonstrable in the symbols each period used to describe space—and she imposed that structure on her version of history, making, in the process, sweeping statements that overlooked diversity in any culture coming under her macroscopic inspection. Despite her claims, she did not "discover" an underlying structure to each period based upon any gathering and normalization of data, any more than Spengler

had done in his morphological concept of the rise and fall of civilizations. For her, data were essentially irrelevant; hers was an eventless history. She sought order, some grand unified theory, to make sense of history as she saw it and to privilege her own sociopolitical position in culture by linking her work, ultimately, to that of Classical Greece, perceived as the birthplace of the highest values of secular Western civilization. Although her sincerity in her beliefs should not be doubted, Pereira's historical writing was essentially a strategy by which she might establish her own pedigree, to cast her own work as the legitimate heir to this classical tradition. By emphasizing conceptualism over empiricism, she relieved herself of the obligation to verify or document her assertions.

There are two major assumptions inherent in Pereira's study of the acquisition of knowledge. The first is the existence of eidetic memory. Since the discovery of the cave paintings at Lascaux in 1940, there had been much general discussion concerning this topic. Herbert Read, for instance, was intrigued by "the fact that such vital and accurate representations of animals could be drawn without an accompanying model—that is to say, from memory. We have to assume, therefore, that paleolithic man carried into the depths of his cave a very clear, *eidetic* image of the animal he wished to depict."[85] Plotinus had discussed a similar concept in the *Enneads*, where he noted that whatever was no longer in our scope of vision existed still within the memory as a source of activity.[86] There is also a connection between eidetic memory and Jung's archetypal theory. Pereira explained her understanding of the process as follows:

> *We can assume that when the outer visual picture of the object, or thing, is no longer within the framework of optical reference, there is an imprint of the picture in the space of the mind. It would then follow that the space which was once occupied by the object no longer exists in outer experience. However, since man has been able to make a mental picture of it, an imprint or memory pattern is formed in the mind. In other words, the objective reality no longer exists, but it has not disappeared from the reality of experience, since it now occupies a space in the mind.*[87]

In addition to speculating upon the ways human memory functions, Pereira was also fascinated by mnemonics, particularly with respect to the practices of the hermetic philosophers. She marveled at their uses of talismanic diagrams, zodiacal symbols,

or designs on architectural columns to cue recall of long memo-
rized passages of manuscripts or speeches.[88]

For Pereira, as humanity gains experience of the outer world,
ever greater numbers of patterns are stored in the memory. These
memories are then available as symbols for future intellection,[89] a
concept based in part upon the following passage from *An Essay
on Man:* "[Recollection] is not simply a repetition but rather a
rebirth of the past; it implies a creative and constructive process.
It is not enough to pick up isolated data of our past experience;
we must really *recollect* them, we must organize and synthesize
them, and assemble them into a focus of thought."[90] Pereira also
noted that, as humanity accumulates knowledge, individuals be-
come less and less dependent upon the outer world of experience
for the development of consciousness. Again, this is consistent
with what Cassirer had written: "Physical reality seems to recede
in proportion as man's symbolic activity advances."[91] According
to Pereira, once humanity has achieved such a level of indepen-
dence, "Man can then look above to the heavens with less fear—
start to ask questions—dare to inquire. As he activates the heights
with his questions and inquiries, he stimulates his depths of feel-
ing and intuition."[92]

Herbert Read called this process the "expansion of conscious-
ness."[93] Pereira assumed that the mind "spreads out to record and
imprint" the memory patterns, which, she assumed, occupied
space.[94] Therefore, as the amount of space occupied by the mem-
ory expands, the spaces of the mind must also expand to accom-
modate or contain memory. Today one might associate this con-
cept with the memory space in a computer, although Pereira
never made such an analogy. However, she also believed that the
mind may contract in space. She explained, "If man is not able to
give his experience of the three-dimensional world inner solidity,
there will be a contraction of space in his mind when confronted
with the irrational, incomprehensible realm of the infinitely large
and he will lose his balance. What he will sense will be a 'void'
and the chaos of matter."[95] This, then, is the second assumption
inherent in Pereira's study of the acquisition of knowledge, that
the space of the mind has the flexibility to expand or contract.

The concept of the expansive nature of thought also has basis
in the Hermetica. Perhaps the most often quoted passage on this
topic comes from the tenth book of *The Divine Pymander of Her-
mes Mercurius Trismegistus,* which reads:

*Increase thy self unto an immeasurable greatness, leaping beyond
every Body, and transcending all Time, become Eternity, and thou*

shalt understand God. . . . Become higher than all height, lower
than all depths, comprehend in thy-self the qualities of all the
Creatures, of the Fire, the Water, the Dry and Moist; and
conceive likewise, that thou canst be everywhere, in the Sea, in
the Earth. . . .

But if thou shut up thy Soul in the Body, and abuse it, and say,
I understand nothing, I am afraid of the Sea, I cannot climb up
to Heaven, I know not who I am, I cannot tell what I shall be;
What hast thou to do with God? [96]

The expansion or contraction of space corresponds to the bal-
ance between vertical extension and horizontal extension, accord-
ing to Pereira. For her, the degree to which the horizontal or
vertical dominates in a culture indicates the ability of that society
to reconcile itself with the cosmos. Her explanation, with exam-
ples of the cultures she discussed in each context, follows:

The development of a society depends on its ability to participate
in space. If there is no participation, humanity remains in an
undeveloped state and retrogresses to an instinctual level. If there is
too much expansion horizontally, a society will expand materialis-
tically and there will be very little or no creative activity [Roman].
If the vertical becomes too extended, man will lose his balance
and have no sense of reality in relation to the world he lives in
[Egyptian]. If a society possesses the seeds of a new orientation in
space, but is not prepared to participate by establishing frames of
reference, and a center of gravity to hold the balance in tension,
that society will be caught up in a dynamic of uncontrollable forces
[medieval]. The portion of space which goes off balance will act on
the society unconsciously, and man will become the victim of its
action. When man has a center of gravity and frames of reference
within which the vertical and horizontal can be brought into
spatial relations, then he is a participant in space and has the
possibility of translating abstract thought into concrete knowledge.
It was such a balance which enabled the Greeks to give abstraction
concrete form, structure and dimensions. [97]

Despite her veneration of the Greeks, Pereira believed that
their art was "flat" because they were terrified by infinity. [98] For
her, the ideal relationship between temporal and spiritual realms
almost occurred as a result of a renewed interest in Greek philoso-
phy centuries later. She wrote,

In Italy, just before the Renaissance, the possibility did present
itself of uniting the earth once more with the sun, through the

rediscovery of Greek philosophical sources; in particular through the interest in Neo-Platonic light metaphysics. But interest soon waned, for it was considered dangerous to borrow too much from pagan philosophy. Also, Christian dogma necessitated expansion along rational lines so as to preserve the Word of God [*as opposed to the* Light of God]. *Thus, only the reasonable and practical aspects of Greek knowledge were revived.*[99]

This direct reference to Neoplatonic light mysticism and her expressed reverence for its doctrines are unique in her writings.

Pereira ultimately discussed modern society. The crisis in the collapse of the old world-view based upon Euclidean geometry was visible for her in the work of the Cubists, Futurists, and Expressionists (in which category she included the Abstract Expressionists). She claimed that, in the twentieth century,

> *there is no unifying aesthetic principle to hold artistic sensibilities from collapsing at the vanishing point. The artist can no longer retain his position in relation to the world-view when the concept for describing the space of the 20th century is four-dimensional. The result is a frustration in pictorial representation. . . .*
>
> *Most modern paintings tend toward a regression to a two-dimensional flat pattern. In some styles there is a deterioration to a primitive, unconscious level with no subject or object; merely a network of linear movements wherein space becomes negligible. For the most part, modern painting demonstrates that the painter is frozen at the point of reference where the three-dimensional world has disappeared. . . . Vision becomes distorted and only fragments of subjective emotional states register in the mind, because what is felt cannot be reconciled with the object of the experience.*[100]

While much of what Pereira wrote about space has been discussed in order to make some sense of what she meant in the first part of *The Nature of Space,* the book's second section offers further insight into her beliefs. Pereira wrote in the opening paragraph of this section that space is "an absolute—perfect and unlimited, expanding and contracting." Then she continued, "Since there is no tangible proof either of God, the soul, the spirit, immortality, or even the existence of the mind, how could man have proposed the existence of such a thing as space, if it were not an inherent quality of his experience? Like the source of life, the source of space cannot be known."[101] These last sentences were based upon a passage taken from an unidentified book that reads:

"Kant taught that while the matter of experience comes from sense perception, . . . it is the inherent nature of the mind that determines the form of the universe and directs our processes of thought regarding things. As no proof can be adduced of God or immortality, or even the existence of the mind or free will, all of this must be assumed otherwise there can be neither thought nor experience." [102]

Pereira went on to discuss humanity's development of symbolic space and the "proof" of the existence of ideal space. Within that discussion, she characterized space as vital, in its ability to grow, and essential for life. She wrote,

> *Space is the prime material for conception. Nothing could exist without the space to support it. All the requisites, which are necessary for life and growth, must be inherent in its very nature of being perfect and absolute. The relative and tangible qualities and properties imposed on space by man are conditioned by his own reasoning, but do not belong to its essence. [She appears to contradict this statement a few paragraphs later when she wrote that the mind constructs space in order to conceive something.] . . . The proof man has of this abstract symbolic, or ideal space, is the representation of it through its objectification: Geometrically, mathematically, philosophically; through poetry, music, painting. Man's ethical strivings, his aspirations, religious feelings, are all living examples of this homogeneous universal space of creation.* [103]

Following the publication of *The Nature of Space* and *The Lapis,* Pereira continued to write philosophical texts, as well as poetry. She continued to promote her written work, although she found little audience for it in the United States. She was forced to self-publish all her books, although the Corcoran Gallery of Art in Washington, D.C., published reprint editions of *The Nature of Space* and *The Lapis* in 1968 and 1970, respectively. [104] Apart from those essays appearing in the catalogues of her exhibitions, most of the remainder of her philosophical papers and poetry were published in India, particularly in the *Literary Half-Yearly,* out of Mysore, where she found a more receptive audience than in the United States. [105] However, the major aspects of her philosophy had been developed in the works discussed above, and her later writings consisted primarily of restatements or embellishments of these key points. Only Frances Yates' *Giordano Bruno and the Hermetic Tradition,* published in 1966, held any great significance for the artist in the last decade of her life, despite the fact that she

nearly doubled the size of her library during the same period. However, Yates' book, with its thesis that the primary impetus for post-Renaissance scientific studies of the world lay in attitudes fostered by the Hermetic-Cabalist tradition,[106] served merely to reinforce long-held beliefs. Neither this book nor the other volumes Pereira acquired in the 1960s reshaped them.

Pereira versus
Abstract Expressionism

Following Pereira's retrospective at the Whitney Museum of American Art in 1953, the trajectory of her career took a sharp downward turn. Why this happened demands some answer, although the issue is multilayered and involves not only stylistic changes in the artist's work but also critical support of Abstract Expressionism, the impact of McCarthyite conformism and anti-intellectualism, discrimination based on gender, and the painter's own distancing of herself from the New York art community.

The most innovative paintings of Pereira's career were her acclaimed works on glass and parchment. Yet at the height of her career she abandoned them. After producing a half-dozen glass paintings and at least two abstractions on parchment in 1952, the last year she used either support, she worked in oil on canvas, supplemented by numerous figural subjects in gouache on paper. In part, her decision to move away from glass and parchment was a practical one. Her archive contains numerous requests from institutional and private patrons for repairs of damage due to breakage or splitting. Furthermore, the weakness and pain in her right arm, resulting from her earlier mastectomy, became increasingly bothersome with age and, consequently, glass became more difficult to work with. However, the desire to be innovative, to rejuvenate her career, was a primary factor in her decision to break so abruptly with her past. It was a risky move; some would say fatal. Her post-1953 canvases, particularly those filled with her thin, cascading Z-shapes, were never popular with critics. Furthermore, the writings supporting the imagery in these late paintings were seldom taken seriously, either during her lifetime or since. While

it would be virtually inconceivable to discuss Mondrian's paintings, for instance, without taking his philosophical beliefs into some account, Pereira has rarely been accorded the same consideration. When she has been, it has often been with derision.

A portion of *The Nature of Space* and *The Lapis* were given over to a discussion of Abstract Expressionism, and any account of Pereira's life and work would be incomplete without some discussion of her feelings toward this movement. Her objections were both personal and philosophical, and they began about the time of the State Department's exhibition Advancing American Art, which opened in 1946 at the Metropolitan Museum of Art to what was to have been a five-year touring schedule in Europe and Latin America. Among the artists included in the exhibition were John Marin, Georgia O'Keeffe, Milton Avery, Adolf Gottlieb, William Gropper, Werner Drewes, Stuart Davis, William Baziotes, and Pereira. Apart from Baziotes and Gottlieb, none of the best-known artists subsequently associated with Abstract Expressionism were included in the show, which was recalled from abroad because of negative publicity by the Hearst Press and Congress linking it with the spread of Communism.

In the void in federal art patronage created by the government's abandonment of WPA programs and its change of heart regarding support of the State Department show, some of the major galleries and museums in New York began to promote American art, particularly Abstract Expressionism. Through its International Council, for example, the Museum of Modern Art began to sponsor international exhibitions of Abstract Expressionist work in the 1950s, and from 1954 to 1962 it also controlled what was shown in the U.S. Pavilion at the Venice Biennials.[1] Pereira, already concerned about her position within the art world before going to England in 1950, did not jump onto the Abstract Expressionists' bandwagon upon her return to the States the following summer. Instead, she elected to emphasize the difference between her work and theirs. Beginning with the 1951 fall season, she began to promote her writing on virtually an equal basis with her paintings. The very fact that she wrote poetry and philosophical essays set her apart, yet these efforts were also an attempt to link herself to past artist-writers, including Leonardo, Blake, and, more recently, Kandinsky, Mondrian, and Moholy-Nagy. It was in this tradition of the "complete" artist that Lee Nordness placed her, for example, in his introduction to her book of poetry, *Crystal of the Rose,* which he helped her publish in 1959. More than

this, in marked contrast to Jackson Pollock's explosive arabesques of line and color, Pereira emphasized detachment and order, while yet including textured surfaces and an occasional drip of her own. To compound the felony of daring to be different in a conformist age, she began to criticize the Abstract Expressionists in print, and she managed to use Jung—whose writings were as important to many of them as to herself—against them.

Pereira's writings might be legitimately criticized for flawed logic, a ponderous and almost impenetrable writing style, and her reliance upon arcane sources. Certainly, her poetic phrasing was not the accepted language of scholarly discourse. While one might argue that her writing was no more dependent upon metaphor than Jung's, she lacked the authority conferred on his work by his formal education, his association with institutions devoted to "scientific" inquiry into the workings of the mind, and, no less important, his being male. Yet it was not for style nor even for content (since few bothered to spend the time necessary to uncode it) that Pereira was most often attacked during her lifetime. Instead, she was faulted for daring to write at all. Apparently, few critics presumed she had anything important to say. Beginning in 1951, she was repeatedly admonished by friend and foe to focus her energies on her painting and to forget philosophy. When she persisted in going against the grain, her voice was "silenced" by a lack of serious acknowledgment or engagement with her over the issues she raised.

The first to try to dissuade her from writing was Holger Cahill, to whom she had sent her first draft of "Light and the New Reality" in October 1951, and this occurrence marked the beginning of the end of their friendship.[2] His support of her work seemingly decreased proportionally to the increased promotion of Abstract Expressionism by the Museum of Modern Art, where his wife, Dorothy Miller, wielded much power in decisions concerning acquisitions. Pereira's letters to Reavey in 1954, during periods when he was in residence at the Yaddo and MacDowell artists' colonies, reveal her growing frustration with Cahill. Although she continued to be invited to dinners at his home through that year, she noted that he would change the subject whenever she mentioned her philosophy. According to her, this was because Miller and the museum wanted a monolithic style to promote as "American" and any art that did not conform with that vision was suppressed. While she believed that Cahill was naturally intent upon protecting his wife's interests, she also took his comments as warnings

about the consequences of promoting her own opposing philosophical system. According to her notes, he warned her that she would be "starved out" if she did not conform.[3]

Whatever the truth of this allegation, Pereira refused to be quieted. She persisted in writing and portraying herself not only as different, but, where possible, as superior to other artists. Evidence of this is in the calculated choices she made regarding how she would appear in public, in publicity photographs, or in journalists' descriptions of her studio habits. As Therese Schwartz has remarked, she made a point of distancing herself from the paint-splattered smock image of the artist. Standing five feet two inches, according to her passport, Pereira gave Schwartz, who was of similar stature, the following advice in finding a New York gallery: "Wear a hat, your best clothes, and high heels so you'll look taller."[4] James Harithas commented that she was "a woman of great style" who attended gallery openings wearing original dresses by Balenciaga and Givenchy.[5] High fashion and expensive clothing, conventionally signs of one's husband's money and success, was an indicator, in this case, of Pereira's own achievement. Presenting the image of success was only a part of her strategy, however. Knowing that, as a successful woman artist, she was an anomaly in the art world of the 1950s and 1960s and that journalists would inevitably discuss her appearance more than her work, she exploited each opportunity to make her clothing remarkable. If, as Roland Barthes noted in discussing fashion as a system of signs, blue jeans, while useful for working, also "say" work,[6] then one might argue, analogously, that a paint-splattered smock says "working artist." Yet, rather than wearing a smock when interviewers and photographers visited her studio, Pereira wore brightly colored silk blouses and floor-length silk skirts, with dangling "Siamese bangles" on her arms, or velvet robes embroidered with gold thread and trimmed in crystal beads.[7] While wishing to appear industrious, with several paintings in progress simultaneously, she did not allow herself to be portrayed laboring over her canvases. Not only might such an image destroy the illusion of proverbially "divine" inspiration by revealing too much of the effort involved in creation, but it would also link her too closely to the working-class "masses." As she explained in 1965, "The creative individual stands outside of groups and mass and elevates the mass; and, carries the spirit of culture forward."[8]

For Pereira, however, not just any creative individual is endowed with the ability to carry the spirit of culture forward. That responsibility was reserved for "classicists," a term she used to

describe herself from the late 1950s until the end of her life. As she defined it in 1959, a classicist is one who gives meaning to the spirit of her age by extending the horizons of knowledge and opening up new thresholds of experience. To divest the Abstract Expressionists of any claim to lasting importance, she proclaimed further that there is no egoism in "great" art (presumably that created by classicists), for such art is transcendent, impersonal, and universal.[9]

Apart from distancing herself from her contemporaries, Pereira's insistence upon using the term *classicist* to describe herself was also calculated to set her apart from her teachers and former mentors. It was an attempt at self-definition at a time when critics persisted in linking her work to various stylistic progenitors, casting her paintings in a lesser light with respect to the recognized "originator" of the style, and denying to her similar claims to innovation. As she recorded in her notes in 1962, "It is frustrating being put into a category by the so-called authorities, such as the category of constructivist. I am a classicist."[10] These complaints were legitimate ones, and her method of retaliation during the last years of her life has a certain ring of familiarity. Like many painters, Pereira denied the impact of any particular artist's work on her own, refusing to participate in the who-begat-whom discourse of art history and criticism. Where she carried this denial further was in her rejection of all social or historical context altogether. About 1966, she asserted in private notes,

> I have never been influenced by anybody's work: although I have been thrilled by some of the Renaissance painters, but have not been influenced by anyone. The work follows a cultural evolution and bypasses history. It transcends history. It is universal, and symbolic. It stands alongside of cosmologists that is, discovering principles that underly human experience. . . . The work stands alongside of Descartes, Copernicus, Newton, Plato. The work deals with Wholes. Work pioneers a new field of inquiry—the philosophy of space.[11]

The greater Pereira's alienation from the art world, the more she tried to elevate herself above the fray. The end result was that she was increasingly marginalized from the dominant discourse in which she had been a participant only a few years earlier. Yet despite the fact that her words had little impact, she did try to strike a few verbal blows at the Abstract Expressionists. Philosophically, Pereira was opposed to these artists because she felt, as early as

1950, that they were caught in the "void."[12] In the context of Jung-ianism, she saw them as having given themselves over completely to the unconscious, with no reason to guide them. They had re-gressed to the point of "chaos." Their work expressed entropy and nihilism and could lead only to the fragmentation of society, not unity. On one occasion, she even quoted Jung in support of her opinions.[13] While she repeated these views hundreds of times throughout the last eighteen years of her life, her most succinct philosophical statement concerning this movement appeared in the *New York Times* on May 1, 1955, in a letter to the art editor. Pereira wrote,

> *In this expression the painter, himself, has removed everything but the act of painting. In order to paint such a picture the painter must live on a subjective, unconscious level because he has lost his sense of reality. If the world is in disintegration, he becomes personally identified with the breakdown for the simple reason that he has not been able to establish a position of relationships between himself and the world he lives in. Therefore, he can only express fragments of something which once existed but no longer is real. From these fragments he keeps subtracting more fragments until what is left are fragments of fragments. . . .*
>
> *It is regrettable that this word "abstract" has been irresponsibly used to define a style of expression which represents a breakdown of structure, and is so negative that it can only subtract, compensating its subtractions, in many instances, with huge, vacant canvases.*[14]

The critical support that Pereira had received in the early 1940s had begun to dissipate by the end of that decade, although the character of the attacks on her work was telling. Abstract Expressionism had been established as the norm against which her work was judged, although privilege was still reserved for acknowledged male champions of geometric abstraction. For example, Henry McBride, in his review of her Whitney retrospective, sounded rather like the Abbot Antronius in Erasmus' sixteenth-century colloquy, "The Abbot and the Learned Lady," who said to Lady Magnalia, "It's not feminine to be brainy."[15] In attacking Pereira's work for being too ascetic and yet not as "pure" as Mondrian's even more pared-down geometry, he wrote, "'To suppress all emotion and be exclusively brainy' was the mandate that issued from on high. . . . But [Pereira] never got down to such simple equations as Mondrian's. You could scarcely expect a lady to dis-

pense with the trimmings of a design and I suppose in dispensing with touch she thought she had dispensed enough."[16] An earlier critic had also commented upon the fact that her works' "appeal is strictly cerebral, not at all emotional,"[17] and in an ambivalent *Time* magazine review of her Whitney retrospective, her paintings were described as having "no moods" and being "frigidly precise."[18] Stuart Preston, in his review of her show at the Durlacher Gallery in 1954, described her paintings as being "all mental image and style" and "so obtrusively impersonal that they succeed in excluding the spectator as well as the artist."[19]

Clearly, if one accepts the polarized language of the day and the characterization of the work produced by the Abstract Expressionists as "emotional," then Pereira's could be called "intellectual." Yet, had she painted in an "emotional" style, she undoubtedly would have been discredited for merely painting "like a woman" and thereby become as invisible to the New York art critics as women painting conventional flower-pieces. In theory, it was acceptable for the male artist to make himself "whole," to perfect himself, by adding to his innate intellect a drop of "feminine" emotions. Yet it was quite another matter for a woman artist to presume to "complete" herself through the acquisition of "masculine" intellect. This is a key defect, a deformation in favor of the male due to inherent power inequities between male and female, masculine and feminine, in the Surrealists' celebration of the androgyne, as Gloria Orenstein has pointed out.[20]

By the same token, Jung's anima archetype (the alleged source of feminine traits in the male psyche) and the contrasexual animus (the alleged source of masculine traits in the female psyche) were likewise constructed as unequal, for they carried with them all the stereotypical characteristics associated with their respective genders. Although a male analysand might reach a healthy balance between his "masculine" conscious and the "feminine" unconscious, for Jung the primary source of "masculine" traits in women also lay in the unconscious. Thus, by theory, woman is deprived of the ability to have any original thought at all, for the psychoanalyst characterized the material contained within the animus as "learned" judgments, "largely sayings and opinions scraped together . . . from childhood on," "a compendium of preconceptions which, whenever a conscious and competent judgment is lacking [i.e., whenever a man is not around], . . . instantly obliges [the women] with an opinion." Then, he continued, "in intellectual women the animus encourages a critical disputatiousness and would-be highbrowism, which, however, consists essen-

tially in harping on some irrelevant weak point and nonsensically making it the main one. Or perfectly lucid discussion gets tangled up in the most maddening way through the introduction of quite different and if possible perverse point of view. . . . Such women are solely intent upon exasperating the man."[21] A woman "possessed" by the animus was, for Jung, in danger of losing her femininity.[22] Women, through the stereotypical "behavior" of the anima, were also the source of man's psychic problems, for if a man were too possessed by the anima, according to Jung, "she softens the man's character and makes him touchy, irritable, moody, jealous, vain, and unadjusted."[23]

During a time when critics were as affected by such thinking as the artists were, it is not surprising that Pereira was also criticized for presenting herself as an intellectual and insisting that there was content in her abstractions. For example, in his review of her retrospective at the Galerie Internationale in 1964, John Gruen argued that "the artist assigns to her work such mystical overtones that one tends to confuse her pictures' constructivist individuality with messages that ill-fit them."[24] Chicago critic Franz Schulze was even more direct in his review of her exhibition at the Distelheim Gallery in 1965. He complained that her philosophical explanations

> *seek to inflate a very little into a whole lot. Good or bad, these works of Pereira are basically compositions of form and color. . . . They may legitimately be defined with more complication, but to hoist them up onto the level of the "space-time continuum" or the "light-space continuum," as Miss Pereira herself has repeatedly done, and to suggest that she is the "creator of a new metaphysic" who "broke through the space barrier," in the words of another writer, is to move into reaches where the air is just too thin for the visual arts to breathe. It also adds the charge of intellectual pretension to that of artistic mechanicalness and makes one wish that the popular practice of museums and galleries, to extract written statements from artists about their own work, would be abolished by an act of Providence.*[25]

Pereira responded to such attacks in a paper titled "Women and Dimensions in Art" presented on July 21, 1954, at a symposium on "Woman in the World of Man" at the University of Michigan:

> *Once a woman ventures outside the traditional preoccupation with a family, she is confronted with this masculine world of objective*

statements, fact, aggression, competition, thinking and logic. The
role of this kind of woman is very difficult and presents a dilemma;
because, while participating in the objective, masculine world, she
still must preserve her femininity or her personality suffers from
the conflict. . . . In painting, the male artist tolerates the woman
who makes delicate feminine pictures; but should he sense ideas,
masculine strength or force of conviction, he feels his masculine
territory has been violated. The worst insult he can inflict on a
woman is to suggest that she paints like a man as he indifferently
shrugs his shoulders. However, it seems to me that the responsibility
of the artist lies in the fact that whatever his inner need dictates he
must be willing to support it; irrespective of HOW MUCH of this
energy can be translated into the masculine or feminine sex.[26]

Apart from apparent discrimination on the basis of gender, Pereira's "intellectualism" was remarkably at odds with prevailing social currents. The 1950s in particular were marked by open discussions of the so-called egg-head problem, the distrust of intellectuals in the United States. An entire issue of the *Journal of Social Issues* was devoted to the subject of anti-intellectualism in 1955. College professors warned of the consequences of attacks on intellectual freedom. In 1956, the centenary of Freud's birth, writers discussed the ways in which psychoanalysis had been distorted to fuel this phenomenon, an issue also briefly addressed in Richard Hofstadter's Pulitzer Prize–winning *Anti-Intellectualism in American Life*, published in 1962.[27]

One reason critics took aim at Pereira's intellectualism, however, was that to many her art had not evolved beyond its usefulness in the service of architecture. What had been empowering for the artist in the 1930s was now used against her. For example, Ross Edman, in his review of her 1965 exhibition at the Distelheim Gallery in Chicago, complained of her perceived repetitiousness: "Only the colors change, as if she were trying to work within a rigid format and still make a living by providing a painting to crown every sofa in the United States."[28] Her art had become merely "fashionable," a characterization not dispelled by allowing her works to be exhibited as backdrops for fashion mannequins in the windows of Saks and Bonwit-Teller department stores in 1952. Nor was this label shaken with published photographs of her 1955 painting *Landscape of the Absolute* hanging in the living room of the home of celebrity actress Sally Ann Howes and her husband, composer-lyricist Richard Adler.[29] Ad Reinhardt, in one of his caricatures of the tree of life in the art world, titled "Museum

Landscape," published in 1950 in *Trans/formation,* placed Pereira's name on a leaf on the branch labeled "Tea and Dress Shoppe 'Abstraction.'" (Jackson Pollock, Willem de Kooning, and Hans Hofmann were associated with "therapy style" abstraction.)

As her star fell in New York, Pereira allowed herself to be victimized by shady "agents" and one or two unscrupulous gallery owners. Her friend Frances Steloff wrote that because she "was not a businesswoman people took advantage of her, and she was shy about claiming her rights or asking her friends to help her." [30] She continued to have her work shown at the Whitney Museum annual exhibitions. In fact, the last show to which she submitted a work during her lifetime was at the Whitney, its exhibition of Women Artists in the Museum Collection, which opened in December 1970. She also received support late in her life from the Corcoran Gallery of Art, under the direction of James Harithas. Yet Pereira believed herself to be the victim of a conspiracy to suppress her work. In numerous letters and notes she accused her former friend Dorothy Miller of blackmailing galleries into refusing to carry her work by allegedly threatening to cut off the pipeline between the galleries and the museum. [31] In particular, the artist cited Miller's tactics as responsible for creating the situation in which she was forced to resign from the Durlacher Gallery. This was the result, according to Pereira, of her announced intention to publish *The Nature of Space.* [32]

Pereira was not alone in believing that Miller could be a threat to an artist's career. As Russell Lynes has written, because of Miller's "very substantial role in selecting what American artists would be exhibited at the Museum over many years, [she was] looked upon by artists either as a benign goddess or as a disdainful one, depending on whether or not she smiled on their work and included them in her shows." [33] Raphael Soyer also discussed the machinery that was in place to promote some artists at the exclusion of others. He saw it as a "concerted effort on the part of critics, museums, and the so-called cognoscenti to put it over, . . . and they did a wonderful job; overnight all these people . . . became geniuses, and the other artists were neglected." [34]

In fairness, however, it must be stated that, prior to her break with Miller, Pereira's association with the Museum of Modern Art always had its ups and downs. In 1940, she had signed the broadside that posed the question, "How Modern Is the Museum of Modern Art?" The following year, the museum acquired two of her paintings. In 1946, she was included in the major exhibition Fourteen Americans, organized by Dorothy Miller. That same

year, Pereira signed a letter to the editor of the *New York Times* critical of the museum's handling of James Johnson Sweeney's resignation.[35] Pereira began to make vocal her belief that her work was being suppressed in 1953, soon after the closing of her Whitney retrospective. According to her, only one painting sold from that show, despite the amount of publicity it received.[36] She attributed this fact to the systematic "suppression" of her work by the Museum of Modern Art. In April she put her charges in writing to Victor D'Amico, chair of its Committee on Art Education. She accused the museum of relegating everything but Abstract Expressionism to nonexistence.[37]

About this time Pereira received a copy of *Reality: A Journal of Artists' Opinions,* published in the spring of 1953, with a front-page statement, signed by forty-eight artists, reading in part:

> All art is an expression of human experience. All the possibilities of art must be explored to broaden this expression. We nevertheless believe that texture and accident, like color, design, and all the other elements of painting, are only the means to a larger end, which is the depiction of man in his world.
>
> Today, mere textural novelty is being presented by a dominant group of museum officials, dealers, and publicity men as the unique manifestation of the artistic intuition. This arbitrary exploitation of a single phase of painting encourages a contempt for the taste and intelligence of the public. We are asked to believe that art is for the future, that only an inner circle is capable of judging contemporary painting, that everybody else must take it on faith. These theories are fixed in a ritual jargon equally incomprehensible to artist and layman. This jargon is particularly confusing to young artists, many of whom are led to accept the excitation of texture and color as the true end of art, even to equate disorder with creation. The dogmatic repetition of these views has produced in the whole world of art an atmosphere of irresponsibility, snobbery, and ignorance.[38]

Most of the signatories of this statement were artists associated with urban realism and social realism in the 1930s, including Philip Evergood, William Gropper, Robert Gwathmey, Edward Hopper, Jacob Lawrence, and Jack Levine. Many had been associated with Herman Baron's gallery and were among Pereira's old friends. Although she did not sign the statement—in fact, as a painter of abstractions, she was included in the categories of which the signers were critical—she did agree in principle with

what was said. On April 27 she wrote a letter directed to the editorial staff of the journal stating that she was in full agreement with the statement regarding art as an expression of human experience. She was critical, however, of their lumping all abstraction into a single category. She railed against Harold Rosenberg's famous article on "The American Action Painters," which had appeared the previous December in *Art News,* and she refuted this critic's comments one by one. Ultimately concluding that she could not subscribe to "this jungle of weeds and jargon," she wrote, "The artist cannot believe only in the materialistic, mechanical 'act' of the moment. The artist must believe in human values. He values the soul of man and makes a place for it in a time which is eternity."[39] She sent copies of her letter to the Museum of Modern Art, the Whitney Museum, the *New York Times,* the *New York Tribune, Life Magazine,* and *Art Digest.*

Apart from being convinced that her art was being systematically suppressed, Pereira believed her written work was being plagiarized. This is, of course, ironic considering her virtual word-for-word copying of passages by Giedion and Ivins in her 1944 essay "An Abstract Painter on Abstract Art." Furthermore, the passages she identified as those lifted from the pages of her own books were, without exception, general statements based upon ideas with widespread currency, derived from many of the same sources as Pereira's own. For example, she accused Charlotte Willard of plagiarizing her work in two articles from early 1967, a review of the Lights of Orbit exhibition at the Howard Wise Gallery and an article on artist Yaacov Agam. On her copy of the former, Pereira wrote, "This has come right out of my writings" next to a passage that reads: "What about the realities of light, of magnetism, or energy? What about the reality of our feelings, our imagination, our memory? How can these invisible realities be made visible? Is this a proper subject for art? I, for one, think so."[40] With respect to the latter article, Pereira responded to the fact that Agam's work, in its accordionlike folds, has a similar impact on the viewer to that of the corrugated panes of glass in the works she had stopped making fifteen years earlier. Furthermore, as Willard described, his sources were similar:

> The cosmos is Yaacov Agam's playpen. Science and religion are the building blocks he uses to make time visible, to construct a new painting that partakes of becoming—the multiple, simultaneous, changing, flowing nature of the universe. Fusing the past and the future, the ancient Hebrew idea of one God, in everything and

everywhere, with the German physicist Werner Heisenberg's "indeterminacy principle," he tells us that we can only perceive reality in stages, and partially.[41]

Pereira's charges of plagiarism only masked the deep hurt she suffered when Willard, a friend, failed to mention the fact that her glass paintings preceded Agam's work, whether or not he had ever seen them. Her charges came at a time when Op Art and light-generating art were being shown in New York galleries and museums. With the exception of the Heckscher Museum in Huntington, New York, which included Pereira's work in its exhibition Whence Op? in May 1966, her investigations in light reflection and refraction, her inclusion of light bulbs and light-radiating radioactive paints, were ignored as antecedents for the current crop of artists. Her work was not included in the Museum of Modern Art's Responsive Eye show in early 1965, despite the fact that faithful critics, such as Emily Genauer, pointed out her notable absence. Genauer wrote, "If only the Metropolitan would bring a very similar Pereira it owns up from its basement, and dust and hang it, it could serve as a reminder to today's experimenters that art stimulated by science (here the science of optics) is not all that new, and, more important, that it can still be lyric poetry."[42]

As Pereira became alienated from the New York art community, she became increasingly unable or unwilling to distinguish between well-intentioned criticism and mean-spirited attacks. She felt victimized because there were no legitimate channels through which an artist might challenge what was said about his or her work. Failing to find publishers for most of her own expository writings, she self-published them. As a result, she associated with people in the literary world more and more. Through her marriage to George Reavey, which ended in divorce in 1959, she had made numerous contacts, but she also met many figures through Frances Steloff, founder of the Gotham Book Mart. Steloff, also a founder of the James Joyce Society, which met at the Gotham, first saw Pereira's work at the artist's Whitney retrospective, and the two remained close throughout Pereira's life.[43]

Another friend was sculptor, poet, and publisher Caresse Crosby. Although it is not known when the two met, it is likely that they met through Reavey. Crosby was the widow of the poet Harry Crosby, who had founded Black Sun Press in Paris, publisher of work by Joyce, Marcel Proust, and Eugene Jolas during the 1920s. Through her husband, Caresse Crosby had made many

contacts within the *transition* group, with which Reavey had been associated.

During the 1960s, Pereira became involved with Crosby's plans to create a center for humanist studies at the Castle of Roccasinibaldi, a feudal castle once belonging to Cesare Borgia, built in 1530 in the Abruzzi hills of Italy about fifty miles north of Rome. According to Anaïs Nin, Crosby bought the castle for fifteen thousand dollars, and

> *she is having the roof repaired to make it livable. Three hundred and sixty rooms! She just had the imagination to get it, to persuade the Italian government to repair the roof. . . . Her relatives and friends will share the cost of making certain parts habitable. We are all sending books for her library. It is to be the home of "Citizens of the World" and "Women for Peace." She invites us all to stay there, in the summer when it is habitable.*[44]

Pereira stayed at Castle Roccasinibaldi in 1960 and again in 1963. Through Crosby, Pereira met American composer Robert Mann, with whom she corresponded until her death. In 1962 Mann worked on a symphonic score related to a dozen of Pereira's paintings, the performance of which was to be synchronized with light. The score was never completed.[45]

Other names appearing with regularity in Pereira's papers include those of artists Sylvia Carewe and Margit Varga, the latter a life-long friend from the early years at the ACA Gallery. Another is Mercedes de Acosta, whom Pereira knew by the mid-1950s, although the artist is not mentioned in Acosta's autobiography, *Here Lies the Heart,* published in 1960. There is also a long correspondence beginning in the early 1960s with Livio Olivieri, director of the Instituto Italiano di Culture, in Hamburg. Pereira also knew and admired the work of Iris Murdoch and Anaïs Nin, whose *Four-Chambered Heart* (1950) and autographed copy of *The Novel of the Future* (1968) remain with the artist's library. Through the James Joyce Society she met Marguerite Young, to whom Pereira gave a painting of doves on the occasion of the publication of *Miss MacIntosh* in 1965. In return Young presented Pereira with an autographed copy of the book. About 1966, also through the Joyce Society, the artist met Polish poet Andre Sovulevski, who was to remain a close friend until her death from emphysema in 1971.

Conclusion

The last remark made by Pereira appearing in print before her death was one recorded by journalist Leah Gordon in her review of the Whitney Museum's exhibition Women Artists in the Museum Collection for the *New York Times*. According to Gordon, the artist said, "I never encountered any prejudice. My work stood on its own. Whatever trouble I had came from other women."[1] Unfortunate as it is that these sentiments take on added significance due to the accident of timing, they indicate, nevertheless, the bitterness that the artist took with her to her grave and her failure to acknowledge the sources of her support within the art world. Apart from her difficulties with Dorothy Miller, women within the institutional and critical establishment were vital to her success. Where would her career have been had it not been for the efforts of Juliana Force, Audrey McMahon, Marian Willard, Hilla Rebay, Peggy Guggenheim, or Dorothy Miller (prior to 1954) to showcase her work and secure patronage for her? Elizabeth McCausland, Emily Genauer, and Aline B. Louchheim were among those critics who were most sympathetic to her work. Alice Nichols published her first philosophical essay, and Marjorie Falk was her first individual patron. Unfortunately, the artist died just at the time that the women's movement brought about renewed interest and appreciation for work by women artists, even if Pereira was excluded from the major 1976 exhibition Women Artists 1550–1950, curated by Ann Sutherland Harris and Linda Nochlin.

As much as Pereira tried to gain access to the symbolic, she was able to do so only within the limitations set for her by the domi-

nant discourse. So long as her work supported the aims of Bauhaus–International Style artists and designers, she was welcomed to participate on their panels and in their shows. When that style became more commonplace and "individualism" became characteristic of the avant-garde, Pereira's work was dismissed as "decorative" and "fashionable" by many critics, "cold" and "impersonal" by others. Her own attempts at portraying herself as the heroic individualist failed to empower her. Although she challenged the alleged universality of the model of the hero's quest by projecting herself into it, she could never make the story her own. Her search for self-knowledge, based upon the model of the male hero's quest, seemed inauthentic. Ironically, as much as she talked about the source of her imagery as emerging from the depths of the collective unconscious, the source of the spirit, according to Jungianism, she lacked the "soul" critics claimed to find in the work of the Abstract Expressionists. Try as she might to infuse her work with metaphysics, to legitimate her compositions with theory, she lacked the power to make herself heard. Doubly ironic is the fact that when Minimalism dominated the art world and hard-edged, geometric forms were "new" once again, Pereira's works were discounted by critics as being too lyrical.

Clearly, Pereira's options were limited. Her authorial voice was destined to be drowned out by the larger chorus. Perhaps now, in a somewhat different climate, we can examine the choices she made, see how she resisted the patriarchal version of "universality," even if she substituted her own, and acknowledge her significant contributions to the history of modernism.

More than that, we must continue to examine our own models for judging past art. Despite the stylistic differences between Pereira's paintings and those of the Abstract Expressionists, their works had similar roots. It is customary to look upon Surrealism as the progenitor of Abstract Expressionism, particularly in its emphasis upon automatism and the so-called unconscious as the privileged source of artistic creativity. However, as Gloria Orenstein and Whitney Chadwick have pointed out in their work on Surrealism, women artists working within this tradition seldom explored automatism. Instead, they often chose to work with spiritual quest imagery. It is important to understand that Pereira's art maintains the same relationship to this form of Surrealism produced by women as Abstract Expressionism holds to that Surrealist art produced primarily by men. Furthermore, the distinctions conventionally made between geometric abstraction and Surrealism were not cleanly drawn until after 1950, when crit-

ics desired to privilege Abstract Expressionism over other styles
and it became necessary to provide its adherents with a pure-
bred pedigree. When we cease looking at Surrealism—or, more
broadly, the period in American art falling roughly between 1935
and 1945—through the lens of Abstract Expressionism, it will be
possible to see greater cross-over interests between artists work-
ing in various styles, to determine the much broader appeal of
Jungianism, without the need to justify or sanctify the tastes of
those persons in positions of power during the 1950s. In such a
climate, the real contributions of artists such as Irene Rice Pereira
might be better evaluated.

Chronology

August. Irene M. Rice born in Chelsea, Mass., to Emanuel Rice and **1902**
Hilda Vanderbilt Rice. During childhood, family moves around Massa-
chusetts from the Boston area to Pittsfield, to Great Barrington, and back
to Boston. Family subsequently moves to Brooklyn, where she attends
Eastern District High School.

Father dies. **c. 1918**

Takes evening art classes at Washington Irving High School, New York. **c. 1926**

October–May. Studies with Richard Lahey at Art Students League **1927–1928**
(month of April with von Schlegell).

January 8. Marries Humberto Pereira. **1929**

July. Address: 122 Willow Street, Brooklyn.

October–May. Studies with Jan Matulka, Art Students League. **1929–1930**
Resumes, September 1930 through April 1931.

September–December. Travels in Europe. In Halifax, Nova Scotia **1931**
(September 13); in Antwerp, Belgium (September 23); in Paris, possibly
studies with Amédée Ozenfant at Académie Moderne (October); leaves
Paris for Switzerland (November 10); stops in Geneva; in Palermo, Sicily
(December 8).

December. Travels in Africa. In Tunis, Tunisia (December 9). In Algeria:
Biskra (December 16); Gougourt (December 17); Touggourt (Decem-
ber 18); Ouargla, (December 19); Lagouat and Ghardara (December 22).

January 6. Leaves from Cherbourg, France, for U.S. **1932**

Summer. In Provincetown with Humberto Pereira. Begins painting ship
paraphernalia.

January. First one-artist show, ACA Gallery, New York. **1933**

Studies for one month with Hans Hofmann at Art Students League.

Spring. Works on Public Works of Art Project. **1934**

Address: 18 East 13th Street, New York.

January 13. Classes open at WPA/FAP Design Laboratory, 10 E. 39th **1936**
Street, New York. Pereira is member of original fine arts faculty.

Moves to 2 West 16th Street, New York.

1937 **February 17 and 24.** Lectures on "Art in Industry" at the Design Laboratory.

June 27. Design Laboratory loses WPA support.

July 1. Design Laboratory becomes part of FAECT School 114 E. 16th Street, New York.

September 27. Classes open at the Laboratory School of Industrial Design (formerly the Design Laboratory).

November. First abstractions exhibited at East River Gallery, New York. Joins Easel Division of FAP.

1938 **January 28.** Divorces Humberto Pereira.

1939 **March.** Presents lecture, "New Materials and the Artist," Columbia University.

Moves to 121 West 15th Street, New York. Sets up studio on third floor. Apartment and studio occupy third floor.

First major sale of work, to Marjorie Falk.

Begins first glass painting.

October. Resigns from Laboratory School of Industrial Design.

1940 **February 15.** Lecture, United American Artists, Labor Stage. Appears with David Smith and Stuart Davis.

April 15. Signs broadsheet "How Modern Is the Museum of Modern Art?"

July 25. Presents lecture, "Cubism and Abstract Art," Brooklyn Art Center, Brooklyn Museum.

November. Released from Art Project Easel Division.

December 1. Begins work at Museum of Non-Objective Painting as museum assistant.

1941 **January.** Dorothy Rice diagnosed with cancer. Begins radiation therapy.

May. Travels with Dorothy to Haiti and the Bahamas.

September. Dorothy Rice dies of breast cancer.

Museum of Modern Art acquires *Exploration with a Pencil* (1940) and *Shadows with Painting* (1940).

Begins to work with parchment.

1942 **July.** Hilla Rebay asks for Pereira's resignation from Museum of Non-Objective Painting; permits her to stay until September.

July 28. Interviews with J. Boudreau, director, Pratt Institute, for teaching position.

September 26. Marries George Wellington Brown, of Beacon Street, Brookline, Mass.

September. Begins teaching design at Pratt Institute.

1943 **January.** Resigns from Pratt Institute six classes into semester when diagnosed with cancer. Undergoes radical mastectomy.

Metropolitan Museum of Art acquires painting through the dissolution of the New York Art Project.

1944 **January.** Lectures as visiting artist in Lila Ulrich's class, Sarah Lawrence College, Bronxville, N.Y.

August 1. Lectures, "Perspective vs. Space-Time," Oliver Larkin's summer course on "The Arts Today" at Smith College.

1945 **March 19.** Lecture, Artists' League of America. Panel topic: "Some

Trends in American Art." Fellow panelists: Philip Evergood, Nat Werner, and Robert Gwathmey.

August. Signs petition for raising minimum wage.

October. Wins $500 award, Pepsi-Cola Third Annual Exhibition. 1946

November 3. Name appears on list of artists in the *New York Times* protesting the resignation of James Johnson Sweeney from the Museum of Modern Art.

May 13. Pereira's name appears in *Congressional Record* for alleged Communist sympathies. 1947

June 10. Participates in panel discussion on "Why the Conflict over Modern Art?" broadcast by WQXR. Pereira listed as member of Artists' Equity.

February 27. Participates in panel discussion on "New Roads in Science 1948 and Education: The Artist Meets the Critics." Broadcast on March 2.

April 23. Participates in Museum of Modern Art's Committee on Art education program of studio visits for art educators, arranged by Victor D'Amico.

Begins Jungian psychoanalysis.

February 12. Contributes to auction "Artists for Neighborhood Art," 1949 held at Sidney Janis and Betty Parsons galleries, to benefit United Artworkshops of Brooklyn Neighborhood Houses.

March 11. Representative Dondero introduces name into *Congressional Record* for alleged Communist sympathies.

March 12. Presents lecture at New York's Town Hall.

March 25–27. Cultural and Scientific Conference for World Peace, Waldorf-Astoria Hotel, New York. Pereira listed as sponsor in *New York Times,* March 24.

April 29. Paints dress designed by Jo Copeland, one of ten "Living Canvases" auctioned at the Artists Equity Association's annual costume ball.

May 4. Participates in seminar "Abstraction in Modern Art" at Howard University, Washington, D.C.

Summer. Sponsors Mexican Art Workshop, Ajijic, Mexico, associated with the University of Guadalajara.

Before July. Separates from George Brown.

August. Meets George Reavey.

September 18–November 29. In France. Returns via Le Havre.

February 10. George Reavey leaves U.S. on *Ile de France.* Mark Rothko 1950 is in send-off party.

February 26. Flies to Florida to initiate divorce proceedings against George W. Brown.

March 19. Receives invitation to teach at Black Mountain College during the summer. Declines.

March 24. Participates in the Museum of Modern Art's Committee on Art Education program "Art Education 1950, Teaching in Action," with studio visits for art educators. Gives demonstrations on the use of plastics and other new materials.

May. Stays at Bell's Rest Ranch, South Daytona, Fla., to arrange for divorce. Returns to New York June 4 or June 5.

June 6. Divorce granted, Daytona Beach, Fla.

June 14. Sails for England, arrives June 16.

July 30. Pereira and Reavey prepare hand-drawn certificate of "marriage."

September 9. Marries George Reavey, London. Witnesses include Dylan Thomas, Helen McAlpine, and W. R. Rogers.

September. Reavey and Pereira reside in Salford, England. Reavey teaches Russian grammar and literature at the University of Manchester.

Fall. Mark Rothko visits Reavey and Pereira in England.

December 12. Reavey and Pereira attend opening ceremony at Institute of Contemporary Arts, London.

December. Receives "care package" of food from Holger Cahill and Dorothy Miller.

Berenice Kazounoff acts as Pereira's dealer, through August 1951.

1951 **May 8.** Leaves Manchester. Returns to U.S. on S.S. *Washington*. Arrives May 15.

May. Joins Durlacher Brothers Gallery. Celebrates the signing with Holger Cahill and Dorothy Miller.

June 13–July 14. Teaches at Ball State Teachers' College. Stays at 620 North McKinley Avenue. Visits Cincinatti on return trip to New York.

August 1. George Reavey resigns from the University of Manchester. Moves to London.

October 3. Opening of one-artist show at Durlacher's. James Johnson Sweeney and Lloyd Goodrich in attendance. Interview by Aline Louchheim, *New York Times,* broadcast on radio.

October 14. Participates in panel discussion with Philip Evergood and Amédée Ozenfant, broadcast by WNYC from the Brooklyn Museum, in celebration of WNYC's Second Annual Art Festival.

October 17. Conducts broadcasted gallery tour at Durlacher's in connection with WNYC's festival. Participates with painters Minna Citron, Stefano Cusamano, and Jack Levine in broadcast session on the "Artist and the Community."

December. Donates ink and casein drawing to Moholy-Nagy Scholarship Auction to benefit students of the Institute of Design in Chicago.

1952 **Spring.** "Light and the New Reality" published in *Palette.* First publication of Pereira's philosophy.

April 15. Lecture, "Light and the New Reality," Dayton Art Institute.

May. Glass painting *Rhythmic Movement* (c. 1952) exhibited in Sak's window in connection with "Art for Fashion's Sake; Fashion for Art's Sake," Artists Equity Association's Spring Fashion Ball, Hotel Astor, May 15. *Shooting Stars* (1952) and *Seven Red Squares* (1951) used in window display at Bonwit-Teller Department Store. Windows designed by Charles Gene Moore.

Last paintings on glass and parchment.

Hires Shirley Burke as literary agent, through Roger Brown, Inc., Product Publicity and Public Relations, New York.

Teaches in Artists Equity Workshop on exploring new materials and methods. Resigns in November.

1953 **August.** Spends time at the MacDowell Colony, New Hampshire. Meets Thornton Wilder, who introduces her to the work of Kierkegaard.

August. Makes first unsuccessful attempts to find publisher for "Eastward Journey."

October 6. Presents lecture, "Encaustic Methods and Materials," in connection with exhibition Tools and Techniques of Painting at Montclair Art Museum, Montclair, N.J.

Four drawings issued in print series by Arthur Rothmann Fine Arts, Inc., New York.

January. Pereira's introduction appears in catalogue of Robert E. Borgatta's one-artist show at Wellons Gallery, held January 18–30.

April 13. Speaks of her philosophy at Hofstra College.

April 25. Member of panel discussing "The Retreat and Advance of Color in Modern Painting" at the Marcia Clapp Gallery, New York.

May. Takes part-time job as typist at Macy's Department Store.

March–July. George Reavey at Yaddo Colony, Saratoga Springs, N.Y.

July 21. Presents lecture, "Women and Dimensions in Art," at symposium "Women in the World of Men" at the University of Michigan, Ann Arbor. Participates in panel discussion on "The Artist's Values and Perspectives."

August. George Reavey at MacDowell Colony.

December 13. Leaves Reavey.

March 2. Signs separation agreement with Reavey.

February 22. Joins Nordness Gallery, New York.

February. Elected Life Fellow, International Institute of Arts and Letters, based in Lindau-Bodensee, Germany. Begins to use letters FIAL with her signature.

July 16. Divorces Reavey, Marion County, Ala.

May 24–August 3. Sails on S.S. *Saturnia* to Italy. Arrives in Naples June 3. Visits Caresse Crosby's Castle Roccasinibaldi. Visits Venice and Rome. Arranges for exhibition with Rome–New York Foundation to open in October. Returns to New York.

October 25. Returns to Rome for opening of show. Visits the home of John L. Brown in the Torre del Grillo.

December 12. Returns to New York.

April. Gives notice that she will leave the Nordness Gallery effective May 31.

March. Deluxe edition of serigraphs of *Landscape of the Absolute,* signed and numbered by artist, issued.

Summer. Joins Amel Gallery.

August 31. Ree Dragonette writes and sends copies of press release headed "Suppression and the Death of Art" concerning alleged suppression of Pereira's work to the Museum of Modern Art, Metropolitan Museum of Art, S. R. Guggenheim Museum, and Whitney Museum of American Art.

December. In Rome.

April 10. Lectures on "The Self-Destroying Machinery of Mindlessness" at Madison College, Harrisonburg, Virginia, in connection with an arts festival on "Creativity in the Arts."

July 12. Attends Aldo Tambellini's protest demonstrations at the major New York museums. Issues a statement in support of Tambellini's activities.

1954

1955
1956
1958
1959

1960

1961

1962

1963 **February 7–April 7.** In Rome, Hotel Eden.
 May. Juror for annual exhibition of the National Association of Women Artists.
 May 26–June 1. In Rome, Hotel Eden.
 June. Stays at Castle Roccasinibaldi. Travels with Caresse Crosby and Robert Mann to Perugia and Sienna June 25. Continues travel with them to Ferrara, Padua, and Venice June 27–July 2.
 July 27–August 2. In Rome, Hotel Daniel Royal Excelsior.
 July. Joins Galerie International, New York (from Italy).
 September. First days of the month in Zurich to visit Siegfried Giedion. Stays at Hotel Ascot.
 September 4–8. In London, Savoy Hotel.
 September 9–12. In Parma, Jolly Hotel.
 September 12–14. In Milan, Palace Hotel.
 October. Returns to U.S.
 November. Meets weekly with Paulist Father Lloyd at the Church of St. Paul the Apostle, New York, for religious instruction.
 December 4. Baptized into the Catholic Church, with baptismal name of Livia.

1964 **June.** Juror, with Vincent Price, for Southern California Exposition of Art in All Media, San Diego County Fair, Del Mar, Calif.

1965 **January.** Juror of watercolors, Audubon Artists, twenty-third annual exhibition.
 March 1. Lectures on "Art and Space" to the Artists' Guild, Norton Gallery of Art, Palm Beach, Fla. Juror for its Forty-seventh Annual Members' Exhibition.
 April. Travels to Washington, D.C., for opening of one-artist show at Agra Gallery. Accompanied by Frances Steloff.
 June 30. Reading of *Poetics of the Form of Space, Light and the Infinite* by Marian Seldes, Martin J. Kelley, Malcolm Merritt, Jr., and the author at Gotham Book Mart.

1966 **May 27.** Panelist for "Artists' Voices for India," readings to benefit the *Literary Half-Yearly,* published in Mysore, India, held at New India House, New York.
 July 26. Interviewed by Arlene Jacobowitz for the Brooklyn Museum's "Listening to Pictures" Gallery.
 July. Becomes new and regular contributor to the *Literary Half-Yearly,* out of Mysore, India, edited by H. H. Anniah Gowda.
 October. Travels to Wilmington College, N.C., to be exhibition juror.

1968 **January.** Enters St. Vincent's Hospital during first week of the month and returns home during the first week of February. Recuperates an additional six weeks at home. Hospitalized for severe breathing difficulties.
 March 7. Lectures on "The Logos Principle" at Gotham Book Mart Gallery.
 May 15. Name appears in political advertisements for Robert F. Kennedy. Attends luncheon with Ethel Kennedy and other Kennedy supporters in mid-May.
 May. Joins Kennedy Galleries.

June. Becomes Honorary Poet Laureate of United Poets Laureate International, headquartered in the Philippines.

August 26. Interviewed by Forrest Selvig for the Oral History Collection, Archives of American Art, Washington, D.C.

I. Rice Pereira Foundation established.

March. Attends Carl Stough Breathing Institute, New York.

March. Honorary doctorate conferred by L'Université Libre (Asie), Karachi, Pakistan, and the International Federation of Scientific Research Societies of Europe, Asia, Africa, and America. Begins to use the title "Dr." in her signature.

July 14. Attends Rent Administration hearing. Landlord begins eviction proceedings against Pereira.

July. Named to Honorary Advisory Board of *Portal,* a journal of interdisciplinary thought.

July 29–August 19. Travels to Portugal. Arrives Lisbon July 30. Visits Algarve, Portugal, Lisbon, and Praia da Rocha. Travels with sister-in-law, Hélène Rice.

October. Severs connections with Kennedy Galleries.

July 11–August 11. Travels to Paris, Madrid, and Brussels. Accompanied by Andre Sovulevski. Locates and purchases apartment in Marbella, Spain. Visits Clinique Sylvana in Epalinges, Switzerland. Misses August 5 hearing before the New York City Rent Administration due to clinic stay. Letters to friends indicate diagnosis not good.

December. Signs 100 copies of *The Lapis* reprint.

December 12. Leaves the U.S. for Marbella, Spain, following eviction from apartment in New York.

New Address: Skol Hotel, La Fontanilla, Marbella, Spain.

January 11. Dies in Marbella, Malaga province. Survived by her mother and her sister Juanita, both in New York, and her brother, James, in Paris. I. Rice Pereira Trust formed, administered by nephew, Djelloul Marbrook.

Exhibitions

This list has been compiled from catalogues, exhibition reviews, correspondence, packing and transport service records, museum records, and so forth. It includes all known one-artist shows, shows in the New York area during the artist's lifetime, and a sampling of shows outside that area. All listings took place in New York unless otherwise indicated.

The following abbreviations are used: American Contemporary Arts Gallery = ACA; Whitney Museum of American Art = WMAA; Museum of Modern Art = MoMA; Metropolitan Museum of Art = MMA.

1930 **November.** Art Center. Opportunity Show.

1933 **January.** ACA. Exhibition of Painting: I. Rice Pereira.
April. Brooklyn Museum. Annual Exhibition of Allied Artists of America, Inc. Twentieth Century Exhibition.

pre-1934 College Art Association (probably through the College Artists' Cooperative).
New School for Social Research.
New York Public Library.

1934 **February–March.** ACA. I. Rice Pereira.
April. ACA. I. Rice Pereira.
July–August. Theodore A. Kohn and Son, Jewelers. Exhibition of black and white, pencil and ink drawings and watercolors.
September–October. Contemporary Arts. Exhibition devoted to marine painting theme; opened the week of the America's Cup races.
November–January. WMAA. Second Biennial Exhibition.
December. Winter Exhibition of the Academy of Allied Arts.

1935 **December–January.** ACA. Christmas Show.
January. Uptown Gallery of the Continental Club. Water-Colors and Prints.

January. Washington, D.C.

February–March. WMAA. Abstract Painting in America.

March–April. Uptown Gallery of the Continental Club. Group of Modern Artists.

April. ACA. I. Rice Pereira—Hy Cohen.

April. ACA. The Social Scene in Art.

May. Sixtieth Street Gallery. Low-Price Exhibition.

May–June. Uptown Gallery of the Continental Club. Seventeen Madonnas.

May–August. Contemporary Arts at Park Lane. Exhibition of watercolors and drawings.

September–October. Brooklyn Museum. Oil Paintings by Living Artists.

October. Chicago. Art Institute. Forty-Sixth Annual Exhibition of American Painting and Sculpture.

October–November. Uptown Gallery of the Continental Club.

October–November. Roerich Museum.

November–January. Uptown Gallery of the Continental Club.

January–February. Uptown Gallery of the Continental Club. As the Artist Sees Himself.

March. Uptown Gallery of the Continental Club.

April. Municipal Art Committee.

April. Uptown Gallery of the Continental Club.

January. East River Gallery. Exhibition of rental pictures.

April. Municipal Art Committee, City of New York. Sixth Exhibition.

April. Mezzanine Galleries, Rockefeller Center. First Annual Membership Exhibition, American Artists Congress.

November. East River Gallery.

December. Artists' Gallery. Christmas Show.

December. American Artists Congress. An Exhibition in Defense of World Democracy; Dedicated to the Peoples of Spain and China.

March. Howard University Gallery of Art, Washington, D.C. WPA Art Project Show.

March. Howard University Gallery of Art, Washington, D.C. I. Rice Pereira.

March 24. East River Gallery. Four Gala Night Exhibits: I. Rice Pereira, David Sortor, Collages and Poetry.

April–May. Wanamaker's Department Store. American Artists Congress, Second Annual Membership Exhibition.

April–May. La Maison Française Galleries, Rockefeller Center. An American Group, Inc. Roofs for Forty Million.

May. Laboratory School of Industrial Design. Faculty Show.

October. Springfield Museum of Fine Arts, Springfield, Mass. Artists Union. National Exhibition.

November–December. ACA. American Artists Congress, Second Annual 8" x 10" Exhibition.

February–March. Julien Levy Gallery. I. Rice Pereira, with lighting by Feder. Held concurrently with Leonor Fini exhibition.

February. American Artists Congress. Third Annual Membership Exhibition; Art in a Skyscraper.

February–March. Federal Art Gallery. WPA Easel Division. Exhibition: Oils—Gouaches—Watercolors.

March. Riverside Museum. American Abstract Artists Third Annual Exhibition.

May. Federal Art Gallery. WPA Easel Division. Art in the Making.

August–September. Berkshire Museum, Pittsfield, Mass. The World of Today.

September. ACA. Free Speech for Artists. Exhibition in response to W. R. Hearst editorial, August 15, 1939.

1940 **January–February.** Museum of Non-Objective Painting. Three American Non-Objective Painters: I. Rice Pereira, Balcomb Greene and Gertrude Greene.

May–June. Rockefeller Center. United American Artists Annual Exhibition.

May. New World's Fair, American Art Today Building. Exhibition of WPA art.

May–June. Galerie St. Etienne. American Abstract Artists. National Exhibition.

June. Fine Arts Building. American Abstract Artists Fourth Annual Exhibition.

July. Museum of Non-Objective Painting.

October. Museum of Non-Objective Painting. Art of Tomorrow.

October–November. Museum of Non-Objective Painting. Twelve American Non-Objective Painters.

1941 **February.** Riverside Museum. American Abstract Artists Fifth Annual Exhibition.

March. MoMA. New Acquisitions.

May. Rockefeller Plaza. United American Artists.

July. MMA. Works in Use. WPA art allocated to public institutions.

July. Museum of Non-Objective Painting.

August. ACA.

United China Relief, Inc. Art for China Exhibition and Sale.

MMA. Works in Use. Exhibition of WPA/FAP art.

1942 **March–May.** Flint Institute of Arts and Cincinnati Modern Art Society.

March. Fine Arts Galleries. American Abstract Artists Sixth Annual Exhibition.

April. Third New Masses Art Auction.

April–May. Helena Rubenstein's New Art Center. Masters of Abstract Art, an Exhibition for the Benefit of the American Red Cross.

June–September. Museum of Non-Objective Painting; group show.

June–July. ACA. Artists' League of America. Artists in the War.

July–August. MoMA. New Rugs by American Artists. Circulating exhibition of rugs; traveled to Frederick and Nelson Department Store, Seattle, Wash., among other locations.

August–September. Museum of Non-Objective Painting. I. Rice Pereira and László Moholy-Nagy.

Andre Seligmann Gallery. Exhibition in aid of Russian relief.

1943 **January.** Art of This Century. Exhibition by 31 Women.

March–April. Riverside Museum. American Abstract Artists. Seventh Annual Exhibition.

March. Art of This Century. Fifteen Early, Fifteen Late Paintings.

April–May. Art of This Century. Art of Collage.

May–June. Art of This Century. Spring Salon for Young Artists (Under 35 Years Old).

June–July. New Acquisitions Gallery, MoMA. Painting and Sculpture by Young Americans.

November–December 1944. Tomorrow's Masterpieces, Inc. Exhibition opened in November at R. H. Macy and Company, then circulated to other department stores.

January. Art of This Century. I. Rice Pereira.

April. Art of This Century. First Exhibition in America of (Twenty Paintings).

April. San Francisco Museum of Art. Abstract and Surrealist Art in the United States. Exhibition traveled to Cincinnati, Denver, Seattle, Portland, Santa Barbara, and New York City, at the Mortimer Brandt Gallery, in November and December.

May–June. Art of This Century. Spring Salon for Young Artists.

June. MoMA. Art in Progress—Fifteenth Anniversary Exhibition.

October–January 1945. Newark Museum. A Museum in Action.

November–December. WMAA. Annual Exhibition of Contemporary American Painting.

December. 67 Gallery.

March. Arts Club of Chicago. I. Rice Pereira Retrospective Exhibition. Shown concurrently with work of Jackson Pollock.

March–April. Smith Art Museum, Springfield, Mass. A Painting Prophecy—1950. Organized by David Porter and shown through courtesy of David Porter Gallery, Washington, D.C.

June–July. Art of This Century. The Women.

November–December. Mezzanine Galleries of International Building, Rockefeller Center. Artists for Victory, Inc. Pepsi Cola Second Annual Portrait of America. Followed by national tour.

November–January 1946. WMAA. Annual Exhibition of Contemporary American Painting.

February. ACA. Paintings by I. Rice Pereira.

March. Troeger Phillips, Inc.

March–April. American-British Art Center. American Abstract Artists. Tenth Annual Exhibition.

Summer. Tate Gallery, London. 200 Years of American Painting.

September. Walker Art Center, Minneapolis. Third Annual Purchase Exhibition.

September–October. One-artist show. Kraushaar Galleries.

September–December. MoMA. Fourteen Americans.

October. WMAA. New Acquisition.

October. MMA. U.S. State Department's Office of International Information and Cultural Affairs. Advancing American Art. In November, the exhibition was divided into two parts, one traveling to Havana, the other traveling to Paris and Prague. Exhibition was recalled in 1947. May–June 1948 exhibited at WMAA and works sold by the War Assets Administration as war surplus.

October. National Academy Galleries. Pepsi Cola Third Annual. Contin-

ued to Pennsylvania Academy, December; Walker Art Center, Minneapolis, January–February 1947; Syracuse Museum, March–April 1947.

December. ACA. Evolution of a Painter.

December–January 1947. WMAA. Annual Exhibition of Contemporary American Painting.

U.S. State Department. China Show.

1947 **January.** National Academy of Design. 121st Annual Exhibition.

January. ACA. Group show of Pepsi Cola Annual winners.

January. Barnett Aden Gallery, Washington, D.C.

January–February. Riverside Museum. Second Annual Exhibition of the La Tausca Art Competition. Sponsored by Hellar-Deltah Co.

February–March. San Francisco Museum of Art. Paintings by I. Rice Pereira.

April. WMAA. Watercolor and Sculpture Annual.

April. Riverside Museum. American Abstract Artists. Eleventh Annual Exhibition.

April. Renaissance Society, University of Chicago. I. Rice Pereira.

April–June. Brooklyn Museum. Fourteenth Biennial International Watercolor Exhibition.

September–July 1948. MoMA. How the Artist Works. Circulating exhibition.

October–November. Kunsthaus, Zurich. Solomon R. Guggenheim Foundation. Zeitgenossische Kunst und Kunstpflege in USA. Continued to Brussels.

October–December. Wadsworth Atheneum, Hartford, Conn. Fifty Painters of Architecture.

November–January 1948. Art Institute of Chicago. Fifty-eighth Annual Exhibition of American Painting and Sculpture: Abstract and Surrealist American Art.

December–January 1948. WMAA. Annual Exhibition of Contemporary American Painting.

High School of Music and Art.

1948 **January–February.** Newark Museum. Seeing Modern Art.

February–March. University of Illinois. Competitive Exhibition of Contemporary American Paintings.

June–August. Toledo Museum of Art. Thirty-fifth Annual Exhibition of Contemporary American Paintings.

August. ACA.

October–December. Carnegie Institute, Pittsburgh. Painting in the United States 1948.

November. Knoedler Galleries. Miller Company Collection. Painting toward Architecture.

November–January 1949. WMAA. Annual Exhibition of Contemporary American Painting.

December–January 1949. Barnett Aden Gallery, Washington, D.C. I. Rice Pereira.

Venice Biennale.

1949 **January.** U.S. Naval Hospital in St. Albans, Queens.

January. Institute of Contemporary Art, Boston.

February. Addison Gallery, Phillips Academy, Andover, Mass. The Material and the Immaterial.
February. Boston, Institute of Contemporary Art. Milestones of American Painting.
February. Town Hall Lecture by Emily Genauer.
February–March. ACA
April–May. WMAA. Annual Exhibition of Contemporary American Painting.
May. Howard University. Fourth Annual Festival of Fine Arts.
May. Isaac Delgado Museum of Art, New Orleans. Round and About.
May–June. Brooklyn Museum. Nineteenth Biennial International Watercolor Exhibition.
June. Janis Gallery. Post-Mondrian geometric abstraction.
September–October. WMAA. Juliana Force and American Art.
October. Barnett Aden Gallery, Washington, D.C. Sixth Anniversary Exhibition of Contemporary American Art.
October–December. Carnegie Institute, Pittsburgh. Painting in the United States.
November–December. Pennsylvania Academy of Fine Arts. Forty-seventh Watercolor and Print Annual.
December–February 1950. WMAA. Annual Exhibition of Contemporary American Painting.
MoMA. Modern Art in Your Life.

February. Detroit Art Institute. 1950
February. Springfield Art League, Smith College. Thirty-first Annual Jury Exhibition.
April–May. WMAA. Annual Exhibition of Contemporary American Painting.
April–June. Virginia Museum of Fine Arts. American Painting 1950.
May–June. Institute of Contemporary Art, Boston. Six Women Painters from New England.
May–June. Baltimore Museum of Art. Paintings: Loren MacIver, Irene Rice Pereira. Traveled to Santa Barbara Museum of Art, July–August; Portland Art Museum, September; M. H. de Young Memorial Museum, San Francisco, October.
June–August. University of Michigan, Ann Arbor. Postwar American Painting.
October. San Francisco Palace of the Legion of Honor.
October–December. Carnegie Institute, Pittsburgh. The 1950 Pittsburgh International Exhibition of Paintings.
November–December. WMAA. Annual Exhibition of Contemporary American Painting.
December–January 1951. Institute of Contemporary Arts, London. 1950 Aspects of British Art.
Amsterdam. Amerika Schildert.

January. The Memphis Academy of Arts, Memphis, Tenn. 1951
January–March. MoMA. Abstract Painting and Sculpture in America.
February. Syracuse University. Two Exhibitions. Joint exhibition with Frederick Haucke.

Spring. University of Minnesota. Forty American Painters, 1940–1950.
Spring. Philbrook Art Center, Tulsa, Okla. International Watercolor Exhibition.
May–June. Baltimore Museum of Art. Abstraction by I. Rice Pereira.
June. Paris. Paris–New York 1951.
June. Ball State Teachers College, Muncie, Ind.
August–December. Berlin, Munich, Vienna. Cultural Festival.
October. Durlacher Gallery. I. Rice Pereira.
October–December. São Paulo Museum of Art, Brazil. The First Biennial of the São Paulo Museum of Modern Art.
November–December. Gallery of the American Academy of Art. Arts and Letters Grants.
November–January 1952. WMAA. Annual Exhibition of Contemporary American Painting.

1952 **January.** Phillips Memorial Gallery, Washington, D.C. Painting by I. Rice Pereira.
March–April. Dayton Art Institute. An Exhibition by I. Rice Pereira.
June–July. Durlacher Gallery.
July–August. Toledo Museum of Art. Annual Exhibition of American Paintings.
August–November. Barnett Aden Gallery, Washington, D.C.
November–December. Howard University, Washington, D.C. Trends in American Drawings.
November–December. Worcester Art Museum. Painter's Choice. Gallery 16, Zurich.

1953 **January–March.** WMAA. Loren MacIver, I. Rice Pereira: A Retrospective Exhibition.
March. John Wanamaker's, Great Neck, N.Y. Art in America 20th Century.
September. Grace Borgenicht Gallery. New Work in Stained Glass by Contemporary Americans.
September–October. Montclair Art Museum, N.J. An Exhibition of Paintings, Preparatory Sketches, Materials and Tools of the Painter.
September–October. Durlacher Gallery. I. Rice Pereira.
October–November. Syracuse Museum. Abstract Painting in America.
October–December. WMAA. Annual Exhibition of Contemporary American Painting.
October–December. Munson-Williams Proctor Institute, Utica, N.Y. Formal Organization in Modern Painting.

1954 **January.** Adele Lawson Galleries, Chicago. Gouaches by I. Rice Pereira.
January–February. Pennsylvania Academy of Fine Arts. 149th Annual Exhibition.
February–March. Virginia Museum of Fine Arts. American Painting 1954.
February–March. Nebraska Art Association. Sixty-Fourth Annual Exhibition of American Painting.
April. Hofstra College. An Exhibit of Paintings by I. Rice Pereira.
April–May. Des Moines Art Center. American Painting 1954.
May. Durlacher Gallery. I. Rice Pereira.

May. Barnett Aden Gallery, Washington, D.C. Tenth Anniversary Show.
June–August. Toledo Museum of Art. Forty-first Annual Exhibition of Contemporary American Paintings.
July. University of Michigan, Ann Arbor. Three Women Painters, with Kay Sage and Dorothea Tanning.
August. Barnett Aden Gallery, Washington, D.C. Abstractions.
September–October. Durlacher Gallery. Gouaches by I. Rice Pereira.
September–October. Grace Borgenicht Gallery. Accent Rugs by Contemporary American Artists.
October–December. Art Institute of Chicago. 61st American Exhibition Paintings and Sculpture.
November–December. WMAA. Roy and Marie Neuberger Collection of Modern American Painting and Sculpture. Traveled to Arts Club of Chicago, January 1955; Art Gallery of the University of California, February–April 1955; San Francisco Museum of Art, April–June 1955; City Art Museum of St. Louis, June–August 1955; Cincinnati Art Museum, August–September 1955.
November. MoMA. Paintings from the Museum Collection.

January–February. WMAA. Annual Exhibition of Contemporary American Painting.
February–April. University of Illinois-Urbana. Contemporary American Painting and Sculpture.
March. Academy Art Gallery. National Institute of Arts and Letters. Exhibition of Works by Candidates for Grants in Art for the Year 1955.
October. Philadelphia Art Alliance. I. Rice Pereira: An Exhibition of Paintings.
November–December. Delius Gallery. Great Women Artists; 16th–20th Centuries.
November–January 1956. WMAA. Annual Exhibition of Contemporary American Painting.
December–January 1956. Arts Club of Chicago. Accent Rugs Woven by Gloria Finn and Designed by American Painters.
Ball State University, Muncie, Ind. First Annual Drawing and Small Sculpture Show.
Addison Gallery of American Art, Phillips Academy, Andover, Mass. The Naked Truth and Personal Vision.

February–March. Corcoran Gallery of Art, Washington, D.C. I. Rice Pereira.
March. International Association of Plastic Art, U.S. Committee.
April–June. Newark Museum. Abstract Art 1910 to Today.
May. Wellons Gallery. A Comprehensive Exhibition of Paintings by I. Rice Pereira. Held concurrently with publication of *The Nature of Space*.
May. Corcoran Gallery, Washington, D.C. Collecting for Pleasure.
May. Fort Worth Art Center. Five Women Painters.

October–December. Barnett Aden Gallery, Washington, D.C. 14th Anniversary Exhibition Contemporary American Art.

January. Madison Square Garden. Art: USA.
January. WMAA. Nature in Abstraction.

1955

1956

1957

1958

March–April. Nordness Gallery. The Gallery Family.

April. WMAA. Exhibition of reproductions of paintings from Twentieth Century Highlights of American Painting, assembled by U.S. Information Agency for distribution to government posts abroad.

June. Denver Art Museum. Collector's Choice.

September. Nordness Gallery. An Exhibition of Works by the Gallery Roster Completed during Summer 1958.

November. Nordness Gallery. I. Rice Pereira Recent Paintings.

U.S. Information Agency. Twentieth Century Highlights of American Painting. European circulation.

1959 **April–May.** L'Annunciata Gallery, Italy. Undici artisti americani.

September–November. Nordness Gallery. Exhibition of *Crystal of the Rose*.

October. Grand Rapids Art Gallery. Rugs for Today and Tomorrow. Traveled to Seattle Art Museum and Art Center, La Jolla, Calif.

November. American Art Institute of Decorators, New York.

December–January 1960. WMAA. Annual Exhibition of Contemporary American Painting.

1960 **October–February 1961.** Rome–New York Art Foundation, Inc., Rome. From Space to Perception.

October–November. Barnett Aden Gallery, Washington, D.C. Seventeenth Anniversary Exhibition of American Contemporary Art 1930–1960.

1961 **March–April.** Nordness Gallery. Space, Light and the Infinite.

May. Eastern Market, Washington, D.C. Capitol Hill Community Council. Old Market Gallery Art Show.

August. Knapnik Gallery.

September–October. Amel Gallery. The Poetic Image.

December. WMAA. Annual Exhibition of Contemporary American Painting.

1962 **February.** Ann Ross Gallery, White Plains, N.Y. I. Rice Pereira.

March–April. Virginia Museum of Fine Arts. American Painting 1962.

March–May. WMAA. Geometric Abstraction in America.

April. Madison College, Harrisonburg, Va. Arts Festival 1962—Creativity in the Arts.

April. Amel Gallery. Recent Paintings by I. Rice Pereira.

May–June. Makler Gallery, Philadelphia. I. Rice Pereira.

September. Milwaukee Art Center. S. C. Johnson and Son Collection. Art: USA, the Johnson Collection of Contemporary American Painting. Traveled to Tokyo, Bridgestone Gallery; Honolulu, Academy of Arts; London, Royal Academy of Arts; Athens, Zappeion; Rome, Palazzo Venezia; Munich, Haus der Kunst; Monaco, Casino de Monte Carlo, Salons Privés; Berlin, Congress Hall; Copenhagen, Charlottenborg; Stockholm, Liljevalchi Konsthall; Milan, Civico Padilione d'Arte Contemporanea; Brussels, Palais des Beaux Arts; Dublin, Municipal Gallery of Art; Madrid, Cason del Buen Retiro; Lucerne, Kunst-Museum.

1963 **February–March.** Women's College Gallery, Duke University. Women in Contemporary Art.

June. WMAA. Purchase show.

June. Galerie Internationale.

June–August. Norfolk Museum of Arts and Sciences. Alfred Khouri Memorial Collection.

October. University of Rochester. Selections from the Collection of the James A. Michener Foundation.

October. Ball State University.

December–January 1964. WMAA. Annual Exhibition of Contemporary American Painting.

March–April. Galerie Internationale. I. Rice Pereira.

June–September. WMAA. Between the Fairs: Twenty-Five Years of American Art 1939–1964.

October–December. Finch College Museum of Art. Artists Select.

November–December. Burgos Gallery. Contemporary Masters.

April–May. Newark Museum. Women Artists of America 1707–1964.

April–May. Agra Gallery, Washington, D.C. I. Rice Pereira.

October. Distelheim Galleries, Chicago. I. Rice Pereira.

December–January 1966. WMAA. Annual Exhibition of Contemporary American Painting.

March. Jason Gallery. Art for Architecture.

March–April. Norfolk Museum of Arts and Sciences. Contemporary Art USA.

April–May. Grippi and Waddell Gallery. Artists for CORE Scholarship, Education and Defense Fund Show.

May–June. Heckscher Museum, Huntington, N.Y. Whence Op?

August–September. New York State Fair Grounds, Syracuse. 125 Years of New York Painting and Sculpture.

September–October. WMAA. Art of the United States 1670–1966.

November. Birmingham Museum of Art, Ala. Religion in Art.

December. Galerie Internationale. Third "Closed Bid" Auction and Exhibition.

July–September. WMAA.

December–February 1968. WMAA. Annual Exhibition of Contemporary Painting.

American Embassy, Madrid, Spain.

January. Wilmington College, N.C. Traveled to Weatherspoon Art Gallery, Greensboro, N.C., February; Mint Museum, Charlotte, N.C., March.

April–May. Westbrook Junior College, Portland, Maine. The Mysterious Alliance—Artists and Their Poetry.

August. Maxwell Galleries, Ltd., San Francisco. American Art since 1850.

January–March. Corcoran Gallery of Art, Washington, D.C. 31st Biennial Exhibition of Contemporary American Painting.

May–June. Baltimore Museum of Art. Edward Joseph Gallagher III Memorial Collection.

December–January 1971. WMAA. Women Artists in the Museum Collection.

February–March. Salem College, Winston-Salem, N.C. Women: A Historical Survey. Traveled to North Carolina Museum of Art, Raleigh, March–April.

April–June. Baltimore Museum of Art. Women Artists.

249

*Appendix Two
Exhibitions*

1964

1965

1966

1967

1968

1969

1970

1972

1974 **January–May.** Anacostia Neighborhood Museum, Washington, D.C. The Barnett-Aden Collection.

 April–May. Andre Zarre Gallery, I. Rice Pereira.

1975 **January–February.** Corcoran Gallery of Art, Washington, D.C. The Barnett-Aden Collection.

 Andre Zarre Gallery.

1976 **April–May.** Andrew Cripo Gallery. I. Rice Pereira.

 October. Westbeth Gallery. Memorial Exhibition for Josef Albers, G. L. K. Morris, I. Rice Pereira, and Charles Shaw.

1977 **September–December.** S. R. Guggenheim Museum. From the American Collection.

 Andre Zarre Gallery

1978 **April-June.** Montgomery Museum of Fine Arts, Montgomery, Ala. American Art 1934–1956, Selections from the Whitney Museum of American Art. Traveled to Brooks Memorial Art Gallery, Memphis, Tenn., June–August; Mississippi Museum of Art, Jackson, Miss., August–October.

 October–November. Andre Zarre Gallery.

1979 Andre Zarre Gallery.

1981 **November–December.** Andre Zarre Gallery. Irene Rice Pereira.

1983 **November–December.** Museum of Art, Carnegie Institute, Pittsburgh. Abstract Painting and Sculpture in America 1927–1944. Traveled to San Francisco Museum of Art, January–March 1984; Minneapolis Institute of Arts, April–June 1984; WMAA, June–September 1984.

1984 **October–November.** Andre Zarre Gallery. Irene Rice Pereira.

1985 Andre Zarre Gallery.

1988 **October–January 1989.** National Museum of Women in the Arts. Irene Rice Pereira's Library: A Metaphysical Journey.

Notes

INTRODUCTION

1. Ronald W. Clark, *Einstein: The Life and Times* (New York: World Publishing Company, 1971; Avon, 1972), p. 524.

2. Lincoln Barnett, "The Starry Universe," *Life,* December 20, 1954, p. 64.

3. Clark, *Einstein,* p. 527.

4. William Ralph Inge, as quoted in ibid.

5. See Pereira to Cindy Nemser, January 14, 1970, Archives of American Art (AAA) roll 1298; or Pereira to Judy K. van Wagner, October 28, 1969, AAA roll 1298.

6. John Russell, "On Finding a Bold New Work," *New York Times,* May 16, 1976, sec. 2, p. 31.

7. Griselda Pollock, "Vision, Voice and Power: Feminist Art History and Marxism," *Block* 6 (1982): 15.

8. Elaine Showalter, "Feminist Criticism in the Wilderness," in *The New Feminist Criticism: Essays on Women, Literature, Theory,* ed. Elaine Showalter (New York: Pantheon Books, 1985), p. 264.

9. Beverly Wolter, "She Joins Philosophy, Art," unidentified clipping, dated October 7, 1967, Irene Rice Pereira Archive, the Arthur and Elizabeth Schlesinger Library on the History of Women in America, Radcliffe College, Cambridge, Mass. (hereafter cited as IRP-SL).

10. Pereira to George Reavey, August 8, 1951, George Reavey Archive, Harry Ransom Humanities Research Center, University of Texas at Austin (hereafter abbreviated GR-UT).

11. Pereira, notes, February 24, 1964, AAA roll D222.

12. Pereira to Reavey, December 14, 1958, and January 10, 1959, GR-UT.

1. BACKGROUND, TRAINING, AND EARLY
PHILOSOPHICAL READINGS

1. John I. H. Baur, *Loren MacIver; I. Rice Pereira* (New York: Macmillan Company, 1953), pp. 39–66.

2. Forrest Selvig, typed transcript, "Tape-Recorded Interview with Irene Rice Pereira in Her Apartment in New York City August 26 [and 27], 1968" (Archives of American Art, Smithsonian Institution, Washington, D.C.), p. 44; Therese Schwartz, "Demystifying Pereira," *Art in America* 67 (October 1979): 114–119.

3. A copy of Pereira's birth certificate is in the author's possession. The surviving passport is in her archive at the Arthur and Elizabeth Schlesinger Library on the History of Women in America, Radcliffe College, Cambridge, Mass. Pereira's description of her mother may be found in Selvig interview transcript, p. 55. She gave her father's name as Emanuel to John I. H. Baur (Baur, *Loren MacIver*, p. 39) and to the author of the entry on her in *Current Biography* ("I[rene] Rice Pereira," in *Current Biography*, ed. Marjorie Dent Candee [New York: H. W. Wilson Co., 1954], p. 485).

4. The transcript of the Selvig interview remains the most important source of information about her childhood.

5. Ibid., pp. 1, 55–56, 59. (See notes and correspondence concerning her conversion on AAA rolls D222 and 1298.)

6. Ibid., pp. 55, 56; and Irene Rice Pereira, "Woman and Dimensions in Art," transcript of lecture presented at the University of Michigan, Ann Arbor, July 21, 1954, AAA roll 2395.

7. Letter, Djelloul Marbrook (Pereira's nephew) to author, February 28, 1987.

8. Selvig interview transcript, p. 57.

9. Baur, *Loren MacIver*, pp. 40–41.

10. John I. H. Baur, notes, I. Rice Pereira File, Whitney Museum of American Art, New York (hereafter cited as Baur notes, WMAA).

11. Baur, *Loren MacIver*, p. 41.

12. See letters, Pereira to Livio Olivieri, December 15, 1963, AAA roll 1298; and Pereira to Anniah Gowda, February 14, 1968, AAA roll 1298.

13. James Harithas, "I. Rice Pereira: American Painter-Writer with Bold Solutions to Old Problems," *Vogue* (June 1970): 129.

14. Throughout her adult life, Pereira claimed that her father died when she was fifteen. (See, for example, Baur, *Loren MacIver*, p. 41, and *Current Biography*, p. 485.) According to her actual birth date, this would place his death in 1917 or 1918; according to her adjusted birth date, it would be 1922 or 1923. I have been unable to confirm her father's date of death.

15. Baur, *Loren MacIver*, p. 41; and biographical statement in brochure, *I. Rice Pereira: An Exhibition of Paintings*, Philadelphia Art Alliance, October 7–30, 1955.

16. "Costume Ball Top Artist Began Her Art Career in Boro School," *Brooklyn Eagle*, April 14, 1949, p. 21.

17. Cindy Nemser, *Art Talk* (New York: Charles Scribner's Sons, 1975), p. 82.

18. Schwartz, "Demystifying," p. 119.

19. "Costume Ball," p. 21.

20. Letter, Lawrence Campbell to author, February 5, 1987. See "Reviews and Previews," *Art News* 47 (September 1948): 50.

21. Jack B. Moore, *Maxwell Bodenheim* (New York: Twayne Publishers, 1970), pp. 38–39.

22. Djelloul Marbrook, undated memorial essay, c. 1971, AAA roll 1296.

23. These books are located with her library now in the collection of the Library of the National Museum of Women in the Arts, Washington, D.C.

24. Baur notes, WMAA. Rudolf Valentino's *The Sheik* and its sequel, *Son of the Sheik,* were released in 1921 and 1926, respectively.

25. Nancy G. Heller, "The Art Students League: 100 Years," *American Artist* 39 (September 1975): 80.

26. Rosina A. Florio, executive director, Art Students League of New York, to author, August 1, 1985; Marchal E. Landgren, *Years of Art: The Story of the Art Students League of New York* (New York: Robert M. McBride and Co., 1940), p. 115; Baur, *Loren MacIver,* p. 45.

27. George Santayana, *Reason in Art: Volume Four of "The Life of Reason"* (New York: Charles Scribner's Sons, 1905 [paperback reprint edition, New York: Dover Publications, 1982]), p. 206.

28. Selvig interview transcript, p. 56; telephone interview with Dorothy Dehner, New York, January 24, 1985; Elisabeth Sussman, "Pereira, Irene Rice," in Barbara Sicherman and Carol Hurd Green, eds., *Notable American Women: The Modern Period* (Cambridge: Belknap Press of Harvard University Press, 1980), p. 534; Baur, *Loren MacIver,* p. 45.

29. Pereira, notes dated 7-21-62, AAA roll D222; "Camera," *New York Times,* February 9, 1936, sec. X, p. 9. After marriage, Pereira worked as a secretary in an insurance office (Baur, *Loren MacIver,* p. 45).

30. Dorothy Dehner, "Memories of Jan Matulka," in *Jan Matulka 1890–1972,* ed. Carroll S. Clark and Louise Heskett (Washington, D.C.: Smithsonian Institution Press, 1980), pp. 78–79; Patterson Sims, "Jan Matulka: A Life in Art," in ibid., pp. 24, 26.

31. Dehner, "Memories," p. 78; Sims, "Jan Matulka," p. 25.

32. Dehner interview, January 24, 1985.

33. Mary Zucker, "Pereira," in *Art USA Now,* 2 vols., ed. Lee Nordness (New York: Viking Press, 1963), 1: insert following p. 170.

34. Baur notes, WMAA.

35. The photograph is in her archive at Radcliffe. The book appearing in the photograph is otherwise unidentifiable. However, her interest in Corot may also be confirmed by her acquisition of Yvon Taillandier's much later monograph, *Corot,* published c. 1967.

36. Alfred A. Barr, Jr., quoted in L. M. [Leila Mechlin], "Corot and Daumier," *American Magazine of Art* 21 (December 1930): 705–706.

37. Oswald Spengler, *The Decline of the West,* 2 vols. (New York:

Alfred A. Knopf, 1926, 1928; reprint ed., 1983). In her copy of the first volume of this book, an inscription reads "Pereira" and "1928," although the name and date were penned at separate times and with different inks.

38. Ibid., 1: 25.

39. Ibid., 1: 104.

40. Ibid., 1: 103.

41. Ibid., 1: 105.

42. Ibid., 1: 424, 420, 424.

43. Ibid., 1: 174.

44. Ibid., 1: 175.

45. Ibid.

46. Stuart Hughes, *Oswald Spengler: A Critical Estimate* (New York: Charles Scribner's Sons, 1952), p. 97.

47. Lewis Mumford, "'Decline of the West': The First of the Series 'Books That Changed Our Minds,'" *New Republic,* January 11, 1939, 276, 277; William Dray, *Perspectives on History* (Boston: Routledge and Kegan Paul, 1980), p. 100. See also the chapter on Spengler in Theodor W. Adorno, *Prisms,* originally published in 1967.

48. Letter from Henry Miller to Anaïs Nin, July 28, 1933, as quoted in Stuhlmann, *A Literate Passion,* p. 197.

49. Letter, Anaïs Nin to Henry Miller, July 28, 1932, as quoted in ibid., p. 77.

50. Dehner interview, January 24, 1985.

51. Joseph Campbell, *Myths to Live By* (New York: Bantam Books, 1984), pp. 84–85.

52. See Hughes, *Oswald Spengler,* pp. 144–146.

53. Joseph Campbell to Pereira, November 29, 1966. The handwritten letter appears on AAA roll 1298.

54. Elie Faure, *History of Art,* vol. 5, *The Spirit of the Forms,* trans. Walter Pack (New York: Harper and Brothers, 1930), pp. xii–xiii.

55. Emanuel M. Benson, "Forms of Art," *Magazine of Art* 28 (February 1935): 77.

56. Raphael Petrucci, quoted in Emanuel M. Benson, "Forms of Art, IV: Phases of Calligraphy," *American Magazine of Art* 28 (June 1935): 356.

57. Le Corbusier, quoted in Edwin Avery Park, *New Backgrounds for a New Age* (New York: Harcourt, Brace and Co., 1927), p. 96.

58. J[ames] M[aude] Richards, "Towards a Rational Aesthetic: An Examination of the Characteristics of Modern Design with Particular Reference to the Influence of the Machine," *Architectural Review* 78 (December 1935): 218.

59. The Guilds' Committee for Federal Writers' Publications, *New York Panorama* (New York: Random House, 1938; Pantheon, 1984), p. 7.

60. Ibid., p. 19.

61. Campbell, *Myths,* p. 86.

62. Robert Goldwater, *Primitivism in Modern Art* (1938; New York: Vintage Books, 1967, revised edition), p. 30.

63. Charmion von Wiegand, "Sights and Sounds," *New Masses,* June 1, 1937, p. 27; P. W. Wilson, "America Discovers South Africa: Cu-

64. "Art of Our Simian-Like Ancestors on View," *Art Digest,* May 15, 1937, p. 7.

65. Benson, "Forms of Art," p. 73.

66. Hans Mühlestein, "Des origines de l'art et de la culture," *Cahiers d'Art* 5, no. 2 (1930): 139–145; James Webb, "Cosmology (Occult)," in *Encyclopedia of the Unexplained: Magic, Occultism and Parapsychology,* ed. Richard Cavendish (New York: Arkana, 1989; London: Routledge and Kegan Paul Ltd., 1974), p. 68.

67. Sims, "Jan Matulka," p. 16.

68. C. Howard Hinton, *The Fourth Dimension* (London: George Allen and Unwin Ltd., 1904; 1921 reprint of 2d edition), p. 1.

69. See Marianna Torgovnick, *Gone Primitive: Savage Intellects, Modern Lives* (1990), Edward W. Said, *Orientalism* (1978), Gayatri Spivak, *The Post-Colonial Critic* (1990), among others.

70. Schwartz, "Demystifying," p. 117.

71. Pereira's tribute to Alonzo J. Aden, dated September 17, 1960, and first appearing in the catalogue to the exhibition Seventeenth Anniversary Exhibition: American Contemporary Art 1930 to 1960, which opened at the Barnett-Aden Gallery in October 1960, is reprinted in *The Barnett-Aden Collection* (Washington, D.C.: Smithsonian Institution Press, 1974), p. 157.

72. Dehner, Foreword, *System,* pp. xiii–xiv.

73. Ibid., p. xviii; Djelloul Marbrook to author, December 27, 1983 and February 28, 1987.

74. Dehner, *Jan Matulka,* p. 79.

75. Dehner interview, January 24, 1985.

76. "List of Exhibitions," *Jan Matulka,* p. 90.

77. Telephone interview with Dorothy Dehner, New York, February 21, 1987. The etching is located in a portfolio of drawings in the collection of Andre Zarre, New York.

78. Baur, *Loren MacIver,* p. 45.

79. Selvig interview transcript, p. 2.

80. Emily Genauer, "Sketches Show Spontaneity of Pereira Work," *New York World Telegram,* July 24, 1934, unpaginated clipping, Pereira's scrapbook, AAA roll D223.

81. This information appears on a publicity brochure, printed in the summer of 1937, listing the faculty of the Design Laboratory affiliated with the Federation of Architects, Engineers, Chemists and Technicians (FAECT), and in "A Report of the Activities of the Design Laboratory of the Federation Technical School September 1935–September 1937," each of which appears on AAA roll 2395. These sources also indicate that she had "taught" at the Brooklyn Museum, although this appears to be untrue. She had probably presented a lecture/demonstration for the Brooklyn Art Center, one of the community art centers sponsored by the Works Progress Administration (WPA), which used space donated by the museum, as she would do again in 1940.

82. The crossing out of information in her own papers appears to begin about the time of her retrospective held at the Corcoran Museum of Art in Washington, D.C., which opened in January 1969.

83. Selvig interview transcript, p. 2.

84. Baur, *Loren MacIver,* p. 45.

85. I[rene] Rice Pereira, "The Indulgent Be Pleased," *Art Forum* 1 (February 1934): 9–10.

86. Thomas C. Linn, "This Week in New York: Some of the Recently Opened Shows," *New York Times,* January 22, 1933, sec. 9, p. 12. This clipping appears in Pereira's scrapbook, AAA roll D223.

87. Park, *New Backgrounds,* p. 125.

88. Peter Wollen, "Fashion/Orientalism/The Body," *New Formations* 1 (Spring 1987): 5–33; and J[ohn] C[arl] Flugel, *The Psychology of Clothes* (London: Hogarth Press, Ltd., and Institute of Psycho-Analysis, 1950 [1930]).

89. Veblen, *Theory,* pp. 15, 172, 171.

90. Leo Frobenius, *Das bekannte Afrika* (Munich: C. H. Beck, 1923), p. 4, as translated and quoted by Robert Goldwater, *Primitivism in Modern Art* (New York: Vintage Books, 1967, revised edition [1938]), p. 29. For recent discussions of modernism and the "masculine," see Shari Benstock, *Women of the Left Bank: Paris, 1900–1940* (Austin: University of Texas Press, 1986); Griselda Pollock, "Feminism and Modernism," in Rozsika Parker and Griselda Pollock, eds., *Framing Feminism: Art and the Women's Movement 1970–1985* (London: Pandora, 1987); Andreas Huyssen, "Mass Culture as Woman: Modernism's Other," in *After the Great Divide: Modernism, Mass Culture and Postmodernism* (London: Macmillan, 1988); and Janet Wolff, "Feminism and Modernism," in *Feminine Sentences: Essays on Women and Culture* (Berkeley: University of California Press, 1990).

91. See the transcript of her 1954 talk "Women and Dimensions in Art," AAA roll 2395. For a provocative study of the ways in which detail, the ornamental, and the everyday have been associated with the feminine, see Naomi Schor, *Reading in Detail: Aesthetics and the Feminine* (1987).

92. The enclosed garden is also traditionally symbolic of femininity, or virginity, a fact of which the artist was undoubtedly aware.

93. The current location of this painting is unknown. A photographic negative of the work is in her archive.

94. I. Rice Pereira, diary, entry dated October 19, 1963, AAA roll D222.

95. Zucker, "Pereira," insert following p. 170; Baur, *Loren MacIver,* p. 45. Late in life, Pereira reversed her position and claimed a preference for sixteenth-century Italian painting (Harithas, "I. Rice Pereira," p. 129).

96. Now in the collection of the Rose Art Museum, Brandeis University, Waltham, Massachusetts.

97. Emily Genauer, "Sketches Show Spontaneity of Pereira Work," *New York World Telegram,* July 24, 1934, Pereira scrapbook, AAA roll D223.

98. Baur, *Loren MacIver,* p. 45. A statement appearing in a 1938 press release, which indicates that Pereira had traveled "considerably in the

Near and Far East," cannot be confirmed (press release, WPA/FAP, February 15, 1938, IRP-SL).

99. Biography written by Marie McCall, brochure announcing her September 1948 exhibition at the George Binet Gallery in New York, vertical files, National Museum of American Art Library.

100. Draft of undated, unfinished letter, Pereira to Mr. Clark, AAA roll 1296; and Pereira to Reavey, postmarked April 11, 1950, GR-UT.

101. Djelloul Marbrook, undated memorial essay, c. 1971, AAA roll 1296.

102. McCall, 1948 brochure, vertical files, National Museum of American Art Library.

103. Harry Holtzman to author, March 9, 1987.

104. Interview with Djelloul Marbrook, Washington, D.C., October 29, 1984.

2. EXPLORING THE RELATIONSHIP BETWEEN ARTIST AND SOCIETY

1. Hal Foster, "Some Uses and Abuses of Russian Constructivism," in *Art into Life: Russian Constructivism 1914–1932* (New York: Rizzoli International Publications, 1990), p. 247.

2. Reyner Banham, *Theory and Design in the First Machine Age* (New York: Praeger Publishers, 1960; 2d edition, 1967), p. 10.

3. "Three Shows at Once," *New York Times,* March 31, 1935, unpaginated clipping, scrapbook, D223; and unheaded and unpaginated clipping, *New York World Telegram,* April 6, 1935, scrapbook, D223.

4. Robert Ulrich Godsoe-Kohn, "The Art Marts," *Flushing, New York, News,* August 9, 1934, from unpaginated clipping in Pereira's scrapbook, AAA roll D223.

5. Ibid.

6. This organization's name sometimes appears with and sometimes without an apostrophe. As most of its early catalogues print the name without the apostrophe, that is the way I have chosen to spell it throughout this study.

7. Baur, *Loren MacIver,* p. 46. The sketches mentioned are located in a portfolio of drawings in the possession of Andre Zarre, New York.

8. Zucker, "Pereira," insert following p. 170.

9. Ann Sutherland Harris and Linda Nochlin, *Women Artists: 1550–1950* (New York: Alfred A. Knopf, 1976), p. 63.

10. Pereira, "Eastward Journey" (hereafter abbreviated EJ), n.p., AAA roll D223.

11. See William Camfield, *Francis Picabia: His Art, Life and Times* (Princeton: Princeton University Press, 1979), pp. 80–81, 108.

12. I am indebted to my more seafaring colleagues, Drs. Don Kurka and Dale Cleaver, at the University of Tennessee at Knoxville, for their assistance in identifying this form.

13. Cooper, *Symbols,* p. 114.

14. Ad de Vries, *Dictionary of Symbols and Imagery* (Amsterdam: North Holland Publishing Company, 1974), p. 13.

15. Location unknown. A photographic negative of this work remains in Pereira's archive.

16. Pereira, EJ, n.p.

17. The ink drawing is in a private collection; the gouache is in the collection of the Rose Art Gallery, Brandeis University, Waltham, Mass.; the painting is in the collection of the Lowe Art Museum, University of Miami, Coral Gables, Fla.

18. Pereira, EJ, n.p.

19. A davit is a small crane used on ships to hoist boats, anchors, and cargo.

20. Baur, *Loren MacIver,* p. 47.

21. Donald G. Parker and Warren Herendeen, "An Interview with Peter Blume," *Visionary Company* 1 (Summer 1981): 69; Frank Anderson Trapp, *Peter Blume* (New York: Rizzoli, 1987), p. 39.

22. From 1932 until 1939, the museum selected the artists for its biennials, but each artist selected the work to be exhibited (Lawrence Alloway, "Institution: Whitney Annual," *Artforum* 11 [March 1973]: 33). *Wharf Construction* was the first of Pereira's works to be reproduced in a publication.

23. Linn, "This Week," sec. 9, p. 12.

24. Alfred A. Barr, Jr., Foreword, in *Machine Art* (New York: Museum of Modern Art, 1934), n.p.

25. Pereira, EJ, n.p.; Baur notes, WMAA. A preparatory drawing for *Presses* is in the possession of Andre Zarre, New York.

26. Lewis Mumford, *Sketches from Life: The Autobiography of Lewis Mumford: The Early Years* (New York: Dial Press, 1982), pp. 448–449; Lewis Mumford, *Technics and Civilization* (New York: Harcourt, Brace and Company, 1934), p. 447; Sheldon Cheney and Martha Chandler Cheney, *Art and the Machine* (New York: Whittlesey House, 1936), pp. 303–304.

27. Stuart Chase, *Men and Machines* (New York: Macmillan Company, 1929), pp. 217, 318, 347–348.

28. Chase's book appears on the Design Laboratory general reading list, AAA roll 2395. He was also a sponsor of the Public Use of Art Committee of the Artists Union.

29. Pereira, EJ, n.p.

30. The photograph appears with the papers of the Whitney Museum of American Art, AAA roll N679. This is also the caption given the painting when it was reproduced in John I. H. Baur, "The Machine in American Art," *Art in America* 51, no. 4 (1963): 51.

31. Howard Devree, "A Reviewer's Notebook," *New York Times,* February 26, 1939, sec. 9, p. 10.

32. Baur, *Loren MacIver,* p. 48; Baur, "The Machine," p. 52.

33. *Script for a Scenario* appears in EJ, n.p. *Monument I* was exhibited under the title *Surreal City* in New York City in May 1990 ("Surrealism in American Art at Michael Rosenfeld Gallery," *Antiques and the Arts Weekly,* May 25, 1990, p. 36). *Monument II* is in the Edward R. Downe,

Jr., Collection, New York. *The Embryo* is reproduced in Ralph M. Pearson's *Modern Renaissance,* published in 1954. The date assigned there is 1936, although this is inconsistent with the style of the work and must be an error.

34. Devree, "Reviewer's Notebook," p. 10.

35. Adolf Gottlieb included a shape that is a virtual replica of Pereira's embryo, though reversed, in his painting *The Seer,* of 1950, now in the Phillips Collection, Washington, D.C.

36. Alfred A. Barr, Jr., *Cubism and Abstract Art* (New York: Museum of Modern Art, 1936), p. 19.

37. Press release, WPA/FAP Department of Information, February 25, 1938, IRP-SL. This paragraph quoted in "Man and Machine Age, as Represented by a W.P.A. Artist," Washington, D. C., *Sunday Star,* March 20, 1938, clipping in Pereira's scrapbook, AAA roll D223.

38. Pereira, EJ, n.p.

39. K.G.S., "New Gallery Opens," *New York Times,* August 16, 1932, p. 15.

40. For information on Baron, see Elizabeth McCausland, untitled essay, January 1962, pp. 1–2, AAA roll D304.

41. See Herman Baron, "ACA Gallery 61 and 63 East 57th Street," [September 1945], p. 1, AAA roll D223.

42. The ACA Gallery was cited as "Communistic," an appellation given to its member artists as well, by Representative George Dondero of Michigan in 1949. The congressman referred to Herman Baron as "Comrade Baron" (*Congressional Record,* March 11, 1949, pp. 2317–2328; March 17, 1949, pp. 6372–6375).

43. Baron, "ACA Gallery," p. 3.

44. Ibid., pp. 3, 8–9.

45. McCausland, essay, p. 3.

46. Lynd Ward, Foreword, *American Artists Congress First Exhibition* (New York: American Artists Congress, 1936), n.p. (AAA roll N69–98).

47. The list appears in the ACA papers, AAA roll 429. Information about the exhibition appears in Baron, "ACA Gallery," pp. 7–8. The "call" is reprinted in Matthew Baigell and Julia Williams, eds., *Artists against War and Fascism: Papers of the First American Artists Congress* (New Brunswick, N.J.: Rutgers University Press, 1986), pp. 49–52.

48. Jacob Kainen, "Liberty-loving Artists in Momentous Exhibit," *Daily Worker,* undated clipping, Papers of the American Artists Congress, AAA roll N69–98.

49. Selvig interview transcript, p. 72. Pereira intended the interviewer to understand that she was the "one genius" suppressed.

50. Baur notes, WMAA. *Home Relief* is currently in the collection of Andre Zarre, New York.

51. *New York Post,* April 6, 1935, clipping in Pereira's scrapbook (no title or page number appears), AAA roll D223. The current location of this piece is unknown; a photographic negative is in the artist's archive.

52. Anita Brenner, "And Now There's Talk of Murals for Straphangers," unidentified clipping, National Archives, RG 69, series 10, box 2.

53. In response to a review by critic Emily Genauer, Pereira indicated

that Ibsen's *Ghosts* had held great meaning for her since her youth (letter, Pereira to Genauer, January 12, 1953, AAA roll NG-1).

54. In her interview with Baur and in her manuscript "Eastward Journey," Pereira indicated that she felt the artist here was shackled and crushed by the forces of the machine age and the social system (Baur notes, WMAA; Pereira, EJ, n.p.).

55. She later destroyed this painting (Baur notes, WMAA), and no known photograph of the work has survived.

56. H. Glintenkamp, "A Note on the Exhibition," in *An Exhibition in Defense of World Democracy* (New York: American Artists Congress, 1937), n.p., AAA roll 429.

57. Elizabeth McCausland (Elizabeth Noble), "American Artists Congress Exhibition," *New Masses,* January 4, 1938, pp. 28–30.

58. "Congress," *Time,* December 27, 1937, p. 18.

59. "Democracy [word omitted] by World Figures at Art Congress," *New York Post,* December 18, 1937, AAA roll 429. The American Artists Congress brought Picasso's *Guernica* to the U.S. for the first time, in 1939, for an exhibition benefiting Spanish refugees at the Valentine Gallery.

60. "Congress," p. 18.

61. *American Artists Congress Second Annual Membership Exhibition* (New York: American Artists Congress, 1938), n.p., AAA roll N69–98; and "Artists Congress to Open Show Here," *New York Times,* May 4, 1938, p. 21.

62. "To Make the World Safe for Art," *New York Post,* May 7, 1938, clipping, Evergood Papers, AAA roll 429.

63. Elizabeth McCausland, "Artists Congress' Third Annual Show," *Springfield Sunday Union and Republican,* February 12, 1939, clipping, Evergood Papers, AAA roll 429.

64. Djelloul Marbrook to author, February 28, 1987.

65. Emily Genauer, "Municipal Flash-Back Gripping," *New York World Telegram,* January 16, 1937, clipping, Evergood Papers, AAA roll 429. See also Ralph Purcell, *Government and Art: A Study of American Experience* (Washington, D.C.: Public Affairs Press, 1956), pp. 118–119.

66. Baur notes, WMAA, dated September 12, 1952.

67. The location of this work is unknown, and no photographs of the work have surfaced.

68. *Roofs for Forty Million,* invitation to artists, Evergood Papers, AAA roll 429.

69. Baur notes, WMAA.

70. See Evergood's letter regarding this incident appearing in "Artists in Jersey City," *New Masses,* April 26, 1938, p. 21.

71. "Roofs," *Daily Worker,* April 19, 1938, clipping, Pereira's scrapbook, AAA roll D223.

72. Gerald M. Monroe, "Artists as Militant Trade Union Workers during the Great Depression," *Archives of American Art Journal* 14, no. 1 (1974): 7.

73. Gerald M. Monroe, "Art Front," *Archives of American Art Journal* 13, no. 3 (1973): 13.

74. Ibid.

75. Pereira was a participant in this group's national exhibition held at the Springfield Museum of Fine Arts, Springfield, Mass., in October 1938. For her claim to have been chair of its easel division, see Baur, *Loren MacIver,* p. 52.

76. Jerome Klein, "WPA Art Highlights Fair," *New York Post,* May 25, 1940, unpaginated clipping, scrapbook, AAA roll D223.

77. "The Artist's Stake in Peace," *New York Artist* 1 (May–June 1940): 3.

78. Announcement, UAA lecture series, Evergood Papers, AAA roll 429.

79. Ibid.; also Pereira, list of lectures, AAA roll 1296. The same list indicates that she also presented a lecture that year for the UAA with the title "Historical Survey of Abstract Art."

80. Baur, *Loren MacIver,* p. 52.

81. See discussion of these definitions in Chapter 3.

82. Baur, *Loren MacIver,* p. 52; and Elizabeth McCausland, "New League Considers 'Artists in the War,'" *Springfield Sunday Union and Republican,* June 21, 1942, p. 6E.

83. McCausland, "New League," p. 6E. The painting contained representational elements (Edward Alden Jewell, "Europeans and Some Americans," *New York Times,* February 9, 1944, sec. 2, p. 7).

84. Pereira's lecture was very similar in content to that in her talk for Oliver Larkin's class at Smith College the previous summer (AAA roll 2395).

85. Mentana G. Sayers, Executive Committee of the China Aid Council, New York, to Pereira, April 14, 1941, AAA roll 1296.

86. The list of contributors to the auction appears in *New Masses,* April 28, 1942, p. 2.

87. "Fifty-Five Cent Cash Minimum Is Our Right," *Pilot: A National Paper for Maritime Workers,* August 10, 1945, p. 3, AAA roll D223. A second photograph showing Pereira with a larger group of individuals, including Elizabeth McCausland, Elizabeth Olds, and William Gropper, selecting works for the exhibition, appeared in the *Pilot,* July 27, 1945, p. 5, Pereira scrapbook, AAA roll D223.

88. See letter, Frances Serber to Pereira, March 6, 1946, AAA roll 1296; "For Neighborhood Houses," *Art Digest,* February 1, 1949, p. 31.

89. George P. Solomos to Pereira, August 17, 1959, AAA roll 1297.

90. A brochure for a workshop exploring new methods of art instruction sponsored by the New York Artists' Equity in 1952–53 lists Pereira's name on the organizing committee (brochure, AAA roll 1302). Pereira taught in this workshop program for a short time but had apparently resigned by November (letter, Monette Conrad Marrow to Pereira, November 21, 1952, AAA roll 1297).

91. As quoted in "ACA Exhibit Hits Hearst Art Slanders," unidentified clipping, Pereira scrapbook, AAA roll D223.

92. For information regarding this exhibition and the scandal surrounding it, see Margaret Lynne Ausfeld and Virginia M. Mecklenburg, *Advancing American Art* (Montgomery, Ala.: Montgomery Museum of Fine Arts, 1984); and Taylor D. Littleton and Maltby Sykes, *Advancing*

American Art: Painting, Politics, and Cultural Confrontation at Mid-Century (Tuscaloosa: University of Alabama Press, 1989).

93. She was quoted in *PM's Sunday Picture News* as saying, "This whole thing has been a frightening setback to the culture of our country and I don't think it has helped us in the eyes of the world. I think it's a civic responsibility to promote the culture of one's country, but it should be done on a positive and constructive basis" ("State Department Sells U.S. Art Short," *PM's Sunday Picture News,* May 30, 1948, unpaginated clipping appearing on AAA roll D223). Her one-paragraph letter to the editor of the *New York Times,* sandwiched between letters sent in by Ralph M. Pearson and Samuel M. Kootz, also spoke of the need for arts professionals to serve the cultural progress of society (Pereira, "To the Art Editor," *New York Times,* April 27, 1947, sec. 2, p. 10).

94. Report from House Committee on Un-American Activities, introduced by Fred E. Busbey, *Congressional Record,* vol. 93, part 4, May 13, 1947, pp. 5220–5226.

95. George A. Dondero, "Communist Art in Government Hospitals," *Congressional Record,* vol. 95, March 11, 1949, pp. 2317–2318.

96. George A. Dondero, "Communists Maneuver to Control Art in the United States," *Congressional Record,* vol. 95, March 25, 1949, pp. 3233–3235.

97. "Sponsors of the World Peace Conference," *New York Times,* March 24, 1949, p. 4.

98. Emily Genauer, "Still Life with Red Herring," *Harper's Monthly* 199 (September 1949): 90.

99. George A. Dondero, "Modern Art Shackled to Communism," *Congressional Record,* vol. 95, August 16, 1949, p. 11584.

3. THE DESIGN LABORATORY AND PEREIRA'S INTRODUCTION TO BAUHAUS THEORIES

1. Pereira's paintings were called "abstractions" in the *New York Times'* first review of her work (Linn, "This week," sec. 9, p. 12). This label continued to be applied to her paintings throughout the 1930s, although there was no consensus upon its definition, a point made by Ilya Bolotowsky in 1974 (Louise Averill Svendsen and Mimi Poser, "Interview with Ilya Bolotowsky," in *Ilya Bolotowsky* [New York: Solomon R. Guggenheim Museum, 1974], p. 17). Yet one critic wrote, "Her pictures are by no means 'coldly abstract' which danger confronts those who dare roam from the realistic into the more 'absolute' realms of painting. They are built up architecturally, emphasizing color melodiously harmonized into a design most pleasing to our aesthetic sense" (*Art Forum* [April 1934], untitled clipping in Pereira's scrapbook, AAA roll D223). The sentiment against the "coldly abstract," held strongly by many American critics throughout Pereira's lifetime, would also contribute to the negative criticism leveled against her work during the 1960s and 1970s.

Pereira's figural subjects were never very well received by critics, one of whom described them as "rather empty" (*Herald Tribune,* March 4, 1934, untitled clipping in Pereira's scrapbook, AAA roll D223). Howard

Devree called them "less successful" than her "masculine" marine subjects (Howard Devree, "Brief from a Reviewer's Notebook," *New York Times,* March 31, 1935, sec. ii, p. 7). John I. H. Baur wrote, "The truth is that Pereira has seldom been at her best with the human figure, except in her late fantastic drawings" (Baur, *Loren MacIver,* p. 48). Despite popular perceptions to the contrary, Pereira never abandoned figural subjects altogether.

2. See Karal Ann Marling and Helen A. Harrison, *7 American Women: The Depression Decade* (Poughkeepsie, N.Y., 1976). Marling and Harrison's work has also been cited and extended by Ware, *Holding Their Own,* pp. 142–144; Harris and Nochlin, *Women Artists,* pp. 63–64; and Rubinstein, *American Women Artists,* pp. 214–217.

3. The difficulties with perceiving one's self and work to be "special" has been discussed in recent years by feminists. For example, Adrienne Rich has written: "We seem to be special women here, we have liked to think of ourselves as special, and we have known that men would tolerate, even romanticize us as special, as long as our words and actions didn't threaten their privilege of tolerating or rejecting us and our work according to *their* ideas of what a special woman ought to be" (Adrienne Rich, *On Lies, Secrets and Silences,* as quoted in Trinh T. Minh-ha, *Woman Native Other: Writing Postcoloniality and Feminism* [Bloomington: Indiana University Press, 1989], p. 87).

4. Cheryl Buckley has noted the relative lack of attention paid to the women at the Bauhaus, despite the vast literature on the institution, a fact she attributes to the traditionally biased historiographic methods of design historians (Cheryl Buckley, "Made in Patriarchy: Toward a Feminist Analysis of Women and Design," in Victor Margolin, ed., *Design Discourse* [Chicago: University of Chicago Press, 1989], p. 251, n. 2).

5. Selvig interview transcript, pp. 72–73.

6. Irene and Humberto Pereira were apparently separated early in the marriage. For a time in 1933 and early 1934, Irene lived with Berenice Abbott on Waverly Place. A small gouache painting on paper showing Humberto Pereira and Berenice Abbott conversing in an apartment, now in the collection of Andre Zarre, was exhibited in July 1934 at Theodore A. Kohn and Son, Jewelers, under the title *Bernice.*

7. Which, if either, had been the principal contributor to the couple's income is unclear. Little information on Humberto Pereira has surfaced, and Irene's tendency toward self-aggrandizement makes problematic any uncritical reliance upon her own statements in this regard.

8. Jacquelene A. Keyes, "WPA Educators Blazing Trail with School in Industry Design," *New York Times,* October 25, 1936, sec. 2, p. 5.

9. For Pereira's claim to have been one of the founders of the Design Laboratory, see Baur, *Loren MacIver,* p. 51; and Selvig interview transcript, p. 47. For documentation of her work for PWAP, see Francis V. O'Connor, ed., *Art for the Millions* (Greenwich, Conn.: New York Graphic Society Ltd., 1973), p. 288. The Design Laboratory was originally scheduled to open on December 2, 1935, but this date was pushed back to January 9, 1936, and again to January 13, the day classes did begin. The delay was apparently due to difficulties in securing and readying a build-

ing for the school. A roster of faculty and advisory board members at the time of registration for the first term appears in "WPA Establishes Free Art School," *New York Times,* December 2, 1935, p. 19. This list was based upon information provided in a publicity brochure, a copy of which is held in the National Archives, Record Group 69, series 5, box 28. A revised list of faculty was published in "Design Laboratory, New York," *American Magazine of Art* 29 (February 1936): 117. The names appearing in the amended roster were Gilbert Rohde, director; Allan Gould, William Friedman, Roswell Snider, Theodore Müller, Hilde Reiss, Joseph J. Roberto in design; Ruth Reeves, Anna W. Franke, Robert J. Kingsbury, Peter Gonzales in textiles and weaving; Nathaniel Dirk, Hans Foy, I. Rice Pereira in painting; Chaim Gross, Vladimir Yoffe in sculpture; Wesley Walker, Hermann Post in graphics; William Edler, Anton Van Dereck in metal; Saul Yalkert in wood; Harold Tishler in pottery; and Noel Vicentini, Kurt Schelling in photography. The original advisory board members were Alfred Auerbach, Frederic C. Blank, Sidney Blumenthal, Louise Bonney, Holger Cahill, Harvey Wiley Corbett, Donald Deskey, Henry Didisheim, George Eggers, Adolph Glassgold, Percival Goodman, George Hellman, Ely Jacques Kahn, Frederick Kiesler, Philip Youtz, William Zorach, William Lescaze, Raymond Loewy, Earl F. Lougee, Audrey McMahon, Artemas Parker, Ralph Pearson, Austin Purves, Jan Ruhtenberg, George Sakier, Meyer Schapiro, Lee Simonson, Alexis Sommaripa, Eugene Steinhof, Walter Randall Storey, Walter Dorwin Teague, Russell Wright.

10. For capsule biographies of these women at the time of their association with the Design Laboratory, see "A Report of the Activities of the Design Laboratory of the Federation Technical School, September 1935–September 1937," pp. 5a–5c, AAA roll 2395 (hereafter cited as "Report"). For Bauhaus matriculation dates, see Hans M. Wingler, *The Bauhaus,* trans. Wolfgang Jabs and Basil Gilbert (Cambridge: Massachusetts Institute of Technology Press, 1969; paperback edition, 1979), pp. 622–625.

11. "Design Laboratory, New York," *Magazine of Art* 29 (February 1936): 117.

12. Keyes, "WPA Educators," p. 5.

13. Press releases for August 18 and September 23, 1936; and "Report," pp. 7, [37a], 40, [41]. The extant bulletins written by Pereira appear with other Design Laboratory papers on AAA roll 2395.

14. WPA Department of Information press release, July 2, 1937 (National Archives, RG 69, box 40). See also Charmion von Wiegand, "The Fine Arts," *New Masses,* July 6, 1937, p. 31.

15. Elizabeth McCausland, "Federal Art Projects Curtailment of Forces," *Springfield Sunday Union and Republican,* July 4, 1937, p. 6E; and Elizabeth McCausland, "An 'American Bauhaus,' Design Laboratory on Permanent Basis," *Springfield Sunday Union and Republican,* August 22, 1937, p. 6E.

16. Baur, *Loren MacIver,* p. 51. Correspondence dating from the spring of 1937 indicates that several options to save the Design Laboratory, including a possible affiliation with the New School for Social Research, were explored prior to the merger with the Federation Technical

School of the FAECT. There was also an extensive letter-writing campaign on behalf of the school, spearheaded in part by a Faculty-Student Continuation Committee, of which Pereira was a member, formed in June 1937. See correspondence, National Archives, RG 69, box 40.

17. Pereira was on the Easel Division by March 1938 ("WPA Woman Artist Exhibits Her Work at Howard Gallery," *Washington Post,* March 20, 1938, unpaginated clipping, Pereira scrapbook, AAA roll D223). She remained on this division until November 1940.

18. The complete list of faculty and advisory board members in September 1937 appears in "Report," pp. 5–5c. Changes in faculty for the 1938 school year are reflected in the list published in "Design Laboratory: A Cooperative School of Industrial Design," 1938, promotional booklet, n.p., AAA roll 2395.

19. See "Woll 'Explains,' " *New Masses,* January 4, 1938, pp. 12–13.

20. "Design Laboratory," unidentified clipping, Pereira scrapbook, AAA roll D223.

21. "Design Laboratory Exhibition," catalogue, August [1937?], n.p., AAA roll D375.

22. See Materials Laboratory schedules, AAA roll 2395.

23. Elizabeth McCausland, "Design Laboratory on Permanent Basis," *Springfield Sunday Union and Republican,* August 22, 1937, p. 6E.

24. "Report," pp. 1–2.

25. Untitled brochure quoted in "Design Laboratory, New York," p. 117.

26. Frank Whitford, *Bauhaus* (London: Thames and Hudson, 1984), p. 198.

27. Eunice Barnard, "Classroom and Campus," *New York Times,* August 2, 1936, sec. II, p. II.

28. "Report," pp. 3, 4. See also "Design Laboratory: A Cooperative School," n.p.

29. Press release, WPA/FAP, August 18, 1936, AAA roll D374.

30. Press release, WPA/FAP, September 22, 1936, AAA roll D374.

31. Press release, August 18, 1936; "Report," p. 4.

32. Press release, August 18, 1936. To determine how closely the work by students at the Design Laboratory resembled that created by Bauhaus students, see the catalogue of the Museum of Modern Art's Bauhaus exhibition in December 1938 (Museum of Modern Art, *Bauhaus 1919–1928* [New York: Museum of Modern Art, 1938]). Part of the show was devoted to the "Spread of the Bauhaus Idea." The corresponding section of the catalogue included reproductions of four constructions made by students at the Design Laboratory (officially, the Laboratory School of Industrial Design), each work indistinguishable in style from Bauhaus prototypes. Pereira later identified some of the student work in this section as having been created by her students (Selvig interview transcript, p. 61).

33. Press release, August 18, 1936.

34. Elizabeth McCausland, as quoted in Alfred H. Barr, Jr. *Picasso: Fifty Years of His Art* (New York: Museum of Modern Art, 1946), p. 202.

35. Press release, September 22, 1936. See John Dewey, *Art as Experience* (New York, 1934; New York: G. P. Putnam's Sons, 1958). Pereira

endorsed "learning by doing" as a pedagogical model as late as 1947, as is evidenced in her replies to a questionnaire dated June 10, 1947, for a radio program "What's on Your Mind," the topic for which was the public debate about modern art ("What's on Your Mind" questionnaire and responses, AAA roll 1296).

36. Press release, August 18, 1936.

37. Cahill, a strong advocate for the revitalization of the study of indigenous crafts, disagreed with the machine-oriented aims of the Design Laboratory under Gilbert Rohde. For a discussion of this conflict, see Contreras, *Tradition and Innovation,* p. 166.

38. For O'Connor's comment, see O'Connor, *Art for the Millions,* p. 17. For documentation of Dewey's impact on the Design Laboratory, see the press release dated August 18, 1936.

39. Holger Cahill, "American Resources in the Arts," in O'Connor, pp. 33–34.

40. Dewey, *Art as Experience,* p. 246.

41. Ibid., pp. 9–10.

42. For a summary of this issue, see Rudolf Wittkower, "Genius: Individualism in Art and Artists," in *Dictionary of the History of Ideas,* vol. 2 (New York: Charles Scribner's Sons), pp. 297–312. See also feminist critics of this issue, such as that in Griselda Pollock, "Vision, Voice and Power: Feminist Art History and Marxism," *Block* 6 (1982): 2–21.

43. Gilbert Rohde, "The Design Laboratory," *American Magazine of Art* 29 (October 1936): 639–640.

44. Ibid. Rohde's paragraphs here are accompanied by a photograph of a woman sculptor in a classroom. The same article, with different illustrations, appeared in slightly modified form under the title "What Is Industrial Design?" in *Design* 38 (December 1936): 3–5.

45. Buckley, "Made in Patriarchy," p. 253.

46. For a discussion of holism in German philosophy during this period, as well as its roots in Romanticism, see Fritz K. Ringer, *The Decline of the German Mandarins: The German Academic Community, 1890–1933* (Cambridge: Harvard University Press, 1969), pp. 393–403.

47. Max Wertheimer, *Über Gestalttheorie: Vortrag gehalten in der Kantgesellschaft Berlin am 17. Dezember 1924 (Sonderabdrucke des Symposion,* 1; Erlangen, 1925), p. 7, as quoted in ibid., p. 377.

48. Vernon J. Nordby and Calvin S. Hall, *A Guide to Psychologists and Their Concepts* (San Francisco: W. H. Freeman and Co., 1974), pp. 61–62.

49. John R. Lane, *Stuart Davis, Art and Art Theory* (New York: Brooklyn Museum of Art, 1978), p. 64, n. 1.

50. Gardner Murphy, "The Geometry of the Mind: An Interpretation of Gestalt Psychology," *Harper's* 163 (October 1931): 586.

51. Preface, *Art: A Bryn Mawr Symposium,* Bryn Mawr Notes and Monographs, IX (Bryn Mawr, Penn.: Bryn Mawr College, 1940), p. x.

52. Rutherford Boyd, quoted in Barbara Niles, "Pure Abstract Design: A New and Untouched Field for Progressive Designers," *Design* 38 (March 1937): 11.

53. Ralph M. Pearson, *The New Art Education* (New York: Harper and Brothers, 1941), p. 45; and Ralph M. Pearson, *The Modern Renaissance in American Art* (New York: Harper and Brothers, 1954), p. 26.

54. Philip C. Ritterbush, *The Art of Organic Forms* (Washington, D.C.: Smithsonian Institution Press, 1968), p. 87. Ritterbush's study explores the impact of theories of *Naturphilosophie,* beginning with Goethe, on twentieth-century artists.

55. Rudolf Arnheim, "Gestalt and Art," *Journal of Aesthetics and Art Criticism* 2 (Fall 1943): 71.

56. Hans Kreitler and Shulamith Kreitler, *Psychology of the Arts* (Durham: Duke University Press, 1972), p. 88.

57. Dwinell Grant, "Organized Field Composition," *Spiral* 9 (October 1986): 29–30. I am indebted to Mr. Grant for providing me with a copy of this magazine.

58. See "Report," for example.

59. See Wingler, *Bauhaus,* pp. 159–160, for surviving notes from lectures presented by Karlfried Count von Dürckheim in 1930 and 1931. According to Wingler, lectures in psychology had been introduced at the Bauhaus under Hannes Meyer as part of an effort to introduce scientific method into the curriculum.

60. Rohde, "Design Laboratory," p. 640.

61. Pereira did not teach a course on painting and composition following the absorption of the Design Laboratory by the FAECT school in 1937. Thus, the surviving outline of the "working procedure" for the course was probably prepared for the 1936–37 school year. This is supported by the fact that her "working procedure" for design synthesis, taught during the fall term, 1937, is virtually identical to that described in this document. The two were undoubtedly close in time, and the outline for the course in painting and composition is the probable model for the second course.

62. One typed sheet dated June 7, 1937, for "experiment II," concerning tactility, has the following note typed at the bottom: "SUGGESTIONS contained in these Experiments for Instructor's use only. Student work should be unhampered and allowed to rely on their inventive ability" (AAA roll 2395).

63. Copies of the syllabi for the materials laboratories and the courses in design synthesis are contained in "Report."

64. Syllabus, Design Synthesis II; "Working Procedure," Design Synthesis, AAA roll 2395; see also her working procedures for painting and composition, AAA roll D222.

65. Ibid. While her knowledge of Gestalt theories of perception may be inferred from clues found in these class syllabi, confirmation is obtained from lecture notes from 1942. In these, she noted that even when an object is partially concealed, viewers are unconscious of the interruption, for their minds provide the missing information based upon the configuration of the sensory data provided and therefore remain conscious of the whole (Pereira, lecture notes, Pratt Institute, AAA roll D222).

66. Experiment instructions, dated June 7, 1937, AAA roll 2395.

67. An undated outline for the Design Laboratory "fine arts," with no instructor listed, has an appended bibliography, at the top of which was listed Hildebrand's *Problem of Form.* After a space, the following books are listed: Sheldon Cheney's *Expressionism in Art,* C. H. Hinton's

Fourth Dimension, Otto Rank's *Art and Artists,* Worringer's *Form in Gothic,* Barr's *Cubism and Abstract Art,* Kandinsky's *The Art of Spiritual Harmony,* the Bauhaus *Yearbook,* Moholy-Nagy's *The New Vision,* James Thrall Soby's *After Picasso,* Reginald Howard Wilenski's *The Modern Movement in Art,* James Johnson Sweeney's *Plastic Redirections in Twentieth Century Painting,* O. M. Rood's *Student's Textbook in Color,* Oswald Wilhelm's *Color Science,* Herbert Read's *Art Now,* and Albert C. Barnes's *The Art in Painting* (AAA roll 2395). In addition to specialized texts in advertising layout, typography, and layout, *The New Vision* and *Cubism and Abstract Art* were listed as required reading for the course in display design taught during the fall term, 1937 ("Report").

68. Herbert Read, "A New Humanism," *Architectural Review* 78 (October 1935): 150.

69. László Moholy-Nagy, "Better than Before," *Technology Review* 46 (November 1943): 47–48.

70. Cheney and Cheney, *Art and the Machine,* p. 194.

71. The handwritten notes were taken from pages 56 through 61 of the catalogue, a section devoted to Futurist painting and sculpture. In an exercise of appalling ignorance, these notes and nearly all others found in the books in Pereira's library were destroyed during the transfer of the volumes from the Washington Women's Art Center to the library of the NMWA. Sadly, I was the only scholar to see and make any use of them.

72. See syllabi, AAA roll D222; and notes, AAA roll 2395.

73. See syllabi, AAA roll D222.

74. See Moholy-Nagy, *The New Vision,* pp. 50–51; and Pereira syllabi, AAA roll D222.

75. Syllabus, Design Synthesis II, AAA roll D222.

76. Pereira, bulletin, "Definitions and Terminology," AAA roll 2395; Pereira, lecture, "Cubism and Abstract Art," Brooklyn Art Center, Brooklyn Museum, July 25, 1940, AAA roll 2395.

77. As quoted by Pereira, the passage from Plato reads: "I do not now intend by beauty of shapes what most people expect, such as of living creatures or pictures, but for the purpose of my argument I mean straight lines and curves and the surfaces or solid forms produced out of these by lathes and rulers and squares. I mean that these things are not beautiful relatively like other things, but naturally and absolutely, and they have their proper pleasures, no way depending on the itch of desire. And I mean colors of the same kind of beauty and pleasures" (Pereira, "Definitions and Terminology"). The original source for the translation Pereira quoted has not been determined. From Hinton's book, Pereira copied, with minor editing, the following sentences: "A plane being's idea of a square object is the idea of an abstraction, namely, a geometrical square. Similarly our idea of a solid thing is an abstraction, for in our idea there is not the four-dimensional thickness which is necessary, however slight, to give reality. The argument would thus run, as a shadow is to a solid object, so is the solid object to the reality" (Hinton, *Fourth Dimension,* p. 34).

78. Pereira, "Definitions and Terminology." In this glossary, too, "pattern," defined simply as "two dimensional shapes," was related to

abstraction, for following this brief definition she listed the following types: geometric (cross-referenced to "pure" abstraction), intuitional, representational, and machine geometric, a "variation of Geometric Shape inspired by a sensitivity to Machine Form."

79. Her outline of working procedures for painting and composition does not list collage, but her explanation of working procedures for design synthesis does.

80. Pereira, lecture, "New Materials and the Artist," Columbia University, March 1939, AAA roll 2395. Pereira's feelings regarding the artist's role in this celebration of new materials had changed by 1953, when her memories of this period brought forth mixed emotions, as evidenced in the following passage from "Eastward Journey": "On the one hand I was teaching Materials Laboratory and Design Synthesis at the Laboratory School of Design. I was an apprentice to industrial designers and engineers. I was supposed to translate and give aesthetic and structural meaning to the materials of industrial production. In order to perform this function it was necessary to acquaint myself with the mechanical and physical properties of paper, plastics, glass, wood, metals and sundry other materials. I was split in two, an accomplice, an apprentice to the mechanical processes of the possibilities of order, logic and thinking. On the other hand, I was supposed to help students endow their work with the quality of aesthetic meaning" (Pereira, EJ, n.p.).

81. Banham, *Theory and Design,* p. 10.

82. Selvig interview transcript, p. 101.

83. "The Abstract in Art," *Interior Design and Decoration* 9 (December 1937): 116.

84. Ibid.

85. Ibid.

86. Pereira, EJ, n.p. *Pendulum* was reproduced in March 1938 as *Machine Composition* (Washington, D.C., *Sunday Star,* March 20, 1938, unpaginated clipping, Pereira scrapbook, AAA roll D223).

87. Barr, *Cubism and Abstract Art,* p. 142.

88. Ibid., p. 141.

89. According to Chiang Huey-Na, these symbols are meaningless inventions, bearing only occasional likeness to actual ideograms.

90. Pereira, EJ, n.p.

91. The current location or condition of this collage is unknown. It was formerly in the collection of the Baltimore Museum of Art. Approximately 9 1/4 by 11 3/8 inches, it is signed "I. Rice Pereira 37" and was shown at the Baltimore Museum in 1950 in the exhibition Baltimore Owned Paintings by Equity Artists.

92. Despite tolerance for various styles of painting, for the sake of artists' unity, there was much hostility toward anything that allowed "room for mysticism, magic and God" (David Ramsey, "Idealistic Physics," *New Masses,* July 31, 1934, p. 26).

93. Elizabeth McCausland [Elizabeth Noble], "Contemporary Chinese Graphic Art," *New Masses,* January 25, 1938, pp. 26–27.

94. See Mentana G. Sayers to Pereira, April 14, 1941, AAA roll 1296.

95. Pereira, EJ, n.p.

96. Ibid.

97. The original owner of this collage was Alfred Auerbach, one of the members of the advisory board of the Design Laboratory.

98. Pereira, EJ, n.p.

99. "Print Personality," *Print* 13 (January–February 1959): 35. A clipping announcing the exhibition appears in Pereira's scrapbook ("Architects Compete," *New York Post,* undated, unpaginated clipping, Pereira scrapbook, AAA roll D223). A short poem by Sorter, titled "Potion for Irene," remains in the artist's archive. The poem begs for her forgiveness.

100. "Print Personality," p. 36.

101. Pereira, EJ, n.p.

102. Baur, *Loren MacIver,* p. 51.

103. Dwinell Grant used a modified tachistoscope in his teaching prior to his meeting Pereira. Dwinell Grant to author, October 27, 1987, and December 29, 1987.

4. THE "GLASS AGE" AND PEREIRA'S FIRST PAINTINGS ON GLASS

1. Linn, "This Week," sec. 9, p. 12, Pereira's scrapbook, AAA roll D223. The first known public exhibition of a painting by Pereira had also occurred at the Art Center in its *First Opportunity Show* in 1930 (M.P., "The Art Galleries," *New Yorker,* November 1, 1930, p. 79).

2. Baur, *Loren MacIver,* p. 51.

3. "Science and the Artist," *Design* 42 (November 1940): 15.

4. Ibid.

5. Elizabeth McCausland, "I. Rice Pereira," *Magazine of Art* 39 (December 1946): 377. See also the artist's discussions of this substance in Elizabeth McCausland, "Alchemy and the Artist: I. Rice Pereira," *Art in America* 35 (July 1947): 185; and Baur, *Loren MacIver,* p. 51. Supplies of glyptal during World War II were limited because of its military value, but Pereira was able to obtain samples from wartime distributors such as General Electric (see Pereira to Mr. Hastings, General Electric Company, New York City, April 2, 1944, AAA roll 1296). Pereira continued to obtain glyptal from GE as late as 1950 (see J. A. Stollman to Pereira, May 2, 1950, AAA roll 1296).

6. "Science and the Artist," p. 16.

7. Pereira, formula for magnesite, AAA roll 1296.

8. Pereira to Inslee Hopper, Section of Fine Arts, Public Building Administration, Washington, D.C., November 13, 1941, IRP-SL.

9. McCausland, "I. Rice Pereira," p. 376.

10. Ibid., p. 377.

11. O'Connor, *New Deal Art Projects,* p. 253.

12. Elizabeth McCausland, *The World of Today* (Pittsfield, Mass.: Berkshire Museum, 1939), p. 11. Michael Auping has said that Pereira, with others, was "facilitated" by Diller under the Mural Division of the WPA/FAP. His meaning is unknown, and the source of this information

concerning Pereira is undocumented by him (Michael Auping, "Fields, Planes, Systems: Geometric Abstract Painting in America since 1945," in *Abstraction—Geometry—Painting: Selected Geometric Abstract Painting in America since 1945* [New York: Harry N. Abrams, in association with Albright-Knox Art Gallery, Buffalo, 1989], p. 27).

13. Pereira to Hopper, November 13, 1941.

14. See the surviving minutes of meetings of the American Abstract Artists, Alice Mason Papers, AAA roll NY59–11.

15. Lescaze's apartment with its glass-brick exterior wall was featured in *Architectural Review* in 1935 and reproduced in Raymond McGrath and A. C. Frost, *Glass in Architecture and Decoration* (London: Architectural Press, 1937), p. 204, fig. 64.

16. William Lescaze, Introductory Statement, *I. Rice Pereira* (New York: Julien Levy Gallery, 1939), n.p.

17. Edgar Kaufmann to Pereira, December 8, 1938, and her reply, December 9, 1938, AAA roll 1296.

18. Russell Lynes, *Good Old Modern: An Intimate Portrait of the Museum of Modern Art* (New York: Atheneum, 1973), p. 180.

19. That year Kaufmann also gave the museum Pereira's parchment paintings, *White Lines,* of 1942 (Alicia Legg, ed., *Painting and Sculpture in the Museum of Modern Art* [New York: Museum of Modern Art, 1977], p. 74).

20. A photograph of Pereira and her rug, taken during the exhibition, appears in "Prophetic Rugs," *House and Garden* (September 1942): 33.

21. This rug is reproduced in Gloria Finn, "'Artist's Accent' Collection: Hooked Rugs Designed by Contemporary Painters," *Craft Horizons* 14 (September–October 1954): 27; the design for this rug is in the collection of the Oklahoma City Art Museum.

22. According to an advertisement for B. Altman and Company on Fifth Avenue, a short statement about the artist was enclosed in each box with the scarf, described as being predominately yellow, grey, pink, and blue ("Contemporary Scarves by Noted American Artists," *New York Times,* October 31, 1948, p. 73).

23. Publicity announcement, Columbia University Art Classes, AAA roll 2395 or AAA roll 429.

24. Selvig interview transcript, p. 63. Pereira's role in the design of this catalogue is confirmed by Evergood's inscriptions in the two copies of this work in her library, one of which is a limited edition issue with enclosed etching.

25. Ralph M. Pearson to Pereira, May 6, 1955, AAA roll 1297, concerning a letter Pereira wrote to the *New York Times.*

26. Stephanie Kiesler was head of the New York Public Library's French and German Collections ("Design's Bad Boy," *Architectural Forum* 86 [February 1947]: 91). Pereira maintained contact with "Steffi" Kiesler as late as 1956 (Stephanie Kiesler to Pereira, November 13, 1956, IRP-SL).

27. Richard Guy Wilson, Dianne H. Pilgrim, and Dickran Tashjian,

The Machine Age in America 1918–1941 (New York: Brooklyn Museum in association with Harry N. Abrams, 1986), p. 88.

28. László Moholy-Nagy, "Abstract of an Artist," in *"The New Vision" and "Abstract of an Artist"* (New York: Wittenborn and Company, 1946), p. 74; R. L. Held, *Endless Innovations: Frederick Kiesler's Theory and Scenic Design* (Ann Arbor, Mich.: UMI Research Press, 1982), p. 94.

29. Held, *Endless*, pp. 27, 154.

30. Frederick J. Kiesler, *Contemporary Art Applied to the Store and Its Display* (New York: Brentano's, 1930), p. 14.

31. "Design's Bad Boy," p. 138.

32. Held, *Endless*, pp. 48–49.

33. E[manuel] M. Benson, "Wanted: An American Bauhaus," *American Magazine of Art* 27 (June 1934): 307–311.

34. "Design's Bad Boy," p. 140.

35. Pereira to C[ecil] C[lair] Briggs, September 4, 1940, AAA roll 1296. Briggs had been at Columbia University and had organized the panel on which Pereira participated in March 1939.

36. McCausland, "I. Rice Pereira," p. 377. Kiesler wrote, "Pereira's keen paintings have long ago emerged from abstractions of the machine-ego-age. What else could her double-plane-painting mean: when a faintly transparent curtain is rung down over a picture of sharply determined architectonics? It is not *in memoriam* of an age whose industries have lived only for industry and many an art only for art" (Frederick Kiesler, Preface, *I. Rice Pereira* [New York: Art of This Century Gallery, 1944], n.p).

37. Pereira to Reavey, postmarked August 11, 1951, GR-UT.

38. Kiesler, *Contemporary Art*, p. 66.

39. Wilson, Pilgrim, and Tashjian, *Machine Age*, pp. 277–279.

40. Kiesler, *Contemporary Art*, p. 74.

41. The extent to which department-store marketing was applied to art during this period may be symbolized by Tomorrow's Masterpieces, Inc., which distributed art to about twenty stores nationwide, including R. H. Macy Company, New York. About 250 artists contributed paintings for mass sale, although it is unknown whether any of the five paintings Pereira volunteered were sold in this manner (see invoices, Tomorrow's Masterpieces, Inc., AAA roll 1296).

42. "Design's Bad Boy," p. 90.

43. Kiesler, *Contemporary Art*, pp. 69, 73, 78.

44. Dennis Sharp, ed., *"Glass Architecture" by Paul Scheerbart and "Alpine Architecture" by Bruno Taut*, trans. James Palmes and Shirley Palmer (New York: Praeger Publishers, 1972), p. 11.

45. Ibid., p. 52.

46. Both Taut and Gropius became members of the Arbeitsrat für Kunst (Working Soviet for Art), whose aim was to involve architects, artists, and intellectuals in forging a new social order (Whitford, *Bauhaus*, p. 37).

47. Arthur Korn, *Glass in Modern Architecture of the Bauhaus Period* (New York: George Braziller, 1968), n.p.

48. "Tempered Glass," *Scientific American* 153 (September 1935): 127.

See also "The Control of Light," *Architectural Record* 86 (September 1939): 77–84; "Glass in the World of Today—and Tomorrow," *Glass Industry* 20 (May 1939): 182–183; and James McQueeny, "The Glass Age," *Popular Mechanics* 73 (March 1940): 337–344, 128A–129A.

49. McCausland, "I. Rice Pereira," p. 93.

50. New York World's Fair 1939, *Official Guide Book of the New York World's Fair 1939* (New York: Exposition Publications, 1939), p. 41.

51. Ibid., p. 43; *New York Panorama,* p. 488.

52. Frances T. Schwab, ed., *A Design Student's Guide to the New York World's Fair Compiled for PM Magazine by Laboratory School of Industrial Design,* foreword by John McAndrew (New York: Laboratory School of Industrial Design, 1939), n.p.

53. *New York Panorama,* p. 489.

54. *Guide Book,* pp. 43–44.

55. New York World's Fair 1939, *Going to the Fair* (New York: Sun Dial Press, 1939), p. 51.

56. Gerald Wendt, *Science for the World of Tomorrow* (New York: W. W. Norton and Company, 1939), p. 163.

57. The current location of this painting is unknown.

58. Helen A. Harrison, "The Fair Perceived: Color and Light as Elements in Design and Planning," in Helen A. Harrison, *Dawn of a New Day: The New York World's Fair, 1939/40* (New York: Queens Museum and New York University Press, 1980), p. 47. See also Forbes Watson, "Murals at the New York Fair," *Magazine of Art* 32 (May 1939): 283. Polarizing filters were also used to create prismatic light effects projected onto the inner surface of the dome of the Perisphere, what designer Henry Dreyfuss called a "blaze of Polaroid light," in the finale to the Program for Democracity (Harrison, "Fair Perceived," p. 50). For her motif, Pereira might also have seen reproductions of Diego Rivera's murals in Detroit, portions of which depicted the housing of the newly manufactured V-8 engine.

59. Exhibition checklist for Pereira: Evolution of a Painter, ACA Gallery, December 2–28, 1946, AAA roll D223. Pereira also thanked the Burchell-Holloway Corporation for supplying "Polaroid" plastic.

60. Ralph Pearson's article "What Kind of World's Fair" appeared in *Art Front,* in the July–August 1936 issue, as part of a campaign by artists' organizations to expand their representation at the fair (O'Connor, *New Deal Art Projects,* p. 204).

61. See Jerome Klein, "WPA Art Highlights Fair," *New York Post,* May 25, 1940, clipping, Pereira's scrapbook, AAA roll D223.

62. "Wireless Telegraph," *The World Book,* vol. 10, M. V. O'Shea, ed. (Chicago: W. F. Quarrie and Company, 1928), pp. 6323–6324. The painting *Curves and Angles* is now in the collection of John and Marie Bocchieri, Brooklyn, New York.

63. Kiesler, *Contemporary Art,* p. 43.

64. Ibid., p. 39.

65. Robert Beverly Hale and Nike Hale, *The Art of Balcomb Greene* (New York: Horizon Press, 1977), p. 18.

66. Pereira's first glass painting is in a private collection.

67. Frederick J. Kiesler, "Design-Correlation," *Architectural Record* 81 (May 1937): 53.

68. Pereira, "Definitions and Terminology," taken from Hinton, *Fourth Dimension,* p. 34.

69. Ibid., p. 2.

70. For example, Rosalind Bengelsdorf, who married Byron Browne, whose portrait Pereira had painted in 1934, spoke of her own nonobjective paintings of the mid-1930s as "space projections" (Marling and Harrison, *American Women,* p. 18). Throughout the books in her library, Pereira marked passages concerning any type of "projection," but particularly those usages that refer to outward or upward projections of the presumed contents of the unconscious or the soul.

71. Kiesler, "Design-Correlation," p. 54.

72. Kiesler, *Contemporary Art,* p. 115.

73. Kiesler, "Design-Correlation," p. 55.

74. Kiesler, *Contemporary Art,* p. 118.

75. Cheney and Cheney, *Art and the Machine,* p. 202.

76. *Guide Book,* p. 32.

77. This theme is similar to that of Diego Rivera's controversial RCA Building mural, which was destroyed in 1933 after the artist refused to remove a portrait of Lenin. The subject of the mural was "Man at the Crossroads with Hope and High Vision to the Choosing of a New and Better Future." Photographs show the central figure of a man at a control panel standing before two large ellipses crossing one another. One ellipsis represents the macrocosm, with its comets, planets, sun, moon, and other heavenly bodies; the other represents the microcosm, with microbes and cellular matter.

78. O'Connor, *New Deal Art Projects,* p. 258; and *Guide Book,* p. 33.

79. Mildred Lee Ward, *Reverse Paintings on Glass* (Lawrence: Helen Foresman Spencer Museum of Art, University of Kansas, 1978), pp. 57–63.

80. C. Adolph Glassgold to Pereira, January 30, 1938, AAA roll 1296.

81. In Pereira's archive, there are three signed but undated photograms which she must have made about 1938. She underlined the process for making photograms, or "rayographs," on page 170 of the section "Abstract Photography" in her copy of the catalogue of the 1936 exhibition Cubism and Abstract Art. On the same page she underlined the following sentence: "They [rayographs] were acclaimed by Man Ray's fellow-Dadaists because of their anti-'artistic' and apparently casual technique but many of them are in fact consummate works of art closely related to abstract painting and unsurpassed in their medium." On an earlier page, she marked a sentence under the heading "Abstract Films" which noted that abstract films, like those by Eggeling and Léger, were made in the technique of animated cartoons (*Cubism and Abstract Art,* p. 167). Noting Pereira's interest in this filmmaking technique, one must also consider a possible connection between the multiplanar photographic processes of animation and the analogic constructions of her glass paintings.

82. Ruth Rattner, "Projecting the Fourth Dimension: Two Constructions by László Moholy-Nagy," *Bulletin of the Detroit Institute of Arts* 61, no. 4 (1984): 8.

5. PEREIRA'S STUDY OF PERCEPTION:
HILDEBRAND, WORRINGER, HINTON, AND
GIEDION

275

*Notes
to Pages
119–127*

1. See the bibliography appended to the general outline for the "Fine Arts" area, no instructor specified, AAA roll 2395.

2. Adolf von Hildebrand, *The Problem of Form in Painting and Sculpture,* trans. Max Meyer and Robert Morris Ogden (New York: G. E. Stechert and Co., 1907; reprint ed., 1945), pp. 11, 12.

3. Ibid., p. 12.

4. Ibid., p. 17.

5. Ibid., p. 49.

6. Ibid., p. 47.

7. Ibid., p. 49. Hildebrand interchanges "space" and "air."

8. Moholy-Nagy, *New Vision,* p. 156.

9. Hildebrand, *Problem of Form,* p. 36.

10. Ibid., pp. 60, 87, 50.

11. Pereira, Pratt notes, AAA roll D222.

12. Ibid.

13. Ibid.

14. Lincoln Barnett, *The Universe and Dr. Einstein,* foreword by Albert Einstein (New York: William Sloane Associates, 1948; revised ed., 1950), p. 115.

15. Hildebrand, *Problem of Form,* p. 71.

16. Ibid.

17. G. A. Storey, *The Theory and Practice of Perspective* (London, 1910; New York: Benjamin Blom, 1973), p. 20.

18. Pereira, Pratt Institute lecture notes, AAA roll D222.

19. William M. Ivins, Jr., *On the Rationalization of Sight with an Examination of Three Renaissance Texts on Perspective* (New York: Metropolitan Museum of Art, 1938; New York: Decapo Press, 1973), p. 8.

20. Pereira, Pratt notes.

21. Wilhelm Worringer, *Form Problems of the Gothic* (New York: G. E. Stechert and Company, n.d.), pp. 12–13.

22. For example, Goldwater, *Primitivism,* p. 28; and Raymond S. Stites, *The Arts and Man* (New York: McGraw-Hill Book Company, 1940), pp. 41–42.

23. Goldwater, p. 30.

24. Worringer, *Form Problems,* pp. 15–17.

25. References to Hinton's book appear in her essay "Structure and Dimensions of Thought," dated June 24, 1953. Pereira sent one copy of this essay to Emily Genauer (see AAA roll NG1). A slightly different version, with the same date, appears on AAA roll D223.

26. Baur, *Loren MacIver,* p. 52.

27. Pereira's copy of Hinton's book had at least two prior owners, as indicated by inscriptions dated 1922 and 1930. Pereira signed the flyleaf twice, the second over the first. Her first inscription, partially erased, reads "I Rice Pereira, [missing] 30, 1936."

28. As noted earlier, the bookmarkers Pereira left behind in her vol-

umes have, for the most part, been lost between the first time I saw her library in October 1984 and July 1991, when I again had an opportunity to examine them. One marker was remaining in her copy of Hinton's *The Fourth Dimension* in 1991, a bit of paper—a WPA paycheck insert—containing doodles (as well as a handwritten definition of the word *hypothesis*) in three different pencil colors, each of which she had used to mark passages in the book.

29. For further information on Hinton and his importance to artists in the early decade of this century, see Linda Dalrymple Henderson, *The Fourth Dimension and Non-Euclidean Geometry in Modern Art* (Princeton: Princeton University Press, 1983).

30. Hinton, *Fourth Dimension,* p. 89.

31. Ibid., p. 39.

32. Ibid., pp. 4, 85, 56–57.

33. Ibid., pp. 57, 58, 60.

34. Ibid., p. 120.

35. Ibid., p. 59.

36. Ibid., p. 109.

37. Ibid., p. 111.

38. See Alan J. Friedman and Carol C. Donley, *Einstein as Myth and Muse* (New York: Cambridge University Press, 1985), pp. 10–17.

39. According to many writers, Heisenberg's theory also made possible the concept of free will, because free-will decisions are unpredictable. Forces other than those inherent in the undisturbed system, such as human will or divine intervention, might affect the behavior of the material universe. For one example of this interpretation, see C. G. Darwin, "The Uncertainty Principle in Modern Physics," *Scientific Monthly* 34 (May 1932): 387–396, esp. 395–396.

40. Cyril Edwin Mitchinson Joad, *Guide to Philosophy* (London: Victor Gollancz, Ltd., 1955), pp. 362–363. It should be mentioned that Joad's view does not represent that of the majority of scientists during this period.

41. Pereira's copy of Joad's *Guide* is uninscribed. Although published with a 1936 copyright, it is paperbound and may have been a reprint edition.

42. Immanuel Kant, *Critique of Pure Reason,* trans. J. M. D. Meiklejohn (London: George Bell and Sons, 1900), p. 94.

43. Pereira, "The Paradox of Space," publication source and date unknown, p. 26, AAA roll 1299.

44. See, for example, her discussion of this concept in "The Paradox of Space," pp. 23–26.

45. Pereira, "Paradox," p. 26. See also her unfinished and unpublished manuscript "Concept of Substance," wherein she wrote that "the development of dimensions as an attribute of consciousness follows a structural form-giving evolution dimension by dimension" (Pereira, "Concept of Substance," n.p., AAA roll 1299).

46. Pereira, "Paradox," p. 25; and transcript of interview between Arlene Jacobowitz and Pereira at the Brooklyn Museum, July 26, 1966, Brooklyn Museum files.

47. Friedman and Donley, *Einstein,* pp. 8–9. See also the chapter "The New Messiah," in Ronald W. Clark, *Einstein, the Life and Times* (New York: World Publishing Company, 1971).

48. Pereira, "Notes Summary, Perspective vs. Space," AAA roll D222.

49. At the time of my research, Giedion's book appeared to have been unopened since Pereira's death. Folded in the back of the book was an offprint of Giedion's article "A Complicated Craft Is Mechanized," *Technology Review* 46 (November 1943). Pereira also possessed an offprint of Giedion's section, titled "A Need for a New Monumentality," in Paul Zucker's book *New Architecture and City Planning,* published in 1944.

50. Interview notes in John I. H. Baur's handwriting, GR-UT. Pereira's convalescence was difficult, and the strength in her right arm was diminished, forcing her to work ambidextrously. According to Donna Marxer, the skin graft over Pereira's surgical wounds did not heal properly (Donna Marxer, "I. Rice Pereira: An Eclipse of the Sun," *Women Artists Newsletter* 2 [April 1976]: 5). Pereira claimed that she almost lost the use of her arm (M.R. [Maude Riley], "Pereira Abstractionist," *Art Digest,* January 15, 1944, p. 20). A lingering sense of "paralysis" in her arm plagued her throughout her life ("Villagers in Manhattan," *Time,* January 26, 1953, p. 69).

51. Krisztina Passuth, *Moholy-Nagy* (London: Thames and Hudson, 1985), p. 70.

52. Siegfried Giedion, "Walter Gropius et l'architecture en Allemagne," *Cahiers d'Art* 2 (1930): 95–103.

53. Elizabeth McCausland, "I. Rice Pereira," p. 376.

54. Heinrich Wölfflin, quoted in Michael Podro, *The Critical Historians of Art* (New Haven: Yale University Press, 1982), p. 99.

55. Siegfried Giedion, *Space, Time and Architecture* (Cambridge: Harvard University Press, 1941), p. 3.

56. Pereira, "An Abstract Painter on Abstract Art," *American Contemporary Art* 1 (October 1944): 3.

57. Ibid., pp. 3–4.

58. Giedion, *Space,* p. 16.

59. Ibid., pp. 30–31.

60. Ivins, "Rationalization," pp. 8–9.

61. Giedion, *Space,* p. 31.

62. Ivins, "Rationalization," pp. 10, 15.

63. Pereira's undated paperback reprint edition of this 1923 anthology of essays by Albert Einstein, Hendrik Antoon Lorentz, Hermann Minkowski, and Hermann Weyl, *The Principle of Relativity,* is inscribed on the front cover, "Miss Rice Pereira see p. 75 Space & Time—Cy." On the dog-eared page 75 begins Minkowski's chapter on "Space and Time." The author of the inscription on the cover was most likely Cyrus Adler, of the Manhattan Physical Research Group, an acquaintance to whom she sent a copy of her book *Nature of Space* in 1958. She indicated in a letter to him in June of that year that Minkowski had always interested her. This is the first known case in which Pereira referred correctly to the mathematician's name (see correspondence between Pereira and Cyrus Adler, AAA roll 1297).

64. Pereira, "Abstract Painter," p. 4.

65. "Ether," *The World Book,* vol. 4, p. 2082.

66. "A Mystic Universe," *New York Times,* January 28, 1928, p. 14.

67. Pereira, "Abstract Painter," pp. 5, 11.

68. Giedion, *Space,* p. 382.

69. Pereira, "Space vs. Perspective," lecture, Smith College, August 1944, AAA 2395. Ad Reinhardt, in his explanation of Picasso's *Guernica,* described the face of the female figure holding the lamp as "a flying-thrust out of a window (like a fusion of fast photographic images)" (Ad Reinhardt, "How to Look at a Mural," *P.M.* 22 [January 1947]).

70. Giedion, *Space,* p. 13.

71. Ibid., p. 14.

72. Ibid., pp. 13–14.

6. THE IMPACT OF JUNG, ALCHEMY, AND TALES OF TRANSFORMATION ON PEREIRA'S ABSTRACT SYMBOLISM

1. Pereira, "Definitions and Terminology," AAA roll 2395.

2. Judy K. Collischan Van Wagner, *Women Shaping Art: Profiles of Power* (New York: Praeger Publishers, 1984), p. 29.

3. A catalogue for this exhibition is in the Elizabeth McCausland papers, AAA roll D374.

4. A checklist of this exhibition is in the WPA/FAP papers, National Archives, Record Group 69, series 10, box 2.

5. George L. George, "What is Non-Objective Art?" *Mademoiselle* 20 (January 1945): 130, 178. Pereira's painting *Red, Yellow and Blue,* of 1942, is reproduced here and in Pepsi Cola's calendar for August 1947.

6. Esther Levine, "A Mural in a Mental Hospital Created with Therapeutic Consideration," September 18, 1940, four-page typed report, WPA/FAP papers, National Archives, Record Group 69, series 11, box 3.

7. Ibid. In the same location is another report, by artist Leonard Garfinkle, concerning "Some Psychological Aspects [of] Mural Painting in a Mental Institution."

8. Pereira to Virginia Case, April 14, 1958, AAA roll 1297. Other denials of fact include her claim that she used no masking tape in painting hard-edged forms, when, in fact, she outlined her use of tape for this purpose in correspondence with Helen Cumming, vice-president of Roger Brown, Incorporated, a public relations firm that handled makers of tape (letters, Helen Cumming to Pereira, April 15, 1952, and Pereira to Cumming, April 18, 1952, AAA roll 1297).

9. Dwinell Grant to author, July 12, 1986.

10. Nicolas Calas, "The Light of Words," *Arson* 1 (1942): 16.

11. Frederick J. Hoffman, *Freudianism and the Literary Mind* (Baton Rouge: Louisiana State University Press, 1957), p. 330.

12. Carl G. Jung, *Contributions to Analytical Psychology,* trans. H. G. and Cary F. Baynes (New York: Harcourt, Brace and Company, 1928), pp. 187–188. For one of the earliest feminist attacks on Jungianism,

see Naomi Goldenberg, "A Feminist Critique of Jung," *Signs* 2 (1976): 443–449.

13. Carl G. Jung, *The Integration of the Personality,* trans. Stanley Dell (London: Kegan Paul, Trench Trubner and Co., Ltd., 1940; reprint ed., 1948), p. 89.

14. Aniela Jaffe, ed., *C. G. Jung: Word and Image,* Bollingen Series XCVII:2 (Princeton: Princeton University Press, 1979), p. 94.

15. Ibid., p. 78.

16. Silberer's work was translated by Smith Ely Jelliffe. In the translator's preface, Jelliffe acknowledged the assistance of Leo Stein, brother of Gertrude Stein (Smith Ely Jelliffe, translator's preface, in Herbert Silberer, *Problems of Mysticism and Its Symbolism* [New York: Moffat, Yard and Company, 1917], p. v).

17. Carl G. Jung, "Dr. C. G. Jung," *transition* 21 (March 1932): 125–127.

18. Carl G. Jung, *The Collected Works of C. G. Jung,* ed. Herbert Read, Michael Fordham, and Gerhard Adler, vol. 12: *Psychology and Alchemy,* trans. R. F. C. Hull (London: Routledge and Kegan Paul, 1953), p. v (hereafter cited as Jung, *Alchemy*).

19. Alice Raphael, *Goethe and the Philosopher's Stone* (New York: Garrett Publications, 1965), p. ix.

20. Carl G. Jung, *The Collected Works of C. G. Jung,* ed. Herbert Read, Michael Fordham, and Gerhard Adler, vol. 19: *General Bibliography of C. G. Jung's Writings,* comp. Lisa Ress (Princeton: Princeton University Press, 1979), p. 214.

21. "Symbols and Religion," *Time,* March 7, 1938, p. 30.

22. The original inscription reads:

A Irene en la persona de Margarita
Espero que el amor divina que en el corazón de Fausto reinaba para la preciosa Margarita séa simbólico de mi amor para ti
Aun con los intervenciones deabólicas del malbechor Mefistofeles.
Tu Fausto
Humberto

23. The torn snapshot-postcards are in her archive.

24. Pereira, notes, July 21, 1962, AAA roll D222.

25. Mann's book does not deal directly with the Faust legend but concerns the political fate of his native Germany.

26. Jung, *Integration,* pp. 91–92.

27. Silberer, *Problems of Mysticism,* p. 245.

28. Ibid., p. 246.

29. Ibid., p. 244.

30. Mark van Doren, introduction to Goethe's *Faust: A Tragedy,* trans. Alice Raphael (New York: Jonathan Cape and Harrison Smith, 1930), pp. xix–xx.

31. Juliet Mitchell, *Psychoanalysis and Feminism* (New York: Pantheon Books, 1974), p. 428.

32. The *New York Times* account of one of Jung's Terry lectures in October 1937 quoted him as saying, with respect to the political upheavals in Europe, "This state of affairs . . . is the demonstration of our psychological program in a gigantic state. Such problems can only be solved by a general change of attitude. It begins with a change in individuals. The accumulation of such individual changes only will produce a collective solution" ("'Shadow' Carried by All, Says Jung," *New York Times,* October 23, 1937, p. 8).

33. Raphael, foreword to Goethe's *Faust,* p. viii.

34. Jung, *Integration,* pp. 28–29.

35. Ibid.

36. According to Jung, the Homeric chain in alchemy is that series of wise men, beginning with Hermes Trismegistus, who link earth with heaven. It is also the chain of substances and different chemical stages that appear in the alchemical process (Jung, *Alchemy,* p. 110, n. 23).

37. Jung, *Integration,* p. 28.

38. See the bibliography in Ronald D. Gray, *Goethe, the Alchemist* (Cambridge: Cambridge University Press, 1952).

39. The *Reader's Guide to Periodical Literature* instituted a category for "transmutation" in connection with the work of Sir William Ramsey and his 1904 Nobel Prize for chemistry. His discovery that helium was produced during the atomic disintegration of radium led to some interest in alchemy. The category disappeared from the *Reader's Guide* during World War I and did not reappear until 1925.

40. "Ludendorff's 'Gold Maker' and His Magic Power," *Literary Digest,* May 9, 1931, p. 38.

41. "Have the Modern Alchemists Succeeded?" *Literary Digest,* February 6, 1926), p. 25. See also "Changing Mercury to Gold—The Modern Alchemy," *Outlook,* November 12, 1924, p. 396.

42. Bernard Jaffe, "The Human Crucible," *Forum* 83 (May 1930): 316.

43. William Francis Gray Swann, *The Architecture of the Universe* (New York: Macmillan Company, 1934), p. 41.

44. "Transmuting Bismuth into Radium with a 'Frying Pan,'" *News-Week,* February 15, 1936, p. 28. In 1944, in her lecture at Smith College, Pereira indicated her interest in these events when she talked of "the ultra-microscopic atom being smashed by a machine weighing 200 tons" (Pereira, "Perspective vs. Space-Time," AAA roll 2395).

45. This painting, currently in the Frost Collection of the National Museum of American Art under the title *Machine Composition #2,* was exhibited as *Patent Pending* in 1939 in Pereira's one-artist show at the Julien Levy Gallery. Pereira called the work *Power House* in her manuscript "Eastward Journey" and wrote there, "I used to look in at a power house on 16th Street where I was living, to get the feeling of power house; and then made my own, that seemed to end the machine period" (Pereira, EJ, n.p.)

46. Jung, *Contributions,* pp. 45, 46–47, 52.

47. Gloria Orenstein, "Women of Surrealism," *Feminist Art Journal* 2 (Spring 1973): 1, 15–21; Whitney Chadwick, *Women Artists and the Surrealist Movement* (Boston: Little, Brown and Company, 1985); and Carol

P. Christ, *Diving Deep and Surfacing: Women Writers on Spiritual Quest*
(Boston: Beacon Press, 1980). Pereira's early Dufylike paintings were
sometimes called "Surrealist" by contemporary New York critics, particu-
larly with respect to works she exhibited in 1935, including *Brooklyn*
Heights (see clippings for this year, Pereira's scrapbook, AAA roll D223).
The artist's work was also included in numerous shows attempting to
balance surrealism and abstraction. Although such shows forced a polar-
ized view of stylistic "difference," at least one critic, in a review of work
by Pereira and Leonor Fini at the Julien Levy Gallery, noted the "popu-
lous borderland between abstraction and surrealism" in which Pereira's
work fell ("Pereira and Fini: The Abstract and the Surreal," *Art News,*
March 4, 1939, p. 13). On the differences between the works by the male
and female surrealists, Gloria Orenstein has written, "The subject matter
of the paintings and writings of the Women of Surrealism is largely
dominated by the theme of Woman as Subject, rather than as Object."
As part of their strategy in this regard, to search for their own definitions
of their roles, women in surrealism have identified themselves as god-
dess, alchemist, and Great Mother, among other choices (Orenstein,
"Women," p. 15).

48. See Adrienne Rich, "Diving into the Wreck," in Adrienne Rich,
Poems Selected and New 1950–1974 (New York: W. W. Norton and Com-
pany, 1975), pp. 196–198.

49. Pereira, EJ, n.p. The inscription "1934" appearing in the micro-
filmed image was written on the source photograph in the artist's archive
and not on the painting itself.

50. R. G. Torrens, *The Golden Dawn: The Inner Teachings* (New
York: Samuel Weiser, 1973), p. 31. See especially Chapter 6, titled
"Dowsing."

51. William Bernard Crow, *A History of Magic, Witchcraft and Oc-
cultism* (London: Aquarian Press, 1968), pp. 296–297; and Solco Walle
Tromp, *Psychical Physics: A Scientific Analysis of Dowsing, Radiesthesia and
Kindred Divining Phenomena* (New York: Elsevier Publishing Co., 1949),
p. 365.

52. The account of Moses and the brazen serpent appears in Num-
bers 21:4–9. For prevailing beliefs regarding the origins of serpent sym-
bolism in the 1920s and 1930s, see M. Oldfield Howey, *The Encircled Ser-
pent: A Study of Serpent Symbolism in All Countries and Ages* (Philadelphia:
David McKay Company, 1926); and Ernest Ingersoll, *Dragons and Their
Lore* (New York: Payson and Clarke, Ltd., 1928), the latter a book that
Pereira possessed. Jung did note that "Mercurius is likened to the serpent
hung on the cross (John 3:14)," although this particular passage was
published some years later (Jung, *Alchemy,* p. 414).

53. Jung, *Alchemy,* p. 429.

54. Laurinda S. Dixon, *Alchemical Imagery in Bosch's "Garden of De-
lights"* (Ann Arbor: UMI Research Press, 1981), p. 58.

55. John Read, *Through Alchemy to Chemistry* (London: G. Bell and
Sons, 1957), p. 72.

56. Baur, *Loren MacIver,* p. 65; "Villagers in Manhattan," *Time,* Janu-
ary 26, 1953, p. 69; interview with Andre Zarre, New York, October 11,

1984; letter, Djelloul Marbrook to author, December 27, 1983. Marbrook described her singing as sometimes consisting of one or two lines repeated in an incantatory fashion.

57. According to William Bernard Crow, the three major goals of alchemy are (1) the making of gold, the philosopher's stone; (2) the search for the elixir of life, immortality; and (3) the creation of life by artificial means (i.e., without the aid of woman), such as the homunculus (Crow, *History of Magic*, p. 76).

58. Dwinell Grant, "Parchment: New Painting Surface." *Art News,* October 1–14, 1942, p. 16. According to Grant, Pereira benefited from the researches of George A. Hathaway, who had studied the properties of parchment for a decade.

59. Grillot de Givry, *A Pictorial Anthology of Witchcraft, Magic, and Alchemy,* trans. J. Courtenay Locke (London: Spottiswoode, Ballantyne and Company, Ltd., 1931; reprint ed., New York: University Books, 1958), p. 343.

60. In noting Pereira's use of marble dust, Dwinell Grant wrote, "Each particle of marble dust is a tiny reflector and when several million of these, more or less, are glued to a few square inches, the result is sparkling to say the least" (Grant, "Parchment," p. 32).

61. See letters, Pereira to Charlotte Willard, February 11, 1967, Pereira archive, IRP-SL; and Pereira to Edwin E. Land, February 11, 1963, AAA roll 1298.

62. Kim Levin, *Beyond Modernism: Essays on Art from the 70s and 80s* (New York: Harper and Row, 1988), p. 21. In her discussion of Duchamp's *Large Glass,* Levin cited the unidentified publication by "Pauwels and Bergier" of a partial description of the alchemists' procedures, including the treatment of the mixture with polarized light.

63. Worringer, *Form Problems,* p. 16.

64. Jung, *Integration,* pp. 69–70.

65. Anaïs Nin, *The Diary of Anaïs Nin,* vol. 6: 1955–1966, ed. Gunther Stuhlmann (New York: Harcourt Brace Jovanovich, 1966), p. 209. That Pereira intended such a "reading" of these paintings may be inferred from comments she made in her lecture at Smith College about the significance of the work of the Cubists, whom she saw as exploring the theoretical implications of space-time, like herself. For her, in looking at a Cubist painting, "the observer is not in a fixed position. He projects himself through *space-time* exploring the continuum. Also exploring the depths of the sub-conscious" (Pereira, "Perspective vs. Space-Time," August 1, 1944, AAA roll 2395).

66. John Read, *Through Alchemy to Chemistry* (London: G. Bell and Sons, 1957), p. 20; Jung, *Integration,* p. 67.

67. Jung, *Alchemy,* p. 169.

68. "In Modern Moods," *New York Herald Tribune,* January 16, 1944, clipping, Peggy Guggenheim Papers, AAA roll ITVE-1.

69. Rosamund Frost, "Pereira: New Depths of Optical Illusion," *Art News* 44 (February 1946): 100.

70. This painting was reproduced in László Moholy-Nagy's *Vision in Motion,* published in 1946.

71. In 1966, Pereira titled one oil painting on canvas *Mercurial Vessel of Light.*

72. "Local Shows," *New York Times,* May 23, 1943, sec. 2, p. 10.

73. Jung, *Alchemy,* p. 28.

74. Ibid., p. 48.

75. Ibid., p. 69.

76. Ibid., p. 23.

77. Ibid., p. 192, n. 72.

78. Jung, *Integration,* p. 227.

79. Ibid., p. 226.

80. Jung, *Alchemy,* p. 116.

81. Jung, *Integration,* p. 68.

82. Ibid., p. 227.

83. Orenstein, "Women," p. 15.

84. This assertion is based upon numerous comments made to me by Pereira's surviving friends, associates, and family. No conclusive corroborative evidence exists in extant papers.

85. Carl G. Jung, Commentary, in *The Secret of the Golden Flower: A Chinese Book of Life,* trans. Richard Wilhelm (London: Kegan Paul, Trench, Trubner and Co., Ltd., 1932), p. 79; Carl G. Jung, *The Collected Works of Carl G. Jung,* vol. 9, part 1: *The Archetypes of the Collective Unconscious,* trans. R. F. C. Hull (London: Routledge and Kegan Paul, 1959), p. 14; and Jung, *Integration,* p. 129.

86. Cary F. Baynes, Translator's Preface, *Secret,* pp. vii–viii. See also Jung's Commentary, pp. 78–79, 128–131.

87. Jung, *Secret,* p. 135. This passage from Jung's commentary, with other excerpts, appeared in *transition* in March 1932 ("Dr. C. G. Jung," *transition* 21 [March 1932]: 125–127).

88. For information concerning the changes in the museum, see "A Farewell to Mysticism," *New York Post* June 4, 1938, clipping appearing on AAA roll 29.

89. Minutes, American Abstract Artists, March 12, 1937, AAA roll NY59–11.

90. Susan Carol Larsen, "The American Abstract Artists Group: A History and Evaluation of Its Impact upon American Art," Ph.D. dissertation, Northwestern University, 1975, p. 558.

91. Susan Larsen shares this belief (Larsen to author, June 17, 1984).

92. Letter to editor, *Art Front* 3 (October 1937): 20–21, as quoted by Rosalind B. Browne in O'Connor, *New Deal Art Projects,* pp. 230–232. Franklin Rosemont has also argued that the Surrealists, despite their interests in alchemy and magic, were not concerned with mysticism. See Franklin Rosemont, "Introduction," in André Breton, *What Is Surrealism? Selected Writings,* ed. Franklin Rosemont (Monad Press, 1978), p. 46.

93. Pereira to Hilla Rebay, October 15, 1940, S. R. Guggenheim Museum files. Pereira was listed as being on the Easel Division in a press release concerning her talk on "Cubism and Abstract Art" at the Art Center, Brooklyn (press release, Federal Works Agency, Work Projects Administration Arts Program, New York City WPA Art Project, Department of Information, July 23, 1940, AAA roll 2395). The Work Projects

Administration Arts Program was dissolved in 1943. The Metropolitan Museum of Art acquired paintings from the breakup of the New York and Pennsylvania projects that year (Metropolitan Museum of Art, *Seventy-Fourth Annual Report of the Trustees, 1943* [New York: Metropolitan Museum of Art, 1944], p. 27).

94. Employment application and Museum of Non-Objective Painting report, signed by Pereira, S. R. Guggenheim Museum files.

95. Pereira remained friendly with Marie Menken and her husband, poet and filmmaker Willard Maas, and attended several of the frequent gatherings of artists, filmmakers, and intellectuals for screenings of avant-garde films at their penthouse apartment in Brooklyn Heights. Correspondence in 1968 between Pereira and Maas, a collector of her paintings, indicates that he was working on a film about her work (letter, Willard [Maas] to Pereira, January 19, 1968, AAA roll 1298). The day before her own death she read that Maas had died (Marbrook, "Pereira, My Aunt," p. 121).

96. See Joan M. Lukach, *Hilla Rebay: In Search of the Spirit in Art* (New York: George Braziller, 1983) for scattered references to these difficulties, or Rosalind B. Browne, in O'Connor, *New Deal Art Projects,* p. 230.

97. See letter, Elizabeth McCausland to Hilla Rebay, July 13, 1942, McCausland Papers, AAA roll D-374.

98. See Hilla Rebay's handwritten notes for a letter of July 13, 1942, as well as letters concerning this situation: Hilla Rebay to Pereira, May 21, 1942, July 10, 1942, August 4, 1942, August 12, 1942, in S. R. Guggenheim Museum files; Elizabeth McCausland to Hilla Rebay, July 13, 1942, July 28, 1942, August 12, 1942; and Hilla Rebay to Elizabeth McCausland, July 18, 1942, July 31, 1942, in McCausland Papers, AAA roll D-374. The Museum of Modern Art had acquired two of Pereira's paintings by March 1941 (see letter, Pereira to Hilla Rebay, March 17, 1941, S. R. Guggenheim Museum files).

99. See letter, Pereira to Hilla Rebay, August 21, 1942, S. R. Guggenheim Museum files. A letter from Pereira, dated October 4, 1942, remained unanswered by Rebay, who was herself suffering from severe illness, until August 1944. They apparently lost contact from that time until April 1962, by which time Pereira shared Rebay's views affirming spiritual values in art (Pereira to Hilla Rebay, October 4, 1942; Rebay to Pereira, August 16, 1944; Pereira to Rebay, April 15, 1962, S. R. Guggenheim Museum files).

100. Letter, Pereira to Hilla Rebay, October 4, 1942, S. R. Guggenheim Museum files.

101. A diary entry many years later indicates that Pereira felt "George W. B." had been incapable of sharing her feelings regarding the beauty of Italy, especially Venice, suggesting that he had accompanied her on this trip (Pereira, diary entry, October 19, 1963, AAA roll D222).

102. Letter, Djelloul Marbrook to author, December 27, 1983.

103. "Exhibit of Modern Art," *New York Herald-Tribune,* January 2, 1943, Peggy Guggenheim Papers, AAA roll ITVE-1.

104. Emily Genauer, "The Guggenheim Exhibit," unidentified clipping, Peggy Guggenheim Papers, AAA roll ITVE-1.

105. Letter, Lawrence Vail to Pereira, January 21, 1948, AAA roll 1296.

106. Melvin P. Lader and Fred Licht, *Peggy Guggenheim's Other Legacy* (New York: S. R. Guggenheim Museum, 1987), p. 10.

107. Jean Connolly, "Art," *Nation,* May 29, 1943, p. 786.

108. Pereira kept in touch with Peggy Guggenheim for many years following this professional association, and her name is peppered throughout the artist's papers. However, Pereira's name is mentioned only once, in connection with an exhibition at Art of This Century, in Guggenheim's autobiography (Marguerite Guggenheim, *Out of This Century: Confessions of an Art Addict* [New York: Universe Books, 1979 (1946)], p. 314).

109. Elizabeth McCausland, Introduction, in *I. Rice Pereira* (New York: Art of This Century, 1944), n.p.

110. Pereira, untitled statement, December 8, 1942, AAA roll 1296.

111. Pereira, quoted in McCausland, "I. Rice Pereira," p. 374, 376. A portion of this statement appears in the catalogue of the Fourteen Americans exhibition at the Museum of Modern Art in 1946.

112. Pereira, quoted in McCausland, "I. Rice Pereira," p. 374.

113. Pereira, EJ, n.p.

114. McCausland, "Alchemy," p. 186.

115. The friendship between Pereira and McCausland apparently dissolved soon after this article appeared. In addition to their different opinions concerning art, Pereira began to have problems in her dealings with Herman Baron, to whom McCausland was loyal. The artist had rejoined the ACA Gallery in 1946, but she unjustly accused Baron of not trying to promote her works in conversations with Robert Gwathmey in 1949 (Robert Gwathmey to Herman Baron, undated, AAA roll D-304). The number of paintings Baron sent to exhibitions and the three one-artist shows he gave her at the ACA Gallery between 1946 and 1949 indicate his support. However, Pereira's association with Baron's ACA Gallery at this time may have become a liability, for it was during this period that she came under attack by some members of Congress. Her professional association with Baron and his gallery ended in 1949.

116. McCausland, "Alchemy," p. 186.

117. I am indebted to Thomas Dillon Redshaw for some of the biographical information concerning George Reavey. See also Reavey's Application for Immigration Visa, [1951], GR-UT; and "George Reavey, a Translator of Russian Literature, Dead," *New York Times,* August 13, 1976, sec. 4, p. 12. Baptized Niall George Reavey in Belfast in 1909, he later changed his name to George Edmund Reavey.

118. Reavey mentioned that he had left a Magritte collage with Hayter about 1927 (Reavey to Pereira, April 15, 1950, GR-UT).

119. Pereira mentioned coming across this piece in 1963 while she was staying with Caresse Crosby at the Castle of Roccasinibaldi (Pereira to Reavey, June 18, 1963, GR-UT).

120. Reavey, "Editorial Foreword," in Paul Eluard, *Thorns of Thunder,*

ed. George Reavey (London: Europa Press and Stanley Nott, 1936), p. vii.

121. Paul C. Ray, *The Surrealist Movement in England* (Ithaca: Cornell University Press, 1971), pp. 138–140.

122. Kathleen Raine, *Blake and Tradition,* 2 vols., Bollingen Series XXXV.ii (Princeton: Princeton University Press, 1968), 1: xxxi; and Kathleen Raine, "W. B. Yeats," in *Man, Myth and Magic: An Illustrated Encyclopedia of the Supernatural,* ed. Richard Cavendish (New York: Marshall Cavendish Corporation, 1970), 22: 3066–3068. Raine, along with poets David Gascoyne and W. S. Graham, visited the United States just prior to the Christmas holiday season in 1951 to give poetry readings in New York and go on tour. They visited with Pereira and Reavey (letter, Pereira to Alice Nichols, undated [November? 1951], courtesy Alice Nichols and Peter Nichols). Pereira subsequently obtained a copy of Raine's booklet *William Blake,* an illustrated supplement to the *British Book News,* published in 1951. During the late 1950s, Raine's name also appears on lists Pereira prepared for her agents of those notables who might lend their support in publicity regarding the artist's books. For example, see letter and attachments, Pereira to Frank Paul, March 24, 1959, AAA roll 1297.

123. John Graham, *System and Dialectics of Art* (New York: Delphic Studios, [1937]), pp. 84, 131.

124. Application for Immigration Visa, [1951], GR-UT.

125. Reavey to Assia Abel, undated (winter 1950–51), GR-UT. Pereira contributed an etching, *Omega,* to illustrate a poem by Reavey in a portfolio titled *21 Etchings and Poems,* issued in an edition of fifty signed and numbered copies in 1958. Originally conceived by Hayter, the project was undertaken in 1951 by Morris Weisenthal, with the help of Peter Grippe, who had taken over Hayter's Atelier 17. For more information on this project, see "Art: Poems and Etchings," *New York Times,* November 7, 1958, p. 20.

126. Reavey to Pereira, March 21, 1950, GR-UT.

127. Although Jacobson was given a congressional commendation on October 21, 1966 (and Pereira kept a page from the *Congressional Record* documenting the honor [AAA roll 1298]), he was exposed as a "Dr. Feelgood" in 1972, after Pereira's death. The mysterious potions he injected into his patients consisted of enzymes extracted from human tissue, a "substrate" to accelerate the enzyme function, and various vitamins and steroids, according to an undated note signed by Jacobson remaining with Pereira's papers (AAA roll 1298). In 1972, the substrate with the "accelerating" properties was publicly revealed to contain amphetamines ("The Story of a 'Dr. Feelgood,'" *Newsweek,* December 18, 1972, p. 75). Pereira saw the doctor and received his injections regularly for more than twenty years, and in 1968 she equated his photographic imaging process using polarized light with her own "new optic" published in her *Transcendental Formal Logic of the Infinite* (Pereira to Max Jacobson, February 25, 1968, AAA roll 1298).

128. See, for example, Holger Cahill's letter to Pereira dated November 19 [1950], AAA roll 1296, or Pereira's summary of the "suppression" of her work dated November 19, 1962, AAA roll 1299.

129. Pereira, EJ, n.p.

130. Pereira to Reavey, February 23, 1950, GR-UT.

131. I am grateful to the late Jean Bullowa Reavey, who spoke candidly to me about Pereira, George Reavey, and these issues in a telephone interview on January 28, 1987. A playwright and George Reavey's third wife, she maintained a cordial relationship with Pereira, his second.

132. Pereira to Reavey, August 8, 1951, GR-UT.

133. Although Pereira claimed on several occasions to have written poetry as a child, no poems have surfaced that predate her marriage to Reavey (Reavey to Pereira, February 21, 1950, GR-UT).

134. "Passion for Light," *Life,* January 26, 1953, p. 72.

135. Letter, Pereira to Reavey, May 10, 1950, GR-UT.

136. Pereira, EJ, n.p.; Pereira to John I. H. Baur, November 4, 1954, AAA roll 1297. In 1966, Pereira copied notes from ASTARA literature describing the process by which one might communicate with "spiritual beings on a higher plane and ask that they help you attain a goal" (Pereira, ASTARA notes, November 5, 1966, AAA roll 1299). ASTARA was founded in 1951 as the ASTARA Foundation in Upland, California, for persons interested in mystical religious studies. Pereira also possessed Robert G. Chaney's *Transmutation,* published by ASTARA in 1969.

137. Carl G. Jung, "Psychology and Poetry," *transition* 19–20 (June 1930): 44.

138. R. T. Wallis, *Neo-Platonism* (London: Gerald Duckworth and Company, Ltd., 1972), p. 176.

139. Eugene Wallis, "Three Romantic-Mystic Texts," *transition* 23 (July 1935): 85.

140. See letters, Reavey to Pereira, February 23, 1950; Pereira to Reavey, May 7, [1950]; Pereira to Reavey, postmarked April 17, 1950; and Pereira to Reavey, July 27, 1951, GR-UT.

141. Reavey to Pereira, March 21, 1950, GR-UT.

142. Reavey to Pereira, February 27, 1950, and February 28, 1950, GR-UT.

143. See, for example, Jung, *Alchemy,* p. 317.

144. Pereira, *The Nature of Space* (New York: by the artist; reprint ed., Washington, D.C.: Corcoran Gallery of Art, 1968), p. 19 (hereafter cited as NOS).

145. Pereira read *The Sufis* by Idris Shah in April 1965 (see Pereira to Robert Graves, April 20, 1965, AAA roll 1298), and she recommended the book to her nephew, Djelloul Marbrook, who read it in February 1967 (Djelloul Marbrook to Pereira, February 7, 1967, AAA roll 1298). Pereira also sent copies of her manuscripts to the secretary general of the Sufi Movement in Geneva, Switzerland, during the mid-1960s (Pereira to the Secretary General, Sufi Movement, Geneva, Switzerland, undated, AAA roll 1298).

146. Announcement by the U.S. chapter of the Persian Order of Sufis, as quoted in "Arcane Societies in the United States: The Persian Order of Sufis," *Rosicrucian Brotherhood* 2 (July 1908): 113.

147. Reavey to Pereira, February 19, 1950, GR-UT. Pereira considered Mark Rothko an opportunist who befriended George Reavey for his European contacts (see Pereira to Reavey, March 17 [1950], GR-UT).

148. Pereira had obtained a legal separation from Brown by July 1949.

The marriage ended officially on June 6, 1950, when she divorced him in Daytona Beach, Fla. He did not want the divorce (Pereira to Reavey, June 6, 1950, GR-UT). He died while Pereira was in England.

149. Due to Reavey's Russian birth, he had to enter the United States on the Soviet quota (Reavey to Pereira, August 1, [1951], AAA roll 1297). Although he received a Visa number and was ready to embark for the United States on June 22, the State Department delayed his entry several months (Pereira to Reavey, October 2, [1951], with enclosure dated September 9, [1951]). Reavey ultimately arrived in New York in November 1951. Succumbing to the paranoia of the time, Reavey believed that he and his wife were being investigated by the FBI (Reavey to Pereira, August 1, [1951], AAA roll 1297). Pereira suspected that their mail was being opened by authorities (Pereira to Reavey, August 6, 1951, GR-UT). Some years later, while in Rome in June 1960, Pereira received a letter from her landlord alleging that two friends had heard a radio report that the artist had been arrested by French police for espionage activities in North Africa. The landlord claimed that the news report was not rebroadcast (see letter and enclosures, Pereira to Reavey, October 5, 1960, GR-UT). Although unable to obtain any confirmation of the story's airing, Pereira became obsessed with the issue upon her return to the United States, and she complained for years that her mail and phone line were being tampered with.

150. Pereira to Reavey, received February 17, 1950; Pereira to Reavey, [March 2, 1950]; and Pereira to Reavey, March 9, [1950], GR-UT.

151. See, for example, Reavey to Pereira, April 14, 1950, GR-UT.

152. Pereira to Reavey, received February 17, 1950, GR-UT.

153. See letters, Reavey to Pereira, February 23, 1950; Pereira to Reavey, postmarked April 11, 1950; Pereira to Reavey, March 9, [1950]; Pereira to Reavey, postmarked April 3, 1950, GR-UT.

154. Jung, *Integration,* pp. 108–109, 137. Pereira wrote the following statement for John I. H. Baur in 1957: "The symbol has safely guided my course into the unknown realm of experience. The traveller is just a pilgrim. Sometimes he knows a little more, often less, because values change with each voyage. Sometimes one gets a glimpse of the bridge to eternity before it disappears like a rainbow. Somewhere between exaltation and despair lies the answer" (Pereira, quoted in *New Art in America,* ed. Baur, p. 230).

155. Jung, *Alchemy,* p. 110. See also pp. 56–57, 193; and Jung, *Secret,* p. 81.

156. Howey, p. 74.

157. The twin figures seen in Pereira's drawings may be seen as the Greco-Roman Dioscuri, Castor and Pollux, but they are perhaps more closely related to the Mithraic *dadophoroi,* representing the rising and setting sun. Pereira often drew this pair with a starlike motif in the center of each forehead, like the mark of Mithra (Bayley, *Lost Language,* 1: 145). She called her androgynous twins "divine couples," and the lengthiest statement on them appears in notes dated December 5, 1962: "Divine couples—powers of divination—a unity—which has supra personal powers of divination; principles humanized. . . . Divine Couples are elec-

tromagnetic and . . . represent a principle—a whole" (notes, December 5, 1962, AAA roll D222).

158. Bayley, *Lost Language,* 2: 41. Pereira also consulted her copy of Elisabeth Goldsmith's *Ancient Pagan Symbols* (1929) for information on symbolism.

159. Chadwick, *Women Artists,* pp. 78–79. Carrington briefly associated with the New York Surrealists in 1941, and she had a one-artist exhibition at the Pierre Matisse Gallery in New York in 1948.

160. Jung, *Alchemy,* pp. 80, 82.

161. Ibid., pp. 366, 367. The uroboros encircles and encloses the "chaos" and thus is a symbol of the *prima materia.* As a circle, it is also a symbol of unity. The serpent is frequently represented as having two heads and/or two joined bodies, one representing the spirit and one representing temporal existence. In a letter to her friend Shaun Mandy, editor of the *Illustrated Weekly of India,* published in Bombay, Pereira described herself as such a two-headed uroboros in search of her tails (Pereira to Shaun Mandy, June 12, [1953], AAA roll 1297).

162. Levin, *Beyond Modernism,* p. 21.

163. Jung, *Alchemy,* p. 408.

164. Carl G. Jung, *Collected Works of Carl G. Jung,* ed. Herbert Read, Michael Fordham, and Gerhard Adler, vol. 11: *Psychology and Religion: West and East,* trans. R. F. C. Hull (London: Routledge and Kegan Paul, 1958), pp. 101–102.

165. Jung, *Alchemy,* pp. 75, 124.

166. Pereira, dream diary entry, November 5, 1954, AAA roll D222.

167. Ibid.

168. Pereira notes, c. 1951, AAA roll 1300. Although dated 1950, these notes also refer in the past tense to paintings completed in 1951.

169. Bayley, *Lost Language,* 1: 244.

170. Pereira and Reavey were legally married on September 9, 1950, in London. Witnesses included Dylan Thomas, Helen McAlpine, and W. R. Rogers.

171. Pereira to Reavey, March 9, [1950], GR-UT; and Pereira to Reavey, May 10, 1950, GR-UT.

172. See letters, Pereira to Reavey, March 9, [1950] and May 10, 1950, GR-UT.

173. Raymond S. Stites made this observation in his *Arts and Man,* p. 815. The theme of the sculpture was the result of the architects' hiring of an outside "spiritual counselor," a professor of philosophy (Wilson, Pilgrim, and Tashjian, *Machine Age, p. 158).*

174. James Jeans, *The Mysterious Universe* (New York: Macmillan Company, 1930), pp. 138, 159.

175. Jung, *Secret,* p. 11.

176. Pereira, notes, July 6, 1962, AAA roll D222.

177. Pereira to Reavey, March 9, [1950], GR-UT.

178. Jung, *Alchemy,* pp. 202–204, 218–219.

179. Reavey to Pereira, April 23, [1950], GR-UT.

180. She marked this information in her copy of Bayley, *Lost Language,* 1: 267.

181. Pereira's notes from Dantzig's book are dated October and December 1962. See AAA roll D222.

182. This literature appears on AAA roll 1300. A diary entry for January 6, 1962, indicates that Pereira was reading AMORC (Ancient and Mystical Order Rosae Crucis) papers on cosmic consciousness, and this may be the period in which she read the other Rosicrucian literature, as well (Pereira, diary entry, January 6, 1962, AAA roll D222).

183. For example, see June Singer, *Boundaries of the Soul: The Practice of Jung's Psychology* (Garden City, N.Y.: Doubleday, 1972; Anchor, 1973), p. 398.

184. Ralph A. Dungan, special assistant to the president, to Pereira, November 19, 1963, AAA roll 1298.

185. Pereira, notes, February 24, 1964, AAA roll D222.

186. Pereira provided most of the illustrations for Williams' *The Silver Treasury of Light Verse,* published in 1957. Williams gave Pereira a volume of Gene Derwood's poems in March 1955.

187. László Moholy-Nagy, *Vision in Motion* (Chicago: Paul Theobald and Company, 1947), pp. 344, 345–346.

188. In a footnote to their *Skeleton Key to Finnegans Wake,* Joseph Campbell and Henry Morton Robinson noted parallels between Spengler's *The Decline of the West* and Joyce's *Finnegans Wake* (Joseph Campbell and Henry Morton Robinson, *Skeleton Key to Finnegans Wake* [New York: Harcourt, Brace and Company, 1944], p. 5, n. 1).

189. Pereira was a visiting artist in a class taught by Lila Ulrich ("Ulrich's Art Class Goes on Field Trip," unidentified source published by Sarah Lawrence College, January 19, 1944, clipping, Pereira's scrapbook, AAA roll D223). Ulrich, like Pereira, had taught design synthesis at the Laboratory School of Industrial Design.

190. Campbell and Robinson, *Skeleton Key,* pp. 3–5.

191. Campbell, *Hero,* p. 30.

192. Reavey also described the central theme in his work as that of the hero who must ultimately reconcile the duality between temporal and spiritual existence through a series of events that parallel the stages in alchemical literature. See George Reavey, dust jacket to *Colours of Memory* (1955). Reavey's poem "For an August Birthday," dedicated to Pereira, appears in this book.

193. These are terms she sometimes used in her notes and correspondence to refer to her goal of enlightenment. See, for example, her letter to Reavey, September 25, [1951], GR-UT.

194. Campbell, *Hero,* p. 391; Pereira, notes, November 22, 1963, AAA roll D222.

7. RECONCILING THE INNER-OUTER DUALITY: PEREIRA'S PHILOSOPHY OF SPACE, TIME, AND LIGHT

1. Jung, *Secret,* pp. 23–25, 34. Lü Tzu, an adept of the Tang dynasty, is not to be confused with Lao-tzu, founder of Taoism, who lived during the Chou dynasty, sixth century B.C.

2. Pereira notes, July 6, 1962, AAA roll D222; and letter, Pereira to Reavey, March 9, [1950], GR-UT.

3. See letter, Pereira to Frank [Paul], March 24, 1959, AAA roll 1297.

4. Pereira, quoted in Catherine Maxwell, "Famous Abstract Artist Teaching at Ball State," by *Muncie Star,* June 22, 1951, clipping, Pereira's scrapbook, AAA roll D223.

5. See Pereira-Reavey correspondence, GR-UT; Pereira-Cahill correspondence, AAA roll 1296; and Schwartz, "Demystifying," p. 117. Pereira's increasingly serious respiratory problems, for which she had begun to seek medical attention prior to leaving for England, caused her to go to the Carl Stough Breathing Institute in New York in 1969 and led, ultimately, to her death from emphysema in 1971.

6. A letter addressed to "Mr." I. Rice Pereira outlining a need for a painter and requesting that she join the faculty for the summer of 1950 may be found in the Black Mountain College Papers, General Files 1933–1956, box 11, Faculty Applicants 1950, at the N.C. Department of Cultural Resources, Raleigh, N.C. The letter, signed by A. W. Levi, is dated February 27, 1950.

7. See letters, Pereira to Reavey, October 8 and October 13, 1951, GR-UT.

8. Maxwell, "Famous," AAA roll D223.

9. Letters, Pereira to Reavey, postmarked August 11, 1951, and September 20, [1951].

10. See letters, Pereira to Reavey, October 4, 7, and 13, 1951, GR-UT.

11. "The Continuity of Human Experience by Siegfried Giedion," *Art News and Review,* February 10, 1951, p. 2. Pereira's copy of the article appears on AAA roll 1301. See also letter, Pereira to Holger Cahill, October 14, 1951, AAA roll 1297. Although Pereira had been in England at the time of Giedion's lecture and had ties with the institute, her enthusiasm over this review of the talk, rather than the talk itself, suggests that she had not been in attendance.

12. Pereira to Reavey, October 7, 1951, GR-UT. The same comment appears in her letter to Andrew Carnduff Ritchie, October 10, 1951, Museum of Modern Art files.

13. Pereira was fascinated with medieval art and philosophy in the 1950s, and she corresponded briefly with art historian Otto van Simson, who sent her a copy of his book *The Gothic Cathedral* in 1957.

14. *L'écriture féminine* is a term usually associated with French feminist theory, particularly the writings of Hélène Cixous and Luce Irigaray, for writing grounded in women's experience of the body and sexuality. For example, Cixous has explained, "A feminine textual body is recognized by the fact that it is always endless, without ending: there's no closure, it doesn't stop, and it's this that very often makes the feminine text difficult to read. . . . A feminine text goes on and on and at a certain moment the volume comes to an end but the writing continues" (Hélène Cixous, "Castration or Decapitation?" in *Out There: Marginalization and Contemporary Cultures,* ed. Russell Ferguson, Martha Gever, Trinh T. Minh-ha, and Cornel West [New York: New Museum of Contemporary Art; Cambridge: The MIT Press, 1990], p. 354).

15. See Arthur Cohen to Pereira, December 1, 1955, AAA roll 1297.

16. See, for example, Pereira to Arthur Cohen, December 19, 1955, AAA roll 1297. In later notes, Pereira wrote, "Space must be considered as an Absolute—perfect and unlimited—expanding and contracting and continuing. Source of space UNKNOWN—LIKE THE SOURCE OF LIFE. SOURCE OF SPACE MUST EXIST IN THE MIND—IF IT DID NOT THE MIND COULD NOT DIFFERENTIATE OR CONTAIN SOMETHING" (Pereira, notes, January 3, 1955, AAA roll 1300).

17. Kant, *Critique,* p. 24. A bookmarker in Pereira's copy of Kant's *Critique of Pure Reason,* a portion of the *New York World Telegram* for April 15, 1952, suggests that she may have been reading Kant about that time. In later notes Pereira took from page 15 of Edmund Taylor Whittaker's *From Euclid to Eddington: A Study of Conceptions of the External World* (London: Cambridge University Press, 1949) concerning Kant's philosophy of space, she underlined the following passage: "Kant asserted that it [space] has no existence except as a characteristic of human consciousness. . . . Thus space is a necessary mode of thought, or, as Kant expressed it, an a priori form of our sensibility. We could not have experience of the external world at all, unless our minds were first endowed with this faculty." She wrote "true" after it (Pereira, notes, December 6, 1962, D222).

18. *Plotinus: Being the Treatises of the First-Sixth Enneads with Porphyry's Life of Plotinus, and the Preller-Ritter Extracts Forming a Conspectus of the Plotinian System,* 2 vols., trans. Stephen MacKenna (Boston: Charles T. Branford Company, 1916), VI.9.11.

19. Pereira, "Light and the New Reality," *Palette* (Spring 1952): 3.

20. Gerald Holten, *Thematic Origins of Scientific Thought: Kepler to Epstein* (Cambridge: Harvard University Press, 1973), p. 123.

21. Pereira, "Light," p. 4. In 1957, John Baur related that "light is for Pereira both the male principle and the humanizing element in the vastness of interstellar space" (Baur, "I. R. Pereira," p. 230).

22. *Enneads,* IV.3.22.

23. Ibid., VI.9.11.

24. John Locke, *Essays,* Book 2, chap. 15, as quoted by Raine, *Blake and Tradition,* 2: 136.

25. Pereira, "The New Reality Is Dual," undated notes (c. 1951), AAA roll 1300.

26. Pereira, "Light," p. 3.

27. Jung, *Alchemy,* p. 110.

28. Jung, Commentary, *Secret,* p. 107.

29. Pereira, "Light," p. 6.

30. Hinton, *Fourth Dimension,* p. 110.

31. Ibid., p. 120.

32. Pereira, "Light," p. 4. Stories of the pain-filled pathway to enlightenment apparently brought some solace to Pereira. She noted such accounts in several of the books in her library. For example, she highlighted the following passage, published as an epigraph to the chapter "Via Dolorosa" in Bayley's *The Lost Language of Symbolism:* "Of all who have sailed the seas of life, no men have experienced a range of vicissitude

more wide than has fallen to the lot of some among the mystics. Theirs have been the dazzling heights; the lowest depths also have been theirs. Their solitary vessels have been swept into the frozen North, where the ice of a great despair has closed about them like the ribs of death, and through a long soul's winter they have lain hidden in cold and darkness, as some belated swallow in the cleft of a rock" (Bayley, *Lost Language,* 2: 317).

33. Pereira, "Light," p. 4.

34. She may have based this observation upon a passage she marked in Jung's *Contributions:* "Only those objects upon which the shaft of light falls enter the field of perception. An object that is by accident in darkness has not ceased to exist, it is merely not seen" (Jung, *Contributions,* p. 81).

35. Pereira, 'Light," p. 5.

36. Pereira, EJ, n.p.

37. Jacob Bronowski, *William Blake, a Man without a Mask* (1944; reprint ed. New York: Haskell House Publishers Ltd., 1967), p. 9. Pereira corresponded and exchanged Christmas cards with the Bronowskis as late as 1966.

38. Jung, Commentary, *Secret,* p. 109.

39. Pereira, notes, May 18, 1955, AAA roll 1300, and June 21, 1955, AAA roll 1300.

40. R. H. Wilenski, *The Modern Movement in Art* (London: Faber and Faber, 1923 [1927]), p. ix. In the same paragraph, he placed classical art in opposition to romantic art, which "assumes that the artist is more important than art, and the artist's emotional personality should dominate his work."

41. Pereira, "Light," p. 6.

42. Lincoln Barnett, *The Universe and Dr. Einstein,* foreword by Albert Einstein (New York: William Sloane Associates, 1948; revised ed., 1950), p. 40. The page number cited in Pereira's treatise is 342, although the book contains only 127 pages. This may have been the publisher's error, however. Pereira marked numerous passages, including the one cited, in her copy of this revised edition.

43. Pereira, "Light," p. 7.

44. *Enneads,* VI.7.21.

45. Pereira, "Light," p. 7.

46. Wallis, *Neo-Platonism,* p. 171.

47. Thomas Moore, *The Planets Within: Marsilio Ficino's Astrological Psychology* (Lewisburg: Bucknell University Press, 1982), pp. 129, 178.

48. For example, she wrote, "In other words, the mind of man is a solar system. The mind is polarized around a source of energy. The physical world is always an illusion. Only what is real to the human psyche is projected into the world-picture; but only for a split second because the mind is always in a continuous state of ever-evolving. A limit cannot be placed on the mind of man because his constellation of consciousness is, in reality, related to a cosmological functioning of order. The same order exists in the universe. The nuclear core of the mind is a star around which the constellation of consciousness is polarized" (Pereira notes, dated August 26–October 4, 1961, AAA roll D222).

49. In the foreword to the catalogue of her one-artist exhibition at the Corcoran Gallery of Art in 1956, Pereira claimed that "all the infinitudes of man's aspirations [are] contained in a Zero—the unknown quality of a continuum." This statement is dated January 5, 1956. Pereira discussed the zero in her philosophical publications, beginning in the mid-1950s. See, for example, *The Nature of Space,* pp. 52, 62.

50. Pereira, "Light," p. 10.

51. *Enneads,* VI.9.11.

52. Pereira, EJ, n.p.

53. For example, Erich Neumann wrote, "In the course of its onto-genetic development, the individual ego consciousness has to pass through the same archetypal stages which determined the evolution of consciousness in the life of humanity. The individual has in his own life to follow the road that humanity has trod before him, leaving traces of its journey in the archetypal sequence of the mythological images we are now about to examine" (Erich Neumann, *The Origins and History of Consciousness,* Part I. New York: Bollingen Foundation, Inc., 1954 [Harper and Brothers Torchbook edition, 1962]: xvi).

54. Pereira was familiar enough with *Finnegans Wake* in 1953 to discuss it knowledgably with a Joyce scholar whom she met at a Joyce Society meeting (see letter, Larry Wiggin to Pereira, September 1, 1953, AAA roll 1297).

55. Pereira's continued interest in the role of the hero and in immortality is demonstrated in her notes and by passages she marked in her books. See, for example, her notes from Neumann's *The Origins and History of Consciousness,* on the "treasure" of the psyche, defined in part as the elixir of immortality, and the hero (Pereira notes, December 26, 1962, AAA roll D222). There has been much recent interest in women's autobiographies, as well as the heroes women authors portray in their writings. Two essential readings in these areas are Carolyn G. Heilbrun's *Writing a Woman's Life* (1988) and Rachel M. Brownstein's *Becoming a Heroine: Reading about Women in Novels* (1982). See also Elizabeth Abel, Marianne Hirsch, and Elizabeth Langland, eds., *The Voyage In: Fictions of Female Development* (1983); Mary Mason and Carol Green, eds., *Journeys: Autobiographical Writings by Women* (1979); Dana A. Heller, *The Feminization of Quest-Romance: Radical Departures* (1990); Lee R. Edwards, *Psyche as Hero: Female Heroism and Fictional Form* (1984); the chapter "The Woman as Hero" in Carolyn G. Heilbrun, *Toward a Recognition of Androgyny* (1973); the section "Autobiography: The Self as Strategy for Survival," in Florence Howe, ed., *Tradition and the Talents of Women* (1991); and the section "The Novel of Self-Discovery: Integration and Quest," in Rita Felski, *Beyond Feminist Aesthetics: Feminist Literature and Social Change* (1989).

56. Pereira submitted the manuscript to New Directions Publishers, New York, among others, through her literary agent, Shirley Burke (see Robert MacGregor, New Directions Publishers, to Shirley Burke, August 20, 1953, AAA roll 1297). She was unsuccessful in finding a publisher, however, despite the fact that the text is more readily comprehensible than her other writings and her discussion of her metaphysical aesthetic is kept brief.

57. Jung, *Alchemy,* p. 191.

58. On March 2, 1955, Pereira took notes on the Egyptian Ra from A. Bothwell Gosse, *The Civilization of the Ancient Egyptians.*

59. See, for example, Siegfried Giedion, *The Eternal Present,* vol 2: *The Beginnings of Architecture,* Bollingen Series XXXV.6.11 (Princeton: Princeton University Press, 1964), p. 91.

60. Winslow Ames, "The Lapis," *College Art Journal* 17 (Summer 1958): 446.

61. Bayley, *Lost Language,* 1: 145.

62. Jung, *Alchemy,* p. 77.

63. Mercurius personifies the soul, the anima. A clue to the reason for this figure's classical dress may be found in a passage Pereira underlined in her copy of Jung's *Integration of the Personality:* "But the anima is conservative, and clings in a most exasperating fashion to the ways of earlier mankind. Therefore, it likes to appear in historic dress, with a predilection for Greece and Egypt" (Jung, *Integration of the Personality,* p. 78). The artist also wrote "Greece" and "Egypt" to the side of this passage.

64. Jung, *Alchemy,* p. 104. Pereira referred to King Minos' labyrinth and the Minotaur in notes dated April 1, 1955, roll 1301. She also titled a drawing *Ariadne's Thread of Lux* in 1956 (Pereira to Edward Ives, September 15, 1956, AAA roll 1297).

65. Pereira, *Nature of Space,* p. 37.

66. Locke, *Essays,* Book 2, chap. 15, quoted in Raine, *Blake and Tradition,* p. 136. Compare with this quotation the following passage written by Pereira: "In the irrational infinite large arena of symbolic space man must have references representing the unknown mystery of life, as well as a sense of time, so that his thoughts have position, movement and extension. . . . Should perceptions become indeterminate, . . . [they] will collapse and fall into the chaotic abyss of total negation—the void" (Pereira, "The Paradox of Space," p. 25, AAA 1299).

67. Pereira to Herbert Read, May 19, 1954, AAA roll 1297.

68. A. B. D. Sylvester, "1950 Aspects of British Art," *Art News and Review,* December 30, 1950, p. 5.

69. Pereira to Herbert Read, May 19, 1954, AAA roll 1297; and Herbert Read to Pereira, June 23, 1954, AAA roll 1297.

70. "The Preaching Critic," *Newsweek,* May 10, 1954, pp. 97–98.

71. Herbert Read, *Art and the Evolution of Man* (London: Freedom Press, 1951), p. i.

72. Ibid.

73. Ibid., p. ix.

74. Pereira, notes, October 9, 1954, AAA roll 1300. Cassirer's book was listed as "recommended reading on contemporary art" at the end of the catalogue of American Painting 1954, an exhibition that opened at the Virginia Museum of Fine Arts in February 1954. Pereira's *Transforming Gold* was included in the show and reproduced in the catalogue, a copy of which she kept as a memento (AAA roll 1302).

75. Pereira possessed the following books by Cassirer: *An Essay on Man* (1944), *The Individual and the Cosmos in Renaissance Philosophy* (1963), *Language and Myth, The Philosophy of Symbolic Forms,* vol. 1 (1953),

and *Substance and Function and Einstein's Theory of Relativity* (1923). She also copied notes from this author's *The Problem of Knowledge* (1950).

76. Pereira, "Some Notations on Space-Time and Art," *Western Arts Association Bulletin* 40 (November 1955): 8.

77. Cassirer, *Essay on Man,* p. viii.

78. Ibid., p. 22.

79. Ibid., p. 27.

80. Ibid., p. 25.

81. The subject of this book was prompted, perhaps, by a letter from Paul Weiss, editor of Yale University's *Review of Metaphysics.* In October 1954 Pereira sent to him an unsolicited copy of her manuscript "Transformation of 'Nothing' and the Paradox of Space," which he found unpersuasive and of little interest to his readership. Nevertheless, he indicated an interest in a more careful examination of space. In response, Pereira sent a manuscript of "The Nature of Space" to him the following August, which he also rejected for publication for its summarily handled subject and its lack of intelligibility. See letters, Pereira to Paul Weiss, October 30, 1954; Weiss to Pereira, November 3, [1954]; Pereira to Weiss, August 26, 1955; and Weiss to Pereira, September 6, 1955, AAA roll 1297.

82. Pereira, *Nature of Space,* p. [iv].

83. Oliver Lodge, *Evolution and Creation* (New York: H. Doran Company, 1926), p. 44. For examples of Pereira's use of the term, see her *Nature of Space,* p. 61, or her essay "The Paradox of Space," p. 26, date and published source unknown, AAA roll 1299.

84. Pereira, *Nature of Space,* p. 5.

85. Read, "Art and the Evolution of Consciousness," *Journal of Aesthetics and Art Criticism* 13 (December 1954): 144.

86. *Enneads,* IV.4.5.

87. Pereira, *Nature of Space,* p. 7.

88. Selvig interview transcript, p. 95.

89. Ibid.

90. Cassirer, *Essay on Man,* p. 51.

91. Ibid., p. 25.

92. Pereira, *Nature of Space,* p. 8.

93. Herbert Read, *Icon and Idea: The Function of Art in the Development of Human Consciousness* (New York: Schocken Books, 1955), p. 19.

94. Pereira, *Nature of Space,* p. 7.

95. Ibid., p. 34.

96. *The Divine Pymander of Hermes Mercurius Trismegistus,* quoted in Raine, *Blake,* 2: 140.

97. Pereira, *Nature of Space,* p. 25.

98. Ibid., p. 14.

99. Ibid., pp. 26–27.

100. Ibid., p. 35.

101. Ibid., p. 43.

102. Pereira, "Summary of Emmanual Kant," notes, December 1, 1955, AAA roll 1300. Although Pereira completed *The Nature of Space* about three months prior to the date appearing on this particular sheet of notes, there is a clear connection between what she wrote and what appears here. As it was her practice to copy and then recopy and redate her notes,

and as the heading for this sheet indicates that these notes are a "summary," earlier notes, or the unidentified book itself, must have been her source during the preparation of her manuscript.

103. Pereira, *Nature of Space*, p. 45.

104. The publication of *The Lapis* was made possible through the generosity and persistence of Richard A. Madlener. On several occasions, Pereira listed for others the numerous libraries holding copies of her books, implying in each case that these acquisitions were based upon demand. The truth, evident from the thank-you notes in her archive, is that Pereira sent unsolicited copies of her books to these institutions in order to make these claims. For a representative list of libraries, see Pereira, "A Letter to the Editor from Irene Rice Pereira," *Art Voices* (Spring 1965): 80.

105. While in Paris in 1949, Pereira met Shaun Mandy, education officer with the British Council and editor of the *Illustrated Weekly of India*, published in Bombay. Through him, she learned of Mulk Raj Anand, editor of *Marg*, also published in Bombay, with whom she corresponded for several years. Apparently through Mandy she also became acquainted with Ayaz S. Peerbhoy, of the J. Walter Thompson Company in Bombay, who was instrumental in getting her essay "Light and the New Reality" published in the July 25, 1954, issue of *Mysindia*, a popular weekly out of Bangalore. Her essay appeared here in edited form under the title "Structural Core of an Aesthetic and Philosophy." Through these contacts, Pereira had works published, advertised, and reviewed in *Marg, Lalit Kala Contemporary*, and the *Literary Half-Yearly*, the last, for which she became a regular contributor in 1966, edited by H. H. Anniah Gowda. In addition, through Mandy, she was introduced to Ranjee Shahani in 1958. Shahani wrote a short piece about her, published in 1959 by the Nordness Gallery, New York, in booklet form, under the title *Catching a Sunbeam in a Solar Hat: An Appreciation of I. Rice Pereira*. Shahani also provided a prefatory statement to her book *Crystal of the Rose*, published jointly by the author and the Nordness Gallery in 1959.

106. Frances Yates, *The Rosicrucian Enlightenment* (Boston: Routledge and Kegan Paul, 1972), p. 226.

8. PEREIRA VERSUS ABSTRACT EXPRESSIONISM

1. David Shapiro and Cecile Shapiro, "Abstract Expressionism: The Politics of Apolitical Painting," *Prospects* 3 (1977): 208–209.

2. Holger Cahill to Pereira, October 19, 1951, AAA roll 1297.

3. See Pereira-Reavey correspondence for 1954, GR-UT, especially Pereira to Reavey, August 23, 1954, and Pereira to Reavey, August 26, 1954. See also Pereira's "A Very Brief Summary of Suppression of My Work," dated November 19, 1962, AAA roll 1299.

4. Schwartz, "Demystifying," p. 118.

5. Harithas, "I. Rice Pereira," p. 129.

6. Roland Barthes, *The Fashion System*, trans. Matthew Ward and Richard Howard (London: Jonathan Cape, 1985), p. 264. (Originally published in French by Editions de Seuil in 1967 as *Système de la mode*.)

7. "Artist on Glass," *Manchester Evening News*, January 10, 1951, p. 3;

Evelyn Lawson, "Dateline: Cape Cod," *Sunday Cape Cod Standard-Times,* November 3, 1963, unpaginated clipping, Pereira archives, IRP-SL. Lawson ("Daphne" to Pereira) also mentioned that the artist blended her own perfumes.

8. Pereira, "A Letter to the Editor from Irene Rice Pereira," *Art Voices* (Spring 1965): 80.

9. Louise Elliott Rago, "We Visit with I. Rice Pereira," *School Arts* 59 (September 1959): 29–30. For further discussion of Pereira's use of the term *classicist,* see John L. Brown, "Remembering Rice Pereira," in Martha Hill and John L. Brown, *Irene Rice Pereira's Library: A Metaphysical Journey* (Washington, D.C.: National Museum of Women in the Arts, 1988), p. 16.

10. Pereira, notes dated March 25, 1962, AAA roll D222.

11. Pereira, undated notes, c. 1966, part of a four-page typed document with excerpts from her exhibition catalogues, AAA roll 1296. The artist made similar claims associating herself with these figures and others in correspondence and interviews. See, for example, her letters to Emily Genauer, March 17, 1958, AAA roll 1297; Judy K. van Wagner, October 28, 1969, AAA roll 1298; Percival R. Roberts, III, March 2, 1967, AAA roll 1298; and Selvig interview transcript, p. 24.

12. Pereira to Reavey, October 7, 1951, GR-UT.

13. Pereira cited Jung in support of her view. She purchased a copy of his *Flying Saucers* in 1959, the year it was published in English. She sent excerpts from this book to John Canaday at the *New York Times* in response to his article "Art: No Happy New Year," appearing in the September 20, 1959, issue. In that article, Canaday defended himself against attacks by Daniel Catton Rich, who had cited Jung's book in support of Abstract Expressionism. Pereira sought to set the record straight. Among the passages she copied and sent to Canaday were the following: "For some time now painters have taken as their subject the disintegration of forms . . . creating pictures which, abstractly detached from meaning and feeling alike, are distinguished by their 'meaninglessness' as much as by their deliberate aloofness from the spectator. These painters have immersed themselves in the destructive element and have created a new conception of beauty, one that delights in the alienation of meaning and of feeling. Everything consists of debris, unorganized fragments, holes, distortions, overlapping, infantilisms, and crudities which outdo the clumsiest attempts of primitive art and belie the traditional idea of skill. . . . That is what art heralds and eulogizes: the gorgeous rubbish heap of our civilization. . . . [Civilization] must counter the fragmentariness of our world by a striving to be healed and made whole." (Pereira to John Canaday, September 28, 1959, AAA roll 1297. The excerpts also appear on AAA roll 1299.)

14. Pereira, "Question of Terms," *New York Times,* May 1, 1955, sec. 2, p. 9.

15. Erasmus, *The Colloquies of Erasmus,* trans. C. R. Thompson (Chicago: University of Chicago Press, 1965), p. 219.

16. Henry McBride, "Ladies' Day at the Whitney," *Art News* 51 (January 1953): 57.

17. "Pereira Is Back Again among New Gallery Displays," *New York World-Telegram,* December 7, 1946, AAA roll D223.

18. "Villagers in Manhattan," pp. 64, 69.

19. Stuart Preston, "Americans Yesterday and Today," *New York Times,* May 9, 1954, sec. 2, p. 9

20. Orenstein, *Women,* p. 15.

21. Carl G. Jung, *The Collected Works of Carl G. Jung,* ed. Herbert Read, Michael Fordham, and Gerhard Adler. Vol. 7: *Two Essays on Analytical Psychology,* trans. R. F. C. Hull (Princeton: Princeton University Press, 1953), pp. 207–208.

22. Ibid., p. 209.

23. Carl G. Jung, *The Collected Works of Carl G. Jung,* ed. Herbert Read, Michael Fordham, and Gerhard Adler. Vol. 9, part 1: *The Archetypes and the Collective Unconscious,* trans. R. F. C. Hull (Princeton: Princeton University Press, 1959), p. 107. I have presented portions of the arguments outlined here in a paper titled "Gender Bias in Jungian Theory and Its Impact on the Career of Irene Rice Pereira," at the College Art Association annual meeting in February 1990.

24. John Gruen, "Faithful to an Old Fashion," *New York Herald Tribune,* March 29, 1964, p. 32.

25. Franz Schulze, "The Slow Start of This Art Season," *Panorama–Chicago Daily News,* October 16, 1965, p. 10.

26. Pereira, "Woman and Dimensions in Art," AAA roll 2395.

27. *Journal of Social Issues* 11, no. 3 (1955); Brinton Crane, "Freud and Human History," *Saturday Review,* May 5, 1956, pp. 8–9, 35; Donald Barr, "Freud and Fiction," *Saturday Review,* May 5, 1956, p. 36; Irving Howe, "This Age of Conformity," *Partisan Review* 21 (January–February 1954): 7–33; Richard Hofstadter, *Anti-Intellectualism in American Life* (New York: Alfred A. Knopf, 1962), pp. 389–390.

28. Ross Edman, "Banners in Your Living Room?" *Chicago Tribune,* October 24, 1965, sec. 5, p. 4.

29. "Manhattan Living Is 'Loverly' for New 'Fair Lady,'" *New York Journal-American,* July 19, 1958, p. 24. Adler later gave the painting to the Whitney Museum of American Art.

30. Stelloff, "Toward the Radiant Powers," p. 113.

31. Pereira, notes, January 12, 1963, AAA roll D222.

32. Pereira, "Suppression," AAA roll 1299.

33. Lynes, *Good Old Modern,* p. 120

34. Raphael Soyer, as quoted in Barbaralee Diamonstein, *Insdie New York's Art World* (New York: Rizzoli International Publications, 1979), p. 375.

35. "Artists Uphold Sweeney," *New York Times,* November 3, 1946, sec. 2, p. 8.

36. Pereira, "Suppression," AAA roll 1299; and Pereira, notes, January 12, 1963, AAA roll D222.

37. Pereira to Victor D'Amico, April 7, 1953, AAA roll 1297.

38. "Statement," *Reality* 1 (Spring 1953): 1.

39. Pereira to editor, *Reality,* April 27, 1953, AAA roll 1297. For a discussion of this issue of *Reality* and the opinions expressed therein, see

the editorials "The Language of Reaction: THEY," *Art Digest,* May 15, 1953, p. 7; and "The Language of Reaction:'Reality,'" *Art Digest* 27 (June 1953) 5. See also Otis Gage, "Whose Humanism?" *Art Digest* 27 (September 1953): 6.

40. Charlotte Willard, "Really and Truly," *New York Post,* February 11, 1967, unpaginated clipping, AAA roll 1298.

41. Charlotte Willard, "Art in Motion," *Look,* April 18, 1967, p. 49. In response to a letter written to him by Pereira concerning Willard's alleged plagiarism, David R. Maxey, then assistant managing editor for *Look,* asked the artist to document any evidence of plagiarism. Whether Pereira responded is not known. See letter, David R. Maxey to Pereira, May 2, 1967, AAA roll 1298.

42. Emily Genauer, "New Season, New Ism," *New York Herald Tribune,* September 13, 1964, p. 43.

43. Steloff, "Toward the Radiant Powers," p. 113; Herbert Mitgang, "Frances Steloff, 101, Bookseller Who Championed Avant-Garde," *New York Times,* April 16, 1989, p. 20.

44. Nin, *Diary,* p. 202. Most of the information on the castle was taken from a publicity brochure titled "The Castle of Roccasinibaldi" in Pereira's archive. See also Brown, "Remembering Rice Pereira," p. 16.

45. See letter, Pereira to Livio Olivieri, July 22, 1962, AAA roll 1297.

CONCLUSION

1. Leah Gordon, "Judging Art by Gender?" *New York Times,* December 27, 1970, sec. 2, p. 38.

Selected Bibliography

ARCHIVAL SOURCES

Papers of the American Abstract Artists, Archives of American Art, Smithsonian Institution, Washington, D.C., Microfilm Roll NY59-11.

Papers of the American Artists Congress, 1937–1938, Archives of American Art, Smithsonian Institution, Washington, D.C., Microfilm Roll N69-98.

ACA Gallery Papers, Archives of American Art, Smithsonian Institution, Washington, D.C., Microfilm Roll D304.

Holger Cahill Papers, Archives of American Art, Smithsonian Institution, Washington, D.C., Microfilm Rolls 1105, 1106, 1107, 1108.

Philip Evergood Papers, Archives of American Art, Smithsonian Institution, Washington, D.C., Microfilm Rolls 429, 430.

Papers of the Federal Art Project, Works Progress Administration, National Archives, Washington, D.C., Record Group 69.

Emily Genauer Papers, Archives of American Art, Smithsonian Institution, Washington, D.C., Microfilm Roll NG1.

Peggy Guggenheim Papers, Archives of American Art, Smithsonian Institution, Washington, D.C., Microfilm Roll ITVE-1.

Elizabeth McCausland Papers, Archives of American Art, Smithsonian Institution, Washington, D.C., Microfilm Roll D374.

Irene Rice Pereira Archive, The Arthur and Elizabeth Schlesinger Library on the History of Women in America, Radcliffe College, Cambridge, Mass.

Irene Rice Pereira Papers, Archives of American Art, Smithsonian Institution, Washington, D.C., Microfilm Rolls D222, D223, 1296, 1297, 1298, 1299, 1300, 1301, 1302, 2395; and "Tape-Recorded Interview with Irene Rice Pereira in Her Apartment in New York City, August 26 [and 27], 1968," interview transcript prepared by Forrest Selvig.

Irene Rice Pereira File, Brooklyn Museum, Brooklyn.

Irene Rice Pereira File, Solomon R. Guggenheim Museum, New York.

Irene Rice Pereira File, Museum of Modern Art, New York.
Irene Rice Pereira File, Whitney Museum of American Art, New York.
George Reavey Archive, Harry Ransom Humanities Research Center, The University of Texas at Austin.
Eugene Walters Papers, Harry Ransom Humanities Research Center, The University of Texas at Austin.
Papers of the Whitney Museum of American Art, Archives of American Art, Smithsonian Institution, Washington, D.C., Microfilm Roll N679.
Robert Jay Wolff Papers, Archives of American Art, Smithsonian Institution, Washington, D.C. Microfilm Roll N69-73.

WORKS BY IRENE RICE PEREIRA

Books

Crystal of the Rose. Introduction by Lee Nordness. Prefatory statement by Ranjee Shahani. New York: I. Rice Pereira and the Nordness Gallery, 1959.
The Finite versus the Infinite. New York: by the author, 1969.
The Lapis. New York: by the author, 1957; reprint ed., Washington, D.C.: Corcoran Gallery of Art, 1970.
The Nature of Space, a Metaphysical and Aesthetic Inquiry. New York: by the author, 1956; reprint ed., Washington, D.C.: Corcoran Gallery of Art, 1968.
The Poetics of the Form of Space, Light and the Infinite. New York: by the author, 1969.
The Transcendental Formal Logic of the Infinite: Evolution of Cultural Forms. New York: by the author, 1966.
The Transformation of "Nothing" and the Paradox of Space. New York: by the author, 1953.

Published Essays and Other Statements

"An Abstract Painter on Abstract Art." *American Contemporary Art,* October 11, 1944, pp. 3–5, 11.
"Art: Readers' Letters." *New York Times,* October 11, 1959.
Burchard, John E. "Views on Art and Architecture: A Conversation." *Daedalus* 89 (Winter 1960): 62–73.
"The Harmonics of Form." *Literary Half-Yearly* 8 (January–July 1967): 19–22.
"How I Work." *Art News* 46 (September 1947): 26–27.
"The Indulgent Be Pleased." *Art Forum* 1 (February 1934): 9–10.
"The Infinite versus the Finite." in *Recent Paintings by I. Rice Pereira.* New York: Amel Gallery, 1962.
"A Letter to the Editor from Irene Rice Pereira." *Art Voices* (Spring 1965): 80–81.
"Light and the New Reality." New York: by the Author, 1951. Expanded and reprinted in *Palette* (Spring 1952): 2–11.
"The Paradox of Space." Publication source and date unknown, pp. 23–26. Archives of American Art microfilm roll 1299.

"Question of Terms: An Artist Is Critical of Recent Extremes." *New York Times,* May 1, 1955, sec. 2, p. 9.

"The Rationale of the Irrationality of Cause." *Literary Half-Yearly* 10, no. 1 (1969): 13–15.

"The Self-Destroying Machinery of Mindlessness." *Literary Half-Yearly* 7 (July 1966): 75–83.

"The Simultaneous 'Ever-Coming to Be.'" In *Space, Light and the Infinite: A New Cycle of Paintings by I. Rice Pereira.* New York: Nordness Gallery, 1961.

"Some Notations on Space-Time and Art." *Western Arts Association Bulletin* 40 (November 1955): 8–13.

"Structural Core of an Aesthetic and Philosophy." *Mysindia,* July 25, 1954, pp. 15–16.

"Structure and Optics in Modern World-Views." *Literary Half-Yearly* 9 (January 1968): 66–75.

"To the Art Editor." *New York Times,* April 27, 1947, sec. 2, p. 10.

Poetry

"The Creative Light-Giving Form." *Literary Half-Yearly* 9, no. 2 (1968): 8–9.

"The Form of Geometry." *Literary Half-Yearly* 9, no. 2 (1968): 10.

"The Hand That Draws the Heart." *Literary Half-Yearly* 7 (July 1966): 13.

"The Real Hero." *Literary Half-Yearly* 7 (July 1966): 12.

"Two Poems ['The Evolution of Cultural Forms' and 'The Creation of Form']." *Lalit Kala Contemporary* 7–8 (1968): 57–60.

"The Union of Fire and Water." *Literary Half-Yearly* 11, no. 1 (1970): 6.

"The White Dove." *Literary Half-Yearly* 10, no. 1 (1969): 12–13.

Selected Unpublished Manuscripts

Microfilmed by the Archives of American Art, Smithsonian Institution, Washington, D.C.:

"Concept of Substance." Microfilm Roll D222.

"Eastward Journey." Microfilm Roll D223.

"Essays on the Logos." Microfilm Roll D222.

"Forms of Immateriality." Microfilm Roll D223.

"Meaning of Space-Time in Relation to 'Light and the New Reality.'" Microfilm Roll D222.

"Women and Dimensions in Art." Transcript of lecture presented at the University of Michigan, Ann Arbor, July 21, 1954, Microfilm Roll 2395.

"The Imagery of the Constellation of Transcendent Consciousness." Irene Rice Pereira Archive, The Arthur and Elizabeth Schlesinger Library on the History of Women in America, Radcliffe College, Cambridge, Mass.

"One Half of the World is Missing: Some Contradictions and Discrepancies between Structure and Optics in Renaissance and Twentieth Century World-Views Resulting from the Dilemma of the Infinite and Finite in Greek Thought." Eugene Walter Papers, Harry Ransom Humanities Research Center, The University of Texas at Austin.

"The Abstract in Art." *Interior Design and Decoration* 9 (December 1937): 40–41, 116.

Asper. "Light and the New Reality." *Mysindia,* July 25, 1954, p. 14.

Baur, John I. H. "Loren MacIver and I. Rice Pereira." *Pen and Brush* (February 1953): 8–9, 13, 14.

———. *Loren MacIver: I. Rice Pereira.* New York: Macmillan Company, 1953.

———. *I. Rice Pereira.* New York: Andrew Crispo Gallery, 1976.

———. "I. Rice Pereira." In *New Art in America,* ed. John I. H. Baur. Greenwich, Conn.: New York Graphic Society, 1957, pp. 227–231.

"Before Bandwagons." *Vogue,* February 1, 1947, pp. 178–179, 208, 211.

"Costume Ball Top Artist Began Her Art Career in Boro School." *Brooklyn Eagle,* April 14, 1949, p. 21.

Grant, Dwinell. "Parchment: New Painting Surface." *Art News,* October 1–14, 1942, pp. 16, 32.

Harithas, James. "I. Rice Pereira: American Painter-Writer with Bold Solutions to Old Problems." *Vogue* (June 1970): 128–129, 183.

Hill, Martha, and John L. Brown. *Irene Rice Pereira's Library: A Metaphysical Journey.* Washington, D.C.: National Museum of Women in the Arts, 1988.

"I[rene] Rice Pereira." In *Current Biography,* ed. Marjorie Dent Candee. New York: H. W. Wilson Co., 1954, pp. 485–486.

Marbrook, Djelloul. "Pereira: The Evolution of Cultural Forms." *Winston-Salem Journal and Sentinel,* September 4, 1966.

———. "Pereira, My Aunt." *Voyages* 5, no. 1–4 (1974): 115–127.

Marxer, Donna. "I. Rice Pereira: An Eclipse of the Sun." *Women Artists Newsletter* 2 (April 1976): 5–6.

Maxwell, Catherine. "Famous Abstract Artist Teaching at Ball State." *Muncie Star,* June 22, 1951.

McCausland, Elizabeth. "Alchemy and the Artist: I. Rice Pereira." *Art in America* 35 (July 1947): 177–186.

———. "I. Rice Pereira." *Magazine of Art* 39 (December 1946): 374–377.

Miller, Donald. "The Timeless Landscape of I. Rice Pereira." *Arts* 53 (October 1978): 132–133.

"Passion for Light." *Life,* January 26, 1953, pp. 72–75.

"Print Personality." *Print* 13 (January–February 1959): 34–36.

Rago, Louise Elliott. "We Visit with I. Rice Pereira." *School Arts* 59 (September 1959): 29–30.

[Riley, Maude]. "Pereira Abstractionist." *Art Digest,* January 15, 1944, p. 20.

Schwartz, Therese. "Demystifying Pereira." *Art in America* 67 (October 1979): 114–119.

Seckler, Dorothy Gees. "Pereira Paints a Picture." *Art News* 51 (September 1952): 34–37, 54–55.

Shahani, Ranjee. *Catching a Sunbeam in a Solar Hat: An Appreciation of I. Rice Pereira.* New York: Nordness Gallery, n.d. [1959].

Steloff, Frances. "Toward the Radiant Powers: A Note on Irene Rice Pereira." *Voyages* 5, no. 1–4 (1973): 113–114.

Sussman, Elisabeth. "Pereira, Irene Rice." In *Notable American Women: The Modern Period,* ed. Barbara Sicherman and Carol Hurd Green. Cambridge: Belknap Press of Harvard University Press, 1980, pp. 534–535.

Van Wagner, Judith K. "I. Rice Pereira: Vision Superceding [sic] Style." *Woman's Art Journal* 1 (Spring-Summer 1980): 33–38.

Zucker, Mary. "Pereira." In *Art USA Now,* 2 vols., ed. Lee Nordness. New York: Viking Press, 1963, insert following p. 170.

SELECTED EXHIBITION AND BOOK REVIEWS

Ames, Winslow. "The Lapis." *College Art Journal* 17 (Summer 1958): 446–447.

"The Art Galleries." *New Yorker*, November 1, 1930, p. 79.

Coates, Robert M. "The Art Galleries." *New Yorker,* February 16, 1946, pp. 82, 84.

Fitzsimmons, James. "Two Women in a Double Retrospective at the Whitney." *Art Digest,* January 15, 1953, 6–7, 23–24.

Genauer, Emily. "Sketches Show Spontaneity of Pereira Work." *New York World Telegram,* July 24, 1934.

"Judging Art by Gender." *New York Times,* December 27, 1970, pp. 25, 38.

Linn, Thomas C. "This Week in New York: Some of the Recently Opened Shows." *New York Times,* January 22, 1933, sec. 9, p. 12.

Louchheim, Aline B. "The Favored Few Open the Modern Museum's Season." *Art News* 45 (September 1946): 15–17, 51–52.

———. "Prizes." *Art News* 45 (October 1946): 48–49, 70–72.

"Man and Machine Age, as Represented by a W.P.A. Artist." Washington, D.C., *Sunday Star,* March 20, 1938.

McBride, Henry. "Ladies' Day at the Whitney." *Art News* 51 (January 1953): 30–31, 56–57.

"The Poetics of the Form of Space, Light and the Infinite." *Marg* 24 (March 1971): supp. 7.

Polinsky, Ethel [Ethel Polline]. "Pereira—Praise from a Poet." *Voices International* 1 (Winter 1966): 26–28.

———. "Space, Matter, Mind, Cosmos." *Literary Half-Yearly* 9 (January 1968): 118–119.

Sylvester, A. D. B. "1950 Aspects of British Art." *Art News and Reviews,* December 30, 1950, pp. 4–5.

GENERAL SOURCES

American Abstract Artists. *American Abstract Artists.* New York, 1938.

———. *American Abstract Artists.* New York: Ram Press, 1946.

———. *The World of Abstract Art.* New York: George Wittenborg, 1957.

American Academy. *The American Academy in Rome at the New York World's Fair and the Golden Gate Exposition, 1939.* New York: Offices of the American Academy, 1939.

Arnheim, Rudolf. "Gestalt and Art." *Journal of Aesthetics and Art Criticism* 2 (Fall 1943): 71–75.

Art: A Bryn Mawr Symposium. Bryn Mawr Notes and Monographs IX. Bryn Mawr, Penn.: Bryn Mawr College, 1940.

The Artist in America. New York: Art in America, 1967.

"Artists Uphold Sweeney." *New York Times*, November 3, 1946, sec. 2, p. 8.

Barnard, Eunice. "Classroom and Campus." *New York Times*, August 2, 1936, sec. II, p. II.

Barnett, Lincoln. "The Starry Universe." *Life*, December 20, 1954, pp. 44–70.

———. *The Universe and Dr. Einstein*. Foreword by Albert Einstein. New York: William Sloane Associates, 1948; second revised edition, 1957.

Barr, Alfred H., Jr., ed. *Fantastic Art, Dada, Surrealism*. New York: Museum of Modern Art, 1936; third edition, 1947.

———. *Cubism and Abstract Art*. New York: Museum of Modern Art, 1936; reprint edition, 1974.

Baur, John I. H. "American Art after Twenty-five Years: A Richer Diversity than Ever Before." *Art Digest*, November 1, 1951, pp. 15–19.

———. *Nature in Abstraction*. New York: Macmillan Company, 1958.

———. *Revolution and Tradition in Modern American Art*. Cambridge: Harvard University Press, 1951.

Bayley, Harold. *The Lost Language of Symbolism*, 2 vols. New York: Barnes and Noble, 1952 (London, 1912).

Benson, Emanuel Mervin. "Forms of Art: I." *Magazine of Art* 28 (February 1935): 71–77.

———. "Forms of Art: IV. Phases of Calligraphy." *Magazine of Art* 28 (June 1935): 356–363, 384.

———. "Wanted: An American Bauhaus." *Magazine of Art* 27 (June 1934): 307–311.

Berman, Avis. *Rebels on Eighth Street: Juliana Force and the Whitney Museum of American Art*. New York: Atheneum, 1990.

Berman, Greta. *The Lost Years: Mural Painting in N.Y. City under the WPA Federal Art Project, 1935–1943*. New York: Garland Publishing, 1978.

Brakhage, Jane. "The Book of Legends: Part I." *Spiral* 8 (July 1986): 34–43.

Breton, André. *What Is Surrealism? Selected Writings,* ed. and introduced by Franklin Rosemont. Monad Press, 1978.

Bronowski, Jacob. *William Blake, a Man without a Mask*. 1944; reprint edition, New York: Haskell House Publishers Ltd., 1967.

Cahill, Holger. "In Our Time." *Magazine of Art* 39 (November 1946): 308–325.

Campbell, Joseph. *The Hero with a Thousand Faces*. Bollingen Series XVII. New York: Pantheon Books, 1949.

———. *Myths to Live By*. New York: Viking Press, 1972; reprint ed., New York: Bantam Books, 1984.

Campbell, Joseph, and Henry Morton Robinson. *A Skeleton Key to Finnegans Wake*. New York: Harcourt, Brace and Company, 1944.

Campbell, Lawrence. "The Museum of Non-Objective Painting Revisited." *Art News* 71 (December 1972): 40–41.

Cassirer, Ernst. *The Philosophy of Symbolic Forms*. Trans. Ralph Manheim. New Haven: Yale University Press, 1953.

———. *An Essay on Man: An Introduction to a Philosophy of Human Culture.* New Haven: Yale University Press, 1944; paperback edition, 1972.

Caton, Joseph Harris. *The Utopian Vision of Moholy-Nagy.* Ann Arbor: UMI Research Press, 1984.

Cavendish, Richard, ed. *Encyclopedia of the Unexplained: Magic, Occultism and Parapsychology.* London: Routledge and Kegan Paul, Ltd., 1974; New York: Arkana, 1989.

Chadwick, Whitney. *Women, Art, and Society.* London: Thames and Hudson, Ltd., 1990.

———. *Women Artists and the Surrealist Movement.* Boston: Little, Brown and Company, 1985.

Chase, Stuart. *Men and Machines.* New York: Macmillan Company, 1929.

Cheney, Sheldon, and Martha Candler Cheney. *Art and the Machine.* New York: Wittlesey House, 1936.

Clark, Carroll S., and Louise Heskett, eds. *Jan Matulka 1890–1972.* Washington, D.C.: Smithsonian Institution Press, 1980.

"The Continuity of Human Experience by Siegfried Giedion." *Art News and Review,* February 10, 1951, pp. 2, 7.

Contreras, Belisario R. *Tradition and Innovation in New Deal Art.* Lewisburg: Bricknell University Press, 1983.

Cooper, Jean C. *An Illustrated Encyclopaedia of Traditional Symbols.* London: Thames and Hudson, Ltd., 1978 (1990 reprint edition).

Crow, William Bernard. *A History of Magic, Witchcraft and Occultism.* London: Aquarian Press, 1968.

"Department Stores Popularize Art." *Life,* January 3, 1944, pp. 44–47.

"Design Laboratory at FAECT." *Architectural Record* 82 (October 1937): 41.

"Design Laboratory, New York." *Magazine of Art* 29 (February 1936): 117.

"Design's Bad Boy." *Architectural Forum* 86 (February 1947): 88–91, 138, 140.

Dewey, John. *Art as Experience.* New York, 1934; New York: G. P. Putnam's Sons, 1958.

———. "Self-Saver or Frankenstein?" *Saturday Review of Literature,* March 12, 1932, pp. 581–582.

Dixon, Laurinda S. *Alchemical Imagery in Bosch's Garden of Delights.* Ann Arbor: UMI Research Press, 1981.

Elderfield, John. "American Geometric Abstraction in the Late Thirties." *Artforum* 11 (December 1972): 35–42.

Faure, Elie. *History of Art.* Vol. 5: *The Spirit of the Forms.* Trans. Walter Pack. New York: Harper and Brothers, 1930.

Finn, Gloria. "'Artist's Accent' Collection: Hooked Rugs Designed by Contemporary Painters." *Craft Horizons* 14 (September–October 1954): 22–27.

Friedman, Alan J., and Donley, Carol C. *Einstein as Myth and Muse.* New York: Cambridge University Press, 1985.

Frobenius, Leo, and Douglas C. Fox. *Prehistoric Rock Pictures in Europe and Africa.* New York: Museum of Modern Art, 1937; reprint ed., New York: Arno Press, 1972.

George, George L. "What Is Non-Objective Art?" *Mademoiselle* (January 1945): 130–131, 177–178.

Genauer, Emily. *Best of Art*. Garden City, N.Y.: Doubleday, 1948.

Gibbs, Josephine. "State Department Sends Business-sponsored Art as U.S. Envoys." *Art Digest,* November 15, 1946, p. 8.

———. "State Department Shows 'Goodwill' Pictures." *Art Digest,* October 1, 1946, pp. 13, 34.

———. "Whitney Annual of American Painting Moves Far to the Left." *Art Digest,* December 15, 1946, pp. 5, 30, 31.

Giedion, Siegfried. *Space, Time and Architecture*. Cambridge: Harvard University Press, 1941.

"Glass in the World of Today—and Tomorrow." *Glass Industry* 20 (May 1939): 182–183.

Goethe, Johann Wolfgang von. *Faust: A Tragedy*. Trans. Alice Raphael. Introduction by Mark van Doren. New York: Jonathan Cape and Harrison Smith, 1930.

Graham, John. *System and Dialectics of Art*. New York: Delphic Studios, 1937.

———. *System and Dialectics of Art*. Annotated and with an introduction by Marcia Epstein Allentuck. Foreword by Dorothy Dehner. Baltimore: Johns Hopkins Press, 1971.

Grant, Dwinell. "Organized Field Composition." *Spiral* 9 (1986): 28–32.

Gray, Ronald D. *Goethe, the Alchemist*. Cambridge: Cambridge University Press, 1952.

Guilds' Committee for Federal Writers' Publications. *New York Panorama: A Companion to the WPA Guide to New York City*. New York: Random House, 1938; reprint edition, New York: Pantheon Books, 1984.

Gutheim, F. A. "Buildings at the Fair." *Magazine of Art* 32 (May 1939): 286–289, 316–317.

Hale, William Harlan. *Challenge to Defeat: Modern Man in Goethe's World and Spengler's Century*. New York, 1932.

Harris, Ann Sutherland, and Linda Nochlin. *Women Artists 1550–1950*. New York: Alfred A. Knopf, 1976.

Harrison, Helen A. "The Fair Perceived: Color and Light as Elements in Design and Planning." In Helen A. Harrison, *Dawn of a New Day: The New York World's Fair, 1939/40*. New York: Queens Museum and New York University Press, 1980, pp. 43–55.

Hauptmann, William. "The Suppression of Art in the McCarthy Decade." *Artforum* 12 (October 1977): 48–52.

"Have the Modern Alchemists Succeeded?" *Literary Digest,* February 6, 1926, p. 25.

Heilbrun, Carolyn G. *Toward a Recognition of Androgyny*. New York: Alfred A. Knopf, 1973.

———. *Writing a Woman's Life*. New York: Ballantine Books, 1988.

Held, R. L. *Endless Innovations: Frederick Kiesler's Theory and Scenic Design*. Ann Arbor: UMI Research Press, 1982.

Heller, Dana A. *The Feminization of Quest-Romance: Radical Departures*. Austin: University of Texas Press, 1990.

Heller, Nancy G. "The Art Students League: 100 Years." *American Artist* 39 (September 1975): 56–59, 78–81.

Henderson, Linda Dalrymple. *The Fourth Dimension and Non-Euclidean Geometry in Modern Art*. Princeton: Princeton University Press, 1983.

Heydenreich, Ludwig. "Art and Science." *Magazine of Art* 44 (April 1951): 140–144.

Hildebrand, Adolf von. *The Problem of Form in Painting and Sculpture*. Trans. Max Meyer and Robert Morris Ogden. New York: G. E. Stechert and Co., 1907; reprint edition, 1947.

Hinton, C. Howard. *The Fourth Dimension*. New York: John Lane, 1904.

Hopkins, Arthur John. *Alchemy, Child of Greek Philosophy*. New York: Columbia University Press, 1934.

Hughes, H. Stuart. *Oswald Spengler: A Critical Estimate*. New York: Charles Scribner's Sons, 1952.

Hultén, K. G. Pontus. *The Machine as Seen at the End of the Mechanical Age*. New York: Museum of Modern Art, 1968.

Huth, Hans. "Painting on Glass." *Craft Horizons* 14 (January–February 1954): 10–15.

Ivins, William M., Jr. *On the Rationalization of Sight with an Examination of Three Renaissance Texts on Perspective*. New York: Metropolitan Museum of Art, 1938; New York: Decapo Press, 1973.

Jaffé, Aniela, ed. *C. G. Jung: Word and Image*. Bollingen Series XCVII:2. Princeton: Princeton University Press, 1979.

Jaffe, Bernard. "The Human Crucible." *Forum* 83 (May 1930): 316–320.

Janis, Sidney. *Abstract and Surrealist Art in the United States*. New York: Reynal and Hitchcock, 1944.

Jeans, James. *The Mysterious Universe*. New York: Macmillan Company, 1930.

Joad, Cyril Edwin Mitchinson. *Guide to Philosophy*. London: Gollanca Ltd., 1955.

Jung, Carl G. *The Collected Works of Carl G. Jung*. Eds. Herbert Read, Michael Fordham, and Gerhard Adler. Vol. 9, part 1: *The Archetypes and the Collective Unconscious*. Trans. R. F. C. Hull. London: Routledge and Kegan Paul, 1959.

———. *The Collected Works of Carl G. Jung*. Eds. Herbert Read, Michael Fordham, and Gerhard Adler. Vol. 2: *Psychology and Religion: West and East*. Trans. R. F. C. Hull. Princeton: Princeton University Press, 1958.

———. *The Collected Works of Carl G. Jung*. Eds. Herbert Read, Michael Fordham, and Gerhard Adler. Vol. 12: *Psychology and Alchemy*. Trans. R. F. C. Hull. London: Routledge and Kegan Paul, 1953.

———. *The Collected Works of Carl G. Jung*. Eds. Herbert Read, Michael Fordham, and Gerhard Adler. Vol. 19: *General Bibliography of C. G. Jung's Writings*. Bollingen Series XX. Comp. Lisa Ress. Princeton: Princeton University Press, 1979.

———. *Contributions to Analytical Psychology*. Trans. H. G. Baynes and Cary F. Baynes. New York: Harcourt, Brace and Company, 1928.

———. "Dr. C. G. Jung." *transition* 21 (March 1932): 125–127.

———. *Flying Saucers. A Modern Myth of Things Seen in the Skies*. Trans.

R. F. C. Hull. Princeton: Princeton University Press, 1964; Princeton/ Bollington paperback edition, 1978.

⸻. *The Integration of the Personality*. Trans. Stanley Dell. London: Kegan Paul, Trench Trubner and Co., Ltd., 1940; reprint edition, 1948.

⸻. "Psychology and Poetry." *transition* 19–20 (June 1930): 23–45.

⸻. *Psychology of the Unconscious: A Study of the Transformations and Symbolisms of the Libido: A Contribution to the History of the Evolution of Thought*. New York: Moffat, Yard and Company, 1916.

Kant, Immanuel. *Critique of Pure Reason*. Trans. J. M. D. Meiklejohn. London: George Bell and Sons, 1887.

Keyes, Jacquelene A. "WPA Educators Blazing Trail with School in Industry Design." *New York Times*, October 25, 1936, sec. 2, p. 5.

Kiesler, Frederick J. *Contemporary Art Applied to the Store and Its Display*. New York: Brentano's, 1930.

⸻. "Design-Correlation." *Architectural Record* 81 (May 1937): 53–59.

⸻. "Frederick Kiesler's Endless House and Its Psychological Lighting." *Interiors* 110 (November 1950): 122–129.

⸻. "Mural without Walls." *Art Front* 18 (December 1936): 10–11.

"Kiesler's Pursuits of an Idea." *Progressive Architecture* 42 (July 1961): 104–123.

Klein, Jerome. "WPA Highlights Fair." *New York Post*, May 25, 1940.

Korn, Arthur. *Glass in Modern Architecture of the Bauhaus Period*. New York: George Braziller, 1968. (Originally published as *Glas im Bau und als Gebrauchsgegenstand*. Berlin: Ernst Pollak, 1929.)

Körner, Stephen. *Kant*. Baltimore: Penguin Books, 1955.

Kostelanetz, Richard, ed. *Moholy-Nagy*. New York: Praeger Publishers, 1970.

Lader, Melvin P., and Fred Licht. *Peggy Guggenheim's Other Legacy*. New York: S. R. Guggenheim Museum, 1987.

Landgren, Marchel E. *Years of Art: The Story of the Art Students League*. New York: Robert M. McBride and Co., 1940.

Lane, John R., and Susan Larsen. *Abstract Painting and Sculpture in America 1927–1944*. Pittsburgh: Museum of Art, Carnegie Institute, 1983.

Larsen, Susan Carol. "The American Abstract Artists: A Documentary History 1936–1941." *Archives of American Art Journal* 14, no. 1 (1974): 2–7.

⸻. "The American Abstract Artists Group: A History and Evaluation of Its Impact upon American Art." Ph.D. dissertation, Northwestern University, 1975.

Larson, Gary O. *The Reluctant Patron: The United States Government and the Arts 1943–1965*. Philadelphia: University of Pennsylvania Press, 1983.

Lipton, David R. *Ernst Cassirer: The Dilemma of a Liberal Intellectual in Germany, 1914–1933*. Toronto: University of Toronto Press, 1978.

Lukach, Joan M. *Hillay Rebay: In Search of the Spirit in Art*. New York: George Braziller, 1983.

Lynes, Russell. *Good Old Modern: An Intimate Portrait of the Museum of Modern Art*. New York: Atheneum, 1973.

Margolin, Victor. *Design Discourse*. Chicago: University of Chicago Press, 1989.

Martin, J. L., Ben Nicholson, and Naum Gabo. *Circle: International Survey of Constructive Art*. London: Faber and Faber, Ltd., 1937.

McCausland, Elizabeth [Elizabeth Noble]. "American Artists' Congress Exhibition." *New Masses*, January 4, 1938, pp. 28, 29, 30.

———. "Artists' Congress Second Show." *New Masses*, May 17, 1938, p. 27.

———. "Design Laboratory on Permanent Basis." *Springfield Sunday Union and Republican*, August 22, 1937, p. 6E.

———. "Federal Art Project's Curtailment of Forces." *Springfield Sunday Union and Republican*, July 4, 1937, p. 6E.

McGrath, Raymond, and A. C. Frost. *Glass in Architecture and Decoration*. London: Architectural Press, 1937.

McQueeny, James. "The Glass Age." *Popular Mechanics* 73 (March 1940): 337–344, 128A–129A.

Miller, Dorothy C., ed. *Fourteen Americans*. New York: Museum of Modern Art, 1946.

Moholy-Nagy, László. "Better than Before." *Technology Review* 46 (November 1943): 21–23, 42, 44, 47–48, 50, 52.

———. "Design in Modern Theory and Practice." *California Arts and Architecture* 58 (February 1941): 21, 35, 36.

———. "Light: A New Medium of Expression." *Architectural Forum* 70 (May 1939): 44–48.

———. "The New Bauhaus and Space Relationship." *American Architect and Architecture* 151 (December 1937): 23–28.

———. *The New Vision*. Trans. Daphne M. Hoffmann. New York: Brewer, Warren and Putnam, [1930].

———. *The New Vision*. Trans. Daphne M. Hoffmann. Revised ed., New York: W. W. Norton and Company, 1938.

———. *"The New Vision" and "Abstract of an Artist."* New York: Wittenborn and Company, 1946.

———. *Painting, Photography, Film*. Cambridge: MIT Press, 1969. (Originally published as *Malerei, Fotografie, Film*, 1925.)

———. *Vision in Motion*. Chicago: Paul Theobald and Company, 1947 (second edition).

Moholy-Nagy, Sibyl. *Moholy-Nagy: Experiment in Totality*. New York: Harper and Brothers, 1950.

Monroe, Gerald M. "Art Front." *Archives of American Art Journal* 13, no. 3 (1973): 13–19.

———. "Artists as Militant Trade Union Workers during the Great Depression." *Archives of American Art Journal* 14, no. 1 (1974): 7–10.

Moore, Jack B. *Maxwell Bodenheim*. New York: Twayne Publishers, 1970.

Mühlestein, Hans. "Des origines de l'art et de la culture; II—Cosmogonie et préhistoire." *Cahiers d'Art* 5, no. 2 (1930): 139–145.

Mumford, Lewis. "'The Decline of the West': The First of the Series of 'Books That Changed Our Minds.'" *New Republic*, January 11, 1939, p. 276.

―――. *Sketches from Life: The Autobiography of Lewis Mumford: The Early Years*. New York: Dial Press, 1982.

―――. *Technics and Civilization*. New York: Harcourt, Brace and Company, 1934.

Murphy, Gardner. "The Geometry of Mind. An Interpretation of Gestalt Psychology." *Harpers* 163 (October 1931): 584–593.

Museum of Modern Art. *Bauhaus 1919–1928*. New York: Museum of Modern Art, 1938.

―――. *Machine Art*. Foreword by Alfred H. Barr, Jr. New York: Museum of Modern Art, 1934.

New York World's Fair. *American Art Today*. New York: National Art Society, 1939.

―――. *Going to the Fair*. New York: Sun Dial Press, 1939.

―――. *Official Guide Book of the New York World's Fair 1939*. New York: Exposition Publications, 1939.

"The New Bauhaus Dedicated." *Industrial Education Magazine* 40 (January 1938): 13A, 15A.

"New Gallery Opens." *New York Times*, August 16, 1932, p. 15.

Nin, Anaïs. *The Diary of Anaïs Nin*. Vol. 6: 1955–1966. Ed. and with preface by Gunther Stuhlman. New York: HBS, 1966 (1976 edition).

Nordby, Vernon J., and Calvin S. Hall. *A Guide to Psychologists and Their Concepts*. San Francisco: W. H. Freeman and Company, 1974.

Northrop, F. S. C. "Physics and Platonism." *Saturday Review of Literature*, December 27, 1930, pp. 481–483.

O'Connor, Francis V., ed. *Art for the Millions*. Greenwich, Conn.: New York Graphic Society, Ltd., 1973.

―――, ed. *The New Deal Art Projects*. Washington: Smithsonian Institution Press, 1972.

"On Psychic Factors in Human Behavior." *New York Times*, September 8, 1936, p. 15.

Orenstein, Gloria. "Women of Surrealism." *Feminist Art Journal* 2 (Spring 1973): 1, 15–21.

Park, Edwin Avery. *New Backgrounds for a New Age*. New York: Harcourt, Brace and Company, 1927.

Passuth, Krisztina. *Moholy-Nagy*. London: Thames and Hudson, 1985.

Pearson, Ralph M. *Critical Appreciation Course II: The Modern Renaissance in the U.S.A.* Nyack, N.Y.: Design Workshop, 1950.

―――. *The Modern Renaissance in American Art*. New York: Harper and Brothers, 1954.

―――. *The New Art Education*. New York: Harper and Brothers, 1941.

Plotinus: Being the Treatises of the First-Sixth Enneads with Porphyry's Life of Plotinus, and the Preller-Ritter Extracts Forming a Conspectus of the Plotinian System. 2 vols. Trans. Stephen MacKenna. Boston: Charles T. Branford Company, 1916.

Podro, Michael. *The Critical Historians of Art*. New Haven: Yale University Press, 1982.

Pollock, Griselda. "Vision, Voice and Power." *Block* 6 (1982): 2–21.

Pound, Arthur. "Glass Enters a New Age." *Atlantic Monthly* 155 (June 1935): 763–770.

"The Preaching Critic." *Newsweek,* May 10, 1954, pp. 97–98.

Purcell, Ralph. *Government and Art: A Study of American Experience.* Washington, D.C.: Public Affairs Press, 1956.

Raine, Kathleen. *Blake and Tradition.* 2 vols. Bollingen Series XXXV.11. Princeton: Princeton University Press, 1968.

———. "W. B. Yeats." In *Man, Myth and Magic: An Illustrated Encyclopedia of the Supernatural,* ed. Richard Cavendish. New York: Marshall Cavendish Corporation, 1970, pp. 3066–3068.

Raphael, Alice. *Goethe and the Philosopher's Stone.* New York: Garrett Publications, 1965.

Rattner, Ruth. "Projecting the Fourth Dimension: Two Constructions by László Moholy-Nagy." *Bulletin of the Detroit Institute of Arts* 61, no. 4 (1984): 4–13.

Ray, Paul C. *The Surrealist Movement in England.* Ithaca: Cornell University Press, 1971.

Read, Herbert. "Art and the Evolution of Consciousness." *Journal of Aesthetics and Art Criticism* 13 (December 1954): 142–155.

———. *Art and the Evolution of Man.* London: Freedom Press, 1951.

———. *Art Now.* New York: Pitman Publishing Corporation, 1960.

———. *Icon and Idea: The Function of Art in the Development of Human Consciousness.* New York: Schocken Books, 1955.

———. "A New Humanism." *Architectural Review* 78 (October 1935): 150–151.

———. *Through Alchemy to Chemistry.* London: G. Bell and Sons, Ltd., 1957.

Reichenbach, Hans. *The Theory of Relativity and A Priori Knowledge.* Trans. Maria Reichenbach. Berkeley: University of California Press, 1965.

Rhodes, Johnson. "In Defense of Abstract Art." *Parnassus* 12 (December 1940): 7–10.

Richards, J. M. "Towards a Rational Aesthetic: An Examination of the Characteristics of Modern Design with Particular Reference to the Influence of the Machine." *Architectural Review* 78 (December 1935): 211–218.

Ritterbush, Phillip C. *The Art of Organic Forms.* Washington, D.C.: Smithsonian Institution Press, 1968.

Rohde, Gilbert. "The Design Laboratory." *Magazine of Art* 29 (October 1936): 638–643, 686.

Rosenzweig, Roy, ed. *Government and the Arts in Thirties America.* Fairfax, Va.: George Mason University Press, 1986.

Russett, Cynthia Eagle. *Darwin in America: The Intellectual Response 1865–1912.* San Francisco: W. H. Freeman and Company, 1976.

Saroyan, William. *Three Plays.* New York: Harcourt, Brace and Company, 1940.

The Secret of the Golden Flower: A Chinese Book of Life. Trans. and explained by Richard Wilhelm, with commentary by C. G. Jung. London: Kegan Paul, Trench, Trubner and Co., Ltd., 1932.

Seligmann, Kurt. *Magic, Supernaturalism, and Religion.* New York: Universal Library, 1968.

"'Shadow' Carried by All, Says Jung." *New York Times*, October 23, 1937, p. 8.

Shapiro, David, and Cecile Shapiro. "Abstract Expressionism: The Politics of Apolitical Painting." *Prospects* 3 (1977): 175–214.

Sharp, Dennis, ed. *"Glass Architecture" by Paul Sceerbart and "Alpine Architecture" by Bruno Taut*. Trans. James Palmer and Shirley Palmer. New York: Praeger Publishers, 1972.

Silberer, Herbert. *Problems of Mysticism and Its Symbolism*. Trans. Smith Ely Jelliffe. New York: Moffat, Yard and Company, 1917.

Silk, Joseph. *The Big Bang: The Creation and Evolution of the Universe*. Foreword by Dennis Sciama. San Francisco: W. H. Freeman and Company, 1980.

Singer, June. *Boundaries of the Soul: The Practice of Jung's Psychology*. Garden City, N.Y.: Doubleday, 1972; Anchor, 1973.

Soby, James Thrall. "The Younger American Artists." *Harper's Bazaar* (September 1947): 194–197, 264, 270.

Solomon R. Guggenheim Museum. *Frederick Kiesler: Environmental Sculpture*. New York: Solomon R. Guggenheim Museum, 1964.

Squires, Paul Chatham. "A New Psychology after the Manner of Einstein." *Scientific Monthly* 30 (February 1930): 156–163.

Spengler, Oswald. *The Decline of the West*. 2 vols. New York: Alfred H. Knopf, 1926, 1928; reprint edition, 1983.

"The Story of a 'Dr. Feelgood.'" *Newsweek*, December 18, 1972, pp. 73–75.

Stuhlmann, Gunther, ed. *A Literate Passion: Letters of Anaïs Nin and Henry Miller 1932–1953*. New York: Harcourt Brace Jovanovich, 1987.

Susman, Warren I. *Culture as History: The Transformation of American Society in the Twentieth Century*. New York: Pantheon Books, 1984.

Swann, William Francis Gray. *The Architecture of the Universe*. New York: Macmillan Company, 1934.

Thistlewood, David. *Herbert Read: Formlessness and Form, an Introduction to His Aesthetics*. Boston: Routledge and Kegan Paul, 1984.

"Transmuting Bismuth into Radium with a 'Frying Pan.'" *News Week*, February 15, 1936, p. 28.

Tufts, Eleanor. *Our Hidden Heritage*. New York: Paddington Press, Ltd., 1974.

Verene, Donald Phillip. *Symbol, Myth, and Culture. Essays and Lectures of Ernst Cassirer, 1935–1945*. New Haven: Yale University Press, 1979.

Wallis, R. T. *Neo-Platonism*. London: Gerald Duckworth and Company, Ltd., 1972.

Ward, Mildred Lee. *Reverse Paintings on Glass*. Lawrence: Helen Foresman Spencer Museum of Art, University of Kansas, 1978.

Ware, Susan. *Holding Their Own: American Women in the 1930s*. Boston: G. K. Hall and Co., 1982.

Watson, Forbes. "Murals at the New York Fair." *Magazine of Art* 32 (May 1939): 282–285, 318–319.

"WPA Art School." *Architecture* 73 (April 1936): supp. 4.

Wendt, Gerald. *Science for the World of Tomorrow*. New York: W. W. Norton and Company, 1939.

Werner, Alfred. "Making the Invisible Visible." *National Jewish Monthly* (February 1966): 12–13, 22.

Whitehead, Alfred North. *Science and the Modern World*. London: Cambridge University Press, 1927.

Whitford, Frank. *Bauhaus*. London: Thames and Hudson, 1984.

Whitney Museum of American Art. *Geometric Abstraction in America*. New York: Frederick A. Praeger, 1962.

Wiegand, Charmion von. "The Fine Arts." *New Masses,* July 6, 1937, pp. 30–31.

———. "Sights and Sounds." *New Masses,* June 1, 1937, p. 27.

Willard, Charlotte. "Art in Motion." *Look,* April 18, 1967, pp. 48–50.

Williams, L. Pearce, ed. *Relativity Theory: Its Origins and Impact on Modern Thought*. New York: John Wiley and Sons, 1968.

Wilson, Richard Guy, Dianne H. Pilgrim, and Dickran Tashjian. *The Machine Age in America 1918–1941*. New York: Brooklyn Museum in association with Harry N. Abrams, 1986.

Wingler, Hans M. *Das Bauhaus 1919–1933 Weimar, Dessau, Berlin*. Bramsche: Verlag Gebr. Rasch, 1962.

Worringer, Wilhelm. *Form Problems of the Gothic*. New York: G. E. Stechert and Company, c. 1927. (Originally published as *Formprobleme der Gotik,* 1912.)

Yates, Frances. *Giordano Bruno and the Hermetic Tradition*. Chicago: University of Chicago Press, 1966.

———. *The Rosicrucian Enlightenment*. Boston: Routledge and Kegan Paul, 1972.

CORRESPONDENCE

Lawrence Campbell to author, February 5, 1987.
Dwinell Grant to author, 1985–1990.
Harry Holtzman to author, March 9, 1987.
Harold LeRoy to author, 1985–1987.
Richard A. Madlener to Pereira, in the possession of Richard A. Madlener.
Djelloul Marbrook to author, 1984–1990.
Alice Nichols to Pereira, in the possession of Alice Nichols.
Peter Nichols to author, 1990.

INTERVIEWS

Dorothy Dehner, January 24, 1985; February 21, 1987.
Robert and Barbara Liebowits, October 11, 1984.
Djelloul Marbrook, October 29, 1984.
Jean Bullowa Reavey, January 28, 1987.
Andre Zarre, October 11, 1984; October 15, 1984.

92, 94, 162; called Communist, 9, 60–61, 159, 235, 259n.42, 285n.115; constructs identity, xvi, 1, 2, 19–20, 162, 165, 194–196, 218, 230, 256n.82, 297n.104; Cubist works, 9–10, 11, 28, 62, 191, 195; death, 228, 239, 291n.5; "Divine couples," 171, 288n.157; on dreams, 175, 198, 199; dress, 6, 218; education, 4, 5; experimentation with materials, 26, 80, 82–84, 95–99, 151, 152, 154, 163, 165, 269n.80; figural subjects, 23–25, 40, 43–44, 62, 64, 65, 215, 262n.1; on fourth dimension, 130, 208, 212; on gender bias, 222–223; glass paintings, 85, 89, 113, 114–115, 116–118, 136, 139, 151, 152–154, 178, 188, 189, 215, 236, 274n.81; health, 132, 157, 168, 179, 215, 234, 238, 239, 277n.50, 286n.127, 291n.5; as historian, 207–209, 211–213; on Ibsen, 52, 260n.53; and Kennedys, xviii, 175, 238; on linear perspective, 25, 124–125, 133, 134, 183, 184–185, 199; and machine, 28–48, 140, 147, 179, 269n.78; machine/marine paintings, 28–48, 83, 86, 90, 95, 120, 148, 196–197, 201; marriages, 8–9, 63, 142–143, 173, 179, 161, 195, 205, 227, 233, 234, 236, 253n.29, 287n.133, 288n.149, 289n.170; on memory, 209–210, 226; on "mind," 130, 191, 193, 195, 196, 203, 210–211, 293n.48; nicknames, 4, 170, 171; and numerology, 175; and occult, 4, 6–7, 142, 147, 148, 149–150, 151; on "One," 170–171, 173, 197; parchment, 97, 151, 154, 162, 215, 234, 236; on "perceptions," 186–188, 192, 203; philosophical writings, xvii, xviii, 14, 92, 129–130, 131, 159, 213, 215–216, 217; photograms, 118, 178, 274n.81;

on plagiarism 226–227, 300n.41; poetry, xvii, 4, 213, 216, 287n.133; under psychoanalysis, xviii, 168, 173, 235; radio broadcasts, 63, 235, 236, 266n.35; religion, 4, 238; on Renaissance, 25, 133–134, 188, 211–212, 219, 256n.95; research methods, xviii, 17, 82, 135, 179, 180, 192, 208–209; on "rhythms," 149, 151, 175, 192; and Sahara, 27, 170; separations and divorces, xviii, 9, 64, 227, 234, 235, 236, 237, 263n.6, 287n.148; signature, xvii–xviii, 6, 22, 29, 112, 165, 237, 239; singing, 151, 282n.56; social realist works, 28, 52–53, 62; spatial planes, 121–123, 156, 201; on spectator, 183, 184, 187, 188–189, 191, 201–203; store windows, 223, 236; on "suppression" of work, 51, 217–218, 225, 226, 237; and synchronicity, 175; textile designs, 5, 100, 113; trip to France and Africa (1931), 19–20, 23, 25–27, 31, 170; on "void," 186, 193–194, 197, 210, 220, 295n.66; working habits, 1, 25–26, 218, 277n.50, 278n.8; writings, in India, 182, 213, 238, 297n.105; writing style, 169, 182, 183, 208, 217

—lectures: "Art in Industry," 67, 234; for Artists' League of America, 234; "Cubism and Abstract Art" 83, 234, 283n.93; "Encaustic Methods and Materials," 237; "Historical Survey of Abstract Art," 135, 234, 261n.79; at Hofstra College, 237; "Light and the New Reality," 236; "The Logos Principle," 238; "New Materials and the Artist," 84–85, 100, 234; "Perspective vs. Space-Time," 132–133, 136, 152, 234, 261n.84, 280n.44, 282n.65; "The Self-Destroying Machinery of Mindless-